Manga! Manga!

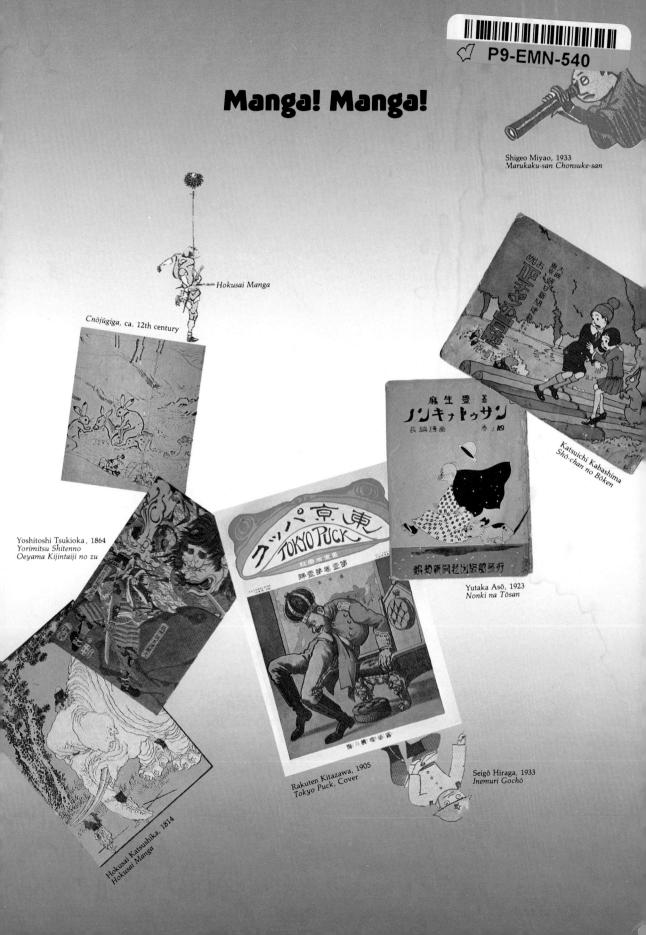

Shigeo Miyao, 1933
Marukaku-san Chonsuke-san

Hokusai Manga

Cnōjūgiga, ca. 12th century

Katsuichi Kabashima
Shō-chan no Bōken

Yoshitoshi Tsukioka, 1864
*Yorimitsu Shitenno
Oeyama Kijintaiji no zu*

Yutaka Asō, 1923
Nonki na Tōsan

Rakuten Kitazawa, 1905
Tokyo Puck, Cover

Seigō Hiraga, 1933
Inemuri Gochō

Hokusai Katsushika, 1814
Hokusai Manga

Ippei Okamoto, ca. 1930
*Warenomika Shaka mo
Daruma mo...Yatsushikeri*

Bontarō Shaka, 1937
Manga Hatsumei Tanteidan

Taisei Makino &
Suimei Imoto, 1930
Nagagutsu no Sanjūshi

Keizō Shimada, 1934
Bōken Dankichi

Shigeo Miyao, 1933
Marukaku-san Chonsuke-san

Sakō Shishido, 1935
Supīdo Tarō

Suihō Tagawa, 1935
Norakuro Sōchō

Suihō Tagawa, 1939
Norakuro Tankentai

Gajō Sakamoto, 1935
Tankutankurō

Noboru Ōshiro, 1940
Kasei Tanken

Kikuo Nakajima, 1937
Hinomaru Hatanosuke

Yutaka Asō, 1935
Kunsuke-kun

Ryūichi Yokoyama, 1950
Fuku-chan no Mametāzan

Hidezō Kondō, 1944
Cover to *Manga*

Etsūrō Katō, (ed.), 1943
Zōsan Manga

Takashi Haga, 1939
Bōya no Mitsurin Seifuku

Takeo Nagamatsu, 1947
Ogon Batto

Osamu Tezuka, 1952
Tetsuwan Atomu

Shōsuke Kuragane, 1952
Ammitsu-hime

Osamu Tezuka, 1954
Ribon no Kishi

Shōtarō Ishimori, 1960
Harimao

Mitsuteru Yokoyama, 1956
Tetsujin 28-gō

Fukujirō Yokoi, 1952
*Fushigi no Kuni no
Putchā*

Masao Tanaka, 1948
Bū-chan no Uchū-hikōtei

Kon Shimizu, ca. 1950
Kappa-ku Hatchō

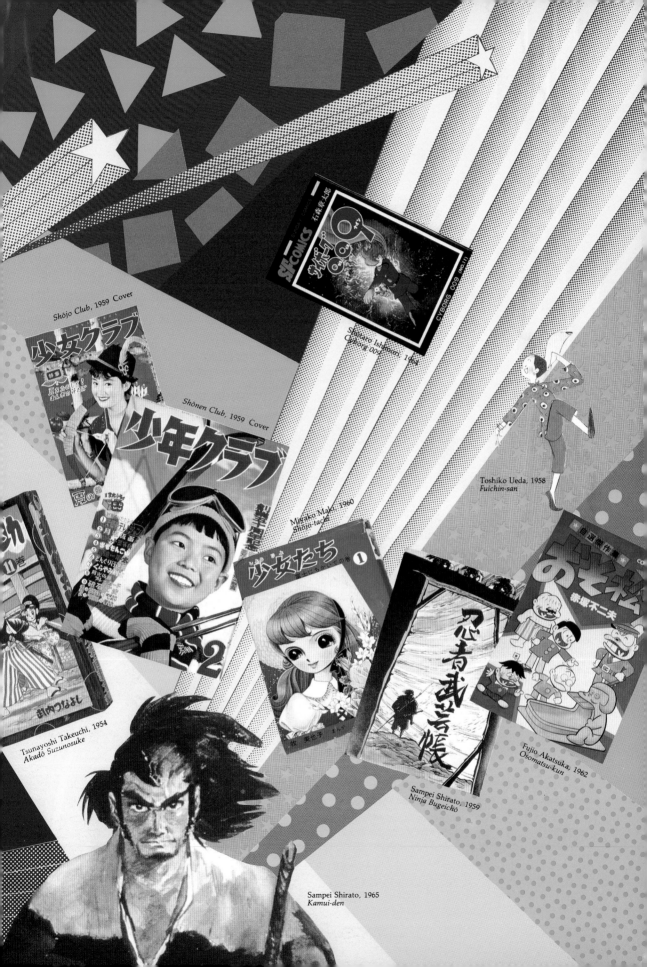

Shōjo Club, 1959 Cover

Shōnen Club, 1959 Cover

Shūtarō Ishinomori, 1964
Cyborg 009 (No.10)

Toshiko Ueda, 1958
Fuichin-san

Miyako Maki, 1960
Shōjo-tachi

Tsunayoshi Takeuchi, 1954
Akadō Suzunosuke

Fujio Akatsuka, 1962
Osomatsu-kun

Sampei Shirato, 1959
Ninja Bugeichō

Sampei Shirato, 1965
Kamui-den

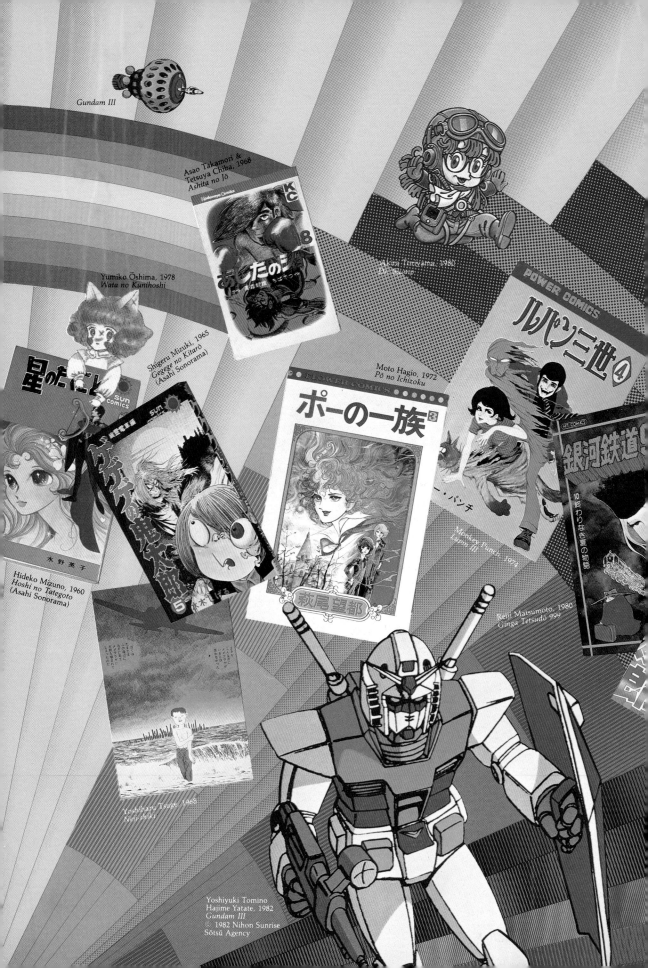

Gundam III

Asao Takamori &
Tetsuya Chiba, 1968
Ashita no Jō

Akira Toriyama, 1980
Dr. Slump

Yumiko Ōshima, 1978
Wata no Kunihoshi

Shigeru Mizuki, 1965
Gegege no Kitarō
(Asahi Sonorama)

Moto Hagio, 1972
Pō no Ichizoku

Hideko Mizuno, 1960
Hoshi no Tategoto
(Asahi Sonorama)

Monkey Punch, 1974
Lupin III

Keiji Matsumoto, 1980
Ginga Tetsudō 999

Yoshiharu Tsuge, 1968
Neji-shiki

Yoshiyuki Tomino
Hajime Yatate, 1982
Gundam III
ⓒ 1982 Nihon Sunrise
Sōtsū Agency

Manga! Manga!

The World of Japanese Comics

Frederik L. Schodt

Foreword by Osamu Tezuka

KODANSHA INTERNATIONAL
Tokyo • New York • London

Big Comic, 1980 Cover

Shonen Magazine, 1980 Cover

Keiko Takemiya, 1980
Tera e (Asahi Sonorama)

Fujio Akatsuka, 1970
Mōretsu Atarō

Kazuo Umezu, 1976
Makoto-chan

Shōnen Sunday Comics

Shūkan Manga Times, 1980
Cover figure

Kaoru Miyamoto, 1976
Haikara-san ga Tōru

Want to know what's inside these Japanese comics?
Excerpts begin on page 159.

PHOENIX
(Hi no Tori)
BY OSAMU TEZUKA
See pages 160-187

GHOST WARRIOR
(Bōrei Senshi from the series *Senjō)*
BY REIJI MATSUMOTO
See pages 188-214

THE ROSE OF VERSAILLES
(Berusaiyu no Bara)
BY RIYOKO IKEDA
See pages 215-237

In memoriam: Osamu Tezuka, revered by all Japanese as the "god of *manga*," died on the morning of February 9, 1989, at the age of 60. A remarkable artist, he entertained and inspired millions, and made *manga* a serious medium of expression, as well as a social phenomenon. His spirit, and his stories, will live forever.

Distributed in the United States by Kodansha America, Inc., 114 Fifth Avenue, New York, N.Y. 10011, and in the United Kingdom and continental Europe by Kodansha Europe Ltd., 95 Aldwych, London WC2B 4JF. Published by Kodansha International Ltd., 17-14 Otowa 1-chome, Bunkyo-ku, Tokyo 112, and Kodansha America, Inc.

First edition, 1983
First Paperback edition, 1986
95 96 97 98 99 10 9 8 7

ISBN 4-7700-1252-7 (in Japan)

Library of Congress Cataloging in Publication Data

Schodt, Frederik L., 1950-
 Manga! Manga! the world of Japanese comics
 Bibliography: p.
 Includes index.
 1. Comic books, strips, etc.—Japan—History and criticism.
I. Title.
PN6790.J3S3 1983 741.5'0952 82-48785
 ISBN 0-87011-752-1 (U.S.)

BAREFOOT GEN
(Hadashi no Gen)
BY KEIJI NAKAZAWA
See pages 238-256

Contents

publication of this book
was assisted by a grant from
the Japan Foundation

Foreword

Comics are flourishing today in America and Western Europe and in all the socialist nations of the world, where they play an important role in information transmission and help shape the feelings and attitudes of children and young adults. The situation in Japan is no different. Each year, printing presses on this little island nation in the Far East churn out hundreds of millions of comic books and magazines for tens of millions of readers. There are over 3,000 active artists. Comics in Japan have not prospered so much as exploded into a phenomenon of extraordinary proportions. Just as incredible, however, is that information about Japan's vast comics culture is hardly available at all in the West, and individual comic stories are rarely introduced to Western readers.

The isolation of the Japanese comic clearly has to do with the way it is published. Captions and word balloons of Japanese comics must of course be printed in Japanese, which is totally indecipherable to foreign readers; translations are rarely provided. Also, Japanese comics, like other Japanese publications, open and are read from right to left, making them hard to follow visually for people used to reading in the opposite direction. Simply as an object to be read, then, a Japanese comic in its raw form is not easily accepted in the West. Rather, it is ignored.

There is also the matter of cultural distance. The Japanese comic is designed for Japanese readers who share particular attitudes and customs, many of which are unknown outside of Japan. There are, therefore, going to be lots of Japanese comics that simply cannot be understood unless the reader is Japanese. But this is really not the obstacle it might first appear to be, for there are also numerous Japanese comics that can be fully understood—and enjoyed—on an international level, as many foreign fans who can read Japanese comics in their original form will attest to.

This is why Japanese animation—which is dubbed and doesn't confuse the viewer by "reading" in one direction or another—has been able to open the door for Japanese comics overseas where printed materials have failed. Having solved the problem of language, animation, with its broad appeal, has in fact become Japan's supreme goodwill ambassador, not just in the West but in the Middle East and Africa, in South America, in Southeast Asia, and even in China. The entry port is almost always TV. In France the children love watching *Goldorak. Doraemon* is a huge hit in Southeast Asia and Hong Kong. Chinese youngsters all sing the theme to *Astro Boy.*

Thanks to animation, people in other countries have begun to learn what Japanese comics are like. Fans go off in search of comics based on their favorite feature-length animation films and in doing so come across other

kinds of Japanese comics. Contacts between Japanese comic artists and animators and their counterparts in other nations have grown more and more productive, and here and there one now begins to spot items about the world of Japanese comics in foreign papers and magazines.

Still, foreigners living in Japan are duly amazed when they first discover just how big the boom in Japanese comics has become. Daily they are surrounded by examples of the vitality of comics culture that would be unthinkable in their own countries. A Japanese businessman on his way to work sits on the train with his nose buried in a children's comic book. That same comic, in a single week, might sell 2.5 million copies. And in that same week on TV there will be more than thirty brand-new episodes in Japanese-made comic-animation series.

As this book explains, the Japanese comics industry first began to show signs of heating up to this fever pitch after World War II. Western comics were imported by the bushelful, and had a tremendous impact. I had a degree in medicine and a license to practice, but the times were such that I was drawn to the utterly different field of cartooning. I debuted as an artist the same year the war ended, and so have seen all the twists and turns that mark the extraordinary growth of Japanese comics over the last nearly forty years.

My experience convinces me that comics, regardless of what language they are printed in, are an important form of expression that crosses all national and cultural boundaries, that comics are great fun, and that they can further peace and goodwill among nations. Humor in comics can be refined and intellectual, and it has the power to raise the level of all people's understanding. I believe that comics culture will continue to grow and develop.

This book will undoubtedly further the cause. I first met its author, Frederik Schodt, when he was living in Japan, several years ago now. He was interested in Japanese comics and was working with his friend on translating them into English. He came to my studio one day to tell me of his wish to do an early work of mine, *Hi no Tori* ("Phoenix"). Needless to say, the translation was a great success. Since then Fred has rendered several other comic stories into English, and he has assisted in the editing of the English version of my animation film *Phoenix 2772*.

Fred's reasons for writing this book? His love for Japanese comics is second to none, and he wanted to analyze their tremendous success. In addition, he wanted to look at Japan's popular culture, at Japan's young people and at what they are thinking and feeling. And he wanted to seek out the Japanese character and identify the wellspring of Japanese vitality. To his task he has brought years of first-hand experience living and working in Japan, and a fresh sensibility marked by deep understanding and sharp critical perception.

Fred started work on this book several years ago. Comics culture, however, keeps changing with the changing times, and so for Fred it has been a constant process of coming to grips with the new and entering revisions into his text. The work you have before you now therefore contains the most up-to-date information available. It is a true picture of comics culture in Japan. Of this you have my guarantee.

Osamu Tezuka

A Thousand Million Manga

AHEM . . .

This book was originally published in hardcover form in 1983, and some works presented as current then are no longer so. All, however, are part of a wider national mythology, and their heroes and heroines stand as essential cultural archetypes. Wherever space and budget allow I have tried to at least update statistics on the industry, and I hope at a future date it will also be possible for me to feature some of the newer artists. A word to the growing legion of fans of Japanese comics in the West: what you are about to read is one person's view of a huge literary and social phenomenon, and has been based on extensive interviews, personal experience, and more reading of comics than is normally wise to admit to. In writing about an industry where a single popular work can run to two dozen volumes and several thousand pages, I have had to make some hard decisions about what to include, and I ask the indulgence of anyone who feels my treatment of a favorite artist or comic has been cursory or cruel. I should mention here that the macron or "long signs" which appear frequently on vowels when Japanese words are transcribed into Roman letters serve to "double" the length of the vowel sound but can most of the time be ignored when pronouncing in English. Also, readers will notice that comic titles in Japan use lots of English words, and not always as native speakers would use them. When the pronunciation of a Japanese word in a magazine or story title is close to the English original I have at times not given the Japanese romanization but simply provided the intended English word instead. Finally, the Japanese comics reproduced in the main text appear in their original form; the sequence of events is usually from right to left, the reverse of normal Western order. End of Speech.—F.L.S.

Over 5 billion books and magazines were produced in Japan in 1984, making it one of the world's most print-saturated nations. But 27 percent of this total, or roughly 1.38 billion, were comics—*manga*—in magazine and book form. As some enterprising reporters have discovered, Japan now uses more paper for its comics than it does for its toilet paper.

What are Japanese comics? Syndicated comic strips, which fill an entire page of most American daily newspapers, do not exist in Japan. Each Japanese newspaper has its own four-panel family strip, barely visible on the next-to-the-last page. Color supplements appear, but there are no "Sunday Funnies" in the American tradition. And political and social satire cartoons, which once thrived, have withered in size and significance.

The most common form of Japanese comic today is the story-comic. It is first serialized in comic magazines and then compiled into books, and in its entirety may be thousands of pages long. The comic magazines—where most Japanese comics first appear—are targeted separately at boys, girls, men, and women, but all are today characterized by an increasing crossover of readership. They bear little resemblance to American comic books (fig. 1).

The American term "comic book" is in fact a misnomer for a magazine of thirty or so color pages, many of which today are advertisements. It is purchased, almost without exception, by young boys who read it and by adult men with comic book collections. Sales of the American comic book have declined dramatically since the 1950s, when the industry was nearly destroyed by overregulation and competition from television. Issued monthly, a circulation of 300,000 is unusual. There are no weeklies.

The most widely read comic magazines in Japan are what are loosely known as *shōnen manga* ("boys' comics") and

shōjo manga ("girls' comics"). They have squared, glued backs, and are as thick as telephone books. The average boys' comic magazine, at less than a dollar, is quite a bargain: it has 350 pages and contains as many as fifteen serialized and concluding stories—only 10 or 20 pages are devoted to ads or text. The cover and the first few pages are printed in eye-catching color on glossy paper, but unlike American comics the stories inside are in monochrome. As if to compensate, the first story may be printed in black ink with one color—such as red—overlaid. For variation, the rest of the stories may be printed on different shades of paper, usually rough and recycled.

Few magazines of any kind anywhere in the world can match the circulations of the Japanese boys' comic magazines. In 1984 the top four, *Shōnen Jump*, *Shōnen Champion*, *Shōnen Magazine*, and *Shōnen Sunday*—all weeklies—had combined sales of nearly 8.5 million. *Shōnen Jump* sometimes sells over 4 million copies a week. The popular American magazine *Newsweek* sells about the same number of copies as *Shōnen Jump*, but Japan's population is only half that of the United States.

Japanese girls' comic magazines follow the same basic format as those for boys, but only two are weeklies. Far more girls' comic magazines take the form of biweeklies, monthlies, and special supplements. Again, circulations over 1 million are common—and so are single volumes with over 600 pages.

Adults in Japan also have their own magazines. Comic magazines originally targeted at young men, called *seinenshi*, or "young men's magazines," now have readers in their forties. Although they are printed in much the same fashion as children's magazines, they usually contain two or three hundred pages, folded and stapled rather than glued. There are five weekly magazines, and dozens of biweeklies and monthlies. *Big Comic*, the most popular adult biweekly, boasts a circulation over 1 million.

Adult women have been the last group in Japan to have their own comic magazines and until recently had no choice but to read those designed for teenage girls, or those of a boyfriend or husband. But in 1980 publishers finally moved to fill this hole in demand with two monthlies, *Be Love* and *Big Comic for Lady*. By 1985 there were eighteen.

New experiments throughout the comic industry are continually being made. Weeklies, biweeklies, and monthlies specializing in science fiction, pornography, sports, or children's stories may hit the stands one week and be gone the next. A tiny publisher may disappear along with its magazine. The only thing most magazines have in common is an English word in the title, an unstated requirement for success.

Japanese comics are not limited to the comic magazines. The major book publishers such as Kōdansha and Shōgakkan own the most popular comic magazines, so when a story serialized in a magazine proves to have lasting popularity it is compiled into paperback form and sold through regular book distribution channels (fig. 2). These comic paperbacks are a means of preserving the best of what is otherwise thrown away. They employ a superior grade of paper, contain a

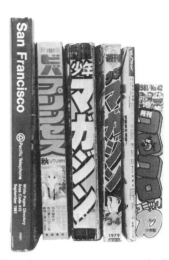

1. Typical comic magazines, next to the San Francisco telephone book.· From left to right, with number of pages: Viva Princess *(506), a girls' comic supplement;* Shōnen Magazine *(468), a boys' monthly;* Shōnen Magazine *(378), same title as preceding but a boys' weekly;* Manga Action *(240), an adult weekly; and* Korokoro Comic *(632), a young boys' monthly.*

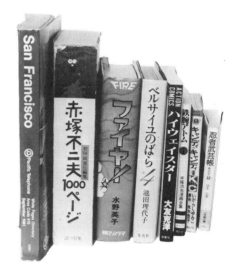

2. Different sizes of comics in book form. From left to right: Akatsuka Fujio 1,000 Pēji *("1,000 Pages of Fujio Akatsuka");* Hideko Mizuno's Fire!; *Riyoko Ikeda's* Berusaiyu no Bara *("The Rose of Versailles"), a 5-volume, deluxe hardbound series; Katsuhiro Ōtomo's* Highway Star, *a single-volume collection of short stories; Osamu Tezuka's* Tetsuwan Atomu *("Mighty Atom"), part of a 300-volume collection of Tezuka's works; Yumiko Igarashi and Kyōko Mizuki's* Candy Candy, *a 9-volume series; Shirato Sampei's* Ninja Bugeichō *("Chronicle of a Ninja's Military Accomplishments"), a 17-volume series.*

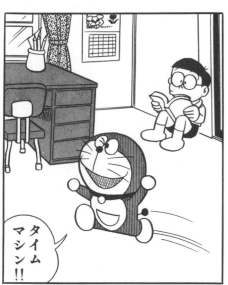

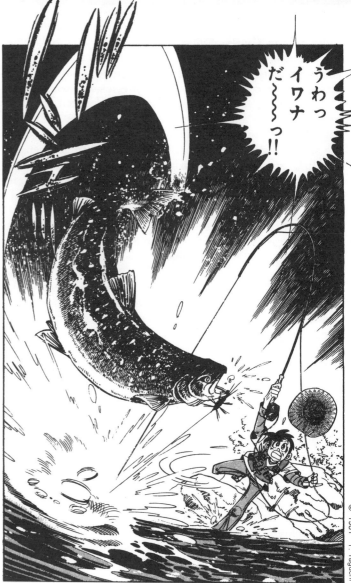

3. Fujio-Fujiko's *Doraemon*, the atomic-powered robot cat, suddenly materialized from the top drawer of young Nobita's desk one day, and thereafter charmed the children of Japan. The desk drawer was a gateway to the Fourth Dimension, and so was Doraemon's kangaroolike pouch, which could produce almost anything Nobita wanted. Doraemon first appeared in a Shōgakkan magazine in 1970 but didn't take off until animated for television in 1979. Japan has subsequently been swamped by Doraemon *comics and merchandise.*

4. Sampei tries fly-casting and hooks a huge char. Takao Yaguchi's *Tsurikichi Sampei* ("Fishing-Crazy Sampei"), serialized from 1973 in Kodansha's Shō-nen Magazine, *combines a strong love of nature with an encyclopedic knowledge of fishing.*

ESTIMATED SALES*	
BOYS' WEEKLIES	
Shōnen Jump	2,600,000
Shōnen Magazine	1,800,000
Shōnen Sunday	1,800,000
Shōnen Champion	1,800,000
Shōnen King	600,000
GIRLS' MONTHLIES	
Ribbon	1,700,000
Nakayoshi	1,600,000
Bessatsu Margaret	1,400,000
Bessatsu Shōjo Friend	1,100,000
*Asahi newspaper, 7 May 1980	

minimum of 200 pages, and retail for anywhere from two to three dollars. For the connoisseur, there are expensive hard-bound editions.

When published in a series, comic paperbacks comprise many volumes, and their sales can skyrocket. Fujio-Fujiko's comedy tale of a robot cat, *Doraemon*, began serialization in a Shōgakkan magazine in 1970 and has already been compiled into a series of thirty-three paperback volumes; over 55 million copies have been sold (fig. 3). *Tsurikichi Sampei*, a tale of fishing by Takao Yaguchi, began serialization in a Kōdansha magazine in 1973 and by 1984 consisted of sixty-five volumes with sales of over 19 million copies (fig. 4). In contrast, as of 1983 the best-selling novel in world publishing history reportedly was Jacqueline Susann's *Valley of the Dolls,* with 27 million copies sold since publication in 1966.

Finally, there is also a trend of publishers serializing comic stories in magazines that have traditionally emphasized only articles with photographs. Why? Because in Japan today, anything with comics sells.

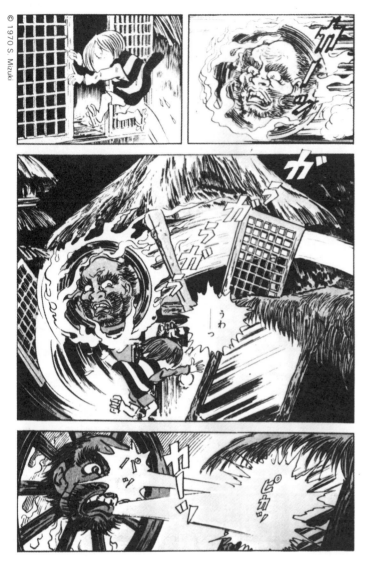

© 1970 S. Mizuki

5. *Kitarō flees from a flaming wheel-demon in* Hakaba no Kitarō *("Graveyard Kitarō"), created by Shigeru Mizuki and serialized in* Shōnen Magazine *in the mid-1960s. Mizuki is Japan's foremost creator of ghost stories, with images and ideas culled from Japan's rich folklore.*

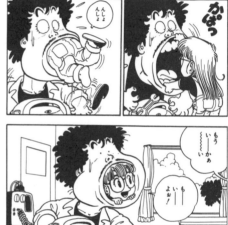

6. *Little Arare, a girl/android robot, uses the mouth of her inventor as a refuge during a game of hide-and-seek.* Dr. Slump, *as Akira Toriyama's story was titled, was the biggest hit of 1981 when it appeared in* Shōnen Jump *and ushered in a new level of artwork for humor strips.*

THEMES AND READERS

The themes of Japanese comics are even more varied than their readership. The huge boys' comic magazines carefully balance suspense with humor: dramatic stories of sports, adventure, ghosts, science fiction, and school life are interspliced with outrageous gag and pun strips (figs. 5, 6). Girls' comic magazines also strive for balance but are distinguished by their emphasis on tales of idealized love, featuring stylized heroes and heroines, many of whom look Caucasian. Adult magazines have themes which range from the religious to the risqué, mostly emphasizing the latter, and teem with warriors, gamblers, and gigolos.

In all categories of comics there has been a trend towards increasing sophistication. Readers today demand, and artists supply, more than simple boy-meets-girl and justice-triumphs-over-evil plots. Osamu Tezuka has for years been creating an epic tale of the life of the Buddha (fig. 7). Reiji Matsumoto, in his story, *Otoko Oidon* ("I Am a Man"), has parodied the pathetic life of what in Japan is called a *rōnin*, or student who has not yet found a university to accept him (fig.

7. *After meditating under the bodhi tree, the young Siddhartha propounds, "Birds, butterflies, bees, ants, and nameless grasses. . . . I now know that we are like brothers and sisters." From* Buddha, *by Osamu Tezuka, serialized from 1972 in* Comic Tom.

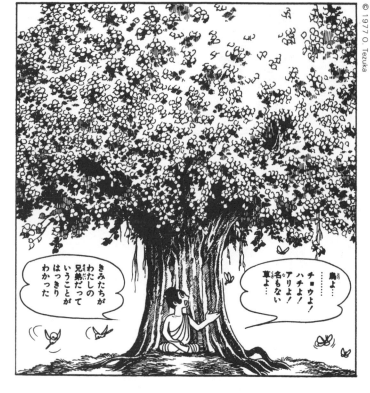

8. *Nobotta Ōyama attempts to fry an egg with a light bulb on top of his physics textbook. Ōyama was the hero of Reiji Matsumoto's 1971–73 series in* Shōnen Magazine, Otoko Oidon *("I Am a Man")—a student without a university who lived in a tiny apartment, owned sixty-four pairs of striped boxer shorts, and subsisted on a diet of instant noodles and mushrooms that he grew in his closet. Chapter title: "The Great Romance: The Great Ringworm."*

8). And Kazuo Kamimura, in *Dōsei Jidai* ("The Age of Co-habitation"), chronicled the psychological problems of two young people living together without being married (fig. 9).

The general consensus among readers in Japan today seems to be that comics have as much to say about life as novels or films. But surely one of their greatest accomplishments is to render visually fascinating the most improbable subjects—such as mah jongg, chopping vegetables, and even school examinations. This is done by exaggerating actions and emotions to the point of melodrama, and by paying loving attention to the minute details of everyday life. As the Japanese describe them, their comics are very "wet," as opposed to "dry"; that is, they are unashamedly human and sentimental.

At the same time, Japanese narrative comics are a very new and unpretentious medium, largely created by artists with little formal education and few aspirations towards literary fame, whose main goal is to entertain. Many comics are wild: scenes of violence, unnatural sex, and scatology are common, even in comics for children. Inevitably, many are also poorly executed. Many are trash. Yet all are an integral part of Japan's popular culture and as such reveal legacies from the past, ideals of love, attitudes to work and perfection, and a basic love of fantasy.

Who reads comics in Japan? Although publications specifically targeted at men, women, or children are plentiful, there is as well a considerable crossover in readership. In 1980, a survey by the National Federation of University Cooperative Associations of Japan showed that four of the ten most popular magazines among university students were *Shōnen Jump, Shōnen Sunday, Shōnen Champion,* and

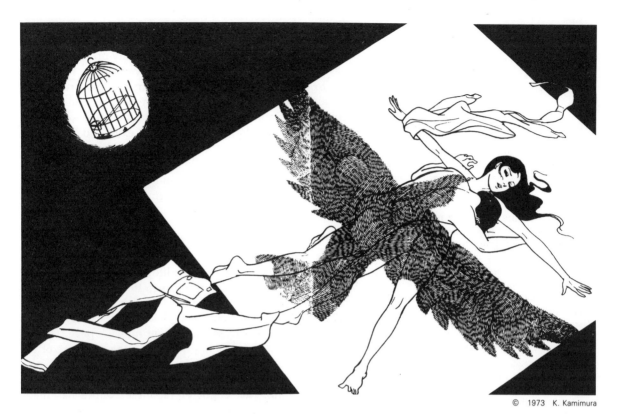

9. *A symbolic scene from a chapter dealing with incest, in Kazuo Kamimura's* Dōsei Jidai *("The Age of Cohabitation"). Dōsei Jidai was first serialized in the adult weekly* Manga Action *in the early 1970s, when young unmarried couples were experimenting with living together.*

Shōnen Magazine—all comic magazines originally designed for children. And it is not uncommon today on a train or bus to catch sight of an impeccably dressed company employee pulling a comic magazine out of his attaché case to read while commuting to work. The odds are that the little schoolboy next to him is reading the same magazine. Most shocking of all, many grown men have recently confessed that they love to read comics created especially for girls.

This has not always been the case. Fifty years ago, the reading patterns in Japan closely resembled those of the United States today. "Comic books" were for children and adolescents; adults contented themselves with newspaper editorial cartoons and the occasional comic strip. Then, after the war, with the advent of a strong narrative structure in stories for children's magazines, children growing up refused to relinquish their comics, and adults began reading material designed for children. The five major weekly boys' comic magazines that are the pillar of the comic industry today were originally targeted at ten- and eleven-year-olds. Yet their readership today ranges from the child to the middle-aged man. This shift in demand patterns has resulted in the creation of a new line of comic magazines for the elementary school child, and stimulated production of comics aimed solely at adults (fig. 10).

There are no reliable statistics available on the number of comic readers in Japan because sales and circulations do not reflect the growing network of people engaged in *mawashiyomi*, passing comics around or sharing them. Nonetheless, the over 1 billion comics published in 1984 represented about 10 for every man, woman, and child in Japan, or slightly over 27 for every household.

WHAT DO YOU CALL A COMIC?

The word *manga* (pronounced "mahngah") can mean caricature, cartoon, comic strip, comic book, or animation. Coined by the Japanese woodblock-print artist Hokusai in 1814, it uses the Chinese ideograms 漫 *man* ("involuntary" or "in spite of oneself") and 画 *ga* ("picture"). Hokusai was evidently trying to describe something like "whimsical sketches." But it is interesting to note that the first ideogram has a secondary meaning of "morally corrupt." The term *manga* did not come into popular usage until the beginning of this century. Before that, cartoons were called *Toba-e*, or "Toba pictures," after an 11th-century artist; *giga*, or "playful pictures"; *kyōga*, or "crazy pictures"; and, in the late 19th century, *ponchi-e*, or "Punch pictures," after the British magazine. In addition to *manga*, one also hears today the word *gekiga*, or "drama pictures," to describe the more serious, realistic story-comics. Some Japanese, however, simply adopt an English word to describe their favorite reading matter: *komikkusu*.

The result: comic magazines and books can be found everywhere there are people—on trains, in barbershops, beauty salons, restaurants, homes, company offices, and factories. Local bookstores may devote over half of their shelf space to comics and post large signs saying "No Browsing": their aisles are often so packed with people reading they become impassable (fig. 11). Train station kiosks, strategically located on platforms and near exits, do a roaring business during rush hour. And for those addicts who simply must have comics in the middle of the night, automatic vending machines litter the urban landscape; a semi-reflecting screen on their display window signifies content unsuitable for minors.

READING, AND THE STRUCTURE OF NARRATIVE COMICS

In order to digest such a mass of comics, the Japanese have to be fast readers. According to an editor of Kōdansha's *Shōnen Magazine*, who must know about such things, on the average it takes the reader twenty minutes to finish a 320-page comic magazine. A quick calculation yields a breakdown of 16 pages a minute, or 3.75 seconds spent on each page. How is this possible? The answer lies not just in the structure of the Japanese narrative comic but in the reading skills that new generations of Japanese have developed.

For one thing, the length of Japanese comics has made possible extensive use of purely visual effects (fig. 12). American comic artists have been gravely limited in space: daily newspapers only provide four or five frames (which have been shrinking over the years) and comic books rarely allot more than twenty pages per month per artist. In contrast, the typical Japanese comic artist has over thirty pages to use as he or she pleases—per week. When compiled into paperback, one story will often consist of ten volumes, or over two thousand pages. Thus, where American artists might use one cramped frame to depict a superhero punching an

10. *Contrasts: On a bullet train, traveling at over 100 miles an hour, a professional sumo wrestler reads the latest issue of the adult biweekly* Big Comic.

11. *Browsers fill the aisles of this comic specialty shop in Tokyo's Kanda district.*

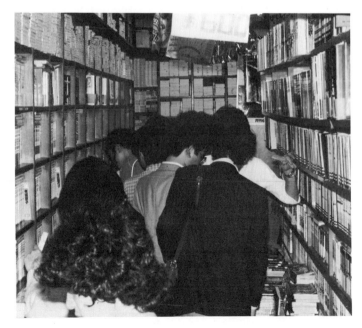

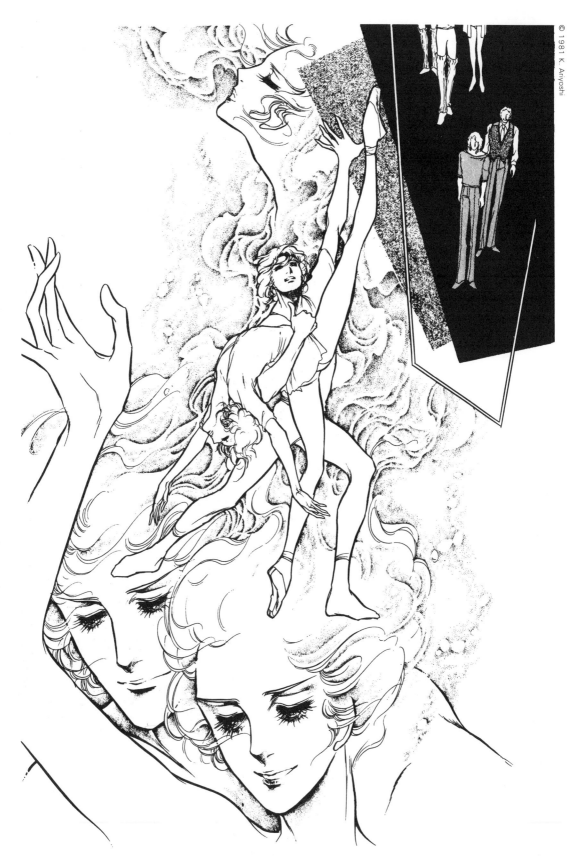

© 1981 K. Ariyoshi

12. *Masumi and Leon dance, stunning the onlookers in Kyōko Ariyoshi's* Swan, *a twenty-one-volume tale of life at the top of the ballet world, serialized in the girls' weekly* Margaret *from 1976 to 1981.*

13. BASHIIN! . . . The spike. An example of action drawing. From Sign wa V *("The Sign is V"), by Shirō Jimbo and Akira Mochizuki, which ran for three years from 1968 in* Shōjo Friend.

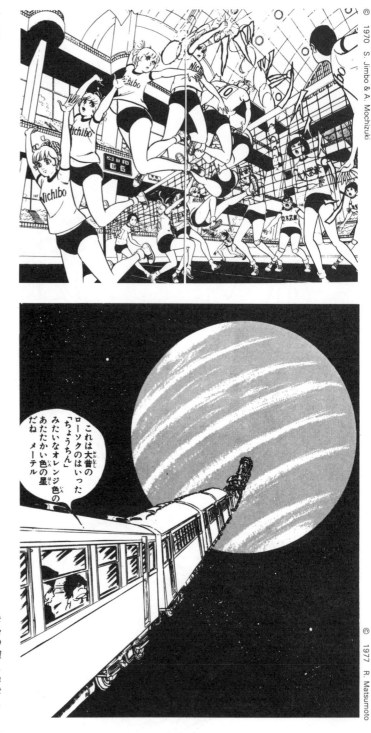

これは大昔の
ローソクのはいった
「ちょうちん」
みたいなオレンジ色の
あたたかい色の星
だね メーテル

14. Tetsurō and Meter head towards a giant orange star. Using an old steam locomotive as the fanciful vehicle for his story Ginga Tetsudō 999 *("Galaxy Express 999"), Reiji Matsumoto managed to create a mood both romantic and mysterious. Tetsurō, the hero, was in quest of a new body—an indestructible machine body—and on every planet the train stopped at a new adventure unfolded. Serialized from 1976 to 1981 in* Shōnen King.

alien villain, Japanese artists are likely to show a samurai warrior hacking away at an opponent over several pages, and to depict the action from a variety of "camera angles." Room to experiment has made Japanese artists experts at page layout. They have learned to make the page flow; to build tension and to invoke moods by varying the number of frames used to depict a sequence; to use the cinematic techniques of fade-out, fade-in, montage, and even superimposition (fig. 13).

Like Japanese poetry, Japanese comics tend to value the unstated; in many cases the picture alone carries the story. Just as a dramatic film might opt for a minute of silence, several pages of a comic story may have no narration or dialogue. The immensely popular science fiction comics of Reiji Matsumoto (fig. 14) have a lyrical, almost melancholy quality through use of this technique. *Kozure Ōkami* ("Wolf and Child"), a classic samurai story scripted by Kazuo Koike and drawn by Gōseki Kojima, is an extreme example. It consists of twenty-eight volumes, or around 8,400 pages. Sword fights sometimes last for 30 pages, with only the sound of blades clashing.

Over the years a variety of conventions that are mutually, wordlessly, understood by artist and reader have been accepted as typical story elements. The passage of time may be suggested by a picture of a rising or setting sun; a change of place may be indicated by a picture of a telephone pole or façade of a building; and a mood may be set by one frame of the comic showing a dead branch, a falling leaf, or a splashing tear (fig. 15). As in Japanese movies, symbolism is important. When two samurai duel to the death, the trees around them

COMICS AND THE BRAIN

What are the measurable effects of over one billion comic magazines and books a year on the people of Japan? No serious research has been done on this subject yet, but in one of a series of articles in the *Tōkyō* newspaper in early 1981 a neurophysiologist speculated that too much speed-reading of the type younger comic readers engage in might not provide much exercise to the synapses in the frontal lobes of the brain and could result in a lack of discipline. But he noted that since comics combine language and pictures, they stimulate both right and left hemispheres and should contribute to improved design capability and pattern recognition. He approved comic reading in moderate doses. A top engineer at Mitsubishi Plastics said that, based on the visual techniques of Sampei Shirato's comics, he and his men had developed a special method of design conceptualization, the results of which had already been manifested in improved plastics and in factory layouts. Others—psychologists, educators, and researchers—said that comics can transmit important information more effectively than text alone; that they develop in readers an ability to quickly perceive the essence of a problem without relying on linear logic; and that they may be a factor in the dexterity with which young Japanese handle computers and related software.

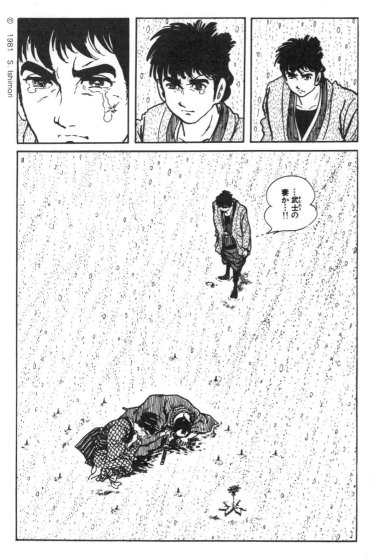

15. *Sabu, a detective in the Edo period (1600–1867), comes across the bodies of a samurai and his lover, a commoner. Forbidden to marry, they have chosen death in the classical manner: the man slitting his belly; the woman binding her legs and stabbing herself in the throat. As the blood seeps into the snow, a spring flower blooms. From* Sabu to Ichi Torimono Hikae *("Detective Tales of Sabu and Ichi"), by Shōtarō Ishimori, serialized from 1968 to 1972 in* Big Comic.

16. Jumpei, the young apprentice fisherman, dresses in his finest and rehearses telling his girlfriend that he loves her . . . but recoils in embarrassment at the thought. The monologue is written both vertically and horizontally. From Tosa no Ipponzuri ("Pole and Line Fishing in Tosa"), by Yūsuke Aoyagi, serialized since 1978 in Big Comic.

17. "Draw the bow back, behind your ear! All the way! More! More! Draw it all the way! All the way!" Hiroshi Hirata is one of the few artists who use calligraphy for dialogue. Words become part of the drawing. From Shikon ("Samurai Spirit"), serialized in the early 1970s.

are usually barren of leaves. And when a hero dies in a story, the last frame on the comic page may show only a few cherry blossoms fluttering to the ground, a poignant metaphor of the fleeting quality of life. Captioned phrases such as "Meanwhile, back at the ranch . . . " or "Fueled by fury, he lashed out at the slavering beast!" are not necessary. Important information is given either in the dialogue or in the picture itself.

Japanese artists in all media have traditionally used a spare approach, concentrating on caricature or on revealing the overall "essence" of a mood or situation. They have favored simplicity of line. Comic artists are the same, so with no coloring, and with shading at a minimum, the mere curve of a character's eyebrow takes on added significance. An example is Yūsuke Aoyagi's popular series about life in a fishing village, Tosa no Ipponzuri ("Pole and Line Fishing in Tosa"); fans are fascinated by the way he has cataloged the subtle facial expressions and gestures of rural Japanese folk (fig. 16).

At the same time, Japanese art styles can bewilder Westerners. It is common, for example, for artists to create a very serious story in a "cartoony" style, or to draw humans in an abbreviated, caricatured style against a superrealistic background. And the emphasis on long stories can sometimes lead to shoddy draftsmanship. A right-handed character may suddenly become left-handed, or the pattern on someone's clothes may be reversed, or even disappear. Why spend several hours drawing a page of a comic magazine if it is to be read in 3.75 seconds?

A second factor influencing reading patterns is the Japanese language itself (fig. 17). Depending on whether one lives in the Western or Eastern hemisphere, Japanese comics are, or are not, read "backwards"; that is, all panels and pages move sequentially from right to left. Usually the writing in each

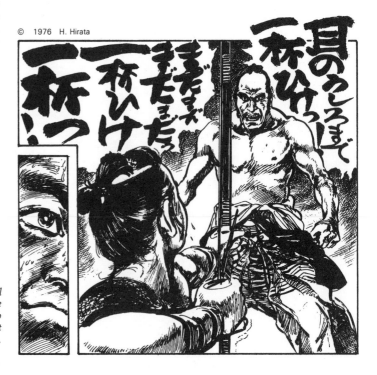

dialogue balloon is vertical and is read from top-to-bottom and right-to-left. But in fact the language can be written in any direction except from the bottom of the page to the top. This flexibility can work as an aid in creative layouts. Titles and onomatopoeia, or sound effects, for example, can be directed to enhance and control the visual flow of the page.

What gives the page even more flexibility is the fact that the Japanese language employs not one, but four entirely separate writing systems: ideograms imported from China; two different syllabic scripts, *hiragana* which is cursive, and *katakana* which is more angular; and the Roman alphabet. The word *manga*, for "comics," transcribed into each of the four systems would look like 漫画, まんが, マンガ, MANGA, respectively. Japanese people normally write a blend of all four systems, but by being selective an artist can create different moods.

When a Chinese person appears in a comic story, his dialogue balloon is liable to show he is Chinese by using many vertically arranged ideograms—for this is what written Chinese text actually looks like. If a Westerner is speaking, his dialogue balloons may be written horizontally in the angular *katakana*—a script usually reserved for foreign-derived words; if the artist is daring, he may throw in some actual English. Sound effects, the equivalent of BANG! POW! etc., are generally written in *katakana*, unless a softer effect is desired—then the more cursive *hiragana* is employed. Finally, comic titles can be written in any of the four writing systems, according to the whim of the artist; the Roman alphabet and English words tend to have an exotic appeal.

It is in the realm of sound effects that the Japanese language performs magic. American comics have a long tradition of using words to represent sounds, but they are usually limited to describing explosions (BAROOM!), fists impacting on jaws (POW!), and machine guns zapping away at Commies (BUDABUDABUDA). The Japanese have won the war of words. They have sounds that represent noodles being slurped *(SURU SURU)*, umpteen types of rain *(ZĀ, BOTSUN BOTSUN, PARA PARA)*, and the sudden flame from a propane cigarette lighter *(SHUBO)*. In recent years artists have wrought miracles of paradox: the use of sound to depict silent activities and emotions. When a ninja warrior-assassin vanishes in mid-air the "sound" is *FU*: when leaves fall off a tree the sound is *HIRA HIRA*; when a penis suddenly stands erect the sound is *BIIN*; when someone's face reddens in embarrassment the sound is *PŌ*; and the sound of no sound at all is a drawn-out *SHIIIN*. Artists regularly vie for the cleverest use of onomatopoeia. Osamu Tezuka is reported to have begun using the silent *SHIIIN*, and Yukio Kawasaki created a bit of a stir with *SURON*, the sound of milk being added to coffee (figs. 18–20).

The total effect of the above is speed reading. In contrast to the American comic, which is read slowly to savor lavishly detailed pictures and to absorb a great deal of printed information, the Japanese comic is scanned. In a sense it demands more of the reader, because he must actively seek out the clues on the page and interpret them. The typical young Japanese reader skims over the page with his eyes, moving

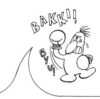

© 1980 Y. Kawasaki

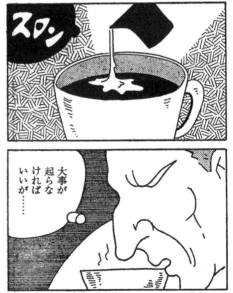

18. Top panel: SURON. Cream melts into coffee. From Tenkiden *("Strange Cosmic Tales"), a 1980 short story by Yukio Kawasaki.*

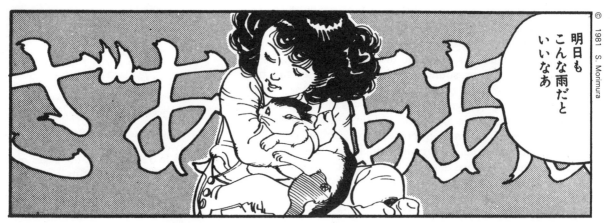

明日も
こんな雨だと
いいなあ

19. "Gee, I hope it rains like this tomorrow," says Noriko, hugging her cat. In the background, ZAAAA, the sound of heavy rain, written in the cursive hiragana script. From a 1981 short story in the collection Adamu no Okurege ("Adam's Stray Locks"), by Shin Morimura, serialized in Manga Action.

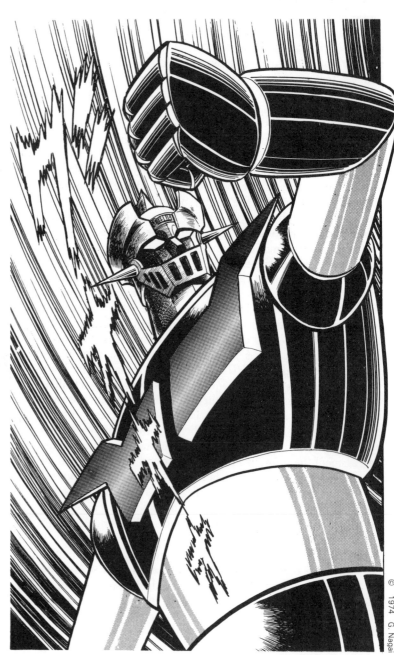

20. GUOOOO!! With a vertical roar written in the angular katakana script, the giant warrior-robot Mazinger Z moves into action, controlled by a young man in a cockpit inside its head. From Mazinger Z, by Gō Nagai, which began serialization in 1972 in Shōnen Jump.

forward and back, absorbing the information the drawings contain and augmenting it with the printed word. Taking in the page as an integrated whole is an acquired skill, like slurping a bowl of piping hot Japanese noodles, in seconds, without chewing.

WHY JAPAN?

Of all the nations of the world, why should Japan alone develop a comics phenomenon of this magnitude? It is possible that to an extent the Japanese are predisposed to more visual forms of communication owing to their writing system. Calligraphy—still practiced in Japan—might be said to fuse drawing and writing. The individual ideogram, in its most basic form, is a simple picture that represents either a tangible object or an abstract concept, emotion, or action. The earliest ideograms, in China, looked much more like what they were meant to represent than they do today. They were, in fact, a form of cartooning (fig. 21).

Over fifty years ago, Sergei Eisenstein, the Russian film-maker, perceived a link between the ideogram and what he called the inherently "cinematic" nature of much of Japanese culture. The process of combining several "pictographs" to express complex thoughts, he said, was a form of montage that influenced all Japanese arts, and he added that his own studies of ideograms had helped him understand the principle of montage on which filmmaking is based. More recently, artist Osamu Tezuka has said of the drawings in his comics: "I don't consider them pictures—I think of them as a type of hieroglyphics. . . . In reality I'm not drawing. I'm writing a story with a unique type of symbol."

Comics, however, could not have become an integral part of Japanese culture unless there was a genuine need for them. To be sure, the small child in Japan reads comics for the same reason children everywhere do—they are immediately accessible when still learning to read, and fun. But for older children, teenagers, and adults, comics are faster and easier to read than a novel, more portable than a television set, and provide an important source of entertainment and relaxation in a highly disciplined society.

In 1979 the Japanese Prime Minister's Office undertook a revealing survey on the use of free time by young people aged ten to fifteen of different nations. The survey showed, to begin with, that Americans have more than twice as much free time as Japanese children and are twice as likely to spend it playing outdoors. Yet while an equal number of Japanese and American children watch television in their idle hours, nearly three times as many Japanese children are likely to read comic magazines.

Two major cultural differences may account for this finding. First, Japan is a very crowded, urban nation, where vacant lots and open fields have rapidly yielded to concrete. There is very little physical space for children in cities to play in. Second, Japan's educational system is set up so that young people must devote nearly all their free time to studying for a grueling cycle of exams that determine their scholastic and, indirectly, vocational futures. The culmination of this is a period known as "examination hell," during which the phrase

The ideogram for "water," today written as 水, thousands of years ago was drawn as ⟨⟨⟨; the ideogram for "eye," 目, was originally drawn as ✏; and "face," now written at times as 面, was once something like 🙂, a distant cousin of today's world-famous ☺.

21. Gao, the former mass-murderer turned Buddhist acolyte, flees in anger after learning how corrupt organized religion is. His word balloons contain the unvocalized ideogram/concept for "anger," which grows larger as he runs. Osamu Tezuka's Hi no Tori *("Phoenix") has been serialized in various magazines since 1954 and still continues today.*

Yontō goraku ("Sleep four hours a night and pass. Sleep five and fail.") is framed and hung on the wall as an incentive to study (fig. 22). Japan does not have an unusually high suicide rate, but research has shown that academic difficulties are the main reason young people take their own lives.

After hours of study comics provide an instant escape into a fantasy world. They are less tiring on the eyes than a novel, and it is easier to read a comic for ten minutes than it is to watch ten minutes of a one-hour drama on television. In a second a boy can be transported to a world where he is active in the sports and adventures he cannot actually enjoy, and a teenage girl can enjoy the romance she has no time for. Fur-

thermore, reading comics is a silent activity that can be carried on alone. The Japanese, pioneers in headphone amps for electric guitars, tiny tape players with headsets, and other self-contained, miniaturized gadgetry, of necessity place a premium on space and on not bothering others.

Two young adult lovers enter a coffee shop, order a drink, and then spend half an hour, without saying a word, immersed in their own comics. Or children, hungrily reading the most hilarious comic story, neither laugh nor show any visible expression. Comics, while a fantasy release in crowded Japan today, are also part of a general trend towards increasingly autistic activities.

Reading patterns instilled at an early age tend to remain. College students in Japan, notorious for their free time, are probably the world's greatest readers of comics, and after graduation and entry into lifelong employment with a company, they do not stop. The typical company employee works in an environment where little recognition is given to personal achievement and where individual wants must be subordinated to the good of the group. The stress on *wa*, or harmony among workers, means that there is no room for idiosyncratic behavior. Therefore, when an employee gets off work in the evening, he heads for the train station, where he buys his favorite comic magazine. During the long commute home, he immerses himself in a fantasy world where he can laugh at his frustrations, seduce beautiful women, machine gun his enemies.

THE CARTOON TEMPLE

Just south of Tokyo in Kawasaki city, the Buddhist temple Jōrakuji nestles in an ancient grove of trees. Commonly known as Mangadera, the "Cartoon Temple," it is devoted to comic art. In the main hall—alongside the usual altar and effigies of the Buddha—are hundreds of cartoons drawn on wooden plaques, scrolls, and sliding paper doors. In the garden outside are two boulders inscribed with caricatures of two of Japan's most famous cartoonists, Rakuten Kitazawa and Ippei Okamoto. The temple dates back 200 years, but the cartoon collection was established by the present abbot, Shūyū Toki, and his wife, Yoshiko, who continue to preside at daily religious services and funerals. Above the central altar is written: "The Idea Priest: Cartoons and the Search for Truth."

22. *During an exam, an enemy releases a fine dust into the air to blind him, but Ichiban assumes his two-fisted test-taking form, and the wind that results blows the dust back on his rival. Exam comics are one of Japan's newest genres, for children in the examination system. Ichiban, the hero of Shimbo Nomura's* Todoroke! Ichiban *("Thunder! Ichiban"), published in 1981 in* Korokoro Comic, *is billed as a "passionate exam warrior."*

A Thousand Years of Manga

23. *When repairs were made on the main hall of Nara's Hōryūji temple in 1935, caricatures were found on the backs of planks in the ceiling, probably scribbled there at the end of the 7th century. Long noses to this day have an erotic implication in Japanese art.*

No one knows exactly when the first Japanese tried his or her hand at cartooning, or why, but it was probably with a playful, irrepressible spirit. The earliest examples of caricature have been found in some very unlikely places.

During the 6th and 7th centuries A.D., the imperial Japanese court was infatuated with Chinese civilization and determined to adopt as much of it as possible. Buddhism was introduced as a powerful new faith and was accompanied by a frenzy of temple building. Caricatures of everything from animals and people to grossly exaggerated phalli have been found behind the walls and ceilings of two of these sacred buildings—the Tōshōdaiji and Hōryūji temples in the region of Nara city—presumably doodled there by bored scribes and construction laborers (fig. 23).

Again, when Japan's first undisputed masterpiece of cartooning was created at the beginning of the 12th century, the artist was a priest—the now legendary Bishop Toba. *Chōjūgiga*, or the "Animal Scrolls," as Toba's work is known, was a narrative picture scroll, an art form originally introduced from China to which the Japanese added their own irreverent brand of humor. What did it portray? Among other things, Walt Disney–style anthropomorphized animals in antics that mock Toba's own calling—the Buddhist clergy (fig. 24).

THE COMIC ART TRADITION

Picture scrolls like *Chōjūgiga* are among the oldest surviving examples of Japanese narrative comic art. Scrolls did not consist of pages or of drawings divided into frames like today's comics; they formed a continuum. At first they were accompanied by a text, but their length (as much as 80 feet) and stylization often rendered this unnecessary. As one untied the string that bound it and began unrolling the scroll from right

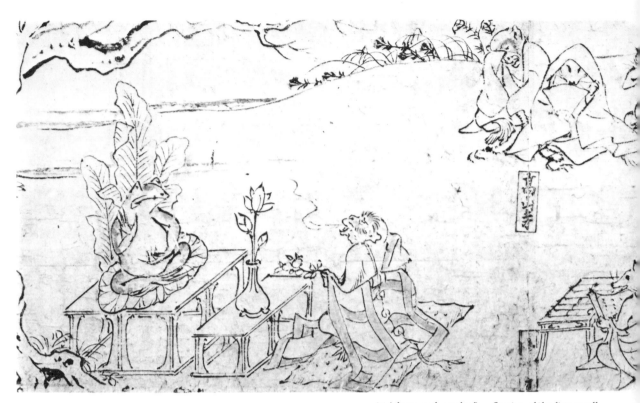

to left, hills faded into plains, roofs of houses dissolved to show the occupants inside, and, like the comics of today, changes in time, place, and mood were signified by mist, cherry blossoms, maple leaves, or other commonly understood symbols.

Like early art forms in all cultures, most early Japanese picture scrolls had religious themes, but the seriousness of their subject often could not disguise the playfulness that artists approached it with. During the Kamakura period (1192–1333), when warfare raged throughout the land, scrolls were made illustrating the six worlds of the Buddhist cosmology—heaven, humans, Ashura (Titans), animals, "hungry ghosts," and hell. They reminded the Japanese of the day of the Buddhist precept of nonattachment to the material world, but in a fashion that was more likely to make him ponder man's stupidity than suffer nightmares of guilt. Thus, in *Jigoku Zōshi* ("Hell Scrolls"), *Gaki Zōshi* ("Hungry Ghost Scrolls"; fig. 25), and *Yamai Zōshi* ("Disease Scrolls"), suffering is depicted with sledgehammer realism: grossly deformed demons mock cowering humans; famished grotesqueries devour corpses and human excrement with gusto; the frailty of mortals is pounded home with a parade of maladies and aberrations—a man with hemorrhoids, a hermaphrodite, an albino. But no matter how grim the world described, the artists employ a light and mocking cartoon style (fig. 26).

When not constrained by religious themes, many of the old scrolls ran positively wild, with a robust, uninhibited sense of humor much like that of today's comics. *Hōhigassen* ("Farting Contests"; fig. 27), told a tale of men vying with each other to create the most vile assault on the senses possible. Centuries later there are farting contests held on Japanese television and

24 (above and overleaf). Section of the first scroll of Chōjūgiga *("The Animal Scrolls"), showing animals in priests' vestments, praying with prayer beads, reading sutras, and giving offerings in front of a Buddha figure, represented by a frog.*

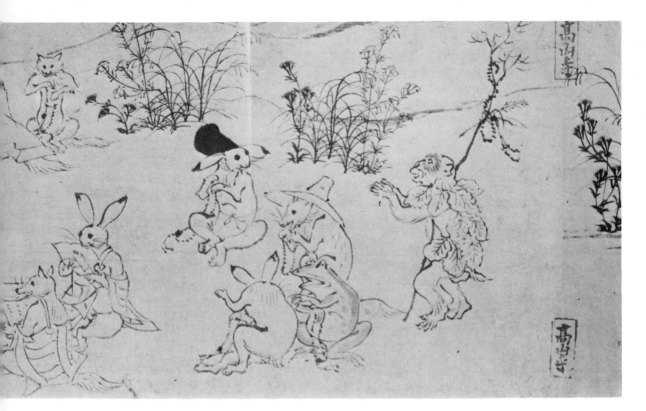

"THE ANIMAL SCROLLS"

Chōjūgiga—literally, "humorous pictures of birds and animals"—is the name of a series of four monochrome scrolls painted with brush and ink around the 12th century. Popular belief says that they were all created by the artist-priest Kakuyū, or Toba (1053–1140), but evidence suggests that he is responsible only for the first two. The first scroll depicts hares, monkeys, frogs, and foxes engaging in human activities—bathing in rivers, practicing archery, wrestling, and worshiping. The frogs are dressed as priests and the hares as nobles, leading scholars to claim that the scroll is a parody of the upperclass's decadent lifestyle. Many regard it as one of the best examples of Japanese brush painting, and it bears an uncanny resemblance to the American style of animal animation in this century. The second scroll is a rather unfunny exercise in animal sketches. But the third and fourth scrolls are hilarious. They show not animals but priests lost in gambling, watching cock fights, and playing a type of strip poker. *Chōjūgiga* is owned by Kōzanji, a Buddhist temple outside Kyoto.

children's comics known as *unko manga*, or "shit comics." The scroll *Yōbutsu Kurabe* ("Phallic Contests") depicted men gleefully comparing their huge erect members and using them in ingenious feats of strength; the visual jokes involving genitals that are so common in comics today are therefore nothing new. What type of person would create such outrageous art? Scholars' opinions vary, but legend attributes both works to the author of the "Animal Scrolls"—Bishop Toba.

The venerable Bishop was no heretic. Buddhism in Japan has a tradition of secularism that, while occasionally leading to excesses among the clergy, also encouraged such seemingly decadent works as the "Contests" scrolls. In the mid-17th century, moreover, there even developed a form of religious cartooning that directed spontaneous humor to a serious purpose. This was the *Zenga*, or "Zen picture."

Zen pictures were a spiritual aid for the artist, whose ultimate goal was not the creation of an image on paper but reinforcement of a state of mind. Imported from China, Zen Buddhism exhibits some qualities of the earthy tradition of Taoism and stresses the attainment of a sudden enlightenment, or *satori*, by freeing one's mind from the phenomenal world. The spiritual acrobatics required for such a feat are boosted by an irreverent attitude and a refined sense of the absurdity of man's "permanent condition." As R. H. Blyth says in his book *Oriental Humor*, "Any orthodox religion is always opposed to, and opposed by, humor. Zen only, in its being . . . unorthodox, or rather non-orthodox, is humorous, and must be humorous." From such an attitude were Zen pictures born.

In their most basic form Zen pictures were simply circles

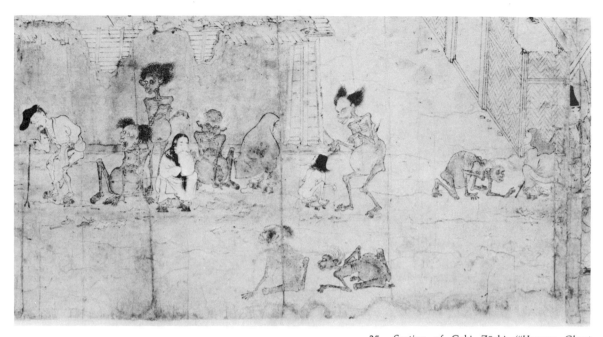

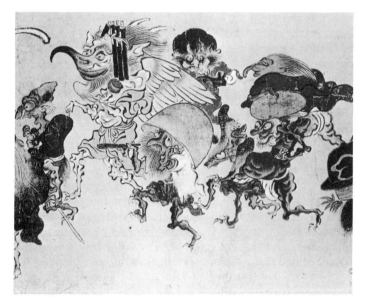

25. Section of Gaki Zōshi ("Hungry Ghost Scrolls"), by an unknown artist in the late 12th century. Painted in color on paper, the scroll illustrates the sufferings of human spirits with the misfortune to be reincarnated as "hungry ghosts," who eat excrement and corpses and generally lead a miserable existence—perhaps a reminder of the importance of good behavior in this life. Eight hundred years later, in 1970, Jōji Akiyama would incorporate the spirit of this scroll, and many of the exact same scenes, in his story-comic Ashura.

26. Section of Hyakki Yakō ("Night Walk of One Hundred Demons"), a 15th-century scroll painted in color on paper by Mitsunobu Tosa. The demons are a playful lot, devoid of religious seriousness, who emerge at night, cavort with musical instruments, and then disappear with the morning mist. Throughout the ages Hyakki Yakō has inspired artists who dabble in the fantastic, including Shigeru Mizuki, today's foremost creator of ghost stories.

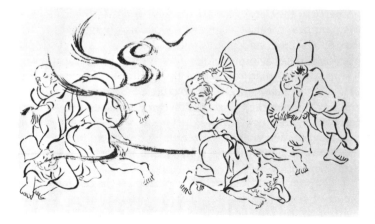

27. Section from the scroll Hōhigassen ("Farting Contests"), copy of a lost original, popularly attributed to the artist-priest Toba. A band of men eat a huge batch of sweet potatoes, and then gleefully compete in a game in which everyone loses—collecting huge quantities of wind in bags, releasing it in each other's faces, farting, and using a fan for self-defense.

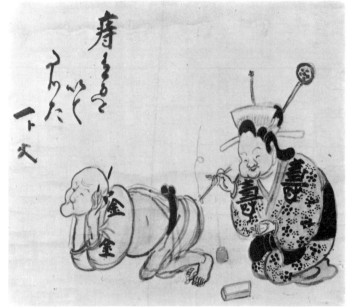

28. "Ōfuku's Moxibustion," a Zen picture by Ekaku Hakuin. A happy matron gives an application of moxa, a traditional cauterization treatment, to a woeful old man's hemorrhoids, implying that a brief shock can not only cure but also open one's mind and bring enlightenment.

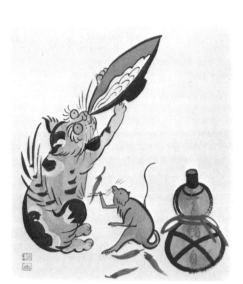

29. A foolish mouse feeds a drunken cat red peppers, thus speeding his own demise. Ōtsu-e developed in the mid-17th century around the town of Ōtsu, near Kyoto. The mass-production artists used paper patterns to paint in solid color blocks and then a brush and ink to add details. The example here is by Shōzan Takahashi, one of two Ōtsu-e painters still practicing today.

drawn to represent the Void. The more humorous pictures illustrated the spiritual riddles called *kōan*, used by a master to open the stubborn, clinging-to-the-here-and-now mind of the novice. They could suggest a profound beauty or be very off-color. Identical Zen pictures were produced by the hundreds by masters like Ekaku Hakuin (1685–1768; fig. 28) and Gibon Sengai (1750–1837). The thought behind the action was of paramount importance; a quick flourish of the brush yielded a black-and-white metaphor of spiritual truth, and the unsigned work was then often discarded.

In their simplicity, Zen pictures exemplified a trait common to almost all Japanese art, including today's comics—an economy of line. Josiah Conder, an Englishman who studied art under a Japanese woodblock artist/cartoonist at the turn of this century, noted: "The limits imposed on the technique of his art, and the constant practice of defining form by means of line drawn with a flexible brush, have enabled the Japanese painter to express in line even the most intangible and elusive shapes, without the aid of shading or color."

But humorous Zen pictures and scrolls were rarely seen by the common people. Almost all art in olden times was the property of the clergy, the aristocracy, and the powerful warrior families. Clearly, ordinary people also hungered for art that entertained, and in the mid-17th century a boom took place in simple cartoons sold only near the town of Ōtsu, near Kyoto, on the main road from the capital to the north (fig. 29). These *Ōtsu-e*, or "Ōtsu pictures," began as Buddhist amulets for travelers but later became uninhibited, secular cartoons with stock themes: beautiful women, demons in priests' garb, and warriors. Eventually they were produced in the thousands by artisans using paper patterns in a crude form of printing.

Truly popular, secular art was spurred by the refinement in Japan of the woodblock-printing process in the early 17th century. During the Edo period (1600–1867), Japan was ruled

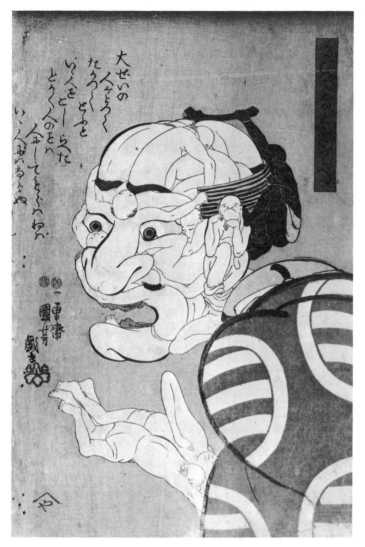

30. *A woodblock cartoon by Kuniyoshi Utagawa, from the early 19th century.*

by a feudal dictatorship that tried to freeze social change in order to preserve itself. A rigid class system was defined; political dissent in any form, including art, was banned; and unlicensed intercourse with foreign nations was prohibited on penalty of death. By the time stagnation and the arrival of the American "barbarians" put an end to this reactionary experiment, peace and unprecedented prosperity among the merchant class in the towns had already generated a money economy, and with it a demand for cheap entertainment. This in turn had stimulated an assembly-line-style, mass production of woodblock prints for popular consumption.

The most popular prints were called *ukiyo-e*—illustrations of the "Floating World," a term suggestive of life's uncertainties and the search for sensual pleasures to sweeten one's feeling of hopelessness (figs. 30–34). *Ukiyo-e* were initially crude, monochrome prints that usually portrayed men and women cavorting at Yoshiwara, the red-light district of old Edo (now Tokyo). The establishment of the day regarded them as trash, but gradually their subject matter diversified and their quality improved. They depicted the pleasures and pastimes of the day—fashions, popular places to visit, the

31. *"The Vertical and the Horizontal Face," by Hokusai Katsushika. An early use of the "split-frame" technique, which preceded the sequential frames of comics later. It is contained in* Hokusai Manga *("Hokusai Cartoons"), a fifteen-volume collection of Hokusai's sketches, issued between 1814 and 1878, that depicted everything which struck the artist's fancy: fat people, skinny people, contortionists, monsters, and serious still lifes. It was so popular it was reproduced until the printing blocks wore out.*

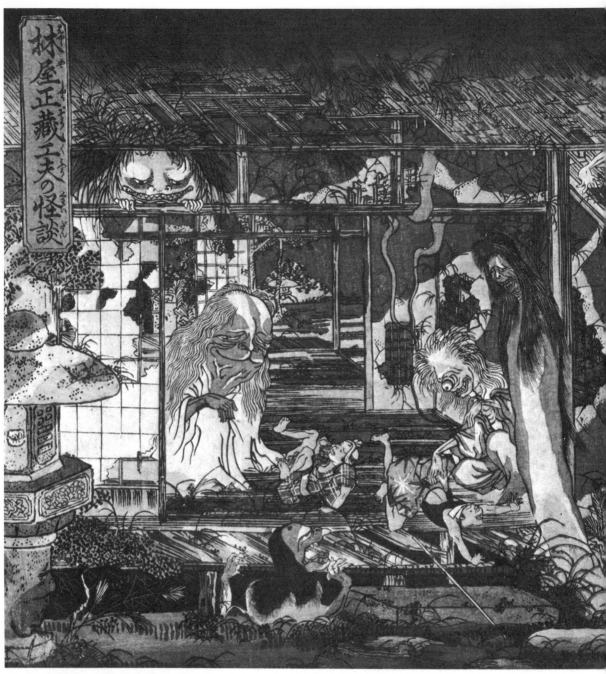

林屋正藏工夫の怪談

32. A mid-19th-century woodblock illustration by Kuniyoshi Utagawa for a popular horror story, showing a very haunted house.

latest Kabuki theater idols, and oft-told historical tales—in flowing lines and multiple colors. They were also compiled into picture books.

Many years later, Europeans would find old *ukiyo-e* prints used as packing in tea boxes sent from Japan, and artists—in particular the Impressionists—would marvel at their strange beauty. Like so much of old Japanese art, *ukiyo-e* projected a spare reality: without dwelling on anatomy and perspective, they tried to capture a mood, an essence, and an impression—something also vital to caricature and cartooning.

Like the comics of today, *ukiyo-e* were part of the popular culture of their time: they were lively, topical, cheap, enter-

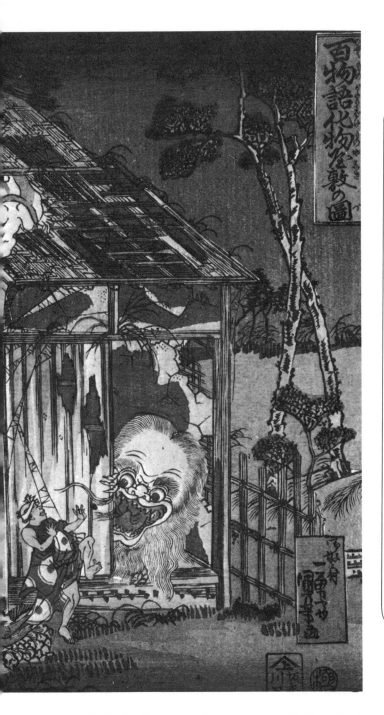

JAPANESE PRINTS—WESTERN ARTISTS

In his book *The Meeting of Eastern and Western Art*, Michael Sullivan describes the "grande explosion japonaise" in Europe during the mid- to late 19th century. Newly "discovered" Japanese prints were the rage at fashionable Paris salons, and their lines, motifs, and formats exerted a tremendous influence on the leading painters of the day, men like Monet, Manet, Whistler, Van Gogh, and Toulouse-Lautrec. William Michael Rossetti in London was a typical fan. Writing in 1863, he praised *Hokusai Manga* for having a "daringness of conception, an almost fiercely tenacious grasp of its subject, a majesty of designing power and sweep of line, and a clenching hold upon the imagination." Almost 120 years later, Frank Miller, the young artist/writer for the current American bestsellers *Daredevil* and *Wolverine*, stated in an interview in *Comics Journal* in 1982, "Lately, I've been immersing myself in Japanese prints. . . . They closely resemble comic book drawing, which in many ways is emblematic. People have come to recognize a certain configuration of lines as being a nose, for example. . . . They deal with a series of images that, like comics, have to convey information." And later: "I was able to 'read' a hundred pages of [a Japanese comic] the other day without ever becoming confused. And it was written in Japanese! They rely totally on the visuals. They approach comics as a pure form more than American comics artists do."

taining, and playful. Masters of the genre regularly infused their works with humor, experimented with deformation of line, and dabbled in the fantastic, the macabre, and the erotic. Hokusai Katsushika (1760–1849), a print artist, was the first person in Japan to coin the word *manga*, the current Japanese term for comics and cartoons. Sharaku Tōshūsai, active in the late 18th century, was a master of caricature. Kuniyoshi Utagawa (1797–1861) reveled in puzzle pictures. And in the violent warrior prints of Yoshitoshi Tsukioka (1839–92) can be seen the same stylized blood spatters that characterize so many action comics today.

Most *ukiyo-e* artists also dabbled in *shunga*, or "spring pic-

tures," which like the erotic comics of today portrayed men and women (and other combinations as well) joined in every conceivable position of lovemaking. It is the uninhibited and often humorous quality of Japanese erotic art that so distinguishes it from that of the rest of the world, then and now. Whereas the Chinese erotic artists of old drew their boudoir stars with dainty little privates, the Japanese *shunga* artists gave free rein to their abundant imaginations. The men in their prints possess extravagantly displayed and exaggerated members (the way most men would see themselves in their fantasies), and the women are appropriately accommodating. Occasionally the authorities would make half-hearted attempts to stamp out *shunga*, but little success was achieved until the 20th century, when Japan bent over backwards to conform to the Christian concepts of morality of the international community. Ironically, it is the Japanese who censor nudity today, while many of the Western nations have ceased to do so. Original *shunga* can only be published or displayed in their unexpurgated state outside of Japan.

Woodblock printing in the Edo period was also used to manufacture what may have been the world's first "comic books." Like the earlier scrolls, they did not have sequential panels and word balloons. Instead they consisted of twenty or more pages of pictures, with or without text, and were either bound with thread or opened accordion-style.

In 1702, Shumboku Ōoka created a cartoon book named

Tobae Sankokushi, depicting mischievous, long-legged little men frolicking in scenes of daily life at Kyoto, Osaka, and Edo. It appears to have started a fad in the Osaka area of what came to be known as *Toba-e*—"Toba pictures," named after the creator of the "Animal Scrolls." *Toba-e* were printed in monochrome and compiled into booklets, and sometimes the pictures were accompanied by fables in text. Like the old *Ōtsu-e*, *Toba-e* sold by the thousands. Admiring readers colored them in, and later generations thumbed them to tatters (fig. 35).

Then there were the *kibyōshi*, or "yellow-cover," booklets, consisting of monochrome prints and captions that told stories, often published as a series. *Kibyōshi* were popular at the end of the 18th century and—in a pattern similar to the development of today's adult comics—grew out of illustrated books for children that stressed fables. *Kibyōshi* dealt with topical subjects for townspeople in a humorous fashion; more than once they were banned for satirizing the authorities. Unlike *Toba-e*, they had a strong story line.

By the middle of the 19th century, the Japanese had a rich tradition of entertaining, sometimes irreverent, and often narrative art. The old art forms would vanish in the years to come, but their spirit would continue to inspire cartoonists and would influence the way Japan was to embrace comic magazines and books in the 20th century.

34. *A miniature god of wealth dances next to a decidedly female-looking Japanese radish. By the 19th-century artist Kunisada Utagawa.*

35. *Illustrated humor books of the Edo period, with varying degrees of narrative. Those in the middle are* Toba-e.

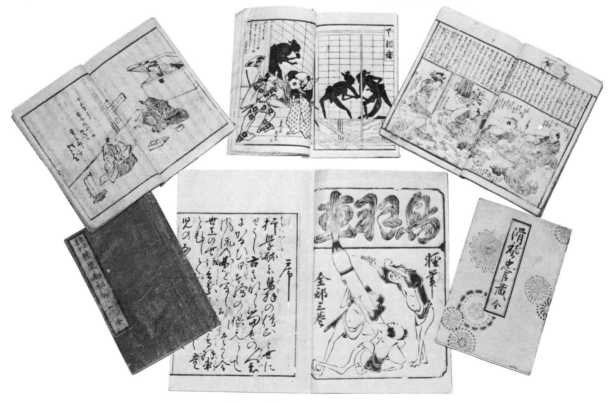

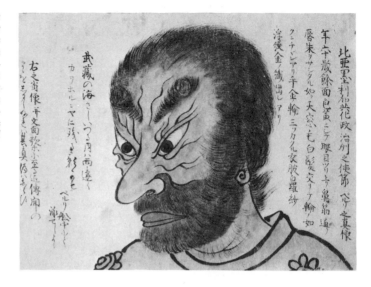

36. *"A True Portrait of Perry, Emissary of the United States of North America." Whether the anonymous mid-19th-century artist ever laid eyes on Perry is unclear; his painting may be based on the description written to the side. As if to compensate, he has Perry waxing romantic in a poem about memories of distant California. What seems a caricature today was the serious attempt of an artist unconcerned with anatomy and perspective. Only a few years after Perry, such styles would vanish from portraiture and only be used in caricature.*

WESTERN STYLES

In 1853 the United States, represented by Commodore Perry (fig. 36) and an armed "goodwill" fleet, forced Japan out of her self-imposed isolation. In doing so it triggered a virtual revolution in all areas of life, including art. Over the next fifty years, Japan accomplished a time-warp transition from a feudal kingdom into a modern industrialized nation.

With a new social order and new technologies came contrasts and confusion. Two-sworded ex-samurai sashayed down streets with top coats and bowler hats, former vegetarians extolled the virtues of eating beef, and people boarded the first trains after leaving their shoes behind at the station—in keeping with the Japanese custom on entering buildings—only to be shocked when they arrived at their destination shoeless. It was a cartoonist's paradise!

European-style cartoons were introduced during this period by two eccentric expatriate artists: a Britisher, Charles Wirgman (1835–91), and a Frenchman, George Bigot (1860–1927). Wirgman, or "Wakuman" as he was called, was a self-taught artist sent to Japan in 1857 as a correspondent for the *Illustrated London News.* He married a Japanese woman and stayed until his death. In the words of Ernest Satow, one of the first British diplomats in Japan, "Wirgman's costume, consisting of wide blue cotton trousers, a loose yellow pongee jacket, no collar, and a conical hat of grey felt, gave rise to a grave discussion as to whether he was really an European, or only a Chinaman after all."

Wirgman recorded some of the most dramatic events of the period, including a bloody attack on the British legation by a band of disgruntled samurai, which he witnessed while hiding under the floor. In 1862 he also published a British-style humor magazine, *The Japan Punch,* for the foreign community in Yokohama. *The Japan Punch* was primarily text and reflected the early isolation of the Europeans—it rarely mentioned the world outside of the foreign compound at Yokohama—but it contained cartoons by Wirgman, who drew in the typically low-key style of the British (figs. 37, 38). In the few he drew of Japanese life, he cast a satirical eye on

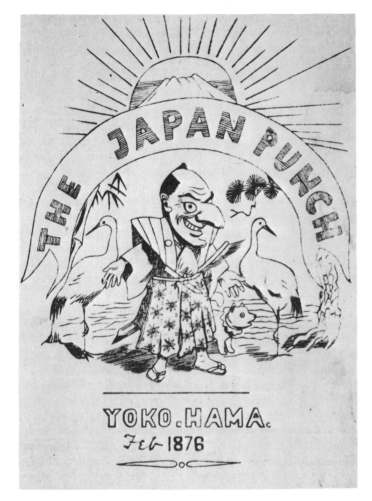

37. *Charles Wirgman's* The Japan Punch, *a monthly with a circulation of around 200, was published in Yokohama from 1862 to 1887. As the first Western-style humor magazine it had a tremendous influence on Japanese artists. The* Japan Punch *used Japanese technologies: its ten pages were of special Japanese paper, printed with woodblocks, and stitched Japanese-style. But the samurai Punch on the cover had a quill in his belt instead of a sword.*

38. *A February 1876 cartoon by Wirgman in* The Japan Punch *showed Europeans as they must have looked to the Japanese—big-nosed, hairy, and ungainly.*

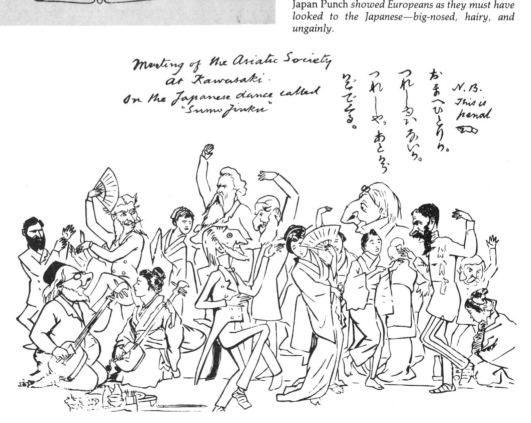

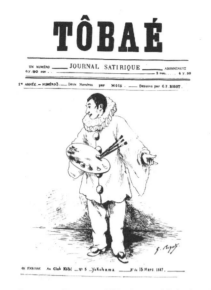

39. George Bigot's Tôbaé, published in Yokohama in 1887, was a biweekly, French-style humor magazine of thirteen pages, with cartoons parodying the "new Japan." Like Wirgman's magazine, it was aimed at the foreign community but had a profound impact on the Japanese.

40. "Tôbaé at Police Headquarters (An Actual Event)," by George Bigot, in an 1887 edition of Tôbaé. In the officer's hand, as an example of what not to do, is Bigot's Tôbaé. While he reprimands the gagged editors of Japan's new Western-style newspapers and magazines, the Tôbaé jester, or Bigot, peers through the window in amusement.

the awe-struck citizens of Tokyo viewing their first bicycle, or caricatured Japan's first students educated abroad who, on their return, he noted, "were supposed to know all about Politics, Laws, Constitutions, Finance, Sport, Congress, Cocktails, Religion, and Pickles, and are therefore perfectly capable of ruling the country." Wirgman's journalistic cartoons were a new type of humor and art to the Japanese, who were so fascinated that they even put out a translated version of *The Japan Punch*. Wirgman is today considered the patron saint of the modern Japanese cartoon. Each year a ceremony is held at his grave in Yokohama.

George Bigot arrived in Japan in 1882 to teach art at an army officer's school, and was an even more flamboyant character than Wirgman. He signed his name "Biko," with the ideograms for "beautiful" and "good," married a former geisha, and wore a kimono and Japanese sandals. In 1887, he also formed his own magazine, *Tôbaé* (after Bishop Toba), in which he drew cartoons that satirized both Japanese society and government. Bigot was constantly in trouble with the Japanese authorities, but to Japanese artists, who had long been forbidden to criticize their government, his acts seemed bold, and worthy of emulation (figs. 39, 40).

The Japanese were fortunate to have Wirgman and Bigot as mentors. Both men were not only excellent cartoonists but accomplished formal artists from whom European advances in perspective, anatomy, and shading (things Japanese artists had not always put fully to use) could be studied. And through them the developed social and political cartooning traditions of England and France, of the British *Punch* and Honoré Daumier, could be absorbed. Furthermore, both men

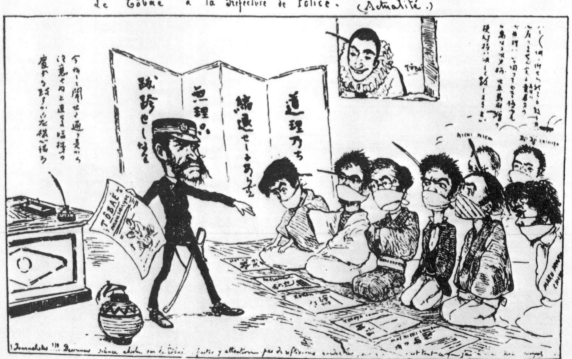

introduced two elements which would later be crucial to the development of today's comics: Wirgman often employed word ballons for his cartoons and Bigot frequently arranged his in sequence, creating a narrative pattern.

From the Westerners with whom they came in contact, the Japanese also acquired new printing technologies. Woodblock printing was expensive and time-consuming. The introduction of copperplate printing, zinc etching, lithography, metal type, and eventually photoengraving finally made the printed word—and the cartoon—a true medium of the masses. Soon after the arrival of Wirgman and Bigot, the Japanese began publishing their own humor magazines and daily newspapers, modeled after those of the West. And artists began using a pen instead of a brush.

The most famous of these Japanese humor magazines was *Marumaru Chimbun*, issued in 1877 and inspired by *The Japan Punch*. It suggests the speed with which the Japanese were absorbing Western techniques, for technically the magazine was superior to Wirgman's and closer to the original British *Punch*. The cover, drawn by Kinkichirō Honda, incorporated Japanese puns but was drawn in a distinctly British style with a pen and was printed using zinc etching. The cartoons inside had both Japanese and English captions (figs. 41, 42).

In 1880, a cartoon by Honda parodying the difficulties of Japan's new parliamentary government resulted in a year's imprisonment, not of Honda but of the magazine's editor. Clearly the government was not altogether pleased with this new genre of journalistic endeavor.

By the end of the 19th century (fig. 43), the focus of Japanese cartoonists began to shift from Europe to the United States, where a lively, less subtle type of political cartoon was popular, and where Joseph Pulitzer's *New York World* was experimenting with color Sunday supplements and the first true comic strips—complete with sequential panels and word balloons. In 1897, the socialist Shūsui Kōtoku, later executed

41. *A cover by Kinkichirō Honda for* Marumaru Chimbun, *a British-style weekly humor magazine founded in 1877 by Fumio Nomura, who earlier had illegally traveled to England. The Japanese government censored publications with little circles, hence* marumaru *("circles"). Chimbun was a pun on the word for newspaper (shimbun), implying "strange tidings." The horse and deer at the top of the page symbolized the ideograms for the word* baka, *or "foolishness." Honda also created cartoons inside. The magazine was printed in Yokohama at a shop supervised by an American.*

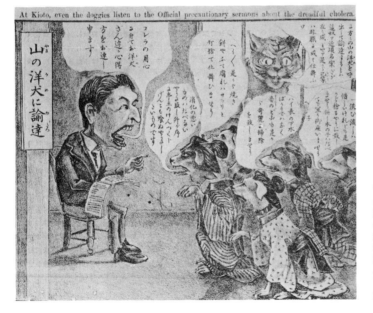

42. *A lithographed cartoon by Kiyochika Kobayashi in* Marumaru Chimbun *in 1886, lampooning the zeal of officials in Kyoto trying to eradicate an outbreak of cholera. The official reads to dogs, who recite the precautions they must take in sanitation. In the window, cholera, personified by a cat, fears that he may become "unemployed." Kobayashi reportedly studied art with Charles Wirgman and was one of the first Japanese artists to use word balloons.*

43. "Patriots of the Meiji Restoration and Today's Government Officials," an 1897 cartoon by Kōtarō Nagahara (an artist influenced by Bigot) in the Japanese magazine Mezamashigusa. *Using a "then and now" split-frame technique, Nagahara parodied the modernization of Japan, contrasting the hungry idealism of young samurai in the 1860s when the feudal shogunate was overthrown, with their portly selves years later as bureaucrats. Actually, Nagahara only drew the bottom frame. The top one was cut out of an 1869 cartoon by Charles Wirgman showing young samurai in awe at the sight of their first bicycle.*

RAKUTEN KITAZAWA (1876–1955)

At age 20, Rakuten Kitazawa was reportedly told the following by Yukichi Fukuzawa, one of the leaders of Japan's modernization drive: "In the West they have pictures that parody and criticize both government and society. These 'cartoons' are the only type of pictures capable of moving the world. If you wish to be an artist, you should pioneer this field." And this is what Kitazawa did. Working first for *Box of Curios*, an English-language weekly, and then for Fukuzawa's *Jijishimpō* newspaper, Kitazawa learned the latest techniques of Western cartooning and used his skills to poke fun at and criticize society and government. In 1905, in the midst of the Russo-Japanese war, he formed his own weekly, color cartoon magazine, *Tokyo Puck*; the cover to the first issue showed the Russian czar biting his bellybutton in frustration. *Tokyo Puck*, with a circulation of over 100,000, made Kitazawa rich and famous, and he went on to form other cartoon magazines as well as train dozens of young artists. In 1929 an exhibition of his work was held in Paris and he was decorated by the French government, making him one of the first Japanese cartoonists to receive international recognition. A museum devoted to his work now stands on the site of his home in Ōmiya, near Tokyo.

for conspiring to assassinate the emperor, wrote a series on American political cartoons in *Marumaru Chimbun*, suggesting that these "crazy pictures" had "shone brilliantly" and been of great help in securing William McKinley's victory over William Jennings Bryan in 1896.

Several years later, two of Japan's most famous cartoonists of this century, Rakuten Kitazawa (1876–1955) and Ippei Okamoto (1886–1948), helped popularize and adapt American cartoons and comic strips.

Kitazawa learned his trade working at an American magazine published in Yokohama, the *Box of Curios*. He went on to become one of the most versatile and skilled cartoonists to emerge in Japan and is today the only one with a museum in his honor (figs. 44–46). When he cartooned with a pen, as was usual, his drawings had the tight lines and attention to anatomy and perspective that characterize Western cartoons. When he used a brush, he could draw in the loose, simple, and subjective style the Japanese excelled at. His political cartoons had a sharp international perspective that makes those of Japan today look insipid by comparison.

In 1902, under the influence of the comic strips then blossoming in American newspapers, Kitazawa created the first serialized Japanese comic strip with regular characters. Called *Tagosaku to Mokubē no Tōkyō Kembutsu* ("Tagosaku and Mokubē Sightseeing in Tokyo"), it ran in the *Jiji Manga*, a color Sunday supplement modeled after those of the United States. But it still did not use word balloons.

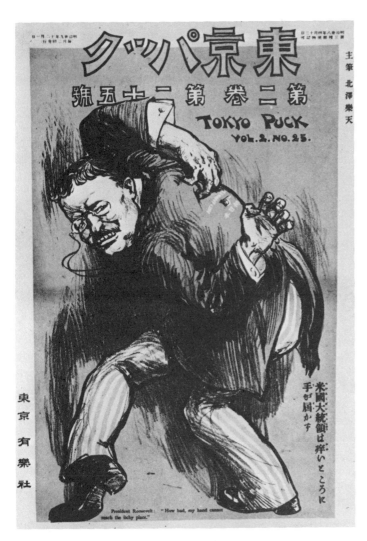

Okamoto worked for years for the *Asahi* newspaper drawing social and political cartoons, and greatly helped popularize the profession of cartoonist-journalist (fig. 47). Until Kitazawa and Okamoto came along, cartooning was something done as a sideline by those whose real goal was success as a "serious" artist. Okamoto tended to draw in a looser, more Japanese style than Kitazawa, but he too was versatile, creating for adults and children and experimenting with a narrative comic strip.

In the 1920s, a remarkable number of Japanese cartoonists (among them Rakuten Kitazawa, Ippei Okamoto, Sakō Shishido, and Yutaka Asō) traveled abroad, often to the United States (fig. 48). Okamoto, after visiting the *New York World*, marveled at the "Sunday Funnies" that were sweeping America. Writing back to the *Asahi* newspaper in 1922, he commented: "The American people love to laugh, but not in the stiff manner of the British. Their laugh is an innocent one, that instantly dispels fatigue. . . . American comics have become an entertainment equal to baseball, motion pictures, and the presidential elections. Some observers say that comics have replaced alcohol as a solace for workers since Prohibition began."

45. *In 1911 Kitazawa issued a special edition of* Tokyo Puck *on women's rights, in which he reacted strongly to a feminist movement stirring in Japan. The cover caption read, "Virgin! Virgin! That is where the divinity of the sex dwells." The cartoons inside were a hymn to traditional values: (1) "Lord husband." (2) "His lordship's domain somewhat reduced." (3) "Still more reduced." (4) "Until my Lady queens it all."*

46. *Tagosaku to Mokubē no Tōkyō Kembutsu* (*"Tagosaku and Mokubē Sightseeing in Tokyo"*), *Japan's first serialized comic strip, by Rakuten Kitazawa, in a 1902 issue of Jiji Manga. Two country bumpkins who speak a humorous dialect stop for a drink at a pump. . . .*

In his other dispatches Okamoto delighted readers with descriptions of two of the then most popular strips, *Bringing up Father* and *Mutt and Jeff*.

Largely because of Okamoto's introduction, on 14 November 1923 George McManus's *Bringing up Father* began serialization in the first issue of the new weekly called *Asahi Graph* (fig. 49). By the time World War II began, American newspaper strips that had been translated and serialized in Japan included Cliff Sterrett's *Polly and Her Pals*, Bud Fisher's *Mutt and Jeff*, Fred Hopper's *Happy Hooligan*, and Pat Sullivan's *Felix the Cat*.

Readers enjoyed American comics as introductions to an exotic culture, and artists adopted their format (fig. 50). But unlike in European nations such as Italy or France, American comic strips (and later comic books) in Japan were no competition for the domestic variety. Japan's relative cultural isolation has always allowed her to be more choosy about foreign influences and then to adapt them to her own tastes. Around the time *Bringing up Father* began serialization, Japanese newspapers realized the power of comic strips to attract readers and began hiring Japanese artists who used American styles. Foreign comics were exotic but, in the end, alien. Japanese comics were a smash hit.

In January 1924, a four-panel family strip by Yutaka Asō entitled *Nonki na Tōsan* ("Easy-going Daddy"; fig. 51) began

47. *Ippei Okamoto portrays himself ordering crab at the Fairmont Hotel in San Francisco, 1922. Being unable to speak English was no handicap.*

48. *In 1931, a clothbound comic book titled Yonin Shosei ("Four Students") was drawn and published by Yoshitaka Kiyama, who had lived in San Francisco for over twenty years. It was a good-natured account of the author's experiences with the language barrier, racism, and the San Francisco earthquake of 1906, and was designed for his friends who spoke both English and Japanese. In this sequence, Henry (the author) finds a job as a houseboy for a rich matron, and assumes he should scrub her back for her, Japanese style. He is saved by his sponsor.*

49. November 1923: Bringing up Father's Jiggs and Maggie speak Japanese for the first time. In the top panel, the butler says, "You called, sir?" A battered Jiggs, nodding at the homily "Home Sweet Home" on the wall, retorts, "Take that thing off the wall and throw it away!" By George McManus.

50. "A New Year's Party for the World's Most Popular Comic Characters," drawn in 1937 by members of Japan's most powerful cartoonist's association, the New Cartoon Faction Group, for the Asahi Graph. Japanese artists were well acquainted with American comic strips.

51. Nonki na Tōsan ("Easy-going Daddy"), begun in 1924 by Yutaka Asō, was the Japanese response to Jiggs and Maggie. Its hero, Nontō, always had different jobs. In this episode he works as a radio announcer. (1) "And that concludes our poetry recital. Next we have a soprano solo." (2, 3) Nontō slips out the back door to avoid her less-than-soothing song. (4) "Wait! She's finished! You can't leave without an announcement! Hurry, you have to tell everyone the solo's over!"

52. "Cool," by Saseo Ono, in a 1929 issue of Tokyo Puck. As lovers neck in the background on a hot summer night, a male shadow approaches. The voluptuous flapper extends an invitation: "Have a seat. . . ."

53. "The Future Coed," a 1921 cartoon by Rakuten Kitazawa. Modernization and education for women brought, among other things, a generation gap. Caption: "My poor dear mother and father, you simply don't know the truth about marriage. You may be older than I am, but I have more education. Besides, can you even read this English?"

serialization in the Hōchi newspaper. It was created at the request of the editor, who wanted something to cheer up the survivors of the September 1923 earthquake that had leveled Tokyo and killed over 100,000 people. Nonki na Tōsan starred a likable "uncle"-type who showed people the way out of gloom and despair; the series became an unprecedented success. It was compiled into best-selling booklets, merchandised as wind-up dolls, puppets, and towels, and eventually dramatized on the radio and made into films. Artistically, it was a direct spin-off of Bringing up Father, but its everyday-life situations and the self-effacing character of its hero had a quality Japanese readers naturally warmed to. Initially, the American influence was obvious: the speech in Nonki na Tōsan's balloons was horizontal.

Around the same time, the first serialized comic strips for children also appeared in newspapers. Some, like Katsuichi Kabashima's Shō-chan no Bōken ("Adventures of Little Shō"), used dialogue balloons. Others, like the works of Shigeo Miyao, were done in the captioned-picture style that would survive in Japan until the 1950s.

Miyao had the distinction of being one of the first professional artists to specialize in children's comics. After an apprenticeship to Ippei Okamoto, in 1922 he began serializing a six-panel strip, Manga Tarō ("Comics Tarō"), in a daily

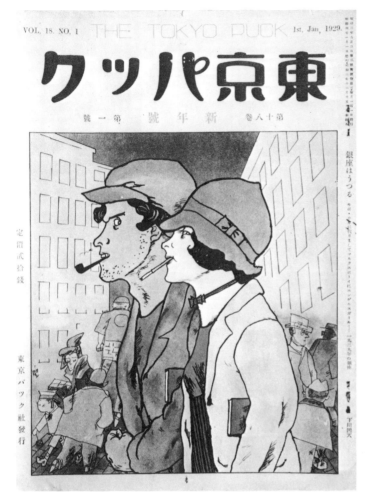

クッパ京東

號一第　號年新　卷八十第

54. *A 1929 cover illustration for* Tokyo Puck, *titled "Changing Ginza," by Hekoten Shimokawa. Caption: "After moga-mobo, Marx-boy and Engels-girl."*

newspaper; it was well received and compiled into book form just in time for most copies to be destroyed in the 1923 earthquake. Undaunted, in 1924 he began a comedy tale of a little samurai-superman, *Dango Kushisuke Man'yūki,* as a successor. When published as a hardbound book by Kōdansha, it became a long-term bestseller, with over a hundred reprintings in the next ten years. Children's comics in Japan, like those in the United States, had begun in the newspapers, but their compilation into a book format already signaled a very different direction.

SAFE AND UNSAFE ART

The 1920s were a dizzying decade in Japan, when unprecedented political and social freedoms led to experimentation in ideology and lifestyle. Like cities in the United States, Japanese cities were swept by many of the fads of the Roaring '20s and the Jazz Age. Western fashions, Harold Lloyd–style glasses, baggy pants, and flapper dresses were the rage among young urban sophisticates, who were labeled *moga-mobo* (a rendering of English "modern-girl, modern-boy"). Artists like Saseo Ono and Hisara Tanaka depicted this decadent-progressive society found in the cafés, bars, and theaters of Tokyo (figs. 52, 53). Ono in particular gained fame for his erotic drawings of flapper girls. Mild by today's standards,

55. *"Two-Headed Quarrel," by Kogoro Inagaki, in a 1930 issue of* Tokyo Puck. *On the top head, labeled "Landlords," rides the military. On the lower head, "Bourgeoisie," rides the government. The carbine in the middle is "Imperialism." Caption: "The present quarrel between the government and the military over who is to rule the nation only exposes what is really a conflict between a feudalistic landlord class and the new bourgeoisie—over imperialism."*

56. Kanemochi Kyōiku ("Bringing up a Rich Man"), by Masamu Yanase. (1) The sound of a bugle (2) grates on the ears of landlords, (3) nationalists, and (4) a policeman in his run-down station, but (5) is music to the rich man soaking in his tub. (6) He finds its sound invigorating—imagines business booming, and maybe even starting a healthy little war. (7, 8) But then a servant tells him the bugle belongs to a group of his sharecroppers organized as the Young Proletarians. (9) As the rich man drives off for the day, he orders his driver to lean on the horn and blot out the dreadful noise. Kanemochi Kyōiku was begun in 1929 in the Yomiuri Sunday Manga, a remarkable U.S.-style color supplement for children and adults that featured works by artists from both ends of the political spectrum.

57. A poster calling on the government to stop its war of aggression in China appears on a telephone pole. A policeman tries to remove it . . . and another appears. By dissident artist Tarō Yashima in New Sun, published in 1943 outside Japan.

his work fell into the category of what was then referred to as *ero-guro-nansensu* (*ero*-tic, *gro*-tesque, and *nonsens*-ical) art, a forerunner of today's erotic comics and gag strips for adults.

But Japan's rush to modernize did not occur without social disruption, especially over economic inequities. Many intellectual artists were radicalized by the problems they saw and opted to work in the new "proletariat" and agit-prop genre of cartoons and comic strips (figs. 54, 55). The success of the Russian Revolution in 1917 handed them an attractive ideology on a platter. To be an antiestablishment artist in the '20s and '30s in Japan almost always meant being a Marxist. Publications such as the *Musansha Shimbun* ("Proletariat News"), *Senki* ("War Banner"), and even several moderate magazines regularly featured the radicalized work of artists in leftist groups like the "Japan Proletariat Art League."

The most versatile ideological artist of all, Masamu Yanase, used his artistic talents to skewer his enemies and further the cause. Drawing in the style of Germany's resistance artist, George Grosz, and the radical United States artists Robert Minor and Fred Ellis, he depicted wholesome laborers and fat, corrupt bosses in cartoons. In 1929 he even created an ideological comic parodying George McManus's *Bringing up Father*. It was called *Kanemochi Kyōiku* ("Bringing up a Rich Man"; fig. 56).

But cracks were appearing in Japan's liberal façade. Even as artists were being politicized, an out-of-control ultranationalistic military, bent on expansion on the continent of Asia, was taking control of the civilian government. Ideological artists like Yanase frequently suffered arrest, and occasionally torture.

In the late '20s and the early '30s, the government's new thought-police, armed with an Orwellian "Peace Preservation Law," learned to control those who harbored subversive ideas (fig. 57). They did so by intimidating artists and their editors. More than one magazine was forced to close; most were coerced into self-censorship. Arrest was the fate of editors who did not comply, and it happened so often that some magazines designated an employee as "jail editor"—he who had the honor of taking the rap and saving the company.

Persecution encouraged artists to work in safer genres, indirectly producing a boom both in children's comics and in *ero-guro-nansensu* for adults.

Comic strips in the 1920s had generally consisted of no more than four to eight frames on a page, serialized in newspapers or their color supplements (fig. 58). In the 1930s, however, fat monthly children's magazines like Kōdansha's *Shōnen Club* began including longer, serialized comics, where each episode often ran to 20 pages and formed a complete story. When these stories were compiled, they were issued as beautiful, clothbound, hardback volumes of around 150 pages, printed in color and sold in fancy cardboard cases. Many children's classics emerged from this period, notably Suihō Tagawa's *Norakuro* ("Black Stray") and Keizō Shimada's *Bōken Dankichi* ("Dankichi the Adventurer"). They call up fond memories for older Japanese people today, and their reprints still sell well (figs. 59–61).

EARLY CHILDREN'S MAGAZINES

The most famous prewar Japanese children's magazines were published by Kōdansha: *Shōnen Club*, a boys' monthly formed in 1914; *Shōjo Club*, a girls' monthly begun in 1923; and *Yōnen Club*, a monthly for very young children founded in 1926. All contained photo-articles, lavishly illustrated stories, advertisements, considerable color printing, and serialized comics which were also compiled into hardback books. They were, in a sense, the prototypes for today's huge children's comic magazines: they specialized according to the age and sex of the reader; they often contained over 400 pages per issue; and in their heyday they had enormous circulations—in January 1931, *Yōnen Club* sold over 950,000 copies. But war took a terrible toll on what were once cheery and entertaining magazines. Photographs and articles increasingly featured the exploits of Japanese soldiers. Covers showed boys scowling and carrying guns instead of smiling and playing. And comics, perhaps regarded as frivolous, began to disappear. The July 1945 issue of *Shōnen Club* consisted of only 32 pages, all text, with no cover. The last page showed readers how to throw a hand grenade. All three magazines survived the war and again began serializing comics, but they were never able to regain their former glory. In the early 1960s, they were completely replaced by magazines that specialized in comics.

58. Spīdo Tarō ("Speedy"), by Sakō Shishido, debuted in the Yomiuri Sunday Manga in 1930 and wowed young readers with its cliff-hanging action. Speedy, the hero, was a little boy combatting an international conspiracy, and he drove cars, flew airplanes, and used a parachute. Spīdo Tarō's layout, pacing, and use of sound-words clearly showed the influence of the American "Sunday Funnies" and action films. Shishido had lived in the United States for nine years and studied American cartooning through a correspondence course. Spīdo Tarō was compiled into book form in 1935.

59. Lieutenant Norakuro yells, "Charge! . . . " Suihō Tagawa's Norakuro ("Black Stray") was a series of stories about a bumbling stray dog who joined the Imperial Army and over the years rose from private first class to captain. In the process he stopped walking on all fours and making mistakes, but he also became less humorous and less interesting. Norakuro featured a series of battles with other "animal" armies and seemed to support the military, but the Japanese Imperial Army eventually frowned upon it as bad for their image. Norakuro ran in Shōnen Club from 1931 to 1941 and was compiled into ten hardcover books of about 150 color pages each.

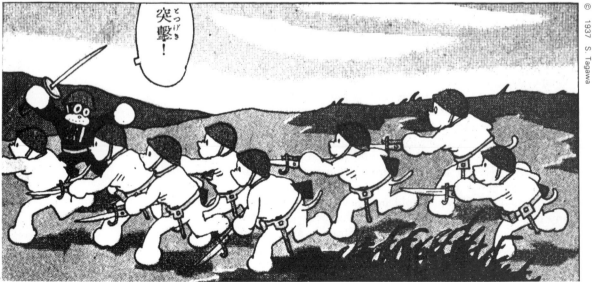

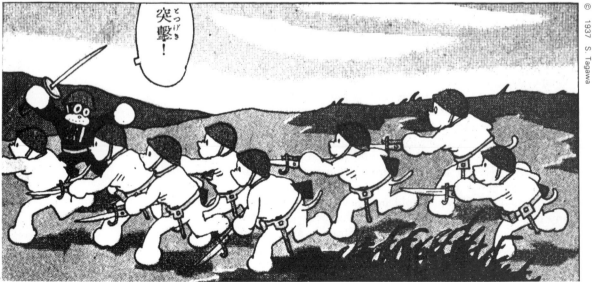

60. *Artist Suihō Tagawa with* Norakuro *merchandise in 1937.*

61. *Dankichi and his mouse sidekick show faithful natives how to worship at the "Rising Sun" shrine, which he had them build.* Bōken Dankichi *("Dankichi the Adventurer"), by Keizō Shimada, was the story of a little boy who became "king" of a Pacific island, painted numbers on the natives to tell them apart, and showed them how to wage war with coconut bombs, elephant tanks, and bird airplanes. When white foreigners encroached on the island, Dankichi and his native army drove them off with fanciful cannons that shot—not shells—but live tigers.* Bōken Dankichi *was serialized in* Shōnen Club *from 1933 to 1939 and compiled into three hardcover volumes.*

62. Kasei Tanken ("Mars Expedition"), scripted by Tarō Asahi and drawn by Noboru Ōshiro, was a precocious science fiction comic published during the dark days of 1940. A complete story in 150 pages, it was printed in three colors and featured a little boy who traveled to Mars in a dream with his pals, a cat, and a dog. It depicted rockets and Martians in detail and incorporated actual photographs of the moon.

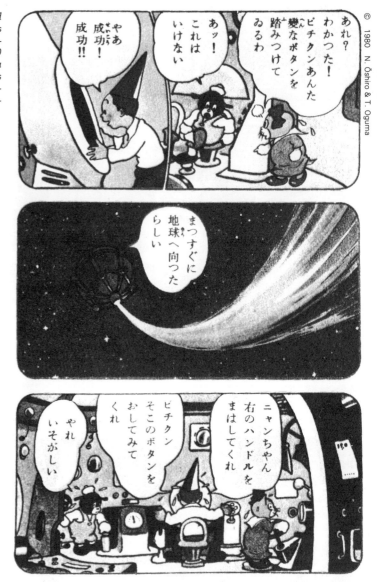

Most of these comics were moralistic, stressing traditional values of loyalty, bravery, and strength for young boys; so much so that in spite of their disarmingly naive style, the degree to which they furthered the cause of militarism is still the subject of scholarly debate. Yet hidden among the lesser-known works of the time was one of Japan's first science fiction comic stories, Kasei Tanken ("Mars Expedition"; fig. 62), foreshadowing the tremendous popularity of this genre in the postwar period.

Compared to today's comics, those of the '30s had slow plots and unimaginative layouts, but many were in color, which today's comics are not. Their lengthy book format, furthermore, represented another Japanese innovation on the American newspaper comic strip. The American comic book, in reality a slim magazine, was just beginning to develop around this time, and it was compiled from newspaper comic strips. Japanese book-comics, however, were being compiled from stories first serialized in magazines—as is still the case today.

World War II began for Japan in 1937 in China. With fanatic militarists in control of the government, the imperialist adventure on the continent spread out of control, ending finally with Japan's defeat in 1945. During the long, dark years of the war the entire nation was mobilized, and artists and their creations were no exception (fig. 63).

The degree of conformity the government was able to impose on artists and intellectuals is frightening. Some, of course, believed in Japan's avowed goal of liberating Asia from colonialism; others underwent what was called *tenkō*, or conversion to the government line. The solidarity of an already very homogeneous nation was marshalled to bear upon dissidents through a carrot-and-stick approach: noncooperation was punished by preventive detention, bans on writing, and social ostracism, while those who recanted were rewarded with rehabilitation programs and support from the community. In Japan, unlike Germany, executions were not necessary. With a few notable exceptions, artists who had spent most of their lives criticizing the government did an about-face and offered wholehearted support to the militarists.

The government skillfully exploited the Japanese propensity for factionalism. Prior to World War II, it was virtually impossible to succeed as a professional cartoonist without belonging to some sort of group. In 1940, after most dissident groups had been destroyed, umbrella organizations like the New Cartoonists Association of Japan *(Shin Nippon Mangaka Kyōkai)* were created with government support to unite cartoonists under an official policy. The New Cartoonists Association absorbed eight existing organizations, including the New Cartoonists Faction Group *(Shin Mangaha Shūdan)*, which had been most powerful. The New Car-

63. Aniki no Tsutome ("An Elder Brother's Duty"), by Etsurō Katō, ca. 1944. Standing in front of a line of school boys mobilized to work in factories, an "older brother" worker shields them from a bottle of beer labeled "temptation." As the war dragged on, one of the primary concerns of the government was to increase—and eventually just to maintain—industrial output. This led to an entire genre of comics and cartoons known as zōsan manga, or "production comics."

64. Kagaku Senshi Nyū Yōku ni Shutsugen su *("The Science Warrior Appears in New York"), by Ryūichi Yokoyama, in a 1943 edition of* Manga. *Towards the end of 1943 the tide of war was turning against Japan. The idea of a giant robot that could stomp the enemy probably helped ease the frustration of the Japanese, who were already suffering bombing raids but were helpless to strike back.*

toonists Association's organ, *Manga,* a monthly edited by Hidezō Kondō, was the only cartoon magazine to continue publication throughout the war years, when paper was in short supply.

After Pearl Harbor in December 1941, cartoonists who were not banned from working or off fighting on the front were active in one of three areas: producing family comic strips that were totally harmless or promoted national solidarity; drawing single-panel cartoons that vilified the enemy in *Manga* or other domestic media; and working in the government and military service creating propaganda to be used against the opposing troops (fig. 64).

Family strips were low-key and optimistic, depicting in a humorous way the trials of living in a state of war for nearly a decade. Fusato Hirai's *Omoitsuki Fujin* ("Innovative Housewife") emphasized conservation and recycling at home when supplies were short. Ichio Matsushita's *Suishin Oyaji* ("Mr. Promotion"; fig. 65) featured an energetic little company president who constantly exhorted his workers and the populace to increase production and thereby win the war. The most popular Japanese newspaper strip of all time, Ryūichi Yokoyama's *Fuku-chan* ("Little Fuku"; fig. 66), had begun in 1936 and survived the war by adapting. In 1940 its title was changed to a more aggressive "Advance, Little Fuku!" and the original pattern on the robe of a supporting character was changed from "ABC" to "123." During the war, ABC was the acronym for the enemy: America, Britain, and China.

Cartoons in the magazines, such as the semi-official

Manga, regularly exhorted the nation to "Annihilate the Satanic Americans and British!" Kondō, the editor of *Manga*, drew skillful caricatures of politicians on the cover—a fanged, green-faced Roosevelt with hair standing on end, and an effete, pot-bellied Churchill (fig. 67).

Artists directed their work overseas towards two objectives: persuading the native populations of Asia that the Japanese were liberators and the Allies the Devil in disguise, and sowing dissension in the ranks of Allied troops. Cartoons were an excellent medium for both goals because they transcended the formidable language barrier. In many regions the people were illiterate.

Many cartoonists were drafted and sent to war zones where they created reports for the public back home, propaganda leaflets for the local populace, and leaflets to be dropped over enemy lines. The greatest success was achieved with native Asian populations, who were often eager to throw off the

65. Suishin Oyaji ("Mr. Promotion"), drawn by Ichio Matsushita in 1943. (1) Mr. Promotion mourns the death of Admiral Yamamoto, the hero of Pearl Harbor. (2) An assistant bursts in, announcing that the men are agitated. (3, 4) Zealous employees with banners respectfully ask their president to write slogans to reinstill the proper spirit in the men. (5) Mr. Promotion, in a burst of energy, churns out slogans such as "Britain and America—Sworn Enemies," "Never Forget the Admiral," and "Increase Production in the Name of Our Hero!" (6) As his employees race off to show "fighting spirit," an ink-covered Mr. Promotion yells, "And I'll write many more!"

66. *Panels from a 1942 episode of Ryūichi Yokoyama's* Fuku-chan *("Little Fuku"), the longest-running Japanese newspaper strip of all time. It debuted in 1936, survived the war, and continued until 1971. It owed its success to its lovable hero, Little Fuku, who made people smile no matter how rough life was.*

yoke of European colonialism. But these influential artists did not always cut an imposing military figure. Yokoyama, *Fuku-chan's* creator, was so small of stature that he had to have his regulation samurai sword shortened to prevent it from dragging on the ground.

There was work for everyone. Even the prewar *moga-mobo* faction was kept busy creating erotic leaflets directed at the American, British, and Australian/New Zealand troops. Erotic-pornographic cartoons and comic strips were designed to make the lonely soldier worry about the faithfulness of his girl back home and thereby decrease his fighting efficiency (fig. 68). Americans on rest-and-recreation in Australia were invariably portrayed seducing the Aussie soldier's wife while hubby slogged through the jungle in the war zone.

But Japan's enemies were also using propaganda cartoons, sometimes obtained from unexpected quarters. The Allies regularly issued a propaganda newspaper called *Rakkasan Nyūsu* ("Parachute News") and dropped it throughout Asia to Japanese troops and civilians in an attempt to weaken their morale. Since international copyright laws had long since lapsed, the Allies felt perfectly free to use the popular Japanese strip *Fuku-chan* in their own newspaper. When Yokoyama, *Fuku-chan's* original creator, was in Java drawing

67. *Hidezō Kondō's Roosevelt with fangs, a cover illustration for a 1943 copy of* Manga, *the officially sanctioned wartime cartoon magazine.*

Japanese propaganda leaflets, it is easy to imagine how surprised he would have been to see his own work fluttering down from the sky. On his return to Japan he was reportedly investigated by the police.

Early Allied propaganda leaflets were mostly ineffective because they were written by people with an inadequate command of Japanese. But towards the end of the war a humanistic, highly effective comic strip called *Unganaizō* ("The Unlucky Soldier") appeared. It had an oddly familiar look, and to the great surprise of those Japanese artists who had formerly been active leftists, it was created by none other than an old comrade, Tarō Yashima, once a member of the proletariat movement in Japan. After being jailed and tortured in 1933, Yashima sailed to America, where he volunteered his services to the United States Army when the war began. Yashima was the only Japanese leftist artist who found a way to continue his overt resistance to Japanese militarism.

As Saburō Ienaga has observed in his book *The Pacific War*, "The flood of crude officially sanctioned 'information' during the war years turned Japan into an intellectual insane asylum run by the demented." Comic art as a tool of politics was both a product and a cause of the madness.

TARŌ YASHIMA (1908–)

Tarō Yashima's *Unganaizō*, produced during World War II on behalf of a desperate U.S. Office of War Information, was a twenty-panel comic leaflet that depicted a Japanese peasant dying for corrupt officers. In contrast to the bumbling efforts of American propagandists with a poor understanding of Japanese, it did not meet with the enemy's derision. *Unganaizō* was repeatedly found on the bodies of dead soldiers, a grisly testimony to its effectiveness. By the end of the war Yashima was in India working on a guide to surrender for the war-weary Japanese soldier, who had been taught that suicide was his only recourse in defeat. One of Yashima's main concerns, however, was to show the American people that the Japanese were not savages or mindless slaves to their emperor, as the Western media often implied. To this end in 1943 he created the *New Sun*, a narrative with captioned drawings. It was an exposé of Japanese militarism and an account of how he and other dissidents had tried to oppose it before the war began. After the war Yashima remained in America, where he became an award-winning author of illustrated children's books.

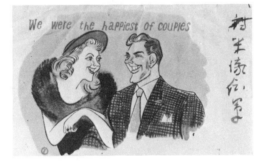

68. *An anonymous wartime propaganda leaflet. Some of the artists who created such erotic material radically altered their drawing styles to please American tastes, and then after the war complained that they had forgotten how to draw Japanese women.*

69. *The cover for the first issue of* Kumanbachi *("The Hornet"), 1947—a hornet attacks the nose of then prime minister Shigeru Yoshida.* Kumanbachi *appeared with the slogan, "I am the hornet of democracy, and for the sake of the democratic revolution, I fly around . . . BZZZ . . . , never tiring." Like many cartoon magazines in the new "democracy,"* Kumanbachi *delighted in pillorying establishment figures, but it was short-lived, lasting only nine issues. Fumio Matsuyama, the cover artist and founder of the magazine, was a former member of the old Proletariat Art League. Today he is well known for his long years of work as cartoonist for* Akahata *("Red Flag"), the Japan Communist Party's daily newspaper.*

70. *Chic Young's* Blondie, *a comic strip of the formerly "satanic" United States, was translated and serialized in 1946 in a magazine and later compiled into booklets. Women readers, taught to be submissive to their husbands, loved to watch Blondie lord it over Dagwood and to glimpse the luxurious, mechanized, and leisured life of the American housewife. Shown here is a cover to a 1947 booklet.*

THE PHOENIX BECOMES A GODZILLA

After Japan's unconditional surrender in August 1945, surviving cartoonists emerged from rural evacuation or straggled home from all corners of Asia to settle in the bombed-out cities. Like a phoenix rising from smoking ashes, their art form began to flourish again—this time beyond anyone's wildest dreams.

Censorship continued in Japan for several years under the Allied Occupation, but it still allowed political artists more freedom than they had ever known before. The first result was a burst of activity. After surmounting a chronic paper shortage, newspapers and new or revived adult cartoon magazines like *Van*, *Manga*, and the leftist *Kumanbachi* ("The Hornet"; fig. 69) gave social and political artists a forum. Adjustment to new political realities progressed with amazing speed (fig. 70). Artists now embraced "democracy." Leftists were joined by prewar comrades who had "converted" to the side of the militarists for the duration of the war. Few questions were asked. It was symbolic of the change that the *Yomiuri* newspaper sent Hidezō Kondō, who had drawn Roosevelt with fangs, to report on the official signing of the U.S.–Japan Peace Treaty in San Francisco in 1951. But the spotlight was no longer on political cartoons.

The immediate postwar period was one of hunger and black markets, of orphans and limbless veterans. More than anything else, people wanted to rebuild their lives. In the daily newspapers, serialized four-panel strips for the family were humorous, reassuring, and immensely popular. Favorite themes were average families making the best of hard times, and lovable little children. Most of the strips were subdued, endearing, and notable for their similarity of style. One which particularly caught the public fancy, however, was *Sazae-san*. As befitted the new era, its star was a young woman, and so was its author, Machiko Hasegawa. In the years after its appearance in 1946, *Sazae-san* spawned songs, a live-action film, an animated TV series, and over 20 million cartoon books. Its success paved the way for a later rush of women artists into a field that had been completely dominated by men (fig. 71).

Comics for children also reappeared in children's magazines like the old *Shōnen Club*, and in special color newspaper supplements (fig. 72). Perhaps reflecting a desire to forget the past, there was a boom in science fiction stories created by such artists as Fukujirō Fukui and Ichio Matsushita. Children's comics at this time were mostly short pieces that employed styles pioneered before the war. But changes

71. *The days of the Occupation: A young Sazae and her little sister emerge from a store that rations bread. "Sazae," says little sister, "I think I dropped a loaf of bread." "Well, start looking for it. . . ." American soldiers in a truck zip by. "There it is!" Machiko Hasegawa's* Sazae-san *was serialized in the* Asahi *newspaper from 1946 until 1974 and still sells well today as a series of sixty-eight volumes of cartoon books.*

72. *Cover for* The Kodomo Manga Shimbun *("The Children's Comics Newspaper"), a three-color weekly founded in 1946 that helped fill the gaps until children's comic magazines began appearing. In the strip in the center, a young boy eats an entire can of jam and then fools his father by putting it upside down on the table. Children were hungry for sweets, and food was a common theme. The* Kodomo Manga Shimbun *was an example of American-style color printing, and it used English on the cover. During the war English had been banned; with peace it appeared everywhere.*

were brewing outside the established publishing industry that would radically transform it. Young people in particular were starved not just for food, but for cheap entertainment.

One immediate result was a surge in popularity of illustrated outdoor storytelling, called *kami-shibai*, or "paper plays" (fig. 73). Using a sequence of hand-painted cardboard story sheets (varnished to keep off the rain), narrators would travel around neighborhoods and present—with sound effects—stories to local children. Often the show was "free," on the condition that those in the audience bought traditional sweets sold by the narrator. From the end of the war to the year 1953, when television broadcasts began, it is estimated that 10,000 people made a living as *kami-shibai* narrators and that 5 million people a day watched a show. Over twenty companies in Tokyo alone hired aspiring artists to produce the story sheets. *Kami-shibai*, like television animation today, was linked with comics. Several stories, notably *Ōgon Batto* ("Golden Bat"), became comics later. And when television rendered *kami-shibai* storytelling obsolete, many of the artists who worked for the industry went on to become comic artists; some, like Sampei Shirato and Shigeru Mizuki, were to become nationally famous.

At the end of the war, the traditionally powerful Tokyo publishers were in disarray, and the old-style hardback comics they issued were too expensive for most children. As if sensing an opportunity, dozens of tiny companies sprang up, mainly in the rival business center of Osaka, publishing "red book" comics: notoriously cheap comics with red-ink covers, printed on rough paper and hawked on the streets. Artists were paid next to nothing but given considerable freedom. And among them was a young medical student named Osamu Tezuka, whose remarkable success would awaken the Tokyo companies to a new potential of the comic medium.

In 1947, when Tezuka was twenty, he created the comic *Shintakarajima* ("New Treasure Island"), loosely based on a script by Shichima Sakai (fig. 74). *Shintakarajima* was 200 pages long. Its creative page layout, clever use of sound effects, and lavish spread of frames to depict a single action made reading *Shintakarajima* almost like watching a movie. Young readers were dazzled. No precise records exist, but sales of the comic are estimated at between 400,000 and 800,000, without the benefit of publicity.

73. Masao Morishita, aged fifty-eight, is one of the few professional kami-shibai *narrators still working today and has been in the business over thirty years. Every afternoon at the same time, he wheels his bicycle to a nearby park, where a crowd of children and their mothers are waiting. Deftly slipping sequential drawings in and out of the upright frame on his bicycle, Morishita provides both narration and sound effects. Timing is crucial to create suspense. Usually the show consists of three parts: drawings involving quizzes and audience participation; a comedy story; and a ghost story. The story shown here is "Blood Screams."*

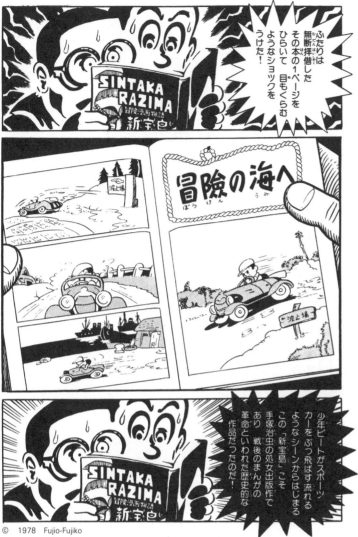

ふたりは無断拝借したその本の1ページをひらいて目もくらむようなショックをうけた！

冒険の海へ

渡止場

少年ビートがスポーツカーをぶっ飛ばす流れるようなシーンからはじまるこの「新宝島」こそ手塚治虫の処女出版作であり、戦後のまんがの革命といわれた歴史的な作品だったのだ！

© 1978 Fujio-Fujiko

74. *Osamu Tezuka's 1947 smash hit* Shintakara-jima *("New Treasure Island") was a goulash of* Treasure Island, Robinson Crusoe, *and* Tarzan. *The artist duo Fujio-Fujiko have described their reaction to Tezuka's new-style comic in their 1978 semi-autobiographical comic,* Manga Michi *("The Way of Comics"). (TOP) "We turned the first page of the book we had borrowed without permission, and reeled in shock!" (MIDDLE) Chapter title: "To the Sea of Adventure." Sign: "Pier." (BOTTOM)* "New Treasure Island *began with a flowing scene in which young Pete roared off in his sports car. It was Osamu Tezuka's debut publication—a revolution in postwar comics!"*

Tezuka is an example of how one talented individual, born at the right time, can profoundly change the field he decides to work in. His heart was not in medicine, and when he eventually abandoned his scalpel to become a professional artist he brought to the medium of children's comics the cultivated mind of an intellectual, a fertile imagination, and the desire to experiment. Comics were merely a forum for Tezuka to express himself. Stylistically his main influence was not comics but film, and the animation of Walt Disney and Max Fleisher. Tezuka was a frustrated animator.

Soon after the appearance of *Shintakarajima*, Tezuka was approached by several newly formed, Tokyo-based, quality boys' magazines, including *Manga Shōnen* and *Shōnen*, in whose pages he began the serialization of what were to become two classics—*Jungle Taitei* ("Jungle Emperor") and *Atomu Taishi* ("Ambassador Atom," later changed to *Tetsuwan Atomu*, or "Mighty Atom"). Years later he would animate both works as pioneering television series. Western readers may already be familiar with these works as *Kimba, the White Lion* and *Astro Boy* (figs. 75, 76).

TEZUKA ON FILMS AND COMICS

From the autobiography of Osamu Tezuka: "I felt [after the war] that existing comics were limiting. . . . Most were drawn . . . as if seated in an audience viewing a stage, where the actors emerge from the wings and interact. This made it impossible to create dramatic or psychological effects, so I began to use cinematic techniques. . . . French and German movies that I had seen as a schoolboy became my model. I experimented with close-ups and different angles, and instead of using only one frame for an action scene or the climax (as was customary), I made a point of depicting a movement or facial expression with many frames, even many pages. . . . The result was a super-long comic that ran to 500, 600, even 1,000 pages. . . . I also believed that comics were capable of more than just making people laugh. So in my themes I incorporated tears, grief, anger, and hate, and I created stories where the ending was not always 'happy.' "

75. *Leo, the Jungle Emperor, and Hige Oyaji are caught in a blizzard while on an expedition to the mountains. To save his friend's life, Leo impales himself on Hige Oyaji's knife and offers his body. A sobbing Hige Oyaji reluctantly accepts Leo's fur and flesh, and lives. One of the moving final scenes from Osamu Tezuka's* Jungle Taitei *("Jungle Emperor"), a humanistic tale of three generations of intelligent lions who try to protect and organize the animal kingdom. It was serialized in* Manga Shōnen *from 1950 to 1954 and made into Japan's first color animated television series in 1965.*

The demand for Tezuka comics (and imitations) seemed insatiable. He experimented with his new style in a spate of productivity, creating science fiction, detective stories, historical works, and romances for girls. Stories of hundreds of pages in length and his new cinematic techniques allowed a level of character and plot development that had been previously unimaginable.

Volumes have been written in Japan about Tezuka and the revolution he triggered. Most striking is the effect he had on young readers. None of the major artists today has escaped his influence. Many have specifically stated that they chose their career when they first read Tezuka's comics.

Manga Shōnen, the Tokyo monthly magazine that serialized *Jungle Taitei,* also played a major role in popularizing comics. It was founded in 1947 by Ken'ichi Katō, a former editor of the prewar *Shōnen Club* who was purged from his job by Occupation forces in the belief that that magazine had been militaristic. *Manga Shōnen* only lasted until 1955, but it was a remarkable experiment in that it was one of the first

76. *After being transported into the past by a time machine, Atom and his surrogate father, Dr. Ochanomizu, are attacked by a dinosaur while fording a stream.* Tetsuwan Atomu ("Mighty Atom"), *Japan's most famous science fiction comic, starred a little boy robot with superpowers and human emotions. In his long (and continuing) career, Atom consistently opposed war and injustice—unlike American superheroes he fought not for freedom but for peace. The story, a pioneer in a huge genre of robot characters, was serialized in* Shōnen *from 1952 to 1968 and made into Japan's first animated television series in 1963.*

77. *In the 1950s young Japanese vied with each other to have their own comic submissions accepted by the magazine* Manga Shōnen. *Fujio-Fujiko treated this theme in* Manga Michi. (LEFT) "Michio Maga was stricken with an indescribable feeling of failure!" (CENTER) "Beneath the large-type name of Shigeru Saino, sandwiched among those of the other entrants and printed so small a magnifying glass was needed to see it, he finally found his own name."

78. *Soon after Osamu Tezuka moved into the ramshackle apartment building Tokiwasō in 1954 he was joined by other aspiring artists, some still in their teens, and eventually they occupied the entire second floor. Poor, but inspired by Tezuka's example, they began submitting their work to the comic magazines. Today, many of these original residents are rich and famous. Eight of them are shown here as they appeared in 1956, in a drawing by Fujio-Fujiko (Messrs. Fujimoto and Abiko, top right). By this time, Tezuka had already left. As for Tokiwasō, it still stands, a tourist attraction slated, rumor has it, for demolition.*

Japanese children's magazines to concentrate on comics. In addition to the work of reigning professionals, it also featured the works of unknown amateurs. Boys—and some girls—from all over Japan sent in samples of short comics, and their names were published and ranked according to the excellence of their submission (fig. 77). Artists of promise were sent little metal badges; the best had their creations published and, in what must have seemed like a dream come true, were sometimes commissioned to create a serialized story.

Partly as a result of Tezuka's success, comics came to be regarded as a creative medium accessible to anyone—unlike novels or films which required education, connections, and money. A list of contributors to *Manga Shōnen* in the early '50s reads like a who's who of the comic industry today—Fujio-Fujiko, Fujio Akatsuka, Reiji Matsumoto, Hideko Mizuno, Shōtarō Ishimori, and on and on—many of whom became professionals at the age of seventeen or eighteen. The list also includes Sakyō Komatsu, a top science fiction writer, Tadanori Yokoo, an internationally famous illustrator, and many of Japan's finest designers, cameramen, actors, poets, and screenplay writers.

Demand for the new story-comics by monthly magazines in Tokyo brought Tezuka to the capital in 1954. There he moved into a rundown apartment building named Tokiwasō, which became a mecca for young artists from all over Japan who wished to follow in his footsteps. Several began living in the same building and eventually became his main competitors (fig. 78). The "red book" comic boom in Osaka had been short-lived, but it had helped popularize comics. The industry was now centered in Tokyo.

Artists who drew serialized stories for Tokyo-based magazines in the 1950s were the elite of the industry. But there was still another group, creating the same kind of story-comics, who worked for a pittance. Their publishers, though centered in Osaka, were linked not with the "red book" comics but with the *kashibon'ya*, or professional book-lenders, who at one time were estimated to number 30,000 nationally. These pay libraries, like *kami-shibai*, were a response to a demand for inexpensive entertainment and lent both books and comics for a small fee according to the number of days borrowed. Many comics were created exclusively for the pay libraries, taking the form of "books" and monthly "magazines," notably *Kage* ("Shadow"; fig. 79) and *Machi* ("City"). Both the comic books and comic magazines were about 150 pages long with stitched bindings and hard covers. They had to withstand the readings of hundreds of people.

The artists who cartooned for the pay-library market, like their counterparts in the children's magazines, made use of the cinematic techniques and novelistic plots coming into vogue. Increasingly, their readership was older, often including high school students and young factory workers. Artists like Takao Saitō, Masaaki Satō, and Yoshihiro Tatsumi dropped the Disney-style of drawing that was popular in the children's magazines and adopted a more serious, graphic approach to depict more adult and action-oriented themes. Appropriately, they even gave their comics a new

name—*gekiga*, or "drama pictures." With the advent of television, many *kami-shibai* artists who lost their livelihoods started drawing *gekiga*, bringing to that genre new talent and narrative skills.

The incredible popularity of story-comics, whether created by the Tezuka camp of artists or by those working for the pay-library market, led Tokyo-based publishers to decrease the amount of text in most monthly children's magazines, add more pages, and increase their size so as to better display the artwork. This was not enough. By the end of the 1950s the Japanese economy was beginning its explosive growth. Young people had spending money, and they wanted more comics.

In 1959 Kōdansha, one of the largest book publishers in Japan, jolted the industry by issuing *Shōnen Magazine*, the first weekly wholly devoted to comics. It soon ballooned into a 300-page monster. Other publishers quickly followed suit, and within a few years seven weekly comic magazines with the same basic format—five for boys and two for girls—engulfed the industry. Meanwhile, since people could afford to buy comics and no longer needed to borrow them, the pay-library market collapsed (today there are only around 2,000 lenders left), and its many talented and productive artists entered the mainstream of the industry. Usually this involved their coming to live in Tokyo.

As artists Fujio-Fujiko have noted, the changeover from a monthly to weekly format was as traumatic for artists as the switch from silent movies to "talkies" had been for actors. It meant that artists had four times as much work to do as before, and only a quarter of the time between deadlines. Their entire lives had to be reordered.

From that point on, the escalator went through the ceiling. In 1966 the weekly circulation of *Shōnen Magazine* topped 1 million; in 1978 *Shōnen Jump* and *Shōnen Champion* passed the 2-million mark; and in December 1984 *Shōnen Jump* sold over 4 million copies in one week.

By the mid-1960s the industry had assumed its present configuration. It was predominantly located in Tokyo. Television and comics were firmly intertwined in a symbiotic relationship. Major book publishers supported themselves with sales of comics, first serialized in magazines and then compiled into series of paperbacks. Meanwhile the average age of the readership was steadily rising, resulting in the appearance of comics for adults. Women had finally entered the field in force as artists for girls' comics, displacing men with the convincing argument that they better understood female psychology.

While the development of comic books in the United States faltered, and sales shriveled, Japan gave birth to a Godzilla. But the explosion of the industry did not occur without a sacrifice. The color printing that was so common before the war all but disappeared. Political and editorial cartoons were virtually destroyed by politics, ideology, and later, apathy. Humor magazines featuring short, sophisticated comics and cartoons in the tradition of the British *Punch* or the American *New Yorker* were driven out of business, and the artists of this genre were demoted to the role of filling in the spaces between the long story-comics in comic magazines.

79. Kage ("Shadow"), a popular hardcover magazine for pay libraries, published from 1956 to 1966. The cover is by Yoshihiro Tatsumi, the first person to coin the word gekiga, or "drama pictures," as distinct from manga, or "comics."

The Spirit of Japan

80. *Ittō Ogami, the outlaw samurai, about to enter his next-to-last battle, in which he slays thirty-seven opponents. From* Kozure Ōkami *("Wolf and Child"), by Kazuo Koike and Gōseki Kojima.*

If the cowboy symbolizes the American ethos, then the samurai warrior surely symbolizes the ethos of Japan. Some of the first Japanese comic strips for children appeared in the 1920s and were stories of little samurai boys. They grew out of tales of bravery, called *buyūden*, popular in feudal Japan in literature, the Kabuki theater, and picture books. With themes that are far more complex today, samurai comics—loosely referred to as *jidaimono*, or "historical tales"—are one of the most established of the Japanese comic genres (fig. 80). The samurai influence, moreover, spreads through all dramatic comics for men and boys.

PALADINS OF THE PAST

During much of Japan's long feudal period, society was rigidly divided into four classes: warriors, farmers, craftsmen, and merchants. The warrior, that is, the samurai, was the elite of this system. He adhered to *bushidō*, the "Way of the Warrior," an idealized code of conduct that blended elements of Buddhism, Confucianism, and the native religion, Shintō. *Bushidō* stressed unquestioning loyalty to one's lord, stoicism, self-sacrifice, and nonattachment to both the material world and to life itself. Its ethic permeated society and helped form what is known as *yamatodamashii*, or the "spirit of Japan," a term applied today mainly to men.

However obscured today by a commitment to liberal democracy, by Big Macs, UCLA T-shirts, and the "high-tech" look of modern Japan, much of the *bushidō* ethic still exists. Japan remains a society where individual desires must be subordinated to the good of the group, and where blind loyalty is more easily justified than unyielding principle. Men in Japan are still raised to be the stoic "warriors," to endure and to persevere in spite of hardship—if only at the office.

Early samurai comics often showcased brave heroes who

七十七

太郎「いたづらに命を取るのは好まぬけれども、僕の油断を狙つて不意討こは卑怯未練である、不憫ながらも返り討だ」ミ太郎は繪の如く鮮かなる腕前を極ひました

© 1923 S. Miyao

81. Shigeo Miyao's Manga Tarō, published in 1922, was one of the first children's comics in Japan, and it starred a little samurai-superman, Tarō. It was done in the captioned-picture style then common: "Tarō: 'I don't like to take a man's life for nothing, but you tried to catch me off guard with a sneak attack, like a coward. Too bad, but take this!' And so Tarō displayed his brilliant swordsmanship, as in the picture."

82. Hatanosuke pursues a brigand with a lasso, a very novel weapon artist Kikuo Nakajima gave his samurai hero. From Hinomaru Hatanosuke ("Hatanosuke of the Rising Sun"), serialized from 1935 to 1941 in Shōnen Club.

were role models for young boys (fig. 81). In the years prior to and during World War II, *bushidō* was revived by the government, and its stress on absolute obedience to authority was skillfully exploited to obtain conformity among the population. The samurai comic easily fit in with the official line. One of the most popular comic strips for children prior to the war, *Hinomaru Hatanosuke* ("Hatanosuke of the Rising Sun"), by Kikuo Nakajima, starred a young samurai who always protected his lord and fought for justice and the good of Japan (fig. 82). It had the type of patriotic theme that the militarists loved, and the hero conformed with what was regarded as an ideal: "a good child, a strong child, and a child of the Rising Sun."

Defeat in World War II caused a brief hiatus in samurai stories, but they revived with the success of *Akadō Suzunosuke* ("Suzunosuke, with the Red Breastplate") by Tsunayoshi Takeuchi in 1954. Like prewar samurai stories, it had a heavy dose of the old ethic and regularly pitted good against evil, but it was neither militaristic nor nationalistic. Japan was now a pacifist nation, and *Akadō Suzunosuke* concentrated on swordplay and the Japanese sport of fencing, or kendo. It was, in a sense, a sports comic (fig. 83).

Until the 1960s samurai comics, like all comics, were targeted at younger audiences; they were usually drawn in a "cartoony" style with rounded, soft lines, and they incorporated frequent gags and puns. But in the last twenty years

© 1954 T. Takeuchi

83. Cover to volume 15 of Akadō Suzunosuke ("Suzunosuke, with the Red Breastplate"). Tsunayoshi Takeuchi's postwar samurai story ran from 1954 to 1960 in Shōnen Gahō.

84. *Kagemaru, star of Sampei Shirato's* Ninja Bugeichō *("Chronicles of a Ninja's Military Accomplishments"), was a feared leader of peasant revolts in the 16th century. The warlord Nobunaga had him killed. But when Kagemaru's head was brought to Nobunaga it announced its own presence! Retainers gasped and noble ladies fainted.*

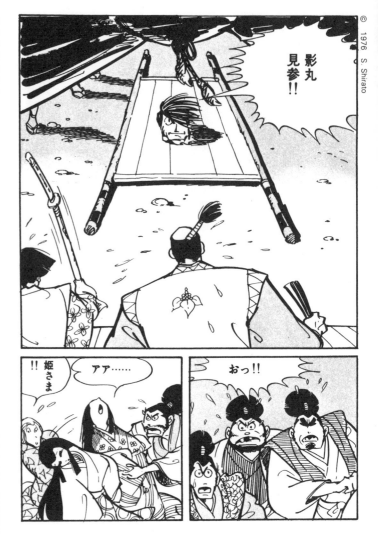

"NINJA BUGEICHŌ"

Published for the pay-library comic market from 1959 to 1962, Sampei Shirato's classic, *Ninja Bugeichō*, is long and raga-like, with multiple intertwined themes and dozens of characters. On one level it is a swashbuckling samurai tale. On another, it is Shirato's attempt to expose the role of peasant revolts in feudal Japan and the interaction of oppressor and oppressed. Scenes in this tapestry include sprawling battles between warlords; burning castles and ravaged villages; executions; masses of peasants armed with shovels and bamboo staves, chanting in suicidal revolt against their samurai masters; crows and wolves fighting each other to feast on human corpses. Central to the story are Kagemaru, the hero, a fictional ninja who aids the peasantry in their struggles, and Nobunaga Oda, the warlord who nearly unified war-torn Japan in the 16th century. Kagemaru was a master of disguises, disappearing acts, and swordsmanship, and he had his own band of seven ninja followers, each with his own special powers. In the end Kagemaru is betrayed. He is drawn and quartered by the Nobunaga forces and his band is annihilated. But Nobunaga too is later killed. What remains is class struggle and the momentum of history. In 1966 *Ninja Bugeichō* was made into a ninety-minute film by Nagisa Ōshima, director of *Realm of the Senses*. Ōshima's gripping drama consisted solely of voices and shots of Shirato's artwork from a variety of camera angles. No animation or actors were used.

the genre has changed radically. As of 1982, samurai stories appear to be temporarily out of vogue in children's comics, and the few stories drawn in a "cartoony" style tend to be parodies of serious strips. Instead, samurai tales appear primarily in comic magazines for young men. Their themes no longer adhere to the old pattern of good versus evil; they incorporate violence, sex, and philosophy, and their art style is among the most graphic and realistic in Japan.

Three artists who elevated action-packed samurai stories to their present level are Sampei Shirato, Gōseki Kojima, and Hiroshi Hirata. All emerged from the pay-library comic market after its collapse around the early 1960s.

In 1959, Shirato began drawing the now classic seventeen-volume *Ninja Bugeichō* ("Chronicle of a Ninja's Military Accomplishments"), an epic tale set in Japan's Warring States period of the 16th century when the whole nation was caught up in a bloody struggle for supreme power. Shirato had formerly also been a *kami-shibai* artist, and he was the son of one of the prewar "proletariat" artists. Instead of merely rehashing old themes of bravery and good versus evil, he wove historical detail into a story that gripped readers with its harsh view of life and the struggle to survive. The hero, Kagemaru, was a ninja (a specially

trained spy-assassin) and a leader of peasant revolts (fig. 84). *Ninja Bugeichō*'s graphic depiction of violence aroused opposition in many quarters, but it found a wide following among certain sectors. At the time, Japan was polarized by issues centering on the Japan–United States Security Treaty, and both campuses and streets were convulsed in demonstrations by students, who feared that a defense treaty with the United States would lead the country into war. *Ninja Bugeichō*, with its stress on class consciousness and reform, had a special appeal to university students and intellectuals, who called its theme one of "historic materialism." Student newspapers printed commentaries on it and recommended that their readers learn from it. For many, *Ninja Bugeichō* became a substitute for reading Marx. The success of *Ninja Bugeichō* and other subsequent ninja stories by Shirato laid the foundation for a new, more intellectual type of samurai story and helped expand the readership of comics to include even higher age groups.

Gōseki Kojima has concentrated on samurai stories, usually working in tandem with writer Kazuo Koike. In 1970 the pair began a twenty-eight volume work that has since set a standard for the genre: *Kozure Ōkami* ("Wolf and Child"; fig. 85). Like *Ninja Bugeichō, Kozure Ōkami* was a story of survival, but it was also a tale of revenge. Its antihero, Ittō Ogami, an executioner for the Tokugawa shogunate in the Edo period, had been driven from his post by the vagaries of factional politics. His wife murdered, he embarked on a mission of vengeance, becoming a paid assassin. What saved the story from becoming nothing but endless scenes of slaughter was the presence of Ogami's infant son, Daigorō, who served as an unimpassioned observer and a metaphor for the relationship between fathers and sons. When Ogami slashed his way through phalanxes of enemy attackers, the chortling Daigorō often preceded him, riding in a wooden baby cart secretly equipped with spears, spring blades, and smoke bombs. The contrast between human bonds and violence on the battlefield is a favorite theme of all samurai stories, and it is the glue that holds this one together.

Finally, Hiroshi Hirata, one of the most realistic of the action artists, has concentrated on portraying the warrior ethic at its most violent in stories such as *Bushidō Zankoku Shikon Monogatari* ("Tales of Cruelty in *Bushidō*"). He revels in portraying the impoverished but proud lower-rank samurai, the type who in history hid his hunger with a toothpick and would kill either an opponent or himself without hesitation (fig. 86). Hirata's art style is the extreme of its type. He incorporates little humor in either story or line and strives for as much historical detail and realism as possible, whether drawing old types of armor or a scene of a warrior disemboweling himself. The novelist Yukio Mishima, who committed ritual suicide in 1970, was a fan of Hirata's work.

Like those of Shirato and Kojima, Hirata's stories have tended to concentrate on life in the war zone when fighting was a way of life for an entire class. But not all *jidaimono* comics have stressed action. Other artists have chosen to concentrate on historical detail and human psychology, and the heroes of their stories are not always samurai. Shōtarō

YUKIO MISHIMA ON COMICS

In February 1970, nine months before his spectacular ritual self-disembowelment, novelist Yukio Mishima wrote on young people and comics in the *Sunday Mainichi* magazine. Mishima's articles and public behavior often suggested the pose of a right-wing nationalist who romanticized the way of the samurai. "The pay-library comics that once could only be purchased in the flea markets of Ueno had ten times more vulgarity, cruelty, wild abandon, and vitality than those of today. They were what is called 'unsuitable reading matter.' But in Hiroshi Hirata's samurai comics, with their direct, serious art style, I find a nostalgia for the *kami-shibai* of old, and a sensibility in the manner of the violent warrior prints of the late Edo period."

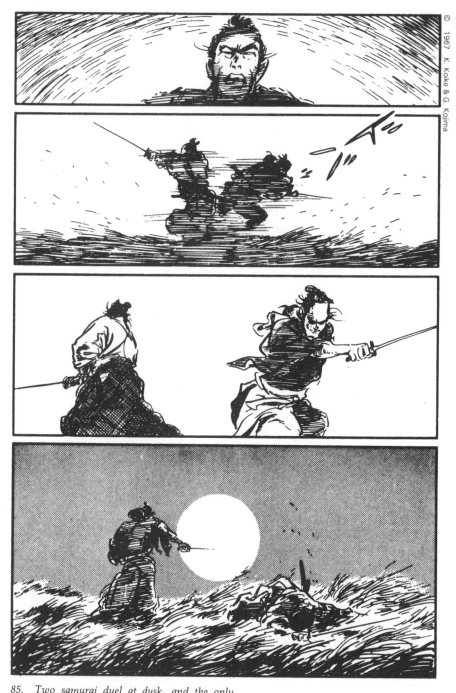

85. *Two samurai duel at dusk, and the only sound is that of sword on flesh. Kozure Ōkami first ran in the adult weekly* Manga Action *from 1970 to 1976 and then sold over 5 million copies in paperback. It spawned popular songs, a TV series, and six live-action films. A re-edited film version, produced in America, was released under the title* Shogun's Assassin *in 1980. John Stanley, writing in the* San Francisco Chronicle *in January 1981, describes how the samurai grunts and groans in the movie were re-created by the staff of a Hollywood sushi bar and how new sounds of swords hacking flesh were produced using a huge supply of vegetables, watermelons, and slabs of roast beef.*

Ishimori's *Sandarabotchi* ("The Round Straw Lid"; fig. 87), serialized for seven years in *Big Comic*, stars a bamboo artisan who moonlights as a debt collector in Yoshiwara, the red-light district of old Edo; it renounced all action for the sake of character development and lavish detailing of the life of the common people. *Haguregumo* ("Wandering Clouds"), by Jōji Akiyama, has the head of a company of palanquin bearers for a hero; a drop-out from the samurai class, he is relaxed and adept at enjoying life. *Haguregumo* does not stress war, stoicism, or even unquestioning loyalty. Instead it uses stories of human relations to affirm the importance of a fulfilled life (fig. 88).

86. *Screaming, "A match for a samurai!!" a warrior charges. From* Shikon *("Samurai Spirit"), by Hiroshi Hirata.*

87. Sandarabotchi *("The Round Straw Lid"), by Shōtarō Ishimori, began serialization in* Big Comic *in 1975. Tombo, the bamboo craftsman/toymaker, is shown launching a traditional toy "helicopter" in front of his store.*

MODERN-DAY WARRIORS

Given the martial quality of most samurai comics, however, one would expect Japan to have developed "war comics" in the American tradition. After all, titles like *Fightin' Marines*, *Fightin' Army*, and *Sgt. Fury* have long helped support the American comic industry. But few Japanese comics today glorify modern militarism, and for a very good reason.

The original samurai idolized obedience and regarded dying for the sake of honor as a privilege, and the government tried to revive this aspect of the *bushidō* ethic in World War II. Total defeat, and the needless death of millions, resulted in its being permanently discredited. Japan today is the only major nation in the world to have a clause in its constitution renouncing war forever and forbidding the maintenance of offensive land, sea, or air forces. While the nation is under pressure—particularly from America—to make a more liberal interpretation of this clause, overt advocacy of warlike posturing is considered the epitome of bad taste among virtually all classes and age-groups in society. In the world of

88. *The serious and studious Shinnosuke climbs on top of a wayside lantern to exclaim, "Mind not little things. Be as the drifting clouds." To which his laid-back father replies, "Ha Ha. . . . That's the way." From* Haguregumo *("Wandering Clouds"), by Jōji Akiyama, serialized since 1974 in* Big Comic Original.

comics this has meant that World War II is a subject approached especially gingerly.

Many artists, in fact, have done their best to ridicule the wartime warrior values. Koremitsu Maetani, a veteran of the war, created an antiwar comic popular in the 1950s titled *Robotto Santōhei*; the title of the story, and the hero's name, express its theme—"Robot, Pvt. Third Class." Shigeru Mizuki lost his left arm during an American bombing in World War II, and in his 350-page comic *Sōin Gyokusai Seyo!* ("Banzai Charge!"), based on his own experiences as a soldier, he describes the result of blind obedience in lurid detail (fig. 89). A detachment of soldiers under the command of a major intoxicated with *bushidō* ideals is sent to an island off Rabaul, New Britain. When the enemy in the form of the Americans arrives, the major orders a "banzai" suicide charge, sending his raw troops to destruction. Some are lucky enough to survive, but they are informed by headquarters in a Kafkaesque announcement that since their glorious death has already been reported they must either commit suicide or attack

89. *Maruyama's unit commits the sin of surviving a banzai charge and is sent to the front one more time—with orders not to return alive. The men sing one last song, and walk straight into an enemy barrage. Maruyama, with a bullet in his cheek and flies gathering in his wound, is the last to die: "Ah, so this is how everyone went . . . unseen . . . and unable to speak to anyone . . . only to be forgotten." From Shigeru Mizuki's 1973 comic, Sōin Gyokusai Seyo! ("Banzai Charge!").*

again. Surrender was a word not even listed in the Japanese soldier's manual.

Others have described the plight of the civilian in war. Keiji Nakazawa, a survivor of the atom bombing of Hiroshima, has recorded his experience in *Hadashi no Gen* ("Barefoot Gen"), a dramatic chronicle of the suffering of the survivors and an exposé of the militarism of prewar Japan.

There is no room for the American type of invincible soldier in Japanese comics. There is no cigar-chomping, unshaven equivalent of Sgt. Fury or Sgt. Rock, eager to kill Krauts and Commies. This does not mean that Japanese men and boys do not fantasize about the romance of combat. It means that there are different standards of acceptability. Japanese comics may be among the most violent in the world, but when World War II is portrayed romantically the emphasis is usually on the bonds formed between men under stress; on death, not of the enemy but of Japanese troops (tragic death has a romantic overtone to it); or on the machinery of war—the planes, ships, and weapons. The

WOMEN IN COMICS FOR MEN AND BOYS

Female characters in the comics for men and boys have often been little more than sex objects to be used and abused, or demure, idealized women who serve as "tenderizer" in plots depicting a harsh masculine world. But times are changing. According to cultural anthropologist Tadahiko Hara, where women in serious dramatic stories were once totally devoted to the man, always ready to sacrifice themselves for his sake, now they are much more passionate and fickle, and are likely to betray the hero. Recent years have also seen an increase in female characters who are quite independent and even eclipse their male counterparts; when sex objects they are often of the Amazon-goddess variety. In the love-comedy stories currently in vogue in boys' magazines, a wholly new type of female has emerged: the American-style "girl friend" who, in addition to being an object of romantic and sexual interest, is also a best friend and confidante. Usually she is drawn larger than the male, who is typically small, physically plain, and shy.

90. *After being told that his unit must become a special attack squad, or kamikaze, young fighter pilot-ace Taka confronts his commanding officer. (1) "Why do we have to die? What for?" (2) "For your country. You must die to save Japan." (3) "But we can't save Japan. It's only a matter of time until we're defeated. Why should we die a dog's death?" (4) "WHAP!" (5) "Say that one more time and I'll kill you on the spot with my sword." (6) "Well, that would be interesting. Go ahead and do it." From* Shidenkai no Taka *("Taka of the Violet Lightning"), by Tetsuya Chiba, serialized from 1963 to 1965 in* Shōnen *Magazine.*

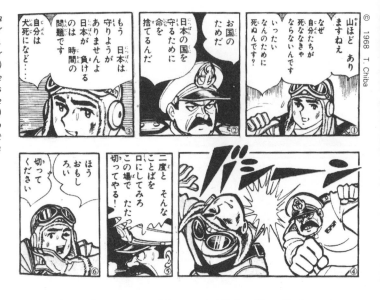

enemy is rarely portrayed in a racist light. Usually he is not at all conspicuous. Stories of fighter pilots have far out-numbered those of infantry or sailors, because aerial combat is more depersonalized, more "fair," and hence more chivalrous. But even the kamikaze pilot, as depicted by Tetsuya Chiba in *Shidenkai no Taka* ("Taka of the Violet Lightning"), goes to his death after realizing that he is but a pawn in a larger game (fig. 90). What survives of the *bushidō* tradition in Japanese war comics is the ability to endure suffering.

The direct heir of the samurai tradition in Japan today is not the military, but the underworld. Things are slowly changing, but most yakuza, or Japanese gangs, still revere the sword and are motivated by concepts of honor that date back hundreds of years. They believe in *on* ("obligation"), *giri* ("duty"), *ninjō* ("honor-compassion"), and *ninkyōdō* ("chivalry"), and their internal organization follows the traditional Japanese pattern of paternalistic chief and devoted followers. Yakuza allow artists who create adventure stories (such as Hiroshi Motomiya) to weave themes from the middle ages into a modern setting and to embroider their stories with romantic paraphernalia like samurai swords, elaborate full-back tattoos, traditional cloth belly-warmers, and rituals such as hacking off one's little finger to atone for a crime against the group (fig. 91). It is above all a man's world, but, given the times, artists can have some fun by making a woman the leader of a gang.

A variation on yakuza themes is the "school-gang" comic, which depicts the juvenile delinquent element of Japanese schools and is popular among student readers. These gangs are usually innocuous in reality (Japanese teenagers are notoriously well-behaved by American standards), but their internal structure closely resembles that of the adult yakuza. Their uniform is the traditional Japanese school uniform, which was modeled after that of German students at the turn of the century and is therefore military in appearance—the girls wear sailor suits. But gang members are always distinguishable by the way they tilt their hats, walk with their

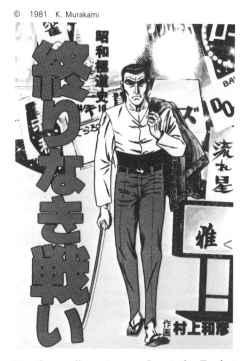

91. *Cover illustration to* Owarinaki Tatakai *("Endless Fight"), the tenth volume in a twenty-three-volume lurid tale of life as a yakuza, titled* Shōwa Gokudōshi *("Evil in the Shōwa Period"). Drawn in 1981 by Kazuhiko Murakami, in a style identical to that of Takao Saitō's* Golgo 13.

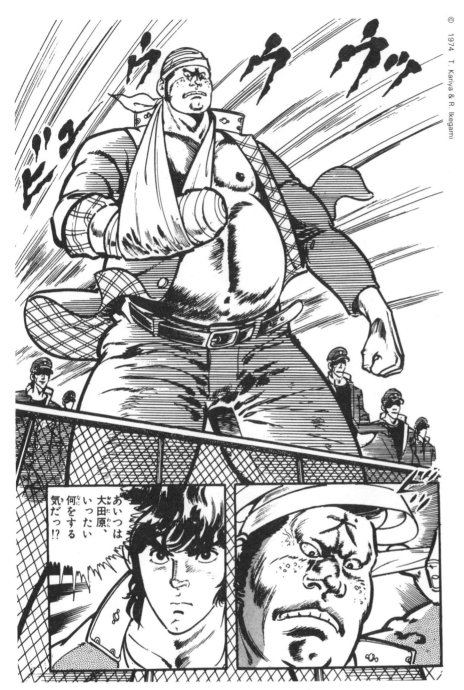

collars unbuttoned, and in other subtle ways suggest that they are BAD (fig. 92). The high point of all school-gang comics is the grand fight, usually staged in an isolated area, where the good forces prevail over evil in a brawl that involves wooden samurai swords, bicycle chains, and fists. Imaginative artists sometimes introduce boomerangs, maces, and even tanks. In this genre, the bad forces, as in American Westerns, are always ugly and heavily caricatured, while the hero in most stories is usually ruggedly handsome.

In America, almost every comic book hero is a "superhero"—with bulging biceps (or breasts, as the case may be), a face and physique that rigidly adhere to classical tradi-

92. An evil, ugly member of a school gang confronts a handsome hero; both youths have their school-uniform collars unbuttoned. The "baddie" removes the bandage from his head to reveal the ideogram for "dog" etched into his forehead. From Otokogumi ("Male Gang"), by Tetsu Kariya and Ryōichi Ikegami, serialized from 1974 to 1979 in Shōnen Sunday.

93. One of Golgo 13's marks imagines his pursuer advancing on him and, realizing he has nowhere to run, breaks out in a cold sweat. The name Golgo 13 was coined from Golgotha, the name of the hill on which Christ was crucified, and from the "evil" number thirteen. It is meant to inspire terror. Artist Takao Saitō's Golgo is outside the bounds of human morality and every two weeks assassinates someone somewhere in the world on the pages of the adult Big Comic, as he has since the series began in 1969.

tions, invincibility accompanied by superpowers, and a cloying, moralistic personality. In Japan, heroes of many genres of comics are rather ordinary in appearance and self-effacing in manner. Even the *sūpahīro* is very down to earth. He may be handsome, but he is not likely to fly (unless he is a jet-powered android robot), nor is he likely to preach. And he is almost always mortal. Artists have found that the tragic death of their heroes not only goes over well with readers but is a convenient way to end a long story.

The typical Japanese superhero has inherited many of the characteristics of his samurai ancestors. He is usually stoic, not very vocal, and part of a group. If not part of a group, he is usually an outsider, a Nietzschean superman, confident of his own ways in an unsupportive world. This type of character holds a particular appeal to the average Japanese man, who, more often than not, is required to sublimate his own personal desires to those of the majority in the organization he belongs to.

The ultimate in the independent character is the hero of *Golgo 13*, one of Japan's most famous comic stories for adults (fig. 93). Created by Takao Saitō and his staff, *Golgo 13* is the story of a professional assassin named Duke Tōgō, alias Golgo 13. Part of the inspiration for Golgo may have come from James Bond, but Golgo is really a super-samurai in a modern setting. He has no known nationality and his ethnic background is unclear: he can pass for either a Japanese or a Spaniard. He is the best at what he does. Owing allegiance to no one, Golgo will gladly hire himself out to whoever pays the highest price, and without batting an eyelash will dispatch his target into eternity. He will kill anyone of any nationality, race, sex, or age. Women are merely a means of satisfying his basic urges, and as soon as the sex is finished he lights a cigarette and ignores his partner. Since 1969, when the story debuted in *Big Comic*, Golgo has never smiled, and his typical response to any query has been a grunt, written in his dialogue balloon as *mu*, or stony silence, represented by five vertical dots. Golgo is the embodiment of *mushin*, the Zen concept of the transcended, amoral state.

SAMURAI SPORTS

Although serious comics for adults tend to be drawn realistically, Japanese comics in general lean in the direction of melodrama in art style and in plot. Everything is exaggerated to milk a situation of all possible drama, a tendency that may stem partly from the broad posturings of the Kabuki theater and the indigenous love of stylization, and partly from the fact that comics are, after all, a form of popular entertainment. Nowhere is the melodramatic touch more pronounced than in sports stories, the most consistently popular genre of comics in boys' and men's comic magazines today.

In the late 1940s the American Occupation authorities took a dim view of all rhetoric and activities that seemed tied to the disastrous wartime mentality. In the comics this meant replacing the old system of censorship by a new one emphasizing democracy. In the schools, anything that smacked of aggressiveness in the educational system, in particular, was attacked. Teachers led their entire classes in blacking out passages of old textbooks that hinted of militarism; educational personnel who did not conform to the new ideals of "democracy" were purged from their posts; and traditional Japanese sports such as judo, karate, and kendo—reflections, it was thought, of *bushidō* values—were banned from the curriculum. This last measure brought all competitive sports into question and proved to be a great disservice to Japanese children. When General MacArthur finally lifted the ban in 1950, the result was a tremendous boom, not only in traditional sports, but all sports. And also in sports comics.

In comics, the way was paved in 1952 by Eiichi Fukui with the series *Igaguri-kun* ("Young Igaguri"; fig. 94) in the magazine *Bōken'ō*. *Igaguri-kun* was a judo strip that thrilled Japanese youngsters with its action and its very Japanese subject. Its hero, Igaguri, was a judo expert whose secret weapon was his "atom bomb" throw.

Igaguri-kun triggered a huge fad that led to comics featuring baseball, professional wrestling, boxing, and volleyball in

94. *Young Igaguri, the judo expert, duels with an opponent whose specialty is karate. Igaguri wins, but in the last frame sits with his arm in a sling, musing, "Karate . . . karate. . . . " From* Igaguri-kun *("Young Igaguri"), by Eiichi Fukui, first published in 1952 in* Bōken'ō.

addition to the traditional sports. The fad, moreover, was spurred on by Japan's successes in the real sports world. As the nation regained its confidence after World War II, Japanese champions began to appear in international boxing, professional wrestling, and volleyball. Sports were a tremendous source of national pride, a legitimate channeling of aggressive tendencies, and also fun. If Japanese boys could no longer dream of growing up to be warriors or soldiers, they could at least become sports stars.

But the concept of sports that Japanese comics present is quite different from that known in America and Europe. One does not engage in sports—especially team sports—in Japan as a means of passing the time. Sports demand total devotion, and they incorporate the best of the old *bushidō* tradition. Words like *shūnen* ("tenacity"), *otoko-rashisa* ("manliness"), *gambaru* ("hang tough"), and *konjō* ("guts") regularly issue from the mouths of professional athletes. When training, raw

recruits must endure *shigoki*, or hazing, and conform to the hierarchy of the team. This means grueling practice sessions, jogging en masse in training suits while chanting *Faitō!* and rituals such as cleaning the shoes of senior team members. Japanese sports comics, by amplifying this serious attitude, become a spiritual metaphor for life and death. Blood flies. Tears flow. People even die. Sports comics are great melodrama, and an acceptable surrogate for war comics.

The most popular sport in Japan today is not judo, sumo wrestling, or karate; it is *bēsubōru.* And in comic magazines highly stylized baseball stories are what male readers demand (fig. 95).

Baseballs in comics are no longer round; they are elastic ellipses contorting in midair as they leave the pitcher's hand. Baseball bats curve like a whip when swung and recoil in shock when connecting with a ball. Likewise, the baseball players who appear are no ordinary mortals. When they step up to the plate, they become actors on a Kabuki stage. The middle ground of human emotions evaporates, and everything experienced is either joyous or tragic. When the odds are stacked against the last hitter in the ninth inning, he approaches the batter's box drenched in sweat. When he belts a home run with all the bases loaded he runs around the field crying great tears of joy. And finally, to make doubly certain the reader understands the seriousness of this game, the artist may give his male hero powerful uplifted Kabuki eyebrows and draw a tiny flame on slow burn in the recesses of his eyes.

In 1966 the success of a baseball comic called *Kyojin no*

95. ZA ZAAA—*Young Tonoma slides home over the plate. "Safe!"* Dokaben *chronicles the thrills of Japan's high school baseball tournament held near Osaka each year before a crowd of 400,000. Forty-eight volumes long,* Dokaben, *which began in* Shōnen Champion *in 1972, has sold over 34 million paperback copies and made a wealthy man of its creator, Shinji Mizushima.*

Scenes from Kyojin no Hoshi ("Star of the Giants"), serialized from 1966 to 1971 in Shōnen Magazine, and its late-1970s sequel, Shin Kyojin no Hoshi, by Ikki Kajiwara and Noboru Kawasaki. (96) GICHI GICHI GICHI . . . Little Hyūma creaks when he moves in his special muscle-building apparatus, which he wears as part of his training. Other exercises included fielding flaming baseballs (soaked in kerosene) thrown by his father. (97) GOOOOOH—a smoking pitch roars towards the batter. (98) The determined pitcher, on slow burn. (99) Hyūma's doctor warns him that if he continues to pitch he will ruin his left arm. But it is too late to stop.

ONWARD, HYŪMA!

With the iron will your father helped you forge
You stake your life; nothing can stop you now!
Give your all! Make those speed-balls burn!
And until you fulfill your vows as a man
You must sweat blood and ignore your tears.
Onward, Hyūma! Ever onward!

(Verse 3 of the theme song from the animated TV series *Kyojin no Hoshi*. Lyrics by Takeo Watanabe. © 1968 Nichion.)

Hoshi ("Star of the Giants") helped usher in what are today known as "sports-guts" comics. Written by Ikki Kajiwara and drawn by Noboru Kawasaki, *Kyojin no Hoshi* starred a young boy named Hyūma Hoshi who dreamed of joining the Giants, Japan's most famous baseball team. Hoshi's father, a former ballplayer himself, puts his son through rigorous training and eventually the boy's dream materializes. He becomes one of Japan's star pitchers. But the father later hires on as the coach of a rival team and trains an American player (Americans often play on Japanese clubs) to counter his own son. The end of the story is a mixture of sadness and joy, for Hyūma beats his rival but tears a tendon in his arm and is forced to abandon baseball. *Kyojin no Hoshi*'s phenomenal popularity derived partly from its realism (actual baseball stars appeared as characters in the story), its pitting of father against son in an age-old loyalty conflict, and its glorification of Hyūma's earnestness, perseverance, and courage (figs. 96–99).

All other sports are depicted in comics with the same intensity as baseball—professional wrestling, kick boxing, moto-

100. *Tiger Mask, the pro wrestler and champion of orphans and the poor, leaps at his enemy, Golgotha Cross. Golgotha Cross is from America, where he was banned because of his brutal tactics (he only fights in a barbed-wire ring with a nail-studded cross in the center). Professional wrestling is popular in Japan, especially among small boys. This chapter in the* Tiger Mask *series, carried in* Kōdansha *magazines in the 1970s, included a sixteen-page introduction to Christianity for the benefit of young readers. By Ikki Kajiwara and Naoki Tsuji.*

cross, car racing, volleyball, judo, and rugby, and the list goes on and on (fig. 100). About the only sport Japanese comic artists have yet to attempt is cricket. All stories, unless they are gag strips, use the game as a metaphor for human endeavor and testing of the spirit, and they rely on the interactions of developed personalities to create interesting plots and maintain reader interest.

One of the most popular sports comic stories of all time, *Ashita no Jō* ("Jō of Tomorrow"; fig. 101), by Tetsuya Chiba and Asao Takamori, was about boxing. It featured a young hero named Jō Yabuki who, like the hero of *Kyojin no Hoshi*, climbed from obscurity to champion status. During the five years he appeared in *Shōnen Magazine* he constantly tugged at the heartstrings of his fans. Jō won victories, went into agonizing slumps, and finally died in the ring in 1973 with a smile on his face, after a last fight with a bantamweight champion named José Mendoza (fig. 102). The finale of the comic was the talk of all Japan. Chiba, the artist, went on to fame with sports stories about sumo, kendo, and golf (figs. 103, 104).

American football comics in Japan, known by the contraction *Amefukomi*, depict a newly discovered game. Football's emphasis on team spirit, strategy, and competition fits the Japanese concept of sports perfectly, and huge uniforms and pretty cheerleaders create a romantic aura Japanese boys love. The artist of *Kyojin no Hoshi*, Noboru Kawasaki, found this to be fertile territory for his "sports-guts" comics. In his series *Football Taka* ("Football Hawk"), the protagonist was a Japanese boy named Taka who was scouted in Japan by a visiting United States team coach. He was then taken to America, where his training program and life in the sport were an interesting overlay of Japanese values on the perceived reality of the gridiron. Taka practiced in an American desert until his hands were bleeding and he dropped from exhaustion and thirst. In the games his agility and courage made up for his light weight in comparison with the American athletes. As an inheritor of the samurai tradition he was required to exert his utmost and did so. Kawasaki the artist could not resist getting in a little nudge by visually equating Taka with a

IS THERE NO LIMIT TO OUR GRIEF?

"Tōru Rikiishi fought valiantly against his arch-rival Jō Yabuki in the pages of *Shōnen Magazine* and was ceded a victory after a terrific K.O., but we regret to announce that he has passed away. We take this occasion to thank Rikiishi's fans for their support while he was alive, and to mourn the passing of one of boxing's greatest heroes." So ran Kōdansha's notice to Rikiishi's grieving admirers. In March 1970 over 700 people converged from all over Japan to attend the funeral service. In a ceremony held at Kōdansha in a full-size boxing ring, presided over by a Buddhist priest, a gong sounded the count of ten, and all joined in a silent prayer.

101.　Tetsuya Chiba and Asao Takamori's *Ashita no Jō* ("Jō of Tomorrow"), which ran from 1968 to 1973 in Shōnen Magazine, featured Jō Yabuki as a champion boxer. In the course of the story there appeared an old rival from Jō's reform-school days, Tōru Rikiishi. Rikiishi embarked on a crash diet so that he could compete in Jō's weight-class, but this regimen led to his premature death in the ring on 15 February 1970. Shown here is the funeral service where the spirit of Rikiishi was offered to eternity by his publisher, Kōdansha.

102.　But then it was Jō Yabuki's time to be counted out. Here, nearing the final sequence of *Ashita no Jō*, Jō and his opponent, José Mendoza, connect with each other. When José hits the mat the crowd goes wild. But on the remaining pages, José recovers and the pair light into each other with a final fury. The gong sounds. Jō slumps in his chair, his face swollen and battered, and hands his gloves to his girlfriend: "I want you to keep them." José is declared the winner. And when Jō's manager turns to console his vanquished hero he finds him seated on his chair with a smile on his face—dead.

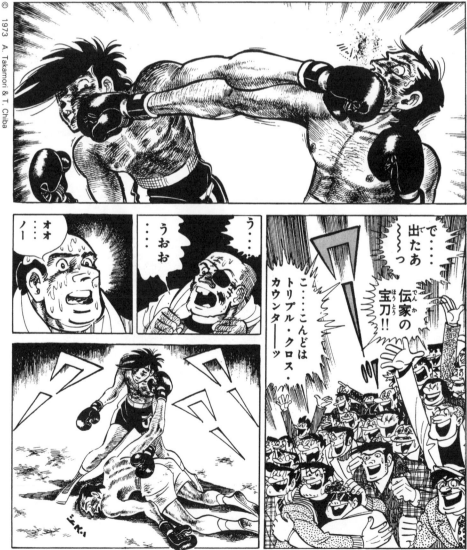

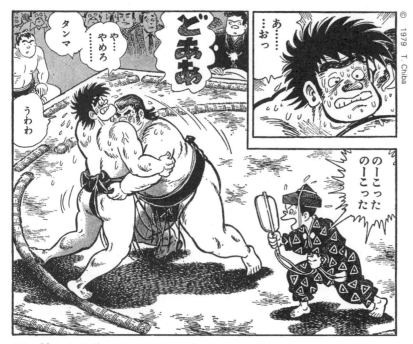

103. Matsutarō, the young sumo wrestler, meets his match. From the still popular series Notari Matsutarō, by Tetsuya Chiba, first published in 1973 in Big Comic.

104. BAKKI! Little Teppei's bamboo sword crashes into that of his larger opponent in a match of kendo, traditional Japanese fencing. From Ore wa Teppei ("I Am Teppei"), by Tetsuya Chiba, serialized from 1973 to 1980 in Shōnen Magazine.

kamikaze plane, and his lumbering, hairy opponents with battleships (fig. 105).

Nearly all comic magazines for boys and men in Japan are filled with melodramatic stories featuring macho samurai/adventurer/sportsmen. But since around 1977, competition has been appearing in the form of light love stories that do not fit the traditional mode; their heroes are not stern-faced, sparing in speech, or even particularly earnest. It is as if a gentle mist has settled over the traditional Japanese male persona, calmed, and feminized it. The change emanates, of all places, from girls' comic magazines.

105. *Taka, the Japanese hero, grabs the ball and charges straight for a giant American opponent, who grunts, "Die, punk!" But in the world of comics anything is possible: the kamikaze plane crashes into the battleship, sinks it, and keeps on flying; Taka slams into the lead-footed defender, knocks him down, and then runs right over him. From* Football Taka *("Football Hawk"), by Noboru Kawasaki, serialized in 1978–79 in* Shōnen Magazine.

Flowers and Dreams

106. *Candy, the young tomboy-waif from Michigan, takes a ride and a walk with her idol, Anthony. As the pair saunter beside a river, the horse whinnies HIHIIIN, and Candy thinks, "Ah, if only this could go on forever." Yumiko Igarashi and Kyōko Mizuki's* Candy Candy, *serialized from 1975 to 1979 in* Nakayoshi, *was one of the biggest hits of the 1970s among young girls.*

In the 1940s and 1950s in the United States there were comic books for girls with titles like *Flaming Love, Romantic Thrills,* and *Teenage Diary Secrets.* They were all created by men, and all were short-lived. Comics like *Wonder Woman* popular today are an extension of the male superhero phenomenon, and most of their readers are young boys. In Mexico and the Philippines, where romance comics are still popular, circulations are limited, and the artists, again, are men.

But in an average month in Japan around forty-five different titles of weekly, biweekly, and monthly girls' comic magazines—called *shōjo manga*—appear on the newsstand. Many have circulations over a million. Like the boys' comic magazines, they are massive, with long serialized stories that are later compiled and sold as series of paperbacks. Yet the artists featured are overwhelmingly women, and their stories emphasize neither bravery, perseverance, nor action. They stress a more passive, inner world of dreams and endless musings about human relationships, and they employ an appropriately different visual style.

PICTURE POEMS

The degree of contrast between boys' and girls' comics is apparent just from their covers. Typical boys' comic magazine titles, when transliterated into English, are "Jump," "Champion," "Challenge," and "King," while those for girls are "Flowers and Dreams," "Princess," "Friends," "Petite Flower," and "Be in Love." And instead of glaring primary colors, girls' comic magazine covers are decorated in soft pastel shades, with a liberal use of lavenders and pinks. The nucleus of the cover is an illustration of a naive, smiling young girl, usually with curly brown or blonde hair and huge, mooning eyes—imploring the reader to turn the page.

はばたいて——

© 1979 Y. Shōji

107. Nakkī, a schoolgirl in her exam years, learns that the man she loves is going to marry her older sister. In a gentle fashion, he has told her that she is destined to spread her wings, for other things. From the popular Seito Shokun! ("Students!"), by Yōko Shōji, which began serialization in Shōjo Friend in 1977.

Inside, girls' comic magazines are characterized by a page layout that has become increasingly abstract. It depends greatly on the use of montage (fig. 106). Pictures flow from one to another rather than progress with logical consistency from frame to frame. They may fuse into a medley of facial close-ups, free-floating prose attached to no particular character, rays of light, and abstract flowers and leaves that waft slowly across pages with no seeming relationship to the story. To the uninitiated this makes for confusing reading, but when the page is absorbed as a whole it evokes a mood. Close-ups of faces—so important in girls' comics—allow artists to stress the sadness or joy of a moment; unfolding roses, drifting petals, and falling leaves symbolize both femininity and the transience of life; and the prose on the page represents the unvocalized ruminations of either the characters in the story or the artist herself. To make doubly certain the reader is in the right frame of mind, exclamation marks and periods are often replaced by small hearts and stars. At the extreme, this page style is a prolonged sigh of inner longing (fig. 107).

108. *Tamaki shocks her class by advocating a modern woman's right to choose her own husband—in defiance of the conventions of the time. Serialized from 1975 to 1977 in the weekly* Shōjo Friend, *Waki Yamato's* Haikara-san ga Tōru *("Here Comes a Dandy") was set at the beginning of this century, when Japanese women were part of the tremendous social change affecting the nation.* Haikara *were the sophisticated, fashionable, and most Westernized elements of society—the men identifiable by their European-style, "high-collar" shirts.*

Fashion, which fascinates Japanese girls as much as their counterparts elsewhere, has greatly influenced artwork. Readers expect artists working in the genre to depict the clothes and hair styles of their characters meticulously—to incorporate the latest trends when their stories are set in the present, and to be historically accurate when set in the past. Characters become fashion models. The clothes they wear conform to the seasons in which the stories are drawn and, to please young readers, may be changed on every other page. If their faces are so stylized that they all look the same, as is often the case, characters may be distinguished by their hair styles.

Because of the importance of fashion, artists also devote a great deal of physical space to it (fig. 108). Rather than limit themselves to one small frame, they show tresses floating free on an entire page, curling around dialogue and into adjacent frames, and they depict elegantly clothed women characters in enlarged, standing poses that occupy one side of the page,

109. *Chiyako (in upper insert and lower enlarged frame) gazes adoringly at her new-found friend, Maiko, the ballet dancer. Kimiko Uehara's* Maiko no Uta *("Song of a Dancer"), which appeared in* Chiao *in the late 1970s, was one of many ballet comics in Japan.*

as if to show off their elaborate costumes while the story unfolds beside them.

But by far the most striking visual aspect of girls' comics is the orblike eyes of the characters (fig. 109). In contrast to men's and boys' comics, where the male characters have thick, arched Kabuki-style eyebrows and glaring eyes, heroines in girls' comics are generally drawn with pencil-thin eyebrows, long, full eyelashes, and eyes the size of window panes that emote gentleness and femininity. Over the years artists have also come to draw a star next to the pupil that perhaps represents dreams, yearning, and romance—and beneath the star to then place one or more highlights. Both males and females in the comics are given this treatment, although the eyes of the males are somewhat smaller, as are those of cold, evil people. The combined effect of the stars and highlights produces what appear to be liquid pools of rapture. Appropriately, there is even a monthly girls' comic magazine titled *Hitomi,* or "Pupils."

"NO ONE UNDERSTANDS"

Some titles of stories serialized in girls' magazines during the syrupy '60s: "Mother's Pupils," "Diary of a Sentimental Tomboy," "Sky-Blue Pupils," "Golden Pupils," "The Mist, Roses, and Stars," "Rose-colored Pearls," "When the Roses Cry," "Like a White Flower," "Flower-Petal Diary," "Barefoot Princess," "The One-Hundredth Boyfriend," "Teacher Likes Me," "Teacher Likes Mini-Skirts," "Tear-Colored Memories," "No One Understands," "The Angel in the Telephone Receiver," "The Cactus and the Marshmallow."

110. *In a story set in Japan's middle ages, young Temari gasps at the sight of her beloved brother, who has come to rescue her from the enemy. Actually, what she thinks is her brother turns out to have been an adopted child—she eventually marries him. From the 1972 short story* Kurenai ni Moyurutomo *("Passionate Crimson"), by Toshie Kihara, published in* Margaret.

Cartoonists and serious artists around the world have often intentionally enlarged the eyes of their subjects. The human eye, and particularly the pupil of the eye, is a window on the soul, and one of the first places emotions are physically manifested. Children, especially, seem to be attracted to cartoon characters with big eyes, and in Japan young girls complain if artists draw them smaller. Nonetheless, the Japanese girls' comic represents an extreme in this tendency. It is evidence as well of a revolution in the way Japanese people view—or wish to view—themselves (fig. 110).

Before the Japanese came into contact with Westerners, they depicted themselves with Asian features, and often smaller-than-life eyes, in scroll paintings and woodblock prints. During this century, however, and particularly after the war, the standards of beauty that many Japanese have aspired to have been those not of Asia but the West. Round eyes, as opposed to the graceful, simply curved Asian eyes with their epicanthic fold, have become a sought-after commodity because they are regarded as more expressive. One of the most popular plastic surgery operations in Japan today will for a thousand dollars put a permanent, extra crease in the upper eyelid, creating a rounder eye with more horizontally protruding eyelashes. For the less venturesome and the less wealthy, girls' comic magazines advertise a special clear glue or adhesive tape that creates the same effect, temporarily.

Comic artists have also adopted the long, leggy look of fashion models of Paris and New York for both their female and male characters. The males are often so thin and wispy in appearance that they can be distinguished from the females only by their clothes and their somewhat larger feet. Ironically, since artists in the girls' comic medium began drawing their characters lithe and lanky, different ways of raising babies, an improved diet, and a different style of living (greater use of desks and chairs, for example) have given many of the younger Japanese readers these exact same physical characteristics.

Because of this preoccupation with Western styles, far more stories in Japanese girls' comic magazines are set in Europe and the United States than is the case with boys' comics (fig. 111). Foreign settings create an exotic quality, with storybook scenery and fashions, and allow heroes and heroines to act in ways that are not always socially possible in Japan. The result is usually a mix of perceived Western values with those of Japan, transplanted. Foreign settings, furthermore, permit a parade of male and female characters with blonde ringlets. In racially homogeneous Japan, where hair color varies in shade but not in color, blonde hair holds a tremendous fascination for young girls (and middle-aged men, albeit for different reasons).

Yet it is the conventions regarding the hair coloring of the characters who are Japanese that may be the oddest of all. Since comics are generally printed in only one color, women artists have discovered that they can help balance the page or differentiate between characters by not inking in their black hair. Often the same character's hair will be inked in in one frame, and then only outlined in the next, especially if set

111. *Yussoupov closes the door, and thinks of the woman he loves, before putting a bullet through his head. His misfortune? Involvement in the unsuccessful plot of General Kornilov to overthrow the Kerensky regime in Russia, 1917. From Riyoko Ikeda's epic romance set in the Russian Revolution,* Orufeusu no Mado *("Orpheus's Window"), which first appeared in 1975 in* Seventeen.

© 1981 R. Ikeda

against a dark background. To the unaccustomed eye a Japanese character may therefore appear to have white or blonde hair, but the fan is never confused. She knows it to be black in reality. Acceptance of this technique by both artists and readers has made further mental gymnastics possible. In recent years, on the covers and initial color pages of the magazines, what can only be Japanese girls are often drawn with distinctly blonde hair and blue eyes.

Since artists, readers, editors, and the public-at-large take these schizophrenic art styles for granted, their effect on the psyche of Japanese girls has never been questioned. Like the unwritten rules that determine when to wear a business suit and when to wear a kimono, or that T-shirts must have English, but never Japanese, logos, they have become just another convention in the cultural mish-mash that is modern Japan. These styles all, however, grow from the notion that the West is a world of romance.

112. *In the 12th century, the more dramatic segments of Shikibu Murasaki's* Genji Monogatari *("Tale of Genji") were illustrated by an unknown artist. The elaborate clothes and flowing hair of the characters are meticulously detailed, but in a flat, two-dimensional style, and the faces all look the same. This creates a static mood, appropriate to the passive lives of the characters in the novel, who value beauty, truth, and love above all else. The text, often copied throughout the ages, is on a special paper speckled with gold and silver and overlaid with abstract representations of bamboo leaves—a treatment foreshadowing the floating leaves and flower petals of today's girls' comics.* Genji Monogatari *has recently been made into a popular comic story by a woman artist, Waki Yamato.*

WOMEN ARTISTS TAKE OVER

Compared to Europe and the United States, women in Japan have had their sex roles rigidly defined and their socialization with the opposite sex restricted. In feudal times, women were often treated like chattel and until World War II a woman's place was in the home before and after marriage—which was arranged. Duty and submission to parents, husband, mother-in-law, and in old age to her own male children precluded love in the Western sense. A web of obligation held most relationships together.

In spite of this handicap, or perhaps because of it, Japanese women have developed a culture separate from that of men. They have their own style of speech, using different personal pronouns, mannerisms, and verb endings. They have formed their own theatrical groups where actresses assume all the male roles and the audience is almost entirely female. And they have the oldest tradition of women's literature in the world.

As early as the 10th century, Japanese ladies at the imperial court in Kyoto carefully chronicled their feelings and their beautiful, leisured lives in diaries, using the cursive, flowing *hiragana* phonetic script (men wrote in bolder Chinese ideograms). In the 11th century, writing in this style, a court lady named Shikibu Murasaki created what has been called the world's first psychological novel. It was the *Genji Monogatari*, or "Tale of Genji," and when lavishly illustrated later it evoked a mood not too different from today's girls' comics. Like them, it stressed love, beauty, and aesthetic yearning (fig. 112).

At the turn of this century, Japanese girls obtained their own magazines. They contained poems, articles about fashion, and illustrated, serialized tales of romance that became an incubator for many of the trends manifested in girls' comics today. Nobuko Yoshiya, a tremendously popular woman author in the 1920s, created saccharin-sweet romantic tales with bisexual overtones. The male artist Jun'ichi Nakahara, who illustrated many of these serialized novelettes in the '30s (such as *Hana Nikki*, or "Flower Diary,"

by Yasunari Kawabata, who later won the Nobel Prize for Literature), incorporated art trends emanating from Europe and drew demure young Japanese beauties with large, dreamy eyes.

The first comics specifically for girls in Japan were drawn by men—not women—and serialized in girls' magazines like Kōdansha's *Shōjo Club*. Artists particularly active before the war were Suihō Tagawa (most famous for his boys' classic *Norakuro*) and Shōsuke Kuragane. Kuragane in particular made a determined effort to cater to feminine tastes, and after the war, in 1949, he created the now famous *Ammitsu-hime* ("Princess Ammitsu"; fig. 113) for the girls' monthly *Shōjo*. It starred a tomboy named Ammitsu, whose name, like the names of all the other characters in the strip, was also the name of a sweet dessert. In food-scarce Japan, this was a formula for success. But like most of the girls' comics of the time, *Ammitsu-hime* was a short comic strip of no more than a few pages, and it relied on gags for its appeal.

Long story-comics, which dominate the girls' comic magazines of today, were popularized by Osamu Tezuka. In

"RIBON NO KISHI"

Osamu Tezuka's *Ribon no Kishi* is marvelously eclectic, blending elements of Greek mythology, Christianity, medieval European pageantry, and more than a hint of bisexuality. The heroine, Sapphire, was a girl, but through an error on the part of the deities, and specifically a mischievous cherub named Tink, she was born to a king and queen who, needing a male heir, decided to raise her secretly as a boy. Thereafter, Sapphire in public acted the role of Crown Prince and vanquished villains with her sword. In private she yearned to wear dresses and have a boyfriend. Evil forces within the kingdom tried to prove she was a woman and therefore unqualified to inherit the throne, and a wicked witch tried to steal her female persona, symbolized in the story by a red heart that occasionally flew out of her body. The story ends happily when Tink, the mischievous cherub, descends to earth, determines that Sapphire will become a total woman, and matches her up with a real Prince Charming—whose name, by the way, is Franz Charming.

113. *Princess Ammitsu and her American tutor, Miss Kastera (Miss "Spongecake"), tour an exhibition of American culture, complete with huge dioramas. (26) "That's the Statue of Liberty." Sign: "New York." (27) "What's this beat-up shack?" (28) "Why, that's where President Lincoln was born." (29) ". . . And Lincoln loved to study." (30) Kastera: "In fact, he studied very hard, and eventually became . . ." Ammitsu: ("My ears are starting to hurt"). (31) Kastera, in front of the White House and the Liberty Bell: "And here we have . . ." Ammitsu: ("Let's pass this one by. . . . She's sure to mention studying"). From Ammitsu-hime ("Princess Ammitsu"), by Shōsuke Kuragane, serialized from 1949 to 1954 in Shōjo.*

114. *In one of her many sex-role switches, Sapphire, the heroine of Osamu Tezuka's* Ribon no Kishi *("Princess Knight"), charges back into the castle, declaring herself to be a boy and therefore legitimate heir to the throne. The comic appeared in* Shōjo Club *from 1953 to 1956, and then in* Nakayoshi *briefly in 1958 and again from 1963 to 1966.*

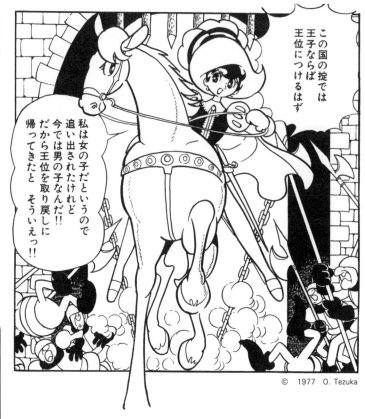

"SAZAE-SAN"

From 1946 to 1975, Machiko Hasegawa's *Sazae-san* warmed the hearts of Japanese newspaper readers. The strip's heroine was Sazae Isono. Supporting characters included her parents, her younger brother and sister, and later her husband and child. All lived happily together under the same roof, and, as was common in comics at the end of the war, all had names that were puns on types of food, in this case seafood. In the early days, *Sazae-san* humorously depicted burglars, beggars, American Occupation forces, ration lines, and even demonstrations for women's rights. Later, as Sazae married and had a child, and as Japan's economy improved, the strip reflected the homelife of a typical, if slightly bumbling, white-collar family. More than anything else, the popularity of the strip stemmed from the "family-next-door" quality of the Isonos, who always maintained their sense of humor. Sazae, the heroine, symbolized the new Japanese woman: still family-oriented and respectful of tradition, but optimistic and independent-minded. Machiko Hasegawa learned cartooning as an apprentice to Suihō Tagawa, author of the prewar children's classic, *Norakuro*. Her other works include *Eipuron Obasan* ("Auntie Apron") and *Ijiwaru Bāsan* ("Stubborn Granny"), starring progressively older generations of women. Hasegawa should have no trouble finding models for her characters: for years she lived in an all-female household with her mother, three sisters, and two nieces. Her own company, *Shimaisha* ("Sisters"), publishes Hasegawa comics in paperback.

1953, he began drawing *Ribon no Kishi* ("Princess Knight") in the girls' magazine *Shōjo Club*. Using his famed cinematic techniques and storytelling skills, Tezuka managed to inject the same vitality into girls' comics that he had into those for boys. *Ribon no Kishi* was a sensation among girls in Japan and had many of the ingredients of today's successful girls' comics: a love story, a foreign setting, and a heroine with large eyes and a somewhat bisexual personality. It is generally regarded as the beginning of girls' comics in their modern format (fig. 114).

Other male artists also began drawing this new type of comic, often because they were unable to break into the more competitive boys' magazines. Many of the superstars of the boys' comic magazines today, such as Tetsuya Chiba, Reiji Matsumoto, and Shōtarō Ishimori, either started in the comic business drawing for girls, or have at one time dabbled in the genre (fig. 115). Like Tezuka, most of these men attempted to cater to the tastes of their readers by drawing in what they thought were "feminine" styles, and by creating plots that emphasized love and emotion.

The entry of women into the field of comics has paralleled their improved status in society. Prior to World War II, there were only a few active women cartoonists. They included Tarō Yashima's wife, Mitsu Arai, who created short cartoons and comics for children in the "proletariat" art publications, and Machiko Hasegawa, who had a short work serialized in *Shōjo Club*. Not one was a commercial success. Then, in the heady days of freedom immediately after the war, when women were given an equal rights clause in the new constitu-

tion and the right to vote, Machiko Hasegawa began drawing *Sazae-san*, a four-panel newspaper strip for the family. *Sazae-san* technically did not qualify as a story-comic or even a girls' comic, but the optimism of its heroine in a time of social and economic disruption made the strip tremendously popular, thus proving that women could make it in the industry.

In the late 1950s, after male artists had popularized story-comics in girls' magazines, a few women like Hideko Mizuno (a protégée of Tezuka's), Miyako Maki, and Masako Watanabe gradually began to join them. And in the early 1960s, girls' comic magazines, notably Kōdansha's *Shōjo Friend* and Shūeisha's *Margaret*, appeared as weeklies devoted to story-comics—paralleling the pattern of development of boys' comics. Comics completely displaced the serialized, illustrated romance novelettes that had formerly filled girls' monthly magazines. Circulations shot up and new magazines were formed.

Girls who had been raised on *Ribon no Kishi* and other girls' story-comics drawn by men began to wonder why there weren't more women drawing them. Machiko Satonaka, an artist prominent today, was one of these: "I thought I could do a better job myself, and that women were more capable of understanding what girls want than men. Drawing comics was also a way of getting freedom and independence without having to go to school for years. It was something I could do by myself, and it was a type of work that allowed women to be equal to men."

With this kind of motivation, other young women artists such as Riyoko Ikeda, Moto Hagio, Yumiko Oshima, and Keiko Takemiya debuted and began consolidating the gains of their older sisters. These exceptionally talented women, and many others, are the stars of the industry today. They are wealthy; their female fans are fanatically devoted; they are respected in society-at-large; and they are given almost total creative control over their work. Although there are still men actively drawing in girls' comic magazines, their number is insignificant, and at least one has gone to the extreme of drawing under the pen name of a woman.

With more and more women taking over editing functions at publishers, girls' comics have truly become a medium created by women for women. Still, girls' comics do not always reflect a higher feminist consciousness. Unlike boys' comics, where heroes are aggressive, in girls' comics heroines are often passive, and dramatic tension in stories is supplied mostly by changes in their environment that work against them. Scenes where a young girl is struck in the face by an angry young male she likes, and then thanks him for "caring," can still be found. Girls in the comics live for love—any love. Kumiko Minami, writing in a biography of Machiko Satonaka, notes that this may in part be a product of men's centuries-long suppression of women and that "if women in the past had any freedom, it was in the world of sentiment, where no outside authority could intrude. In this limited and humble realm, they were free to fantasize of love and dream."

Women in Japanese society have made tremendous strides in the postwar period. Today they can be fashion designers,

115. *Cover of a girls' comic created by Tetsuya Chiba for* Nakayoshi *in 1958,* Mama no Baiorin *("Mama's Violin"). From a 1969 reprint.*

116. In Machiko Satonaka's 1968 story Watashi no Jonī ("My Johnny"), *published in* Bessatsu Shōjo Friend, *Ann White and Johnny Ray cross both class and racial lines in the American South and fall in love. Ann's father is the bigoted local sheriff and tries to frame Johnny. The lovers flee but are cornered by the police. The sheriff aims for Johnny and shoots his daughter by mistake. As Johnny holds the mortally wounded Ann in his arms, he gives her an engagement ring. She says, "Oh, I'm so happy, Johnny. . . . It's so beautiful, just like your pupils," and dies. Her father goes insane. Johnny becomes a social worker.*

journalists, doctors, and politicians. And yet almost invariably what women demand in their comics today is tales of love. "Today the prison door is open," says Minami, "but the legacy lives on."

SOPHISTICATED LADIES

The sticky-sweet aura of many girls' comics today is belied, however, by the increasing sophistication of the genre itself. Talented artists, while adhering to basic styles and formats, have been able to turn girls' comics into a microcosm as rich and diverse as any other genre. Love is, after all, a many-faceted, if not splendored, thing, and there is no end to the stories that can be woven around it.

Early girls' comic stories tended to have themes which followed the same basic pattern. Most were melodramas starring young girls, often waifs and tomboys. Plots progressed inexorably towards a joyful "union" with lost parents, a boyfriend, or man in marriage, or a tragic "separation," usually through death. But even in this format artists were able to inject novel elements. Among the early works of Machiko Satonaka is a short story, *Watashi no Jonī* ("My Johnny"), that depicts a love between a white woman and a black man in a southern town in the United States (fig. 116). The heroine dies after being shot by her own father.

The late 1960s and early 1970s saw a blossoming of attempts by women artists to expand their genre. Chikako Urano's volleyball story *Attack No. 1*, in 1968, helped pave the way for ballet, tennis, and other sports stories for girls later (figs. 117, 118). It reflected the tremendous boom in women's athletics that occurred in real life after Japan won the gold medal in volleyball in the 1964 Olympics. Hideko Mizuno, one of the pioneering women artists, in 1969 began drawing *Fire!*, a long saga of a rock and roll singer in the American counter-culture (fig. 119). She included sex, drugs, death, and disillusionment.

Epic stories, often over a thousand pages in length, were firmly established in the early '70s with romances such as Machiko Satonaka's melodrama *Ashita Kagayaku* ("Tomorrow Will Shine"; fig. 120), which spanned over thirty years of

117. Title page for volume 1 (1968) of Chikako Urano's Attack No. 1, *one of the first popular volleyball stories, serialized from 1968 to 1971 in* Margaret.

118. During a tennis match in Australia, Hiromi Oka blames the lawn court for throwing her timing off. Sumika Yamamoto's Ēsu o Nerae! ("Aim for the Ace!") skillfully wove a love story with tennis and employed a more realistic art style than was usual when it first appeared in 1973 in Margaret.

119. *The final scene of Hideko Mizuno's* Fire!, *serialized from 1969 to 1971 in* Seventeen.

"FIRE!"

Hideko Mizuno's *Fire!* was a pioneering girls' comic with a message and aimed for an older audience. Young Aaron is unjustly sent to a reformatory, where he meets Fire Wolf—older, a born rebel, and a talented singer. After Wolf dies in a motorcycle crash Aaron becomes a rock musician, thus beginning a frenzied odyssey through late-1960s America. Tormented by visions of Wolf, Aaron explores drugs, mysticism, and love. With his band he becomes a national star, but after a rock festival turns violent Aaron drops out to tour around the country with an idealistic band of young people. They are persecuted by the Establishment, and Aaron's hand is damaged in an attack by the Hell's Angels. Aaron burns his guitar and confesses that in attempting to become like his idol, Fire Wolf, he has failed in everything. The final scene shows Aaron seated in a mental hospital, sealed in his own world of dreams. For a girls' comic, *Fire!* was sharply realistic, but true to its genre it contained pages of poetry, skillfully incorporated into the story as song lyrics.

postwar history, and Riyoko Ikeda's *Berusaiyu no Bara* ("The Rose of Versailles"; fig. 121), a fictionalization of the life of Marie Antoinette. Filled with romance, adventure, a background of revolutionary struggle, and accurate historical detail, *Berusaiyu no Bara* was dramatized in 1974 by the all-female theatrical troupe Takarazuka. As a result boys as well as men—including academics and literary types—finally took note of what was happening in girls' comics.

For years it had also been said that girls' comics and women artists lacked humor, but Yoshiko Tsuchida, who had studied under the male gag artist Fujio Akatsuka, proved that assumption false. In *Tsuru-hime Jā!* ("Here's Princess Tsuru!"; fig. 122) and other works, she beautifully parodied the stereotypical girls' comic heroine. Her characters were ugly, obnoxious, and had runny noses and beady eyes.

Traditionally, girls' comic stories starred only young girls or women, but in the 1970s women artists began to portray male heroes, and often exclusively male worlds. In 1971 Moto Hagio's short work *Jūichigatsu no Gimunajiumu* ("The November Gymnasium") helped to establish a genre of stories set in a European boarding school where the pupils are all males (fig. 123). Keiko Takemiya, with *Kaze to Ki no Uta* ("A Song of Wind and Trees"), in 1976 further expanded this genre to include love between young boys. In the opening scene of this lengthy work, the young hero was shown writhing in bed with a classmate (fig. 124). Tales of homosexual relationships between young boys, when depicted

"aesthetically," are very popular among female readers and are an extension of the underlying bisexual theme traditionally present in many girls' comic stories.

Fifteen years ago kissing scenes were regarded as radical in girls' comics, but today abortion, illegitimate birth, incest, and homosexuality have all been depicted. Nudity and scenes of lovers in bed are commonplace, even in magazines where the target reader age is between eleven and thirteen. Artists must adjust the degree of realism in their stories according to the readership of the magazines they are working for, but sex today is almost always included.

Unlike boys' and men's comics, however, girls' comics have an unstated rule that all characters (except in gag strips) must be physically beautiful, and that all subjects, no matter how decadent, must be depicted with delicacy. Today's women artists are therefore masters of sexual suggestion. Unfolding orchids and crashing surf are superimposed on scenes of lovers embracing. Close-ups of clenched hands, tousled hair, and sweating faces allow the reader to imagine the rest.

Like comic magazines for boys and men, those for girls today contain sports stories, comedies, gag strips, mysteries, and science fiction fantasies, although love is still the main

120. In a hospital room, Kyōko takes off her clothes and snuggles next to her dying husband. Before passing away, he thanks her for the good memories, and images of his family stream through his mind. From Ashita Kagayaku ("Tomorrow Will Shine"), by Machiko Satonaka, serialized from 1972 to 1974 in Shōjo Friend.

121. Oscar François de Jarjayes, beautiful head of the palace guards, takes the hand of Queen Marie Antoinette and leads her in a dance. Oscar has her dress uniform on. Riyoko Ikeda's Berusaiyu no Bara ("The Rose of Versailles"), a smash hit in the pages of the weekly Margaret from 1972 to 1974, included lavish costuming, historical accuracy, and sexual ambiguity, and stretched to over 1,700 pages.

夏バテ防止マッチリ!?の巻

マッチリ

122. Tsuru-hime Jā! . . . "Here's Princess Tsuru!" By Yoshiko Tsuchida, serialized from 1973 to 1979 in Margaret.

123. Title page of the 1971 story Jūichigatsu no Gimunajiumu ("The November Gymnasium"), published in Bessatsu Shōjo Comic. When the tough, rebellious Eric (wavy hair) arrives at a German boarding school, there is one fellow student he hates: Thoma (with bangs). Thoma bears a striking resemblance to Eric, but is gentle, delicate, and idolized by his classmates. When Thoma suddenly dies later, Eric discovers that they were actually identical twins, separated at birth. Moto Hagio, the artist, is a master of the short story with a clever twist.

KEIKO THE CONSTRUCTIVIST

"Viewing the page layouts of Keiko Takemiya, one is reminded of the designs of the constructivists—of the exaggerated slanted lines in Rodchenko's posters and film montages, and the concentrated power of the films of Reifenstahl. Her clear and high-contrast frame progressions are reminiscent of Eisenstein's montages and several of the documentaries of Nagisa Ōshima. . . ." From the article "Keiko Takemiya: A Meeting of Wills" by critic Norio Nishijima in a special 1981 edition on girls' comics issued by Eureka, a Japanese literary magazine of poetry and criticism.

emphasis. And readership of girls' comic magazines is steadily expanding (fig. 125). As is the case with the so-called boys' comic magazines, girls' magazines originally targeted at junior high school students now have readers in their thirties. Weekly women's magazines that formerly contained only text and photographs are increasingly devoting pages to long, serialized story-comics. And since 1980, monthly comic magazines specifically targeted at adult women—such as Kōdansha's Be in Love and Shōgakkan's Big Comic for Lady—have flooded the market. As was the case with men, publishers have found that women raised on comics want and demand their own magazines. Over eighteen of what are today called "ladies comics" thus give women artists a chance to experiment with more adult themes and art styles; the stories are more likely to be set in Japan and to have more realistically drawn characters, with smaller eyes (fig. 126).

There has also been a fair amount of crossover. Until a few years ago most boys and men in Japan regarded girls' comics and the work of women artists with a mixture of puzzlement and derision. They could not understand the obsession with

124. "Tick . . . RINNGG! . . ." At a French boarding school for boys, the clock strikes two. Gilbert Cocteau, the school vamp who drives his admirers to distraction, is late for class. From Kaze to Ki no Uta ("A Song of Wind and Trees"), by Keiko Takemiya, serialized since 1976 in Shōjo Comic.

syrupy romance, and they were repelled by the strange art style. Recently, however, women artists capable of drawing in a more realistic, "masculine" style, such as Moto Hagio, Keiko Takemiya, and Akimi Yoshida, have drawn outside the girls' comic magazines and won many male fans (figs. 127, 128). And males, bored with the overworked action and sex themes in boys' and men's comic magazines have found themselves attracted to the girls' comic magazines they used

125. Ryōko Yamagishi's Hiizurutokoro no Tenshi ("Emperor of the Rising Sun"), which began in 1980 in LaLa, represents a new trend in girls' comics of dealing with more traditional Japanese themes. The hero is the young Prince Shōtoku, an actual historical figure from the 6th century who was instrumental in propagating Chinese culture and Buddhism and in consolidating the Japanese nation. The artist's twist is to give the prince supernatural powers and a bisexual personality.

© 1980 R. Yamagishi

126. Mahiru's young boyfriend teases her about her sex drive. Miyako Maki's Mahiru Lullaby is the tale of a woman torn between two lovers, one young and one middle-aged. Currently running in the adult monthly Big Comic for Lady.

© 1981 M. Maki

127. "Sometimes, there are people who look at my face and don't turn to stone. . . ." From a 1980 short work titled Medusa, by Ryōko Yamagishi, in a science fiction comic magazine for adults of both sexes.

© 1980 R. Yamagishi

128. A scene from Keiko Takemiya's Tera e ("Towards Terra"), a science fiction story serialized from 1977 in the boys' comic Manga Shōnen. In 1980 Tera e became a popular animated theatrical feature.

to scorn. Some read girls' comics in order to learn how women think. Others find the emphasis on emotion and psychology refreshing.

As a logical outcome of crossover, and partly as a result of men and women having more and more in common at school, work, and play, comic magazines aimed at both males and females are starting to appear. In September 1981, for example, *Duo*, a monthly, emerged. Its catchy slogan? "We reached out for the same magazine at the store, and that was our beginning—*Duo*, for the two of us." By 1982, however, *Duo* had clearly drifted into the girls' comic camp.

At present, girls' comics and their women artists are riding a wave of popularity that shows no sign of cresting. As more and more males read girls' comics, one result is a boom in the genre known as "campus romance comedies" in the boys' comic magazines. In these stories the emphasis is on relationships, not action; male characters are often drawn in standing poses on the side of the page—sometimes their sentences are punctuated with small hearts and stars. And as women artists like to point out, the traditionally huge, dreamy eyes of girls' comics are beginning to shrink, while the eyes in boys' comics are slowly growing bigger, and bigger.

The Economic Animal at Work and at Play

129. SHIIN—the sound of shocked silence. Sabu, with hammer in hand, stares as a professional pachinko player/wandering mendicant tries out a pachinko machine. One of the monk's tricks: the beads of his rosary are the exact size of pachinko balls, thus enabling him to visually gauge the spacing between the pins on the machine that block the jackpot holes. Kugishi Sabuyan ("Sabu the Pin Artist"), by Jirō Gyū and Jō Biggu, ran in 1971–72 in Shōnen Magazine.

Thirty-eight years after the end of World War II, Japan leads its former enemies in radios, televisions, cars, literacy rates, distribution of income, average life expectancy, and (of course) number of comics. Much of this has been made possible through hard work. But the Japanese people are not the diligent, dull automatons often portrayed in Western media. Comics reveal a very different image.

PRIDE AND CRAFTSMANSHIP

From an early age in Japan, children, especially male children, are taught that work and the effort put into it are the measures of a man's worth. In the comic magazines for boys, stories stressing perseverance in the face of impossible odds, craftsmanship, and the quest for excellence have appeared with regularity over the years. More often than not, the heroes are young men from disadvantaged backgrounds who enter a profession and become the "best in Japan."

Kugishi Sabuyan ("Sabu the Pin Artist": story, Jirō Gyū; art, Jō Biggu) was one of the first such tales, serialized for three years in *Shōnen Magazine* in the early '70s. It starred a young man named Sabu who worked in a pachinko parlor.

Pachinko is a Japanese version of American pinball, and a neon-bedecked arcade featuring the game can be found in nearly every Japanese community. Silver balls must descend a vertical surface through a strategically arranged maze of metal pins blocking the jackpot holes. The payoffs can be considerable (though legally they are not supposed to involve cash), and the clatter and mechanical action of the machines have a mesmerizing effect on the players. Pachinko "pros," or *pachi-puro*, are fanatics who spend half their lives studying pin placements and ball trajectories. Sabu's job was that of the *kugishi*, or "pin artist"—the skilled technician who carefully adjusts the spacing of the pins on pachinko

130. *Ajihei gasps at the sight of a true professional. When awkwardly peeling onions behind the restaurant on his first day at work, Ajihei meets a passerby—who shows him how it's really done. Little does he know that the man is the restaurant's head chef, in street clothes. From* Hōchōnin Ajihei *("Ajihei the Cook"), by Jirō Gyū and Jō Biggu, serialized from 1973 to 1977 in* Shōnen Jump.

machines with his hammer and his gauge, thereby controlling both the popularity of the store and its revenue.

Sabu was orphaned when his parents died of the mumps, and raised by his grandmother. When he is a teenager, she also dies, but on her deathbed gasps, "Become whatever you want . . . but never give up! . . . Become the best in Japan! . . . the best . . . in . . . " Sabu thereafter becomes the disciple of wizened old Sasuke Negishi, the "god" of Japan's pin artists. And with hammer and gauge he devotes his life to the world of pachinko, constantly pitting his wits against the pachinko professionals who try to better him, and becoming a legend in his profession (fig. 129).

The author and artist were able to keep their readers spellbound with this basic formula alone, but they made the story doubly interesting by packing it with inside information on the complex, mysterious world of pachinko. *Kugishi Sabuyan* showed the reader how pachinko developed in Japan from an early pinball game called Corinth, imported from America in 1920, and provided tips on how to "read" a machine. The comic was not only entertaining; it taught one how to play a better game of pachinko.

The same duo, Gyū and Biggu, followed their success with what is perhaps the best known work comic in Japan, *Hōchōnin Ajihei* ("Ajihei the Cook"), a story of a young man who, like Sabu, strives for perfection in his chosen field. Ajihei's father was one of Japan's expert traditional chefs, skilled in preparing raw fish—he could strip a live carp and prepare its flesh so fast that the skeleton would keep swimming when thrown back in the water. But in the eighth grade Ajihei shocked his father by becoming an apprentice at a "Western" food restaurant. Japanese-style food of quality is prohibitively expensive in Japan today. Ajihei's goal was to make food for the masses: inexpensive, but tasty (fig. 130).

As Ajihei underwent *shugyō*, the traditional Japanese period of training in which the novice learns by a long process of watching and imitation, readers were initiated into the secrets of fast ways to peel onions, chop carrots, make noodles, and even fry ice cream without melting it. Like *Kugishi Sabuyan*, the story was filled with factual informa-

"KUGISHI SABUYAN"

In *Kugishi Sabuyan*, Sabu the pin artist was constantly challenged by professionals who wanted to test their skill against his. He also had to be on the lookout for spies trying to learn his methods, and for cheaters whose tricks ranged from using pachinko balls coated with butter so they would slide past the pins easier, to using a concealed magnet to "guide" the balls into the jackpot holes. In between Sabu's adventures, the story showed readers the different ways to snap the pachinko machine lever and—with elaborate diagrams of pin angles and ball trajectories—how to tell if a machine is likely to pay. The scriptwriter, Jirō Gyū, knew what he was talking about. Before *Kugishi Sabuyan* he wrote a column on pachinko for a newspaper.

131. After the death of his older brother, Kenta, an inspired Kenji begins delivering newspapers. "Don't worry, Kenta," he says, "I'll make Mama the happiest woman in the world!" Then he sings, "All we want is happiness. . . . The work is very hard, but the sweat of our brow holds the promise of tomorrow." From Ohayō ("Good Morning") in the series Shigoto no Uta ("Ode to Work"), by Keiji Nakazawa, published in the early 1970s in Bessatsu Shōnen Jump.

© 1976 K. Nakazawa

132. Here, in the story Tateshi no Kensaku ("Kensaku the Builder"), by Jirō Gyū and Fujio Akatsuka, a journeyman carpenter shows Kensaku, the apprentice, how to really pound in nails. Published in the mid-1970s in Shōnen Magazine.

tion, helped in this case by the writer's having had actual restaurant experience. All in all, Hōchōnin Ajihei ran to twenty-three volumes in paperback (nearly 4,600 pages). The Asahi newspaper ran a special article on work comics; the artist was invited to lecture at the graduation ceremony of an Osaka culinary school; and a radio dramatization of the story was broadcast in 1978. Japanese noodle shops with the name Ajihei even sprang up as far away as California.

Other artists have also explored the work comics genre. Keiji Nakazawa, most famous for his antiwar stories, created

a series called *Shigoto no Uta* ("Ode to Work"). It concentrates less on technical information and more on what it means to work hard and do a good job, spiritually. Nakazawa's heroes are all young boys from underprivileged families, making rice-curry, noodles, and even doing construction. The stories are essentially melodramas in praise of traditional values. In *Ohayō* ("Good Morning") the young hero, Kenta, begins skipping school to work secretly at odd jobs and thereby earn money to support his ailing mother and younger brother. He becomes popular throughout the local community for his hard work and happy smile. But unbeknownst to his family, Kenta has terminal cancer. Finally, on his deathbed, he gives his mother the money he had secretly saved. His little brother is so inspired by this example that he too, thereafter, begins doing odd jobs with a smile on his face (fig. 131).

Visually, the comic medium, with its emphasis on the theatrical effect, is ideally suited to these stories (fig. 132). Hammers fly through the air of their own accord to pound in nails; razor-sharp knives slice cabbages in a blur; close-ups of faces show the joy of creation and the agony of failure. Drama is further enhanced by the deep reverence for craftsmanship in Japan. Knives used in sushi-making become semireligious objects. Old, worn tools used in building houses glow with a mystic aura. And the art of peeling onions to make noodle dishes is mastered by a nervous apprentice who stays up all night long practicing on his own.

The heroes of most work comics are apprentices, and the more traditionally Japanese the occupation the more potential there is for psychological drama. Carpentry and sushi-making, for example, require life-long commitments and periods of intense training under a master who demands total loyalty and obedience: he must be addressed in formal language; his word is law. The apprentice must learn, not by being creative on his own but by mimicking the master step-by-step until the craft is internalized. Correct attitude is most important, and in order to cultivate it the master will employ *shigoki*, or hazing. In its mildest form *shigoki* involves the master's regularly yelling at his student and making him do menial tasks. In its extreme form in the comics it involves beatings, screams, and bloodletting (fig. 133). Hazing may be regarded as old-fashioned in many circles in Japan today, but

"TEKKA NO MAKIHEI"

"A melodramatic introduction to the tradition-bound world of raw-fish cuisine" could be a publicist's description of *Tekka no Makihei*. Its 1,800 pages trace young Makihei's rise from apprentice to "best sushi chef in Japan" as he fights, bleeds, and puts in hours of lonely practice to perfect his skills and struggles under strict masters who beat him with bamboo staves. Although the story was serialized in an adult comic magazine it contained almost no sex. When Makihei was shown with an undressed woman it was always in the context of learning about sushi: to help him memorize the right "touch" to make sushi patties, for example, a generous geisha lets Makihei feel her breasts. Near the end of the tale one of Makihei's masters turns out to be his long lost grandfather. The proud old man eventually commits ritual suicide in front of a stone monument to the souls of fish that have fallen in the cause of a good meal.

133. Makihei, the apprentice sushi-maker, is struck by his master—for taking his eyes off his work when a guest walks into the restaurant. Hazing is used to drill in fundamental rules. From Tekka no Makihei ("Makihei the Sushi-maker"), by Yūichirō Ōbayashi and Yasuyuki Tagawa, published in the mid-1970s in Comic Magazine.

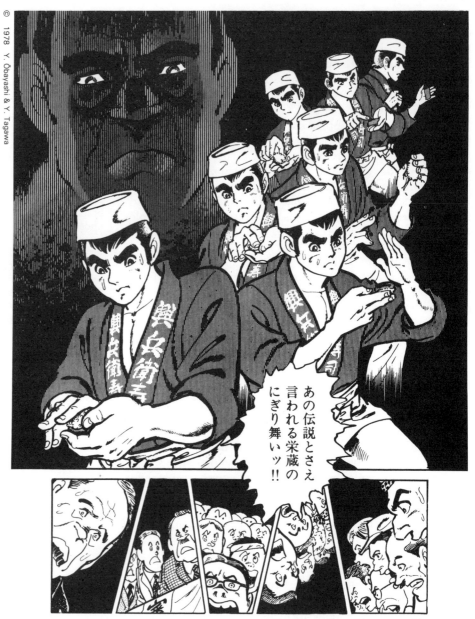

あの伝説とさえ言われる栄蔵のにぎり舞いッ!!

134. *During a sushi-making competition, young Makihei shows the form and technique of his legendary father, whose spirit is shown looking on. The judges and the spectators gasp. From* Tekka no Makihei.

135. SHABA SHABA SHABA GU! *Young Shatta practices speed-shooting his camera, using cars whizzing by on a highway as his subjects. From* Pimboke Shatta *("Out-of-Focus Shutter"), by Jō Biggu, published in 1978–79 in Shōnen Jump.*

young readers have experienced enough of it in mild form at school or in sports clubs to be able to appreciate it in the comics. If the goal is excellence, the heroes of work comics lay their lives on the line.

One of the main themes is competition. In *Tateshi no Kensaku* ("Kensaku the Builder": story, Jirō Gyū; art, Fujio Akatsuka), the hero is a young apprentice carpenter who becomes embroiled in a competition with a rival journeyman carpenter. Sponsored by a publishing company, both are given houses to build in their own way, on adjacent lots. In front of television cameras and crowds of spectators, they set to work. In *Tekka no Makihei* ("Makihei the Sushi-maker": story, Yūichirō Ōbayashi; art, Yasuyuki Tagawa), a youth apprenticed to a sushi master is involved in a series of competitions which judge his knife-handling skills as well as the aesthetic quality of his platter arrangements (fig. 134). And in *Hōchōnin Ajihei* the young hero participates in a ritualistic cabbage-cutting contest on the grounds of a Shintō shrine, again with television cameras present to capture every slice of the action.

Emphasis on professionalism is not limited to the traditional Japanese occupations. Jō Biggu, for example, has created stories for young people like *Pimboke Shatta* ("Out-of-Focus Shutter"; fig. 135), a tale of a youth becoming the best photographer in Japan. *Yasuuri Saizensen* ("On the Front Lines of the Discount War") is a story of salesmen in the highly competitive discount camera stores of Tokyo's bustling Shinjuku district. And, inevitably, there are the stories, usually semi-autobiographical, about young people becoming professional comic artists, a notable example being Fujio-Fujiko's *Manga Michi* ("The Way of Comics"). While they do not contain the dramatic episodes of hazing and competitions that other work comics do, they nevertheless emphasize the need for hard work, dedication, and perseverance in order to achieve success.

MR. LIFETIME SALARY-MAN

The work comics mentioned thus far are targeted at boys and young men who have not yet entered the work force, or those who have just done so. The mass of Japanese white-collar workers—the nation's hard-working, blue-suited, briefcase-toting organization men—have their own genre of short comics known, appropriately, as *sararīman*, or "salary-man," comics (fig. 136).

Japan essentially has a two-tiered economy. One level, where there is considerable mobility, consists of craftsmen, laborers, employees of small- and medium-sized businesses, and part-time workers. The other, so ballyhooed in the West, is that of the huge corporations and bureaucracies with their legions of devoted employees—the so-called elite of the system. These organizations hire young men newly graduated from universities and in exchange for long work hours and lifetime commitments, provide job security, adequate base pay, huge bonuses, and extensive benefits. Such workers gain, above all else, security and prestige. But they forfeit an ability to exercise individual initiative. Promotions are by seniority. Aside from a basic intelligence, the most sought-

136. *Sampei Satō claims that when he tried to draw modern man in his comic strips, automatically the figure became a "salary-man." Satō's pioneering salary-man strip,* Fuji Santarō, *stars a little man (shown in last frame) who manages to find absurdity both at the office and in society. In spite of his almost total lack of expression, he remains a flamboyant individual. The example shown here appeared in the Asahi newspaper in 1974.*

137. After asking a young office lady if she would loan him both some money and her body, a rejected employee goes to his superior for sympathy. From an episode in the series Hana mo Mi mo Aru Tsutomenin *("The Worker with Form and Substance"), by Shūhei Nishizawa.*

138. After trying in vain to attract the attention of someone in the office, a lonely Hōsuke threatens to urinate on a desk. When no one responds, he does, and bursts into tears. Hōsuke Fukuchi's Hōsuke-kun *("Young Hōsuke") was a twenty-six-panel strip serialized in the weekly newsmagazine* Shūkan Taishū.

after quality in a young recruit is loyalty and the ability to cooperate with the group, to preserve interpersonal harmony; in short, not to make waves.

Salary-man comics are the Japanese employee's natural response to his condition. They are easily recognized by their minimalist style, which all artists in the genre employ either for the purposes of parody or because they cannot draw. Heads are huge in proportion to bodies, and always in profile, never face on. Mouths are always downturned, except when in the position of *kushō*, the Japanese smile of chagrin. Stage perspective dominates: in contrast to long story-comics, the angles at which characters are depicted never vary. There are no fancy unfolding flowers, rays of light, or any of the other flashy techniques that story-comic artists use to create moods. Nor is there any shading of the characters or the backgrounds. A single prop of a desk represents the interior of an office; a clock on the wall marks time and boredom; hanger-straps symbolize the inside of a commuter train; and a spread-out futon mattress on the floor stands for home or a motel room. Reality is a stylized skeleton.

The typical hero of salary-man comics is a middle-class everyman known in Japan as the *hira-shain*, or rank-and-file employee. His is a pathetic existence. He is married to an ugly woman, dreads going home, and hangs his head low after being scolded by his boss. Since many Japanese corporations discourage women from working beyond the age of twenty-five, women characters in the genre usually appear in supporting roles as wives, bar hostesses, or young "office ladies," who have little function but to serve tea or sex (fig. 137).

Comic strips depicting the lives of workers in Japan have been around since the 1920s, but a genre concentrating exclusively on these white-collar samurai did not emerge until the 1960s, when Japan's economy grew at a dizzying pace and what seemed like the entire population plumped itself into the middle class.

One of the first works was a four-panel strip by Sampei Satō titled *Fuji Santarō* that began serialization in the *Asahi* newspaper in 1965. It starred a very unmotivated company employee who, in an early sequence, was shown painting

139. A frame from Sararīman Senka ("A Special Course for Salary-men"), by Sadao Shōji—the classic salary-man strip, serialized in the weekly newsmagazine Shūkan Gendai. The boss enters the office with a repairman and announces to his employees that things are going to get tough. He removes their fixed desk-top titles of section chief, chief clerk, and department head and replaces them with electronic titles that he can alter at will.

open eyes on his glasses so that he could sleep safely during boring meetings. *Fuji Santarō* also included current events, but in it and other works in both newspapers and magazines Satō was able to hammer out much of the format for the genre today. Satō was eminently qualified; before becoming a cartoonist he worked for seven years in a typical Japanese office.

Today, when long story-comics are in the overwhelming majority, the abbreviated salary-man comic strip almost seems like an aberration. But it, too, is becoming longer, because length allows artists more room to experiment and provides a higher income. In addition to newspapers, salary-man comics appear in weekly news magazines, adult comic magazines (as filler between long story-comics), and in paperback collections, and they may range from four panels to fifty (fig. 138). Many serialized comedy story-comics—notably *Tsuribaka Nisshi* ("Diary of a Fishing Fool": story, Jūzō Yamasaki; art, Ken'ichi Kitami)—also cover the same ground as traditional salary-man comics but with a strong narrative and a detailed art style. Minimalism may be threatened. But as long as millions of workers feel anomie and frustration in Japan's corporations and bureaucracies the genre will continue to thrive.

Hierarchy is important in both Japanese organizations and in salary-man comics. Key figures which appear in both are the president (likes to golf, is old and not too bright), the department head (hardworking and stern), the section chief (desperately wants to become a department head but fears he can't), the "eternal chief clerk" (incompetent, and stuck for life in his position), and the rank-and-file members, many of whom are also *madogiwa-zoku,* or "those who sit beside windows"—deadbeats in a system of lifetime employment, employees with little real function who spend most of their time gazing out the window and napping. In this world, different levels of formal language and who-lights-whose cigarette or who-pours-whose-drinks become highly important, both on and off the job (fig. 139). Of course, the vast majority of "heroes" in the salary-man genre fall into the lower ranks. During the day they kowtow to their superiors,

SALARY-MAN CARTOONISTS

Story-comic artists frequently begin drawing as small children and debut as professionals in their teens, but many "salary-man" cartoonists start drawing late in life and have work experience and education. Shūhei Nishizawa worked for a mining company before turning professional. Ryūzan Aki produced his first cartoons while working for the post office. Sampei Satō drew his first cartoons on his application for work at the Daimaru Department Store. Shunji Sonoyama joined and quit an advertising agency in the same day. Sonoyama, with Hōsuke Fukuchi and Sadao Shōji, is a former student of Japan's prestigious Waseda University and a founding member of its now-famous cartooning club (1954). By stressing clever ideas over artwork, these men were able to carve out successful careers as "salary-man" artists. At the time, the idea of elite students abandoning futures in business and law to become cartoonists seemed radical, but cartoon study groups and clubs are now an indispensable part of life in most universities and turn out some of Japan's best salary-man and gag artists.

140. *Westerners admire Japanese management techniques, but how about the way they negotiate? Here, rank-and-file employee Hamasaki and his section chief try to win an important contract from a client company by entertaining the president who, like them, is an avid fisherman. With geishas, they do an impromptu fishing dance and assume the roles of the fish. From Jūzō Yamasaki and Ken'ichi Kitami's story-comic* Tsuribaka Nisshi *("Diary of a Fishing Fool"), currently running in* Big Comic Original.

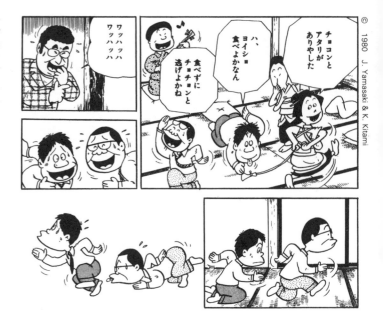

but at night, after work, they bad-mouth them over drinks at a local bar—until the day that they, too, are promoted.

As the baby-boom generation rises in the ranks of today's organizations, a common problem is how to create new management positions for workers—who all expect them. Sadao Shōji, in one episode of his series *Sararīman Senka* ("A Special Course for Salary-men"), has the company bosses making all the employees assistants of each other. In another episode, the company president taps a lowly section chief on the shoulder and tells him that two new sections—thermal energy and water resources—have been created and unified under the title of Department of Water Resources. Asked to become the new department head, the employee weeps in gratitude, only to find out later that his new role is that of heating water and serving tea to his colleagues.

American and European executives infatuated with Japanese management techniques may wish they could change their ornery, union-dominated workforce into one more obedient, loyal, and productive, such as supposedly exists in Japan. Salary-man comics show how the Japanese workers really view themselves (figs. 140, 141). Hiroshi Kurogane, in a series titled *Hirarī-man* (a pun on the words for "nimble" and "salary"), has one episode in which four employees emerge bleary-eyed from a mah jongg parlor after an all-night game. At work the next day, the boss finds them all sound asleep and as punishment orders them to work overtime. The last frame shows the same men, late at night in the office, engrossed in yet another game of mah jongg.

MAH JONGG WIZARDS

Japanese men work hard. But they play hard, too, and a favorite form of recreation for men is gambling, at pachinko parlors, in mah jongg salons, and at race tracks and government-sponsored lotteries. The first two games require a certain amount of skill and are not supposed to involve cash transactions, but the police have an unwritten understanding

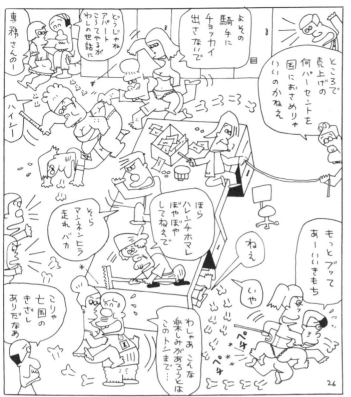

141. *First a company employee and then the president are swept up by horserace fever. So the boys and girls in the office decide to stage their own race and lay bets on the winner. Artist Shunji Sonoyama's salary-man comics are always identifiable by their chunky characters. From a twenty-six-frame episode in the series* Hana no Kakarichō *("The Chief Clerk in His Prime"), serialized in the weekly newsmagazine* Shūkan Post *from 1969.*

with the citizenry that as long as the sums of money exchanged are not too large they will look the other way. Gambling in Japan, whether legal (such as horseracing) or illegal (such as in mah jongg), usually does not involve the fantastic losses and winnings experienced at Las Vegas and Monte Carlo. Yet its immense popularity has led to the appearance of gambling comics and, in what is one of the most surprising developments, to a tidal wave of comic magazines devoted exclusively to mah jongg stories.

Jirō Gyū, the author of *Kugishi Sabuyan,* has written a story from the standpoint of the professional pachinko player, called *Pachinkā Nimbetsuchō* ("A Registry of Pachinko Players": art, Ryō Sakonji; fig. 142), and Kei Tsukasa has created a series of stories about horseracing, called *Jinsei Keiba* ("Life in Horseracing"; fig. 143). Horseracing comics regularly appear in publications connected with the track, but gambling stories in comics, whether about pachinko, bicycle racing, horseracing, or boat racing, have never become firmly established—with the exception of mah jongg stories. The normal tendency in the comics industry is to develop magazines aimed at a particular age or sex. The only subject genres that regularly rate their own magazines in Japan are erotica and mah jongg.

Six or seven monthly comic magazines, each with a circulation of around 150,000 and each devoted to mah jongg stories, have appeared in the last three or four years. In construction they are similar to all adult comic magazines. They consist of over 200 pages stapled together, and contain four or five serialized stories. In between the stories are light gag pieces (fig. 144) and short articles written by the editorial

142. *The professional pachinko player shows his stuff: BAKKI—a deft flick of the machine lever, and—KYURURURU—the ball spins upward. FUWARI—the ball loses momentum; and— PITA!!—freezes in just the right spot for it to fall straight into the jackpot hole. From* Pachinkā Nimbetsuchō *("A Registry of Pachinko Players"), by Jirō Gyū and Ryō Sakonji, serialized from 1975 to 1980 in* Manga Goraku.

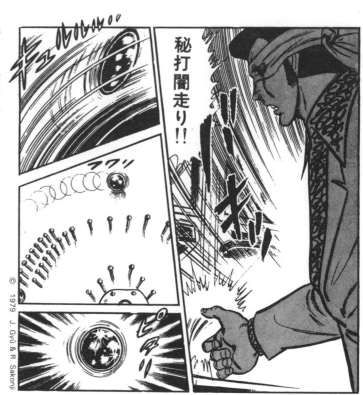

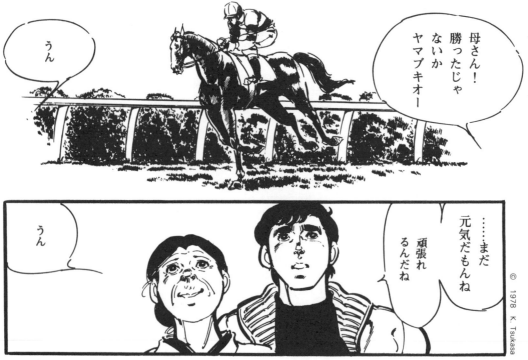

143. *The young hero of Kei Tsukasa's* Jinsei Keiba *("Life in Horseracing"), serialized in 1977–78 in* Manga Magazine, *visits his aging mother on the weekend and asks if there is anything she would like to do. After she shyly suggests a day at the races the two head for the track. The mother bets on an aging horse, which wins, and she silently sheds tears of joy. As the sun sets, her son lovingly carries her home on his back.*

staff; everything is in some way connected with mah jongg. And as with all comic magazines, popular serialized stories are compiled and issued as paperbacks. Only a devoted legion of fans could sustain such specialized publications. Mah jongg fans are nothing if not devoted.

Mah jongg, of Chinese origin, is played by four people (although it is possible with three); 136 or 144 small tiles

are drawn and discarded from a central pool until one player has a winning hand. It is a game with complicated rules that has made addicts out of millions of players around the world because of the delicate balance of luck and skill required to win. Apparently introduced into Japan at the beginning of this century from China and, indirectly, from America, mah jongg today is played in homes and also in the thousands of legal mah jongg parlors that dot Japan's cities. Sakè, women, and gambling have long been part of the macho image of Japan's low-life elements, but public perception of mah jongg has gradually shifted from that of a corrupting influence to a respectable pastime. Along with golfing, drinking and eating, and singing at piano bars, it is today an important part of the constant socialization that company employees engage in, both to preserve harmony in the company and to cultivate business relationships outside. There are an estimated 10 million mah jongg players in Japan today.

Mah jongg had always been thought of as too static a pastime to be depicted in comic form. But around 1975 the artist Eimei Kitano created a comic version of a story by Tetsuya Asada called *Mājan Hōrōki* ("Tales of a Wandering Mah Jongg Player"; fig. 145). In several paperback volumes, it told the story of a young man who became a professional mah jongg player after World War II. It was an unprecedented hit; in paperback form it has already gone through thirty reprintings. Kitano had worked for Osamu Tezuka for ten years before becoming independent, and with skill sharpened by exposure to both story-comics and animation he was able to parlay an interest in mah jongg into a career and spawn an entire genre. Subsequent works by him, such as *Gyambura no Uta* ("Song of a Gambler") and *Pai Majitsushi* ("The Mah Jongg Tile Wizard") have made Kitano the equivalent of an Osamu Tezuka within the microcosm of mah jongg comics. Today many other star artists, such as Eichi Muraoka and Sei Narushima, as well as many qualified story writers, create exclusively for the genre. Needless to say, they all must have a specialist's knowledge of the game.

Like girls' comics, in which the common denominator of all stories is love, all mah jongg comics must in some form or another incorporate a game of mah jongg. It is a minor limitation. Lurid murder mysteries, love stories, fantastical tales of sex, comedies, and even surfing stories have all been glued together with this basic ingredient. And each mah jongg magazine has its own emphasis. Some stress stories with no basis in reality, some stress sex more than the game, some stress highly technical stories, and some, like Hōbunsha's *Tokusen Mājan*, emphasize "family style" mah jongg.

Of all the Japanese comic genres, mah jongg is the most esoteric. In order to read the stories, one must have a rudimentary knowledge of the game because at some point in any story, whether it be about sex in Singapore or a tense game with the company boys, mah jongg tiles will begin to fly across the page, form abstract patterns in the air, and punctuate the sentences of the players (fig. 146). It is in fact by liberating the mah jongg tiles from the table and the immediate context of the game that artists were able to make fascinating what would normally be a very dull affair to

144. *Gag mah jongg. From* Uradora Nēchan *("Sister Uradora"), by Taku Shiraki, published in 1981 in* Tokusen Mājan.

"THE LEWD MAH JONGG DEVIL"

Here are some typical titles of mah jongg stories: "Fighting Mah Jongg," "Blood-Spray Mah Jongg Tiles," "No-Panty Mah Jongg with the Tables Turned," "Mah Jongg Turkish Bath," "The Wild Animal's Mah Jongg Tiles in Shinjuku," "Song of Wandering Mah Jongg," "The Lewd Mah Jongg Devil," "Wild Rider Mah Jongg Tiles at Sunrise."

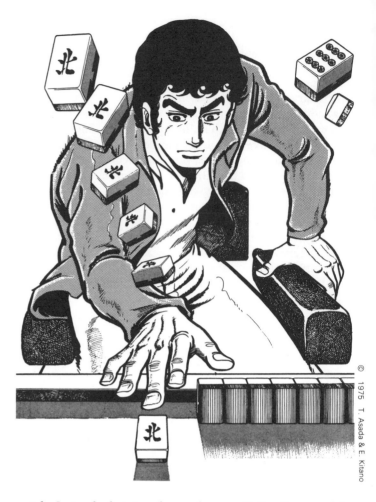

145. *A 1975 chapter title-page illustration for the immensely popular* Mājan Hōrōki (*"Tales of a Wandering Mah Jongg Player"*), *by Tetsuya Asada and Eimei Kitano, published in* Bessatsu Manga Action.

"JIGOKU MĀJAN"

With script by Yasuhiro Itasaka and Asatarō Nada and art by Yōsuke Tamaru, *Jigoku Mājan* ("Mah Jongg Hell") was published as a single-volume paperback in 1979. Its hero, Taira, is the only son of a wealthy family and a member of the archery team at a top Tokyo university. When he learns that he was conceived not through love but artificial insemination he begins to hate society. Playing vicious games of mah jongg he proceeds to ruin himself and those around him. In one game he betrays his best friend; in another he puts his girlfriend and co-archer, Saeko, up for collateral. He bankrupts his professor and his father's business associate. Eventually he comes to see himself as a "wolf" in an insane society, an image the artist reinforces with superimposed drawings of wolves. Taira renounces everything and drops out of university. His life disintegrates. He becomes a day laborer and plays mah jongg games where the losers pay by giving blood to be sold. Saeko receives treatment at a mental hospital but is unable to stop loving Taira. She decides that she can achieve peace only by killing him, and enlists an old college friend to help. After a fierce, final game of mah jongg, the friend tries to run Taira down in his car. But Taira escapes by climbing the scaffolding of a building. His pursuer climbs after him. As Taira stands silhouetted against the sky, Saeko appears with bow and arrow, takes aim, and then collapses in tears because she is still in love. Taira, high above, starts to cry out that he loves her, too, but before he can finish his sentence his pursuer—unaware of Saeko's change of heart—slugs him from behind. As Taira tumbles off the building to his death the artist again inserts the image of a wolf. Saeko runs to Taira's crumpled body, takes the arrow that she never fired, and plunges it into her own heart. The last scene shows the bodies of the lovers on the cold pavement and the images of two wolves trotting off together to another world.

watch. Instead of giving the reader a realistic glimpse of the individual hands, artists today show the formations of tiles as an abstract symbol through the mind's eye of the players. Panels are filled with the cries of the players as they call out the names of tiles, and with the sounds of picking up a tile (*GUI*), placing one on the felt-topped table (*TAN*), sliding one forth silently (*SU*), slapping a formation down (*TCHA!*), and, lastly, a sound that irritates the residents of Japan's older, thinner-walled apartments—*JARAJARAJARA*—the noisy scrambling of the tiles after a round is completed. Without a knowledge of the game it is impossible even to read the text or the dialogue between characters, because artists insert pictures of individual mah jongg tiles in the middle of sentences rather than write out their names in full.

Who reads mah jongg comics? Players are frequently portrayed in the stories as being of both sexes (women players often disrobing during or after the game), but the readers appear to be overwhelmingly male, aged eighteen to twenty-five. According to Hōbunsha's Saburō Watanabe, a surprising number are university students who, having finished the rigorous cycle of exams in high school, at last have time to relax and learn how to enjoy life. Other readers are young factory workers and company employees. Older men, too busy to play mah jongg regularly, may read the magazines and indulge in fantasies of some great game once played.

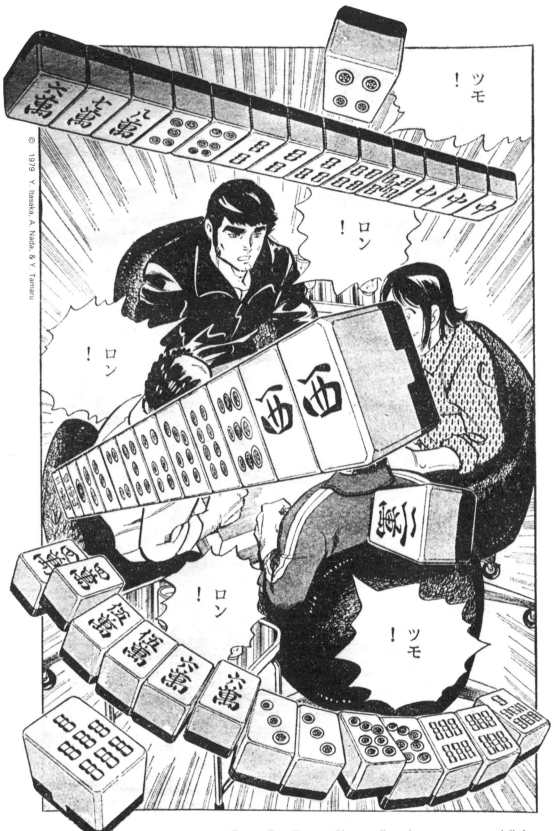

146. "Tsumo! Ron! Tsumo!" Players call out their moves in a story billed as "strategic mah jongg," and the tiles jump off the page. From Mājan Fūunroku ("Mah Jongg Crises"), by Yasuhiro Itasaka and Yōsuke Tamaru, published in 1981 in Tokusen Mājan.

THE ECONOMIC ANIMAL 119

Regulation versus Fantasy

147. *A beautiful woman is whacked with a sword, and her true identity turns out to be . . . Lupin III, star of artist Monkey Punch's popular series of the same name. Lupin III first appeared in the adult weekly* Manga Action *in 1967. Subsequently, its clever twists and turns of plot and its jazzy fashionable art style combined with humorous eroticism have won it many fans among senior and junior high school students—a typical example of crossover.*

In his travel book *The Great Railway Bazaar*, Paul Theroux picks up a fat comic magazine left by a girl seated next to him on a train in Japan: "The comic strips showed decapitations, cannibalism, people bristling with arrows like Saint Sebastian . . . and, in general, mayhem. . . . Between the bloody stories there were short comic ones and three of these depended for their effects on farting: a trapped man or woman bending over, exposing a great moon of buttock and emitting a jet of stink (gusts of soot drawn in wiggly lines and clouds) in the captors' faces. . . . I dropped the comic. The girl returned to her seat and, so help me God, serenely returned to this distressing comic."

IS THERE NOTHING SACRED?

Popular art for adults in Japan has always had an earthy quality to it, but prior to the 1960s most children's comics were like those of the United States today. Well-behaved, moralistic heroes dominated the pages; rebelliousness was confined to limits adults would tolerate. Then subjects long regarded as taboo—sex, violence, and scatology—were introduced in quick succession by artists and, after a flurry of panic on the part of parents, incorporated into the normal repertoire (fig. 147). Two groups of male artists were instrumental in this revolution: those who created comedies in boys' magazines, and those who drew action/adventure stories for the pay-library market.

The gag comics of Fujio Akatsuka helped set the stage.

In the 1960s, under the influence of old American slapstick movies, Akatsuka began creating serialized gagstrips for newly formed boys' comic magazines (fig. 148). Previous children's humor strips had been short, restrained, and naive, often depending on quaint puns and scenes of characters bumping into each other. Akatsuka's strips were around six-

148. "Professor!! I want you to write something!" says Bakabon's father to a flattered cat. Sōseki Natsume's famous novel I Am a Cat was written from the standpoint of a cat, and Bakabon's father has decided he can do one better—by asking a real cat to write a novel. Fujio Akatsuka's classic Tensai Bakabon ("Genius Idiot"), published in a variety of magazines beginning in 1967, represents the culmination of his gagstrip style.

teen pages per episode, fast-paced, and wacky. In his topsy-turvy world, idiot fathers fished for birds in rivers, policemen burst into tears when told they were ugly, rugged he-men wore dresses, and everyone lied, cheated, and stole from his neighbor. Akatsuka's comics were simply drawn and not particularly erotic or violent, but his new style of irreverent parody of the real world delighted readers of all ages and cleared the way for later, more radical artists.

In 1970 a former assistant of Akatsuka's named Kazuyoshi Torii began drawing a series titled *Toiretto Hakase* ("Professor Toilet"; fig. 149) in *Shōnen Jump*. It starred a scientist who specialized in scatology and worked in a toilet-shaped laboratory. The first episode set the tone for the rest: in a parody of the film *Fantastic Voyage*, the professor and his assistant cured a beautiful girl of constipation by shrinking to microscopic size, entering her digestive system through the mouth, and attacking the problem in the rectum with shovels. When the assistant carelessly lights a cigarette there is an explosion and the pair are "blown" to freedom.

In the same year another assistant of Akatsuka's introduced a hint of sado-masochism into children's humor comics with a popular series that parodied Japan's traditional family structure. Mitsutoshi Furuya's *Dame Oyaji* ("No Good Daddy"; fig. 150) starred a small, pathetic "salary-man" with the misfortune to have married Onibaba ("Demon Hag"), a scowling woman built like a warrior-robot. Early episodes all follow the same pattern: Damè Oyaji tries to assert himself, fails, and is bound, burned, beaten, or drowned by his family. In male-oriented Japan, where the father has traditionally been an aloof, authoritarian figure, Damè Oyaji was the

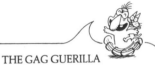

THE GAG GUERILLA

He was born in Manchuria. His mother was so poor she entrusted him to relatives. He barely finished junior high school. But Fujio Akatsuka became the "king of gag comics" in Japan. In the 1950s, while working at a chemical plant in Tokyo, he began submitting short cartoons to *Manga Shōnen*. Eventually he found his way to Tokiwasō, where he became Shōtarō Ishimori's roommate. At age twenty-one he made his debut as a professional—as an artist for a girls' comic. For several years thereafter, Akatsuka worked in a genre he never felt comfortable with, and spent all his spare time watching American movies with Chaplin, Abbot and Costello, and Jerry Lewis. When he finally did get to draw the gag comics that were dearest to his heart, his star ascended rapidly, and he produced such classic series as *Osomatsu-kun* ("The Young Sextuplets") and *Tensai Bakabon* ("Genius Idiot"). Children read Akatsuka's comics for their simple, funny pictures; teenagers read them for their gags and the clever puns to which the Japanese language is so well suited; adults read them for their social satire. Akatsuka, through his Fujio Productions, has subsequently fostered the work of other gag artists who share his style, and he continues to promote his zany vision through comics, books, movies, and TV appearances. In doing so he is helping transform the humor of Japanese comics and, indirectly, of Japanese society.

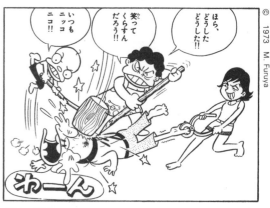

149. After becoming trapped in an elevator, the passengers all finally overcome their inhibitions and defecate on the floor. Professor Toilet and his assistant pontificate on the fundamental equality of man. Japan's cities have been notoriously slow about installing flush toilets, so even in 1970 when Kazuyoshi Torii's Toiretto Hakase *began in* Shōnen Jump *many young readers confronted powerful smells and the sight of maggots every day. Perhaps this had something to do with the comic's popularity.*

150. "Wazzamatter, Pop!? Why aren't you smiling, eh?" *From* Dame Oyaji *("No Good Daddy"), by Mitsutoshi Furuya, serialized from 1970 to 1982 in* Shōnen Sunday.

reverse of the stereotype; and when his wife attacked him, his children gleefully joined in.

Artists outside the Akatsuka line have also drawn taboo-smashing humor comics, often of a very different art style. In 1968, Gō Nagai's *Harenchi Gakuen* ("Shameless School"; fig. 151) series aroused the wrath of PTAs across Japan by introducing overt eroticism into children's comics and mocking Japan's monolithic educational system. Harenchi Gakuen was a fantastical school of bedlam, where the main preoccupation of both male students and teachers was not study but catching glimpses of girls' underwear or contriving to see them naked. Teachers included "Bearded Godzilla," dressed in a flimsy tiger skin that exposed his rear end, and a muscular oaf of a gym teacher, naked except for a laborer's shoe that stra-

151. "How's this?!" . . . and the boys go wild. *From* Harenchi Gakuen *("Shameless School"), by Gō Nagai, serialized from 1968 to 1972 in* Shōnen Jump.

tegically covered his privates. Every episode broke all the rules: students cavorted naked; classtime was taken up by mah jongg games and sakè parties. In a reflection of the flak the story received in real life, the last episode in the series ended in total war between the PTA and the school, with machine guns, tanks, and missiles all thrown into the fray. Everyone was destroyed.

By 1974 most traditional taboos in children's comics had been broken, but Tatsuhiko Yamagami's *Gaki Deka* ("Kid Cop"; fig. 152) series proved humor comics could still have shock value. The hero of the series was an improbable policeman/boy who lived in a very normal family and attended a very normal elementary school. He never doffed his police hat or removed his polka-dot tie, but he regularly shed the rest of his clothes to expose mooning buttocks and to wow onlookers with the tricks he could do with his testicles. All his actions were punctuated with quick poses and shrieks of "I sentence you to DEATH!" and at the most unlikely times he would change into a deer or a suspiciously erotic-looking elephant. In spite of protests, *Gaki Deka* was so popular among children (and the millions of adults who read children's comics) that it is said to have boosted the weekly sales of *Shōnen Champion* by over a million copies.

All the early Japanese adventure comics contained some element of humor in plot or drawing style. Violence—such as scenes of little samurai lopping off the heads of brigands—existed as early as the 1920s, but the drawings were always in a

152. *Gaki Deka, the little police-boy, goes to the department store to purchase a new pair of underwear and selects those with a rattlesnake pattern in the crotch. Three members of the Nerima Pervert Club appear, and ask him to become their president, but he protests his lack of qualification. Gaki Deka ("Kid Cop"), by Tatsuhiko Yamagami, was serialized from 1974 to 1981 in* Shōnen Champion. *Its brand of surrealistic sequence is now an indispensable part of today's humor comics.*

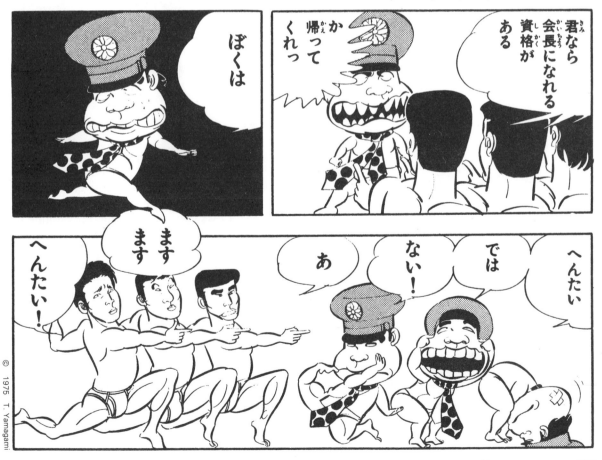

153. *The forces of good and evil do battle in a scene from* Devilman, *an occult tale which Gō Nagai began drawing in 1972 for Shōnen Magazine.* Devilman *had a novel twist: when its young hero learns that a host of demons are attempting to destroy mankind, he becomes Devilman in order to combat them on their terms.*

VIOLENCE

More from the January 1982 interview with *Daredevil* artist Frank Miller, published in *Comics Journal*: "The Japanese comics are as violent as anything I've ever seen. . . . The violence in them is rather honest. They're willing to be violent, and admit that that's what they want in their fiction. I think that we are much more hypocritical about it. Violence in fiction has a stigma attached to it here. It's obvious that people want it, it's obvious that people get a certain degree of pleasure out of it, and it's obvious that people feel guilty about it. I don't see the guilt as necessary. It is definitely not the same thing to read a violent story as it is to hit somebody." . . . "To have moral concepts worked out on paper, and a world where people fight for them. . . . I think that's a lot of what draws our audience to comics."

"cartoony" style, and blood was never shown. In the 1960s, however, the artists who worked for the pay-library market brought new realism to the action/adventure genre. Poorly paid, unknown, and hence less fettered by public opinion, when they felt the story warranted it they did not hesitate to draw blood.

Sampei Shirato's novelistic classic, *Ninja Bugeichō* (1959–62), was one of the first comic stories from the pay-library comic market to achieve national notoriety for its violence. In its portrayal of the struggle of the peasant class during one of the most violent periods of Japanese medieval history, it showed heads rolling, eyes gouged out, and showers of blood (created by soaking a brush in ink and then blowing on it).

When the pay-library comic market died in the 1960s, its artists moved over to the weekly and monthly magazines and brought their violence and realism with them. Many declared their work to be not "comics" but *gekiga*, or "drama pictures," and they consciously aimed at an older audience. They were influential in the growth of adult comic magazines

that stressed more graphic sex and violence, and in an escalation of realism in children's comics.

As a result, grotesquely stylized deaths and blood spatters became commonplace in boys' comics. Then came cannibalism in Jōji Akiyama's *Ashura* in *Shōnen Magazine* in 1970 (fig. 154). Like *Ninja Bugeichō*, *Ashura* was set during a time of terrible hardship in Japan's middle ages. The mother of the story's hero (Ashura) was a starving, deranged woman who lived long enough to give birth during a famine by eating corpses. Baby Ashura personified the amoral, animalistic will to survive present in all human beings; he was not evil, but he would kill, consume human flesh, and steal to live. Scenes of people eating each other, mountains of corpses, and maggots offended the PTAs, but those who bothered to actually read the story could see that it was a remake, in comic form, of the old 13th-century narrative picture scrolls depicting Buddhist purgatories; some of its opening scenes had been copied from the ancient "Disease Scrolls."

Magazines for girls, with their emphasis on love, are relatively free of such graphically depicted violence. But in both boys' and girls' comic magazines, stories regularly offer kissing, nudity, lovers in bed, homosexuality, and scatology. Only graphic depiction of the actual act of sex is missing. To be sure, in boys' comics the goal is often titillation, a trend that has been increasing as violence levels off; girls are drawn from ground perspective to better display their underwear, and a disproportionate number of frames on a page are devoted to enticing shots of bare breasts and exposed thighs.

What was once unthinkable in Japanese comics is now the norm. Horribly well behaved Japanese children are reading

VIOLENCE

More from Yukio Mishima's article on comics and youth in the *Sunday Mainichi* magazine, February 1970: "In 1952, when I visited the United States for the first time, I was surprised first by the flood of comics I saw there, and second by the fact that they were 'cheap,' without a shred of the sophistication of the old *Blondie* strips, and read mainly by adults. Compared with American comics, those of Japan contain a brooding sort of eroticism and violence, but their gags verge on the avant-garde. My own interest in Japanese comics developed through samurai comics, in a search for something that did not exist in America."

© 1977 J. Akiyama

154. *Baby Ashura hacks off the arm of a pursuer, and later retreats to the hills to eat it. From* Ashura, *by Jōji Akiyama, serialized in 1970–71 in* Shōnen Magazine.

stories with scenes that make adult visitors from other, more "liberal," cultures blanch. While the elimination of taboos in Japanese children's comics has given rise to many stories of questionable artistic value, it has also been a vital factor in the growth of the whole medium. Freedom from regulation allowed what was originally material exclusively for children to appeal to adults. It made it possible for artists to explore the potential of comics as other artists have explored the potential of novels and film (figs. 155–60).

SOCIAL AND LEGAL RESTRAINTS

Children's comic books in the United States provide a dramatic contrast. When creativity and circulations were at a peak in the 1950s, a moralistic coalition of educators, religious leaders, and legislators claimed that comic books were linked to juvenile delinquency and depravity, and they advocated censorship.

Under pressure, in 1954 the United States Senate Subcommittee to Investigate Juvenile Delinquency held a special hearing into the matter. While it did not specifically prescribe censorship, it helped establish a mood of condemnation.

155. DOSSHU! "AND CUT THROUGH BONE. . . ." Musashi, Japan's legendary swordsman, lops off the head of an opponent with a broken sword. From Miyamoto Musashi, a 1981 work by Baron Yoshimoto, published in Shūkan Manga Times.

© 1979 S. Shirato

156. *Bacchos stabs himself in front of his followers, then withdraws the sword and smiles; his seeming immortality reasserts his dominance over his tribe. Sampei Shirato's* Bacchos, *serialized from 1976 to 1978 in* Big Comic, *was one of a series of adult epics that dealt with mythology. Bacchos was an androgynous, hedonist-mystic: in special rituals his followers drank his drug-laced urine and went ecstatic; Bacchos himself slept with men and women, but was strangely attracted to animal feces. The story may have represented a culmination of a decadent trend in serious adult comics yet at the same time it was a study in the mechanism of human charisma. Shirato's bibliography included books on mythology, leadership, and sociology, by authors such as Max Weber.*

Across the land, outraged PTAs burned comics, and state and local governments enacted ordinances. In Salinas, California, anyone who tried to sell or give away comics that contained crime stories, horror stories, or "licentious" stories was liable to a $700 fine, forty days in jail, or both.

The comic book industry was so intimidated that it established the Comics Code Authority to enforce a strict system of self-censorship. The seal of the Code still graces the covers of most American comic books today. The authorities—police, judges, and government officials—must always be portrayed in a good light; good must always triumph over evil; the word "crime" must not appear alone on a cover; and the family system must not be mocked. Graphic violence, intimations of sex, and bad language are all prohibited. The vast majority of Japanese children's comics today would immediately be disqualified.

There were unhealthy trends of racism, sexism, and glorification of violence in American comics in the 1950s, but they were present in all media—and in society at large. The Code was a form of overkill that virtually crippled the comic medium. Artists were left with moralistic superheroes, a glorified United States military, and fuzzy animals as subjects suitable for depiction. Circulations plummeted, as did the number of artists and publishers who stayed in the business. In 1954 total American comic book circulation was estimated at 1 billion; today it is around 138 million. Thirty years ago there were over 100 publishers; today there are less than 10. Overregulation made American comic books a creative ghetto: it stereotyped them as something for small children and adolescents, and it made the industry unable to compete with television. In the 1960s, moreover, it contributed to the explosion of the so-called underground comics for adults—that gleefully portrayed everything the Code forbade.

157. *After trying to flee in a boat, Aota, leader of a school cheer squad, is attacked by a not-so-ravishing beauty yelling "Balls!" Dōkuman's Aa! Hana no Ōendan ("Aah! The Beautiful Cheer Squad"), serialized from 1975 in the adult weekly* Manga Action, *was a parody of Japan's disciplined, slavish cheer squads and, indirectly, of the "macho" element in Japanese society.*

AMERICAN CENSORSHIP

Japanese cartoonists are no strangers to government censorship: as early as 1698, Itchō Hanabusa was exiled for caricaturing the reigning shogun's mistress as a local tart. Not until the end of World War II did a new, American-authored constitution officially prohibit government censorship and allow cartoonists to lambast the establishment, even to criticize the emperor. Still, during the Occupation (1945–51) the American authorities censored work which seemed to reinforce feudal values, and they frowned on criticism of Americans. Ichio Matsushita, a prominent children's artist, was forced to stop drawing swords on the heroes in his fantasy comics. Kōdansha's *Shōnen Club*, the largest children's magazine before the war, was deemed a purveyor of "feudalistic" ideas: editors were purged and comic strips with traditional themes removed; upon request, the title of the magazine was printed in English and English-language comics were included inside. Ryūichi Yokoyama, creator of the popular newspaper strip *Fuku-chan*, was reprimanded for drawing Americans with red noses.

Perhaps because of its political proximity to the United States, Japan was also singed by protests against comics. In the mid-'50s, the Campaign to Banish Bad Reading Matter emerged with the slogan *Uranai, kawanai, yomanai* ("Don't sell them, buy them, or read them"). Initially its target was cheap erotic magazines, but when a PTA in Okayama city burned offending material, comics were also thrown on the fire. Pressures on the industry increased, yet in Japan's case the children kept on reading, the publishers held tight, and the parents eventually gave up. In 1963, when a group of artists and industry representatives pledged to create more "humanistic and conscientious" comics for children, it was like shouting into a storm. And in 1979, when an educator named Mitsuo Matsuzawa came out with a book titled *Nihonjin no Atama o Dame ni Shita Manga-Gekiga* ("The Comics That Have Ruined Japanese Minds"), it showed what a huge phenomenon comics had become. It castigated not only children for reading comics, but also their parents.

This is not to imply that there are no restraints on the content of Japanese comics today. On a national level, censorship is prohibited by the Japanese constitution, but Article 175 of the Japanese penal code makes it illegal to distribute, sell, or

display obscene printed matter. It is a law applied primarily to adult erotic magazines.

At the prefectural level, PTAs and watchdog "committees to protect youth" often scan comic magazines. If they find something offensive they may initiate boycott campaigns and complain to local police, who relay the message to publishers and enforce local ordinances. Minority groups with new political muscle are more active. The Korean residents of Japan, the Ainu (Japan's aboriginal race), the Burakumin (an "invisible" class of former social outcasts), and organizations

158. Before stealing the world's largest diamond, Lupin III and the jewel's owner share a brief moment of ecstasy. Monkey Punch's Lupin III is a descendant of the famous French gentleman-thief Arsene Lupin and a master of disguises who is always one step ahead of the law.

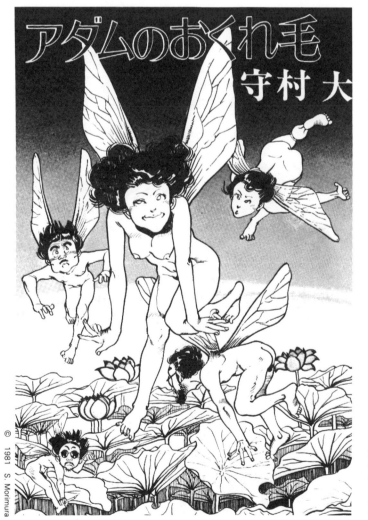

159. Shin Morimura's Adamu no Okurege ("Adam's Stray Locks") was serialized in the late 1970s in Manga Action as a collection of short comedy stories that deal with first sex, and gay sex, among young Japanese people. Morimura is one of the most realistic, yet fluid artists active today, drawing mostly for the mainstream adult weeklies.

to protect the mentally and physically handicapped have developed a new awareness after years of discrimination. They are quick to identify material they consider offensive, and their pressure on store owners and distributors can instantly ruin the sales of a magazine or book. As early as 1962, the Buraku Liberation League in Japan was protesting Hiroshi Hirata's *Chidaruma Kempō* ("Blood-drenched Fencing"), a gruesome and violent tale of revenge that, while seeming to take a sympathetic view of Japan's "outcast race," reveled in scenes of their abuse and brought into the open again the cruel words and emotions that most people simply wanted to forget. Copies of *Chidaruma Kempō* were collected from pay-libraries and burned.

Certainly the most powerful restraint on comics is the marketplace itself. Comics for men, women, and children tend to find the subject matter and level of violence and sex that readers and the general public will tolerate. It is a level reached by trial and error and influenced by changing public tastes, this process being eased by the relative homogeneity of Japanese society, with its stress on consensus as opposed to

160. *Frontispiece to* Itsuka Monogatari *("Tale of Five Days"), a short story of lust and violent revenge in old Japan, by Keizō Miyanishi in* Kin'iro no Hanayome *("The Golden Bride"), a collection of his works published in 1982. Perhaps because of the lack of constraints on artists, the erotic comic magazines have been a repository of eccentric talent.*

五日物語

161. *A scene from Akira Narita's* Furifuri-damudamu, *serialized during the 1970s in* Manga Sunday. *Consciously or unconsciously, the artist is duplicating the theme of the "Phallic Contests" scroll from Japan's middle ages.*

confrontation. Japanese publishers and artists have a long history of being censored: by the shogunate during feudal times, by the militarists before and during World War II, and by the Americans after the war. Freedom from regulation is a cherished right today.

One must also ask what the point of regulation would be anyway. The enervation of the comic in America did nothing to stem the growth of violence among young people in that society. By the same token, it does not appear that Japanese youth—avid readers of sadistic and wanton pulp stories—are at all in jeopardy. For one thing, as citizens of the first modern, industrialized democracy outside of the Judeo-Christian tradition, the Japanese naturally have their own ideas of what is acceptable in art and what is not. The stylized sprays of blood and death grimaces so common to Japanese action comics (and movies) today are part of an aesthetic of violence in art that has been in existence for hundreds of years. Kabuki, for example, makes extravagant use of styl-ized battle scenes between armed warriors. And one can find the roots of the comics' eroticism and nudity in the uninhibited woodblock prints produced in great numbers during the 18th and 19th centuries (fig. 161).

Yet when these same Japanese people first saw Western oil paintings of nudes in the late 19th century, they were scan-dalized. Although both sexes bathed together in public baths in Japan until the American Occupation, scenes of kissing, embraces, and cheek-to-cheek dances were banned in movies. When the first kissing scene in a Japanese movie was shown in 1945 the audiences went wild, even though the female star had reportedly covered her mouth with cellophane.

Japan has come a long way since 1945, but attitudes there can still differ in significant ways from those in the West. Erotic and scatological jokes, for example, regularly appear in respectable—even staid—newsmagazines and daily news-papers, but there is no concept of the "dirty joke" and neither the readers nor artists are immature adolescents. Hiroshi Kurogane has won thousands of men and women admirers for his puns and parodies using genital themes, with series like *Pokochin Kyōwakoku* ("The Penis Republic"; fig. 162).

162. *This figure first appeared on a paperback edition of Hiroshi Kurogane's* Pokochin Kyōwa-koku ("Penis Republic"), *which starred a young, unmarried salary-man named Pokochin, that is, "Penis." The mildly erotic escapades of the slow-witted hero won the story many fans when it was serialized in the weekly magazine* Shūkan Heibon Panchi *in the mid-1970s.*

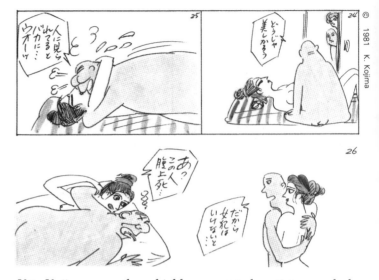

163. Concerned that a young acolyte does nothing but study sutras, a temple abbot takes it upon himself to teach him the ways of the world. When demonstrating how to make love to a woman, however, he becomes so aroused at the thought of being watched that he has a heart attack and dies. From Oshaka Bōzu Retsuden *("The Life of a Buddhist Monk"), by Kō Kojima, serialized from 1967 in* Manga Action.

Kō Kojima, another highly respected artist, regularly reworks the theme of lusty women faced with men who can't perform. One of his most famous series, *Oshaka Bōzu Retsuden* ("The Life of a Buddhist Monk"; fig. 163), portrays the weak-willed clergy being seduced by amorous women—a theme common enough in Japanese literature, films, and comics, but of questionable taste in many other cultures.

More to the point, perhaps, is that violence in the comics is offset by a remarkably unviolent society. Japan's constitution forbids war; guns are strictly controlled; and the national crime rate, including that of sex crimes, is extremely low. Moreover, during the years that sales of comics in Japan soared, the crime rate was actually dropping. When a young boy in Tokyo reads a lurid action comic, it is far more difficult for him to associate it with his surrounding environment than it would be for a child in New York or Detroit.

Also, in spite of the decadent, promiscuous image projected in the comics, Japan is a very conservative society, and its citizens are paragons of virtue by most Western standards. The Japanese worry incessantly about a "decline in morals." Pandering to this concern sells newspapers, but there is little evidence to support it. The divorce rate is still low. Sexual standards have changed, yet there certainly has been no "sexual revolution." Statistics released by the Prime Minister's Office in 1980 show that 40 percent of young people aged fifteen to nineteen have no friends of the opposite sex at all. Only 7 percent admit to having "boyfriends" or "girlfriends."

Comics thus depict a fantasy world outside of the rigid conventions, where the truly impossible is possible. While comics can convey a message about reality, very few of them depict it realistically. And Japanese comic readers, who are very much at home in their medium, rarely confuse the two worlds.

EROTIC COMICS

No genre of comics better illustrates the role of fantasy in Japanese society than adult erotic comics (fig. 164). Ironically, they are the most strictly regulated, even as young children feast daily on sex and blood in *their* comics. As Arti-

"NO-PANTY ANGELS"

Erotic comic story titles are often characterized by their silly exaggeration, by their parodies of well-known films, novels, and events, and by ridiculously long strings of complex ideograms that form sexual double entendres. Titles, after all, help sell magazines. Some typical examples in translation: "No-Panty Angels," "Defiled Married Women," "Teach Me Love!" "Flesh Slave Dolls," "Perverted Flight of Love," "Lolita Complex ABC's," "Lewd Labia Diary," "Lured by the Infinite Climax," "Lewd Lens," "Ascension to the Flower Garden of Worm-Eaten Taboos," "Women! Live for Sacrificial Ripe Love!" and "Enema Rock Climbing."

cle 175 is presently interpreted for comics, adult genitalia, pubic hair, and sexual intercourse may not be graphically depicted, and certain slang words may not be written; children's genitals and extremely "cartoony" renderings are permissible, however. It is an antiquated law that threatens to crumble at any moment, but because it is still applied in a blanket approach to both art and pornography, offending scenes of American movies are regularly blurred; imported *Playboy* magazines have scratched out centerfolds; and the best Japanese erotic woodblock prints can never be displayed in the land of their manufacture.

In spite of this regulation, or perhaps because of it, the Japanese have developed a huge genre of erotic comics for adults. Erotic stories can be found in one form or another in nearly all comic magazines, but it is estimated that from seventy to one hundred different titles of magazines (usually monthlies) specialize in them. Like mah jongg comic magazines, erotic comic magazines are a relatively new addition to Japan's world of comics and constitute a microcosm of their own.

The cover is usually a photograph or delicately airbrushed

164. Mugen, champion courtesan of the Yoshiwara red-light district of Edo, is challenged by a stud with the unlikely name of Hi-hi-hi-suke Shōjō. Masami Fukushima and Kōichi Saitō's Yūjo Mugen *("Mugen the Courtesan") was serialized in a 1979 issue of* Bessatsu Manga Action *billed as an "Ark of Romance and Carnal Desire."*

165. A symbolic rape scene from Ken Tsukikage's 1981 samurai-porno Tōzoku Tōshin Shikirōgari ("The Bandit Constable: Hunt of the Sex Maniac"). Tsukikage specializes in samurai stories, not only in erotic comic magazines but in mainstream magazines for adults and children.

portrait of a young woman. The rest of the magazine, like most adult monthlies, consists mainly of six or seven stories of twenty pages or so, interspliced with gag strips. All, of course, have something to do with sex. Then there are centerfolds, titillating letters to the editor (usually concocted by the same editor who answers them), articles about such things as the best massage parlors in Tokyo, and, finally, ads for novelties like penis enlargers and "panties formerly worn by famous movie starlets."

Erotic comics visually express the sex fantasies of Japanese males, and therefore can have little basis in reality (fig. 165). Sex with high school girls in sailor suits (the typical Japanese schoolgirl uniform), the wife of the neighbor next door, and buxom blondes from overseas takes place in motels, in outerspace, and on the backs of speeding motorcycles. Traditionally popular themes are the "peeping tom" and the decrepit man attacking young morsels in sailor suits—who later thank him. In recent years, women are just as likely to be the "attackers." Most of the artists, of course, are men, but women, such as Yōko Kondō and Ikumi Nakamura, have also worked in the field.

The relationship between the authorities and the erotic comic industry has been one of cat and mouse: overworked police do their best to oversee the flood of magazines, while the artists continually invent new ways to circumvent the restrictions imposed upon them.

Small publishers with little capital are careful not to incur the wrath of the authorities, because a ban on the sale of an issue can be a financial death blow. Editors therefore carefully screen the artwork that is submitted and white-out all offending areas. Occasionally, however, carelessness will result in a call from the police department, and a superbly polite voice, as befits Japan, may request the appearance of the editor at the police station. If the offender assumes an appropriately humble attitude, promises never to repeat the offense, and signs a written apology, the matter is usually closed. One exception was Manga Erogenika, a monthly with a circulation of 95,000. The November 1978 edition featured such stories as "Dirty" Matsumoto's "Crazed Feast of Fallen Angels," featuring oral copulation, enemas, and torture, but of course no direct depiction of genitals or intercourse. Whether because of the magazine's content or, it was also suggested, because of some boastful statements made by the editors on television earlier, sale of the magazine in its original state was banned. Reprinting was done at a cost to the publisher of about $35,000. Shortly thereafter the magazine folded.

The task of the erotic artist is indeed formidable: he must weave sex scenes into interesting stories, and depict the sex as graphically as possible—without depicting the sex. Unlike the erotic artists of the "Floating World," who drew their subjects intertwined in the most physically impossible positions to better display their genitals, today's erotic comic artists often draw men and women in equally awkward embraces— because neither genitals nor touching groins may be shown. When "unavoidable," strategic areas are left blank or are covered with black patches. To compensate, artists stress the suggestive: shots of groaning faces, drooling mouths,

sweating bodies, and mysterious, viscous fluids. All this is accompanied by men groaning *AUOOO*, and women crying *Yada!* and *Yamete!* (words which mean "stop" but of course don't mean "stop" at all).

One of the most distinctive products of regulation in all Japanese comics—not just the erotic comic magazines—is the use of symbolism. Unable to draw genitals, artists creating comedy stories have taken to drawing substitutes—phallus-shaped objects such as turtle heads, Japanese eggplants, and Titan rockets, and lingam shapes such as conch shells, clams, and orchids (fig. 166). One artist, Masamichi Yokoyama, has practically made a career out of this technique. His series *Yaruki Man-man* ("Ready an' Rarin' to Go": story by Jirō Gyū; fig. 167) is so popular it regularly runs not in an erotic comic magazine but in the *Nikkan Gendai*, a daily newspaper.

The Japanese authorities are so busy looking for technical violations of the antiquated laws on nudity that they may be overlooking the real pornography, and even encouraging it. Japan remains a male-oriented society; many of the stories in the erotic comic magazines read by men are "sexist," and some are degrading. There is violence against women—such as the surrealistic sado-masochism of "Dirty" Matsumoto,

166. *Chapter title-page from Yū Nakano's Tane-tsuke Kozō ("The Stud Kid"), showing a Buddhist monk and his girlfriend, and the erotic symbols of eggplant and chestnut. Nakano's skillful use of caricature complements the humorous themes of erotic stories.*

167. *The seal dives into the sea shell. . . . The young president of an aphrodisiac company is involved in a series of sex competitions. To win he must make the women climax before he does. In this sequence, he begins in the missionary position with a lead singer from the Pink Sexies band. The crowd goes wild. From* Yaruki Man-man *("Ready an' Rarin' to Go"), by Jirō Gyū and Masamichi Yokoyama, currently appearing in* Nikkan Gendai.

whose name derives from a Clint Eastwood film. And, since the law tends to overlook nude scenes of children, several artists have pioneered the *rori-kon* or "Lolita complex" genre, drawing little girls as sex partners for grown men, as surrogates for the mature women that cannot be realistically depicted. Disturbingly, this has become a major trend. The *rori-kon* comics of erotic artist Aki Uchiyama have become so popular that, in 1981, by toning down the emphasis on the sex act and concentrating on voyeurism and diapers, he was able to break into the mainstream boys' magazine *Shōnen Champion.*

Not all publishers are unhappy with regulation. Artists have cleverly circumvented most of the restrictions placed on them, and by not revealing everything their stories are possibly more provocative than they might be otherwise (fig. 168). As one editor of a rather successful company admits, "In countries where pornography is legal, the locals have little interest in it, and most of the people buying the magazines and watching the films there are Japanese tourists. We want to be sure the demand for our product lasts."

Who reads erotic comics? The vast majority of readers are male. But contrary to a stereotype of frustrated middle-aged men in unhappy marriages, or lonely day-laborers indulging in masturbatory fantasies, many readers are apparently junior high school and high school boys curious about sex. "Most of our readers," claims the same editor, "have no experience with real women. If they did, why would they read these stories?"

What about women? While some may be stealing glances at the magazines of their brothers, boyfriends, or husbands, probably few would want to buy an erotic comic magazine for themselves. Eroticism for females, particularly in girls' comics, is couched in the softer tones of romance. Yet perhaps

168. *A sequence from Takashi Ishii's* Tenshi no Harawata *("Entrails of the Angel"), serialized from 1977 in* Young Comic. *Ishii, whose hard-boiled action/romance stories have earned him a cult following, is one of the best artists to emerge from the erotic comic magazines. His frame progressions are among the most cinematic in Japan.* Tenshi no Harawata *has been made into a successful, live-action feature film by Japan's largest maker of soft-core porno movies.*

女狂いの
あんたに

男の味を
たっぷり
教えてやるよ

© 1982 T. Naka

169. "I know you're crazy about women, but let me teach you what it's like to love a man." . . . and shortly thereafter the young and beautiful Lee changes his lifestyle. Tomoko Naka's short story Tokei no Ue no Ribon *("The Ribbon on Top of the Clock") appeared in the girls' comic magazine* Junè *in 1982.*

the best illustration of the Japanese tolerance of fantasy, and of the unique dichotomy between fantasy and reality, is in stories of male homosexual love, currently popular among young girls.

While most of these stories appear in regular girls' comic magazines, one of the largest publishers of erotic comics in Japan, San Shuppan, also issues a magazine called *Junè*, featuring mainly stories of love between beautiful teenage boys overseas, drawn by women artists (fig. 169). The target readership is junior and senior high school girls. Why are sweet, naive Japanese girls interested in such a seemingly decadent subject? As an editor at San Shuppan says, "At that age in Japan, most girls, in fact most boys, have very little to do with the opposite sex, but they have a great deal of curiosity. Love between boys in another country is so completely distant from their own reality that it's not threatening, yet it still gives them a vicarious experience. They also think it is pretty."

"JUNÈ"

The January 1982 edition of *Junè* was issued with the logo, "Beyond a Dangerous Love." Its 150 pages were dedicated to the popular theme of the *bi-nanshi*, or "beautiful boy," and contained the following: pin-up color photographs of androgenous foreign rock stars and scantily clad teenage boys, with poems; eleven comic stories and short strips about young gay men; a short, illustrated prose story of gay interracial love in prewar Japan; interviews with famous artists on the aesthetic of the "beautiful boy"; articles on travel, TV, and art museums; lessons on how to draw the "beautiful boy"; color reproductions of drawings by a 1930s illustrator who specialized in the "beautiful boy"; drawings by readers of young boys embracing; reviews of amateur comic magazines devoted to the "beautiful boy"; confessions of gay love, purportedly written by readers; and letters to the editor praising the magazine. In his advice column, gay counselor Yanagi Kawabata, in answer to a young girl's question about what love between males was really like, told her that it was similar to love between men and women but not always so pretty as the comics implied. Ignore harsh reality, he told her, and continue to fantasize about gay love on the aesthetic level of girls' comics.

The Comic Industry

One "hit" comic rolls through Japan's economy like the snowball that becomes an avalanche, enriching artists, publishers, animators, and merchants. In 1984, total sales of comic magazines and books amounted to 297 billion yen, or about 1.2 billion dollars, yet this was only a portion of an industry valued at several times that figure. Sales of comic magazines trigger those of comic paperbacks, which in turn lead to television animation, theatrical film animation, toys, posters, key chains, stickers, novels, and, finally, more comics, all spreading the wealth with a mutually multiplying effect. Individual artists, with the aid of their publishers, are what power and feed the entire system.

ARTISTS

In the United States artists are often only one member of a team of writers, letterers, inkers, and colorers under the control of a publisher. In Japan, artists are usually independent and individually responsible for the conceptualization and completion of their work, even if they have assistants helping them. Their status would make many of their American counterparts drool with envy, for they retain not only creative control but also the rights to their work. They are rich and they are famous (fig. 170).

Yet best-selling artists lead unenviable lives. Few take off weekends; many who have offices spend days away from home and family as they work on five or six stories for different magazines at the same time. It is not uncommon for artists to sleep only four or five hours a night, and not at all when there is a deadline to meet. Hiroshi Fujimoto of the popular duo Fujio-Fujiko (fig. 171) has described how "the longest I ever continuously worked was around seventy-two hours. I only did it twice. First, I got out some water and food—bread, some fried mincemeat cakes, Chinese fried

170. *The elite of the comic industry hobnob at a ceremony to mark the 1,000th issue of* Shōnen Magazine. *The man in the center in the light sports coat is Tetsuya Chiba, whose sports stories have been a selling point of the magazine.*

dumplings—all things I could reach out and snack on with one hand. I kept the other hand that held my pen constantly moving. For two days and three nights I worked straight, not resting a minute except to go to the bathroom. When I finished, the paper appeared to float before my eyes. . . . "

Osamu Tezuka has reportedly become so exhausted that he has inadvertently drawn samurai sandals on a spaceman. And no wonder. Tezuka's manager, Takayuki Matsutani, estimates that Tezuka has drawn nearly 150,000 pages in the last forty years. Altogether, nearly 100 million copies of his stories in comic paperback have been published. Another artist, Shōtarō Ishimori, has created 70,000 pages in the last thirty years, and may hold a record of sorts: he has drawn over 500 pages in one month. This huge volume is possible partly because of the simplicity of Japanese drawings, which stress line over shading or color, and the use of assistants, who free the artist from the tedium of drawing background details. Still, the artist is usually in sole charge of story concept, layout, penciling, and inking. Substitutes, rotation of artists, and ghostwriting, so common in American comic books and strips, are rare. Comics and their heroes are inextricably linked with their creator in the public's mind: at least the comic artist in Japan has the satisfaction of knowing that when he dies from overwork his creations will accompany him to the grave.

But why work so hard? Two factors are that hard work has always been esteemed in Japan and artists love what they are doing. Another is that volume production, as the industry is configured today, is a sign of popularity, particularly for male artists. The number of stories he can simultaneously run in different magazines determines his unofficial "rank," which affects the amount he is paid per page, which in turn determines the amount of pressure publishers apply on him to get the job done. And, as many artists point out, most agreements between artist and publisher are still based on trust, not contracts. Such goodwill only creates the anxiety that "I better do as much work as I can while the demand lasts." An artist soon becomes a prisoner of his own success.

The real pay-off, of course, is fame and fortune. The American comic book industry is rife with tales of famous works that have earned millions for the publisher and nothing for their aging, impoverished, and unknown artists. Popular artists in Japan are millionaires and household words. They are the subjects of biographies, autobiographies, and documentaries on television chronicling their lives and careers. There are even comics about them. For a break from work, they may tour the nation, signing autographs in front of adoring crowds in department stores or participating in staged media events (fig. 172). Artists who are not utterly tone deaf may record albums of their own songs or stories. Those with outgoing personalities, like Taira Hara, are darlings of the media, and regularly appear on TV talk shows or shows that are specifically created around cartoonists. Some lend their names and faces to advertisements for products unrelated to comics. Osamu Tezuka advertises Japanese word processors on television.

The term *hanguri ātisto* may apply to the thousands of

171. One name, Fujio-Fujiko, is actually two artists, Hiroshi Fujimoto (left) and Motoo Abiko. In the twenty-five years of their professional career they have been inseparable, sharing the same tiny room when starting out and later living next door to each other after becoming a success and starting families. Hard work and the charm of their characters have made them two of the most successful children's artists in Japan. How do they divide the work? It's a secret, says Abiko.

THE CARTOONIST AS GOD

In Japan doctors, artists, teachers, and especially learned persons are addressed with the honorific term *sensei*—"teacher," "master," but literally, "one born before." Today's comic artists, if they have any standing in the industry at all, are automatically called *sensei* by their assistants, fans, editors, and the mass media. Persons of *sensei* status in Japan tend to be older, as the title implies, but the nature of the comic industry, wherein a very young artist can become the idol of millions, has meant that there are now even teenage *sensei*, especially among the women artists, who often debut early. This presents a rather awkward problem for the age- and status-conscious Japanese, for if an eighteen-year-old artist is a *sensei*, what do you call an older, more experienced artist? The mass media's solution has been a steady escalation of honorifics. The words applied to the superstars of the industry so far include *sōsho* (slightly above *sensei*), *kyoshō* ("great master," or "maestro"), *ōsama* ("king"), and *kyōso* (founder of a religion). Osamu Tezuka, regarded as the pioneer of the modern Japanese story-comic, is the only artist accorded the supreme accolade: *manga no kamisama*, or "the God of Comics."

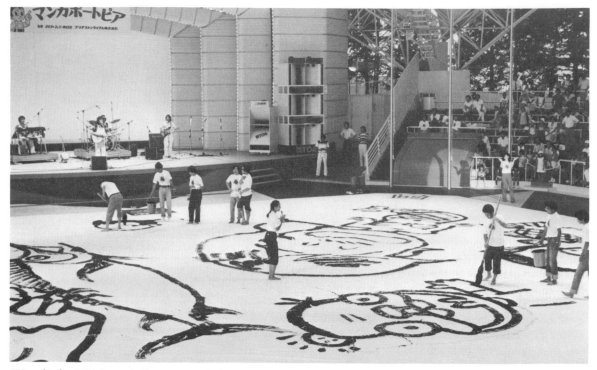

172. At the 1981 Portopia Exposition in Kobe, accompanied by a rock-and-roll band and watched by a thousand people, two teams of artists use giant brushes and buckets of ink to complete huge drawings of their characters. In the foreground Mitsutoshi Furuya works on Damè Oyaji, while in the background Osamu Tezuka starts on the head of Tetsuwan Atomu, or Astro Boy. The fish was drawn by Takao Yaguchi.

amateurs trying to break into the industry, but not to those who have already made it (fig. 173). A newcomer in boys' magazines can easily make $50,000 a year. Whether man or woman, an established artist, in what defies the public imagination in land-scarce Japan, may live in a huge mansion with a swimming pool.

Payment is traditionally by the page and may vary from $15 to $250, depending on the status of the artist in the industry, but it is generally equal for men and women. Volume production, 10 percent royalties from paperbacks, and subsequent licensing of character rights for animation and merchandising are what add extra digits to an artist's income.

Usually artists try to keep their taxable income low, by forming corporations or creating deductible expenses. But sometimes they just make too much money. In 1978 popular baseball artist Shinji Mizushima made the celebrated chō-jabanzuke, a list published every spring of the highest income earners in the nation. He had earned about $1.3 million. His baseball story, Dokaben, had sold over 25 million copies in paperback. Three years later, the incredibly successful duo Fujio-Fujiko made the same list. Their combined personal income for fiscal 1980 was nearly $1.7 million and had tripled from the year before, largely because of the success of their children's story of a robot-cat, Doraemon, and its subsequent animation. Most recently Akira Toriyama broke all records. His income in fiscal 1981 from his comedy series, Dr. Slump, and its animation was over $2.4 million, a ten-fold increase from the previous year. Toriyama was twenty-seven years old.

What does it take to be a successful artist? Like rock and roll in the United States, comics in Japan are an expressway to stardom for anyone with the right touch. But long-term sur-

173. Gō Nagai signs an autograph for a fan at Kōdansha's 1981 awards ceremony. Most of the crowd—but not Gō—is attired in fancy tuxedos or gowns.

vival requires physical and intellectual stamina. Hundreds of artists debut annually; only a few will make it. The level of their education is irrelevant. Few artists have any formal art training and many never graduated from high school. More important is that they possess a vivid imagination and the ability to keep creating interesting stories.

Conceptualizing a story may be done while staring at a blank piece of paper, walking around the block, sitting on the toilet, or even meditating under a pyramid, like Shōtarō Ishimori (fig. 174). But running out of ideas, or losing touch with the latest trends in Japan's information-saturated and fashion-conscious society, can be calamitous. Many artists, therefore, use what little free time they have with maximum efficiency by reading or by watching movies. Film, in particular, is a vital source of inspiration, and artists are quick to apply what they see on the screen to the story and visual aspects of their comics.

Only rarely can artists afford a real change of environment. Shinji Nagashima, who had great influence in the 1960s, once left his wife and family and took up residence in a cheap apartment in Shinjuku, at the time Tokyo's equivalent of Greenwich Village. The experience produced his classic *Fūten*, which chronicled the lives of Japan's urban hippies. Most recently there was Hiroshi Motomiya, popular creator of many school-gang adventure stories. After publicly announcing that he suffered from mild manic-depression and would no longer draw, Motomiya took off for Hawaii to recharge his batteries. Six months later a photo-feature in a Japanese magazine showed him firing pistols at a local rifle range (a favorite fantasy of men in gun-controlled Japan), driving a fancy convertible, and relaxing by a pool with voluptuous blondes in bikinis. For a while it looked as if he would never return to work, but soon he was back in Japan, as active as ever, developing a new type of political comic and declaring that he would run for a seat in the Japanese Diet. Still, both Nagashima and Motomiya were exceptions. Few artists are capable of breaking their work cycle, or would even want to.

When the imagination flags, professional scriptwriters can be a solution. Young artists, in particular, may rise to stardom on the basis of one clever work and then find they are unable to cope with the demands of publishers for more, more, more. They lack the real-life experience necessary to create interesting stories and are under so much pressure that they have no time to accumulate it.

Three of Japan's most famous scriptwriters, Jirō Gyū, Ikki Kajiwara, and Kazuo Koike, supply what artists need. Gyū, among other things, has worked in a pachinko factory, run a restaurant, played alto sax in several jazz bands, and been a newspaper columnist. Appropriately, he is the author of some of the most famous work comics, including *Kugishi Sabuyan*. Kajiwara, who sometimes writes 600 pages a month, has parlayed his expertise at karate, judo, aikido, and other sports into fame and fortune by scripting some of the most successful sports comics in Japan, among them *Ashita no Jō*. Koike, formerly an official with the Ministry of Agriculture and Forestry, a professional mah jongg player,

174. Artist Shōtarō Ishimori built this pyramid on top of his house to test the theory of pyramid power. "Instead of thinking up new stories," he laments, "I usually wind up drinking sakè and admiring the moon."

A RECORD BREAKER

If a comic story in Japan is popular, its animation is virtually guaranteed. And because of the tremendous spin-off in profits, the time between a story's first appearance in a magazine and the decision to animate it is rapidly shrinking. Akira Toriyama's little girl/android comedy, *Dr. Slump*, was first serialized in the weekly comic magazine *Shōnen Jump* in January 1980, and within five weeks Tōei decided to animate it. Television broadcasts of the animated series began in May 1981, and in July the story was released as a theatrical feature. This further boosted book sales. By December of the same year, the five paperback volumes of *Dr. Slump* had sold nearly 15 million copies. Volume 6 of the paperback series was therefore published with an initial print run of 2 million copies, a record in the Japanese book publishing world.

175. *Late at night, Gō Nagai begins penciling in a series,* Pendora, *while his assistants wait at their desks in a room next door.*

and a writer for the series *Golgo 13*, has drawn on his experience to create many action stories, including the samurai classic, *Kozure Ōkami*.

More and more, the demands of their job have resulted in the Japanese artists delegating some of their responsibility to others. In the old days, when the most an artist could create was around 100 pages a month, family members would be enlisted to help draw frames around the page, or erase pencil lines. But in the 1960s, when the boys' comic magazines went from a monthly to a weekly format, artists who drew long stories found that they had to hire help in order to maintain their position in the industry. Today this help takes the form of a production system that enables an artist with ten assistants to churn out 400 to 500 pages of comics a month and still be called the creator (fig. 175). It is also a convenient way of reducing one's taxable income, although the use of paid staff makes volume production imperative. Two different approaches to the system are represented by Osamu Tezuka and Takao Saitō.

Osamu Tezuka, who has ten assistants for comic-related work, is an example of a purist who has retained all the creative work for himself. He thinks up his own stories, plots the frame layout on the page, and first pencils, then inks in the characters and the backgrounds. His assistants are left with the tasks of blackening in certain designated sections, applying zip-tone patterned paper for shading, and adding in minor details on automobiles, buildings, and costumes. This system works fine for Tezuka, whose speed, stamina, and imagination are legendary, and he is able to turn out stories for boys, girls, and adults at a rate of over 300 pages a month. But if Tezuka becomes sick, or busy with other work, everything comes to a halt. He may be responsible for more ulcers among editors than any other artist in Japan.

Takao Saitō, the creator of *Golgo 13*, works with fifteen full-time staff members of his company, Saitō Productions, and has seven or eight outside people contracted to supply story scripts (fig. 176). Saitō regards comic story production as comparable to filmmaking, with himself as director. When he receives a job order, he assigns four assistants, according

176. *Takao Saitō, creator of* Golgo 13, *goes over some of the fine parts of the artwork with two assistants. At many production studios the job of assistant is monotonous and uncreative, often involving little more than drawing borders, shading, or tidying up a page. At Saitō Productions, however, creative input is encouraged.*

to their particular talents, to work with him as a team, and he stimulates creativity by holding lively discussions with them about the story and artwork. Assistants may specialize in drawing realistic pictures of buildings, machinery, background characters, or landscapes, and for many of them the job is good training and the first step to independence (fig. 177). Saitō at times only pencils in the faces of the main characters. Saitō Productions has been criticized in Japan for being too businesslike, or too American-style an operation, but Saitō, the artist, nonetheless retains creative control.

Using artist and assistant, the production system as it has evolved is an extension of the traditional Japanese master-disciple relationship and helps cement a weblike pattern of relations among artists in the industry. But it is also a business, and requires a manager. The manager must pamper the artist to ensure that he is in good health and spirits and capable of working; he must ward off rabid fans when a story is a hit and editors when a deadline is missed; and he must negotiate page rates, collect information, handle publicity, and run the company. The artist, after all, must devote his time to creating stories.

As the comic business in Japan has boomed, productions have expanded dramatically. Gō Nagai's Dynamic Productions employs fifty people, including janitors, artists, and accountants. Gō, who requires thirteen assistants, is the major shareholder in the corporation and concentrates on the drawing. His younger brother is vice-president, and his older brothers serve as president and accounting executive. Dynamic Productions also owns five subsidiaries, including a children's theater group and an editing company, involving over one hundred people. Scriptwriter Kazuo Koike's production, Studioship, is similar to an artist-writer's cooperative, with forty regular employees, including five artists and four writers. But it also operates, in the same building, a school for writers and artists (as hard to get into as the prestigious national universities), a publishing company, and a coffee shop.

PUBLISHERS

In 1984, there were around seventy different publishers of weekly, biweekly, and monthly comic magazines in Japan and nearly fifty publishers of comics in paperback form (fig. 178). Like the Japanese economy, the publishing world is two-tiered. Small publishers, often operating on a shoestring budget with a handful of employees, engage in fierce competition for the readers of specialized comics, issuing special editions and even changing the titles of their magazines in order to attract new readers. It is a world in which both publishers and magazines appear and disappear overnight. The more powerful publishers, such as Kōdansha and Shōgakkan, have a virtual monopoly on children's comics and on the more "serious" adult comics where huge sales and profits are possible.

Kōdansha issues over twenty titles of comic magazines and compiles their serialized stories into paperbacks at the rate of about fifty volumes a month. Over 150 people are employed in comic production, most as "editors"—there may be as many as 20 people on the editorial staff of one weekly

177. One of Takao Saitō's assistants inks in a Hiller helicopter while checking a well-worn reference book. Since many of the stories created at Saitō Productions depend on their topicality and realism, the company has a huge reference library and a professional cameraman.

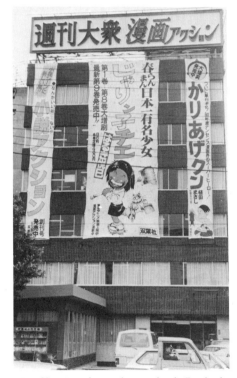

178. Hanging from the roof of Futabasha, publisher of the adult weekly Manga Action, giant hand-painted banners advertise new volumes of comic paperbacks in the series Jarinko Chie, by Etsumi Haruki (center), and Kariage-kun, by Masashi Ueda (right). Ten years ago advertising for comics was limited to the back pages of the comic magazines. Today ads appear in newspapers, as glossy color posters inside commuter trains, and as short spots on radio and television.

179. *An editor at Kōdansha's girls' monthly,* Shōjo Friend, *cuts out dialogue printed on separate sheets and carefully glues it to the original artwork before it is sent to the printer. With the exception of gag and newspaper strips, word balloons in most Japanese comics are not hand-lettered but typeset.*

boys' comic magazine. Why so many? Since comic pages are completed by the artist they should require far less editing than regular text. Some of the smaller publishers of erotic comic magazines have but one editor in charge of an entire magazine.

While the employees of the big companies perform some normal editing functions, such as story selection, proofreading, and layout, their job is far more complex. Editors of magazines with circulations in the millions must carefully plan well in advance what type of stories to run, which artists to use, and how to secure their services. Popular works, after all, sell magazines and power the industry. The artists who can create such works are worth their weight in gold, but unless part of a growing contract system they are free to work for whomever they please. Editors of rival firms may therefore find themselves wooing the same artist, whom they flatter, coax, and, as a last resort, hound into submission.

If an artist likes the financial and artistic terms offered, he or she will consent to create a serialized story, and an editor will then be assigned to make certain that, no matter what, each installment is completed on time. It is an awesome responsibility. Successful artists working on more than one story at a time for the weekly magazines are particularly prone to "forget" certain deadlines in favor of others.

If the commissioned artist is famous, the editor must be very circumspect in the way pressure is applied. This may take the form of polite phone calls to the artist's manager, coy visits daily to coffee shops or other places the artist frequents in hopes of meeting him, and, in short, anything to subtly remind him of his obligation. If all else fails, a more drastic method must be employed: the offending artist is confined to a room, supplied with food, and not let out until he or she finishes the job. Editors, with the full cooperation of the artist's manager, totally control access. At the extreme, phone calls are not allowed, passwords are used to keep out competing editors, and, if in a hotel, visitors may be told at the front desk that the party they seek is not in. The editor must stay by the artist's side night and day until he has the completed work in hand, for to return to the office empty-handed would be a great loss of face. Some artists are so used to this system that they cannot meet their deadlines without it, and they are even known to get angry if the editor dozes while they are still at work in the wee hours of the morning.

It is impossible to do business effectively in Japan without a harmonious relationship among all parties. The editor, therefore, spends an inordinate amount of time socializing with artists and their managers. Over drinks at a local bar or coffee shop, friendships are cemented, antagonisms are forgotten, and new ideas for stories may emerge. To make the most of the association, the editor must be an avid reader of comics, regular magazines, and books and have a curiosity that is equal to or greater than that of the artist.

Editors of girls' comic magazines can become even more involved in the lives of artists. Since women artists often debut right out of high school and come to Tokyo to work as professionals on contract, their families sometimes expect the publishers to act as surrogate parents. Editors may find the

women apartments, help them adjust to life in the big city, and even serve as a shoulder to cry on in times of emotional distress. Not surprisingly, more than a few male editors have eventually married their young charges.

When all the art work, articles, photographs, and ads that are scheduled to go into a comic magazine have been collected, and when the entire text has been typeset and proofread (fig. 179), the editor-in-chief gives the go-ahead and the assembled package exits the editing room. The typical comic magazine then enters a labyrinth of subcontractors that transform it from one copy into millions and finally deliver it to the reader.

Because the publishing industry is concentrated in Tokyo, so too are printers, binders, and distributors, and they number in the hundreds. A major publisher may use a dozen of each to ensure competitiveness. Monochrome pages, color pages, and covers may be printed in different locations, and even at different printers, and then sent by truck to the binders, where they are assembled, glued, and stapled (fig. 180). Thereafter the magazines are transported to huge sorting warehouses in Tokyo, and at this point over fifteen distribution companies (fig. 181), each with its own specialty, ensure that the flood of magazines reaches not only bookstores, but also train-station kiosks, vending machines, and the over 1 million magazine racks in front of bakeries, candy shops, grocery stores, and stationers throughout the nation (fig. 182). Copies are air-freighted to outposts of Japanese civilization throughout the world. By the time a weekly comic magazine reaches the reader's hands, it has already helped support dozens of businesses and employ thousands of people.

180. At the Saitama plant of Kyōdō Insatsu, one of Japan's largest printers, 3.2 million copies of the weekly magazine Shōnen Jump were printed in one week of January 1981. One volume is an inch thick. If stacked, the comics would make a pile fifty miles high. Virtually all were sold.

PROFITS

A 300-page comic magazine like *Shōnen Jump* with a weekly circulation of 4 million and a return rate of as low as 3 percent (as compared with 20 percent for other magazines), can only be called a dazzling success. But few comic magazines attain these figures, and fierce competition keeps the price of all comics very low (less than a dollar), resulting in slim profit

181. Nippon Shuppan Hambai is one of the largest distributors in Japan. At its Ōji center in Tokyo, magazines and books from over 2,000 publishers are sorted and sent to clients. A computerized order system and high-speed automatic classification system permit sorting of 20,000 orders an hour. Managers estimate that nearly half the orders are comic magazines and paperbacks.

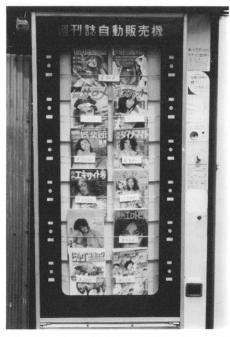

margins. Comic magazines can still generate plenty of money on their own, but for big publishers they have another role to play. By first testing the popularity of comic stories serialized in the magazines, publishers have virtually guaranteed sales when they decide to compile the stories into the more lucrative paperback form. As the big money-makers, they help support the publication of less profitable "serious" literature.

The beauty of this system is evident when sales of comic paperbacks are compared with those of paperback novels. Both are marketed through the same basic channels (fig. 183). Novels are more heavily advertised, and if one has an initial print run of 100,000, it is regarded as a bestseller. A comic paperback bestseller, however, will typically consist of not one, but many volumes in a series, some of which have a first print run of 1 million copies. There were over 3,000 new volumes of comic paperbacks published in 1984. Kōdansha alone published 600 new volumes and printed and shipped 60 million copies. Their total value, at list price, was over $110 million.

An even more lucrative spin-off of the comic magazine is the animated cartoon. Japan's animation industry today is the largest in the world, with much of the product developed for television. Toshio Naiki, curator and owner of Japan's largest comic library, has researched the subject and claims that in an average week in May 1981 there were over a hundred animated programs showing on Japanese television. More than half, he says, were based on comic stories.

The typical pattern is for a popular story first serialized in a comic magazine to be compiled into books and sold as a paperback series, then made into an animated television series, and, if still popular, finally made into an animated feature for theatrical release. Like comics, animation in Japan is popular among both children and adults, and many adult comics (Monkey Punch's *Lupin III* being a notable example) have been successfully animated. Animation stimulates further sales of magazines, reprints of comic paperbacks, and massive merchandising. And often the entire cycle is repeated by the demand for a sequel.

One of the first successful tie-ups between publishers and television involved the popular comic *Obake no Q Tarō*, a tale of a friendly ghost, by Fujio-Fujiko. Serialization began in the weekly boys' *Shōnen Sunday* in February 1964, but the story was so popular that the publisher, Shōgakkan, ran it in seven other magazines for even younger readers by the end of the year. Total circulation of all eight magazines was 5.7 million. In the summer of 1965, *Oba Q*, as the story came to be known, was animated for television and became the rage among Japanese children. Over forty contracts for merchandising were subsequently signed. The extent of Shōgakkan's profits from the whole enterprise is hinted at by the fact that its huge, ten-story head office in Tokyo is called—in jest?—the Oba-Q building.

More recently, the popular girls' comic *Candy Candy* triggered a similar phenomenon. A sentimental tale of an American tomboy waif, it was first serialized in 1975 in Kōdansha's *Nakayoshi* and then animated for television in

182. *An estimated 3,000 to 4,000 outdoor vending machines in Tokyo sell magazines and comics twenty-four hours a day. The absence of public vandalism makes their display possible. The machines are particularly suited to the sale of erotic comics, for there is none of the public embarrassment that accompanies an over-the-counter purchase. Some of the titles displayed in this machine: "Carnal Comics," "Night of the Angels," "Excite," "Dynamite," and "Married Women's Love Thrills."*

COLLECTING COMICS

Only a fanatic in Japan would try to keep all of the comic magazines he reads. If he purchases one or two children's magazines each week, as is quite common, by year-end he will have a mountain over 9 feet high. Most people in Japan, then, dispose of their magazines and later purchase their favorite stories compiled into paperback or hardback editions. Perhaps because of this, the highest price an old comic has ever reached in Japan is around $2,000, compared with $17,500 in America. Hardback comics in Japan use a high-grade paper and stitched bindings, and often come with both a dust jacket and thick cardboard case. They are built to last. For the true connoisseur the top of the line is probably a special 1980 reprint of Osamu Tezuka's early works. Comprising twenty-three volumes, each in its own case, the set comes in a fancy cardboard box with a display lid. It costs about $350.

the same year by Tōei, one of Japan's largest animation companies. In 1981 the president of Tōei was quoted in a Tokyo newspaper as saying that animating *Candy Candy* had boosted the monthly circulation of *Nakayoshi* by 1 million and earned roughly $45 million through licensing the use of characters on merchandise—toys, stationery, clothes, and candy—$650 million worth of which had been sold. As a comic paperback series, moreover, *Candy Candy* consists of nine volumes, and has to date sold over 13.5 million copies.

The spin-offs from this cycle spiral ever outwards, beyond television, regular comics, and toys, to plays, radio dramatizations, "operas," and record albums, all derived from the stories and characters created by the comic artists (figs. 184, 185). And publishers have shown remarkable ingenuity in finding ever newer ways to exploit residual demand.

Deluxe glossy magazines like *Animage*, with a circulation of 300,000, feature photos and articles about animated works, often including selections from the original comic stories on which the animation was based. Hefty, illustrated "encyclopedias" catalog trivia on animation/comic characters for starved fans. For those people who would rather read a story in text than in comic form, publishers offer novelizations of comic bestsellers such as *Ashita no Jō* and *Kyojin no Hoshi*.

But the newest field being explored is a true hybrid of animation and comics. Shūeisha, Kōdansha, and Futabasha —all major publishers—now vie with each other for sales of what Kōdansha calls *animekomikkusu*, or "animation comics": full-color comic paperbacks that are created not from the original comic artwork but from a print of an animated film. Individual film frames are selected and then enlarged, printed, and laid out on a page with dialogue balloons to create a story in comic form. Since these comics retail at double the price of regular comics they have even more potential for profit. And they close the cycle of comics—animation—comics in yet another way.

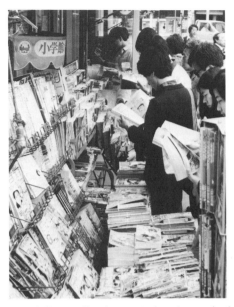

183. *Where it all ends: a typical outdoor rack of comic magazines. Stores take comic books and magazines on consignment and thus tend to overstock their shelves—the distributors' device to ensure demand is saturated. The paper of unsold comic magazines is recycled at once, but an unsold comic paperback will likely be sent to another store after its cover (if soiled) is replaced and its edges burnished. What doesn't generate profit in the whole comic enterprise is the national pastime of standing and reading without buying.*

184. *In 1980 there were over 150 "animation" and "comics" albums released in Japan. Records linked with comics in Japan can be music or poems composed or performed by popular comic artists; dramatizations or musical interpretations of popular comic stories; or theme songs and background music from television animation, theatrical feature animation, and live action films based on comics.*

185. *Merchandising of Osamu Tezuka's characters, from a brochure issued by Tezuka Productions. "We grant licenses only to those enterprises we can trust to truly love our family of Tezuka characters."*

The Future

186. A poster in front of a Tokyo rice store informs residents that gas, electricity, and water may be cut off if an earthquake occurs, but that the store's rice will be donated to government officials, who will cook and distribute it to the hungry.

The Japanese have discovered that cartoons and comics are an effective and often polite way of transmitting information, and they use them everywhere: on notes to each other, on street signs, shopping maps, instruction manuals, electricity and gas bills, and even in phone books (figs. 186–89). Cartoons in train stations, often drawn by employees, ask people to be more considerate of others during rush hour, not to hog space on train seats, and not to litter. Stick figures show the uninitiated how to use Western-style toilets.

Aiding this explosion in the use of cartoons is the fact that so many people learn how to draw them. In one sense every schoolchild starts his or her career by practicing holding a brush and drawing well-formed Chinese ideograms. Young girls carefully copy the bug-eyed heroines of their favorite comic stories. In fifth and sixth grade the more talented children create short comic strips which they compile into miniature comic books; in junior and senior high school they join comic clubs and publish their own magazines. For adults, there are comic clubs and study groups in universities (fig. 190), and there are groups in labor unions to produce political cartoons. As early as 1973 it was estimated that in Japan there were around 4,000 amateur comic publications being created, distributed, and sold outside of regular channels.

THE NEW VISUAL GENERATION

For younger generations comics are *the* common language. New fashions, catch phrases, and ideas spring forth from comics and spread instantly throughout the nation. Parents were somewhat shocked in the mid-1970s when they found their children striking odd poses and crying "I sentence you to DEATH!" but the little people were only mimicking the wacky police man/boy hero of Tatsuhiko Yamagami's *Gaki Deka*.

187. "Hold it!! Not so fast, now. First put out that fire!" In front of a Tokyo fire station, two life-size cut-out characters from Takao Yaguchi's Tsurikichi Sampei ("Fishing-Crazy Sampei") explain what to do in case of a small fire.

Young Japanese live in an age that emphasizes the image: televisions and video tape recorders are everywhere; comics comprise roughly 17 percent of all books published, 24 percent of all monthly magazines, and over 42 percent of all weeklies. People raised in this environment naturally have little bias against comics. They are, appropriately, referred to in Japan as the *shikaku sedai*, the "visual generation." Their love for comics, even in adulthood, is their badge of identity.

One result is that many talented young people—who in other times might have become novelists or painters—are becoming professional comic artists. They are discovering that the long story-comic format pioneered in the 1950s offers many of the same creative possibilities that other media do. Some comic artists today concentrate on long epics; others specialize in short stories. There are surrealists, realists, and romanticists, all very respectable and intensely serious (figs. 191, 192). The artist Yū Takita recently teamed up with a famous contemporary novelist, Akiyuki Nosaka, to produce *Enka Gekijō* ("Theater of Laments"), a lyrical series about civilian life during and after the war. It was serialized not in a comic magazine but in a monthly literary journal (fig. 193).

Readers are demanding, intelligent, and informed, and to assist them there are professional comic critics and historians.

188. One of many posters using comic characters, hand-drawn and plastered on the wall of a Tokyo train station by union employees protesting rationalization of the work force. The character depicted is Mitsuteru Yokoyama's giant robot, Tetsujin 28-go ("Iron Man No. 28"), saying, "I, too, oppose rationalization."

189. "Don't follow strange men." A hand-drawn sign placed on a neighborhood fence by a local PTA.

190. A huge billboard in front of Meiji University welcomes new students to the school's comic study group—particularly coeds.

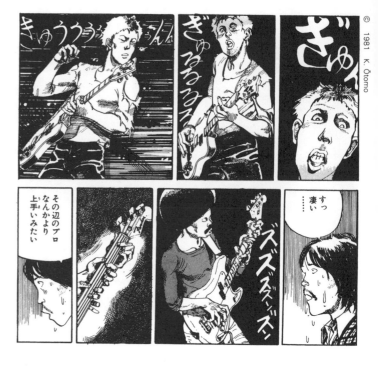

191. *A young Japanese musician waits for an audition in a New York studio. While he watches, and breaks out in a cold sweat, an energized punk rocker runs through some fast licks (GYURURURURU) and bends a high note (GYUUUUUN), and a black bass player waltzes up and down the neck of his guitar (ZUZUZUZUN-ZUN). From* Sayonara Nippon *("Farewell Japan"), by* Katsuhiro Ōtomo, *serialized in the late 1970s in* Manga Action.

There are now dozens of biographies and autobiographies of artists. There are magazines that review comics, books with histories of various genres, television documentaries, and, increasingly, columns in newspapers on comics.

In 1985 a publisher's full-page ad in Japan's most prestigious newspaper trumpeted "Comics Now a New Advertising Medium!" and ran an interview with the Director of the Agency for Cultural Affairs, who happily proclaimed that Japanese comics were fully equivalent to regular books and, moreover, the best in the world. Comics have come of age.

CHALLENGES FOR THE INDUSTRY

But perhaps the comics industry has become too successful. Japanese comics, like American rock and roll music, began as a limited form of entertainment for young people. Now both are ponderous industries in the mainstream of society. Comics in Japan try to offer something for everyone: just as there is country rock, disco, and punk, so there are love comics, science fiction comics, and mah jongg comics; just as there is bland supermarket music, so too are there comics that do nothing more than lull the mind.

Publishers are keenly aware that to maintain the vitality of the medium they must continue to seek out new talent and foster its growth. New artists are culled from the hundreds of assistants to established artists, from unknowns who send in samples of their work, and from a pool of potential stars that the magazines actively scout and train.

Given the number of aspiring cartoonists in Japan today and the fact that design schools and even universities have steadily been adding courses on comics to the curriculum, there should be a constant blossoming of fresh talent. But few of the young artists who debut in a given year are actually capable of becoming the work-horse professionals the industry craves, and even fewer have the right touch. The com-

192. *"Damn it!! Nothing but eye doctors here. . . ." The hero of Yoshiharu Tsuge's short story* Neji-shiki *("Screw Style") searches for a doctor after being bitten by a giant jellyfish. Tsuge claims to have conceptualized his story in a dream seen during a nap on top of his roof in 1967; intellectuals acclaimed it and others by Tsuge as a new type of avant-garde, surrealistic comic.* Neji-shiki *first appeared in 1968 in* Garo, *a now-famous comic magazine that has often featured nonconformist artists.*

193. *After their parents have been killed in a World War II fire-bombing of Tokyo, two hungry children visit their aging aunt. She suggests they sell their mother's kimono to buy food, and that the boy eat well so he can become a soldier. Images of rice bowls pop into their minds. From the story* Hotaru no Hakaba, *or "Graveyard of Fireflies," in the collection* Enka Gekijō *("Theater of Laments"), by Akiyuki Nosaka and Yū Takita. Serialized from 1969 to 1973 in* Bessatsu Shōsetsu Gendai.

petition, the work load, and the fickleness of the reading public quickly thin the ranks of new artists. Some can produce one or two good works; few can compete with the older generation of superstars who have been in the business for over twenty-five years and thrive on the pressure.

Many of the newer artists, despite their technical skill, seem short on soul. Their works lack the power to move the reader. When the pioneers of the industry began their careers, they often did so in the face of parental opposition and with the prospect of an exceedingly bleak economic future. They had to be motivated by a tremendous love of their medium. Now that these same hungry artists of yesterday are being chauffeured to work, the youngsters who seek to follow in their footsteps have developed high expectations. Some enter the profession in the naive hope of becoming millionaires or are even pushed into it by their parents.

Publishers in Japan engage in a fierce struggle not just for artists but for what makes it all possible—market share. To this end publishers often pursue short-term profits at the expense of long-term planning and quality. They pander to readers, whose appetites are insatiable and fickle. When a story is a hit in one magazine, imitations in competitors spring up like mushrooms after the rain. When light campus romances sell well, suddenly all magazines seem to contain nothing but such stories, all drawn in similar styles and with formula plots. Readers are bored, and young artists, who are never given enough time to develop their own style, drop out in frustration. One result: in 1981, after ten years of explosive increases, the overall circulation of comics dropped 0.4 percent. The industry was only catching its breath, but it was a warning. As Fujio Akatsuka laments, "Major publishers have made millions off the youth of this country. They at least owe it to them to produce a few quality magazines."

A major side-effect of the rise of story-comics has been the decline of the cleverly constructed single-panel "editorial" or satirical cartoon as known in the newspapers and magazines of the West. With the possible exception of Shōji Yamafuji's superb political caricatures, the works of the modern genre display none of their former influence or quality. The old-style cartoon/humor magazines that once showcased political and social satire cartoonists have disappeared, and the most talented artists have gravitated to the more lucrative story-comics. Some cartoonists have gone so far as to suggest that political and social satire cartoons need a certain amount of repression in order to thrive, that Japanese politicians and public figures today are too "wishy-washy," more clearly villainous deeds and villains being required. Part of the problem, however, may also lie with the reader. Critic Kōsei Ono

COMIC AWARDS

There are some forty comic awards in Japan, administered by magazines, publishers, and artists' associations. The most prestigious awards include prizes of up to $5,000, and are presented at ceremonies held in luxury ballrooms and attended by the elite of the industry dressed in tuxedos and gowns. Judging committees may include artists, novelists, and even Diet members. Ostensibly these awards are given to encourage work of exceptional quality by new and established artists, but there is a trend today of publishers rewarding money-making potential instead. Awards billed as "industrywide" tend to go to those artists whose works are serialized in the sponsoring publisher's own magazines. One of the newest awards in Japan, however, is the comic "Oscar": bronze trophies weighing over ten pounds are presented each year at a huge comic fair, not to the artists but to the characters they create. Winners are chosen by fans, who mail in the names of their favorites to be tallied. There is also the *Yomiuri* newspaper's international cartoon contest. In 1980, 9,846 entries were received from thirty-four nations; the grand prize went to a young woman from Thailand.

complains that "Japanese raised on the fast-paced, cinematic style of story-comics are just not used to trying to figure out what a clever cartoon says—they have no patience."

But the most frequent criticism leveled against comics in Japan has been that they are too frivolous and interfere with the child's education. The jacket of educator Mitsuo Matsuzawa's book condemning comics for "ruining" the minds of Japanese youth screamed out this warning in 1979: "IS YOUR CHILD SAFE? . . . Children hold the key to Japan's future, and their minds are being turned into mush. This book tells how comics might ruin the nation . . . and issues a bold warning to parents whose children face the exams!"

Do comics really contribute to illiteracy? The Japanese frequently bemoan the new visual generation's lack of knowledge of ideograms, but often this is an unfair comparison of today's schooled masses with an educated elite of the past, and it disregards the utterly different linguistic environment the postwar generation lives in—thousands of phoneticized English words have replaced older Japanese terms written in ideograms. And certainly television would seem more open to criticism than comics, which at least familiarize children with printed matter and reading at an early age. It is in any case worth noting, as Harvard sociologist Ezra Vogel does in his *Japan as Number One*, that the rate of illiteracy in Japan's enormous comic-saturated culture probably doesn't exceed 1 percent, whereas in the United States that figure may be close to 20 percent.

The most persuasive argument against comics in Japan— and this is what Matsuzawa was trying to say in his book—is that comics, like TV, can become an addiction for the child who lacks self-discipline and woo him away from the studies that are so vital to his future.

Yet it must in part be the constant emphasis placed on schooling and test-taking that accounts for the appeal of the comic in Japan. Japanese children live in an unbalanced environment, going from school classrooms to after-school study sessions with special tutors, then returning home to cram for tests. As Keizō Inoue, an editor of Shōgakkan comics, commented in the *Asahi* newspaper in 1980, "Children today are immersed in the examination system and isolated. Since they have little real opportunity to interact with other people, they seek their friends on the pages of comics."

Sensitive to these issues, editors, artists, and publishers are steadily trying to upgrade the public image of comics. The largest-selling comic magazines for adults now include fine print at the bottom of each page that discusses everything from history to health tips, with none of this information being related to the comic stories above. Mitsutoshi Furuya, an artist who once shocked parents with his sado-masochistic series for children, now creates a popular strip for middle-aged men titled *Genten Papa* ("Demerit Dad"). It is known as an *unchiku manga*, or an "erudition comic," and it incorporates information on everything from winemaking to hemorrhoids. Other artists who draw serious history comics are often careful to include scholarly bibliographies.

Finally, in what seems like a cruel hoax on the children who are reading comics in order to avoid doing their schoolwork,

COMICS, THE RUBY, AND READING

Young children in Japan spend far more time acquiring basic reading skills than their counterparts in most other countries, for to become literate in modern Japanese one must master the ideograms imported from China and two native syllabaries, as well as the Roman alphabet. The ideograms are most difficult; there are about 2,000 approved for daily use, and any one can have several different pronunciations depending on its context. For this reason, the dialogue balloons in comics for young Japanese just learning to read all have a tiny pronunciation key called a "ruby" (not a gemstone but a size of type "intermediate between non-pareil and pearl") written to the side of each ideogram in easy-to-read phonetic script. With the aid of the ruby, a small child can understand the most difficult ideograms and learn to recognize them, all while enjoying a comic story. At the same time, however, the ruby also allows the many adults who read children's comics to become lazy and forget the ideograms they once diligently mastered.

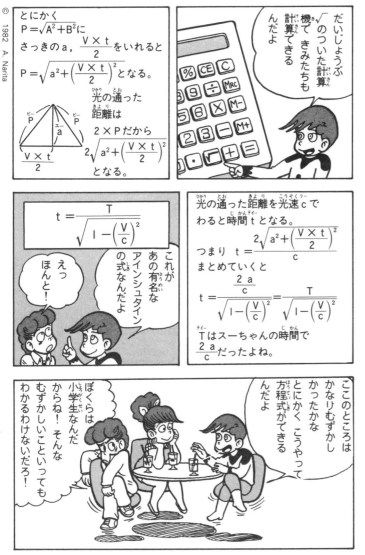

194. *Even in story-comic format, Einstein's mathematics befuddle the eager reader. From a 165-page paperback in 1982 by Akira Narita called* Time Machine, *with a subtitle that reads, "A Crash Course on the Theory of Relativity."*

the industry is actively promoting hard- and paperback *benkyō manga,* or "study comics." These comics that introduce history, mathematics, reading, and even the theory of relativity are being gobbled up by parents for their comic-addicted children and promise to be the growth area of the future (fig. 194).

FIRST JAPAN, THEN THE WORLD?

American comics have been distributed around the world, often in translation—*Superman* alone sells in over forty-five nations. Japan's comic industry today dwarfs that of any other country. Will Japanese comics now follow Toyotas and Sonys overseas? The obstacles they face are formidable. The same cultural isolation that has helped Japan develop such a rich comic culture is also a factor limiting the ability of people in other nations to understand—and enjoy—them.

For example, to publish Japanese comics in most other languages the pages must all be redrawn or photographically reversed (at considerable cost) so that they can be read from left to right, and word balloons must be altered to accom-

STOCKS AND BUNS

One novel attempt to capture older readers has proved surprisingly successful. *Comic Morning,* a biweekly aimed at middle-aged white-collar workers, serializes a work that, instead of eroticism or typical salary-man stories, imparts information on the stock market. Every other week a "Professor Yasuda" lectures on the mechanisms of the marketplace and the economy to his less-than-bright pupil, nicknamed "S.I.," and recommends a stock, referred to as a "steamed bun stock"; hence the name of the work, *Manjū Kowai,* or "Steamed Buns Are Scary." The episodes are in typical story-comic fashion, half tongue-in-cheek, with much comedy and exaggeration. But as the subtitle of the work, "On the Front Lines of Making Money," implies, they also contain hard information. The series is authored by Jirō Yasuda, a stock analyst and novelist, and drawn by Mitsuru Sugaya. In 1983 it was widely reported in Japanese newspapers, as well as the *Asian Wall Street Journal,* that recommendations in *Manjū Kowai* were actually moving stock prices on the market.

© 1965 NBC

GOLD KEY

ASTRO BOY 12¢

ASTRO BOY

An indestructible robot monster threatens to destroy the world—unless Astro Boy can stop it!

© 1965, NATIONAL BROADCASTING COMPANY, INC.

195. *The Gold Key* Astro Boy *comic book, based on Osamu Tezuka's creation and redrawn from the Japanese original by an American artist.*

AMERICAN COMICS IN JAPAN

While short, "cartoony" American newspaper comic strips—particularly *Blondie* and *Peanuts*—have had great success in Japan, popular American comic books like *Superman* and *Captain America*, when translated, have never really been commercially viable. Japanese readers consider them too wordy and simplistic. Nevertheless, Japanese artists regularly scan mainstream America comics for ideas, and they are aided by professional comic critics, like Kōsei Ono, who analyzes the latest American trends. Ono writes extensively for magazines and newspapers and has translated *Superman*, *Fritz the Cat*, and *Doonesbury*. Ironically, one of the more successful American cartoonists in Japan is scarcely known in his own country. The wild, almost primitive work of Gary Panter, a "New Wave" artist, recently caught the fancy of Japan's graphics/fashion industry. His "comic book" *Jimbo* appeared widely. Panter himself was on Japanese television and even has a coffee shop named after him.

modate dialogue written horizontally. Compounding this problem is the fact that many of the "classics," which are the best candidates for translation, are thousands of pages long.

Many Japanese comics deal with subjects—like "salarymen"—that are incomprehensible or uninteresting to people unfamiliar with Japanese ways, or they may contain an unacceptable level of violence and eroticism. They also have their own patterns of logic (like Japanese novels), picture frame progressions, and visual styles. To the outsider, the comics—particularly humor comics—may appear to jump, twist, and dash off into nowhere for no apparent good reason.

The shared symbolic vocabulary is also a problem. What non-Japanese would guess, for example, that when a huge balloon of mucous billows from a character's nose it means he is sound asleep; that when a male character suddenly has blood gush from his nostrils he is sexually excited; or that when the distance between his nose and his lips suddenly lengthens he is thinking lascivious thoughts? There are dozens of other esoteric gestures and symbols inextricably linked with Japanese culture and a host of topical in-jokes shared between artists and millions of readers. If the comic is not redrawn, then, the act of translation can be arduous indeed. The translator must take some liberties with the original text to convey the implications of the panels to the reader, and heavy editing may be required.

So while Japanese comics have managed in several instances to cross the cultural barrier between East and West, rarely have they done so in their original form. In 1965, for example, when a comic book called *Astro Boy* was published in America by Gold Key comics, some young readers may have noted how different it was: instead of cute animals or the usual superheroes, it starred a little boy who was actually an atomic-powered robot (fig. 195). Many knew that it was a spin-off of an animated television series of the same name, but probably few suspected it was originally a comic story created by a Japanese, Osamu Tezuka, in 1951. *Tetsuwan Atomu*, as it was originally called, became Japan's first animated television series in 1963, and the rights to it were subsequently sold to over twenty nations, including the United States (fig. 196). The *Astro Boy* comic (a collector's item today) had to be rescripted, redrawn, and colored by Americans, but it was unmistakably Tezuka's creation.

In recent years a variety of Japanese comics have been published in Japan in English, either as study aids for Japanese youth, or for limited export to the United States. The former tend to be uninteresting to Western readers and suffer from awkward translation. The latter, even when done well (as was the case with a carefully edited anthology titled *Manga*), often encounter obstacles in marketing.

The only Japanese story comics published in America using the original artwork are the autobiographical A-bomb stories of Keiji Nakazawa. After an abortive attempt to publish the 1,400-page epic *Barefoot Gen* in American comic-book format, a publisher in San Francisco, Educomics, issued *I Saw It* in 1983. With color added, this concise, 50-page story fits neatly into the American concept of a "comic book," but still has never achieved a wide distribution. To an

196. *Because of the television connection, Astro Boy comics also appeared in Argentina, Peru, and Venezuela, again redrawn by local artists.*

audience weaned on science fiction and superheroes, its content may be too realistic (fig. 197).

Despite format problems and limited exposure, interest in Japanese comics and artists is growing fast in America. Osamu Tezuka and Monkey Punch (Kazuhiko Katō) won the coveted Ink Pot awards in 1980 and 1981, respectively, at the San Diego Comic Convention. American fans of Japanese comics, moreover, regularly appear at comic conventions dressed in the costumes of their favorite Japanese characters, and often their zeal puts their Japanese counterparts to shame. One enthusiast in San Francisco has a tattoo of Reiji Matsumoto's Captain Harlock on his arm and drives a car with a HARLOCK license plate.

Usually interest is sparked by animation. Since *Astro Boy* in 1963, Japanese animated series based on comic stories or using comic characters that have been dubbed and broadcast on American television include *Kimba, the White Lion* (Osamu Tezuka's *Jungle Taitei*, or "Jungle Emperor"), *Gigantor* (Mitsuteru Yokoyama's *Tetsujin 28-go* or "Iron Man No. 28"), *The Starvengers* (Gō Nagai's *Getta Robotto*), *Star Blazers* (Reiji Matsumoto's *Uchū Senkan Yamato*, or "Space Cruiser Yamato"), and *Force Five* (a package of Japanese warrior-robot animation, with characters by Gō Nagai and Reiji Matsumoto). *The Space Giants*, a live-action robot series, is based on Osamu Tezuka's *Magma Taishi*, or "Captain Magma."

Like Japanese comics, Japanese animation dubbed in English has had problems. Many shows have been ruined by being placed in time slots for small children, where their complex plots (a spin-off of story comics) are reedited and censored to conform to a broadcasting code even more stringent than the Comics Code. Most American TV viewers are not even aware they are watching Japanese animation, let alone animation based on Japanese comics.

Raw animation, however, can be seen on local Japanese-language broadcasts on the West Coast, and with the new profusion of video cassette recorders a subculture of fans who trade their favorite shows from Japan has emerged. Most do not understand Japanese but are drawn to the medium by their fascination with the artwork. They often

197. I Saw It, *published in 1983 in the United States by Educomics, is Keiji Nakazawa's eyewitness account of the bombing of Hiroshima, and the story of how he became an antiwar cartoonist. It first appeared in Japan in 1972 under the title* Ore Wa Mita, *in Bessatsu Shōnen Jump. Like most Nakazawa comics, it "tells of the horrors of war so that people will be inspired to work for peace."*

198. *American comics based on Japanese robot animation and toys. Clockwise, from top left: Shogun Warriors; The Transformers; Robotech Defenders; Macross.*

JAPANESE ROBOTS TO THE RESCUE?

Robot characters in Japan are either cute "pets" or "giant warriors." The former fill the same role as funny animal characters in the West and indeed may assume the form of animals or of android, human lookalikes. The insectoid, samurailike warrior robots are images conjured up from the Japanese subconscious; their main function is to ward off evil, a task aided by armor plate, rockets, protective force fields, heat-ray vision, and the ability to transform into fighter planes and even tape recorders. As the Japanese robot fad has swept the world they have become a gold mine for Japanese toy makers. In Japan the genre is often thought of as "trashy." Abroad it can generate controversy. A member of the Italian parliament has accused Gō Nagai's *Grandizer*—full of the simplistic battle scenes central to all robot stories—of being "an orgy of annihilating violence. . .a cult of allegiance to great warriors, a worship of the electronic machine." In America in 1984, a woman was injured in a near riot of shoppers who were vying to purchase transforming robots for Christmas.

purchase comics imported from Japan and have Japanese friends informally translate them for more information.

In the television age, demand can be created. There are enough fans of *Star Blazers*, for example, for a Japanese firm to publish several volumes of a rather awkward English version of the Japanese animation comic and ship them to the United States. Television has also recently resulted in a flurry of locally produced robot comics, which, if not directly based on Japanese comics, at least have their roots in them.

Giant warrior robots—transforming, combining mechanical monsters deployed to save earth from invading forces—are Japan's high-tech answer to America's superhero characters. They stem from comics created by Osamu Tezuka, Mitsuteru Yokoyama, and Gō Nagai in the 1950s and 1960s, and perhaps because they are mechanistic and culturally neutral they have thoroughly stomped their way into the American consciousness. In 1984/85, animation shows like *Voltron, Defender of the Universe, Robotech, Transformers,* and *Gobots*—all based on Japanese concepts—created an astounding boom in toys, coloring books, and even locally scripted and drawn comics. Hasbro Bradley's robot toys, Transformers (designed and manufactured by Takara), reaped $100 million in their first year to become the most successful toy introduction ever (fig. 198).

In the long run, Japanese comics may have their biggest impact on American artists by demonstrating a new potential of the medium. Wendy Pini, who draws the long, novelistic, and very popular *Elf Quest* series, claims Osamu Tezuka as a mentor, as does Scott McCloud, author of the *Zot* series. Frank Miller, a brilliant young American artist/writer presently dazzling fans with cinematic layouts and frame progressions in his series *Rōnin*, credits the Japanese samurai classic *Kozure Ōkami* as his main inspiration.

Japanese comics have actually had far greater influence in Europe (figs. 199, 200), perhaps because the French and Italians, like the Japanese, accord comics a higher status than Americans. *Candy Candy*, by Yumiko Igarashi and Kyōko Mizuki, has been a remarkable success in Italy, for example. There the Japanese made-for-television series was broadcast and 225 American-style comic books were published, using the original artwork but adding color. Other Japanese girls' comics, such as *Lady Love* and *Morning Spank*, have also been published. *Candy Candy* is a rare example of the internationalization of Japanese comics: little Italian children most certainly have no idea that the starry-eyed, blonde-haired heroine of the story was created in Japan. And because of the television link, the comic is accompanied by heavy merchandising of stationery, toys, and records with the *Candy Candy* theme, thereby transplanting the entire Japanese comic–animation–merchandise profit cycle.

Animation based on Japanese comics in Europe is often accompanied by the merchandising of deluxe hardbound comics, rescripted, redrawn, and colored by local artists. Particularly popular are the giant robot characters of Gō Nagai, such as Grandizer (Goldorak in France), Mazinger Z, and Great Mazinger, and a space-fantasy, *Captain Harlock* (*Albator* in France), by Reiji Matsumoto (figs. 201, 202). Gō

Nagai's representative for Europe estimates that over 5 million copies of comic books and deluxe picture books featuring Nagai's characters have been sold on the Continent.

But the Europeans have not limited themselves to Japanese children's comics. One French publisher now issues Japanese action–soft-porn comics, merely adding translation.

Given their inroads in the distant European market it is not surprising that Japanese comics have scored their biggest success in an area much closer to home: Asia. The cultural proximity of Hong Kong, Taiwan, and South Korea has made it easier for Japanese comics to catch on, and since the languages of these nations can also be written the same way as Japanese—right-to-left and top-to-bottom—only translation is required, although publishers in Korea generally prefer to flip the pages as well. As a result, nearly all genres of Japanese comics have been published, usually in monochrome paperback format identical to that of Japan (fig. 203). Unfortunately for the artist, these have not always resulted in income. In Thailand, a pirate version of Fujio-Fujiko's story of a robot cat, *Doraemon*, has become a national phenomenon. In Korea, the popularity of Japanese comics has led the government to heavily restrict their entry.

But Japanese comics have also accomplished something in Asia that American comics were never able to do. Two of mainland China's latest heroes are not members of the Party

199. *The Italian edition of Candy Candy. The series has been so popular in Italy that it has been continued even though the Japanese series has ended. The Italian publisher hired a local artist to draw in Igarashi's style, and all the stories are new.*

200. Le Cri Qui Tue—*100 pages published privately three times a year by Atoss Takemoto in Switzerland—was billed as an "Honorable Revue of Exotic Comics" and contained serialized selections, in French, of the works of such artists as Osamu Tezuka, Shōtarō Ishimori, Fujio Akatsuka, and Yoshihiro Tatsumi. It was an adult, connoisseur's comic and also ran articles on Japanese comics, animation, and culture.*

201. *Inside a deluxe Italian edition of Gō Nagai's Mazinger Z, redrawn and colored by Spanish artists.*

202. *Reiji Matsumoto's late-1970s space fantasy,* Captain Harlock, *redrawn, colored, and sold as a deluxe hardbound comic in France and Canada under the title* Albator.

but Osamu Tezuka's characters, Tetsuwan Atomu and Jungle Taitei. In December 1980 the old black-and-white *Astro Boy* series became the first foreign animated TV series in China, and it was soon followed by publication of comic booklets (fig. 204). Over six volumes with a print run of around 200,000 each have been published, accompanied by sales of *Astro Boy* dolls and other merchandise. The same cycle has been repeated for *Jungle Taitei.*

Given the size of the industry, and the almost-saturated domestic market, Japanese publishers understandably dream about riches overseas. But expectations run ahead of reality. In 1980, when Shinobu Kaze managed to place a ten-page work, "Violence Becomes Tranquillity," in *Heavy Metal,* one Japanese magazine, somewhat overcome, ran the sensational headline, "Japanese Comics Finally Exported!" In 1985, a major newspaper trumpeted, "Japanese comics inundate the world!. . .Disney is finished. Is it now the age of Japanese comics? Will this, too, lead to trade friction?!"

In reality, most Japanese comics are unlikely to cross the cultural barrier between East and West in their original format. Those that do will probably be select classics with universal themes or works specifically created with Western audiences in mind.

But in the years to come the sheer size and momentum of Japanese comics culture will make itself felt around the world indirectly, through the commercial spin-offs of toys, animation, picture books, videogames, and even locally scripted and redrawn comics. It bears keeping in mind that this watered-down, internationalized format will be only a shadow of Japan's enormous comics culture.

Fears of "trade friction" aside, however, the very fact that Japan can export any of its popular culture is astounding, considering how difficult this is to do. More than cars and radios, it is a tribute to the stature of Japan in the world today, and a tribute to the vitality of Japan's comics—a new visual culture.

203. *Until recently, South Korea and Taiwan published Japanese comics as "authorless" pirated editions, thus denying many Japanese artists needed international exposure. Shown here are pirated Taiwanese editions of famous works by Osamu Tezuka. Left to right:* Hi no Tori *("Phoenix"),* Mitsume ga Tōru *("The Three-Eyed Ones"), and* Black Jack.

204. *Volume 2 of the People's Republic of China's edition of Osamu Tezuka's* Tetsuwan Atomu. *Atom's high-tech body and the story's stress on the use of science and knowledge for the good of mankind may have special appeal to the Chinese government, now trying to speed modernization. The publisher's name: "Science Promotion Publishers." Not a pirate edition.*

Selections from Japanese Comics

Osamu Tezuka

Phoenix

·

Reiji Matsumoto

Ghost Warrior

·

Riyoko Ikeda

The Rose of Versailles

·

Keiji Nakazawa

Barefoot Gen

The following selections are offered, through the courtesy of the artists, to provide an experience of reading Japanese comics. Most are only fragments of long stories for young people, and should be read in that context. They do not necessarily represent the most famous works, or even the most popular genres; war stories are relatively rare in Japan. But all will show how Japanese artists are reaching beyond the themes of funny animals, superheroes, and a glorified military, so often associated with the comic medium.

All the comics have been altered, either through photographic reversal or rearrangement of frames, so that they may be read from left to right. In some cases, therefore, people originally drawn as right-handed may appear left-handed, and face in the opposite direction.

OSAMU TEZUKA

Phoenix

Osamu Tezuka was born in 1928 and as a child was a fanatical fan of early Walt Disney animation. His cinematic-style stories in the immediate postwar years completely changed the entire concept of children's comics. Today Tezuka remains on the front lines of the industry in creativity, productivity, and popularity. Among the people raised on his comics, he is akin to a national hero.

One of Tezuka's greatest strengths is that he is more than a comic artist. He has a parallel career in animation. In 1962 Tezuka formed Mushi Productions, where he animated some of his most popular stories, including *Tetsuwan Atomu* ("Mighty Atom," known also as *Astro Boy*), *Jungle Taitei* ("Jungle Emperor" or *Kimba, the White Lion*), and *Ribon no Kishi* ("Princess Knight"), for television. As with comics, his work in animation has been pioneering; yet, as Tezuka often confesses, comics, are his "wife" and animation is his "mistress"—a great deal of money being lavished on the latter. Unlike Walt Disney, Tezuka is more artist than administrator; in 1973 Mushi Productions went bankrupt. Tezuka still creates animation today with a new company, but investment is more restrained.

Tezuka's works are characterized by their humanism and respect for life—as can be seen in his long-running series *Buddha*, and in *Hi no Tori*, or *Phoenix*. And as is the case with *Black Jack*, a saga of an outlaw doctor, his stories often have a scientific and medical bent. Why? Tezuka is a licensed physician with a medical degree from Osaka University's College of Medicine. His research was done on the sperm of pond snails.

Phoenix is Tezuka's most intellectually challenging experiment. Man's quest throughout the ages for the mythological phoenix, and for immortality, is used as a framework to analyze the meaning of life. The story converges on the present from both the future and the past, and jumps at random from ancient Japanese history to thousands of years in the future. Often the same characters appear in different reincarnations. Tezuka began drawing *Phoenix* in 1954 and despite several long lapses continues it today. It is what he calls his *raifu wāku*, or "life work."

Phoenix has been serialized in comic magazines for girls, boys, and young adults and now runs to over 3,000 pages, usually published as a nine-volume series of hardback or paperback books. In 1978, parts of *Phoenix* were dramatized on the radio and made into a rather unsuccessful live-action feature film. In 1980 Tezuka created the more successful *Phoenix 2772*, a science fiction animated feature based on the story. Volumes 1 through 5 of *Phoenix*, although they have been translated, have not yet been published in English. The following excerpt is from volume 4, called *Karma* in the English version and *Hōō*, an old word for the Chinese phoenix, in Japanese.

Karma is set in 8th-century Japan, and its main protagonists are Gao, a former mass murderer turned spiritual seeker, and Akanemaru, a master carver. The lives of both men intersect dramatically against a background of the political and religious upheaval of the time. A high-ranking politician obsessed with the phoenix and the idea of immortality orders Akanemaru to carve its image, or face death. But in order to execute this task properly, Akanemaru feels he must see the bird, reported to live on a faraway island south of Tang-dynasty China. It seems an impossible task. Desperate, Akanemaru pleads with Kibi no Makibi, a famous scholar/official of the imperial court, for help. . . .

PHOENIX

by Osamu Tezuka

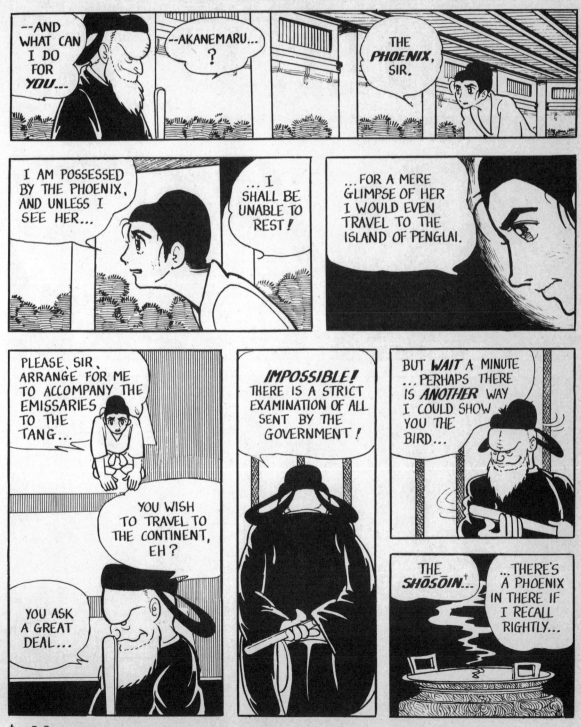

--AND WHAT CAN I DO FOR *YOU*...

--AKANEMARU...?

THE *PHOENIX*, SIR.

I AM POSSESSED BY THE PHOENIX, AND UNLESS I SEE HER...

...I SHALL BE UNABLE TO REST!

...FOR A MERE GLIMPSE OF HER I WOULD EVEN TRAVEL TO THE ISLAND OF PENGLAI.

PLEASE, SIR, ARRANGE FOR ME TO ACCOMPANY THE EMISSARIES TO THE TANG...

YOU WISH TO TRAVEL TO THE CONTINENT, EH?

YOU ASK A GREAT DEAL...

IMPOSSIBLE! THERE IS A STRICT EXAMINATION OF ALL SENT BY THE GOVERNMENT!

BUT *WAIT* A MINUTE ...PERHAPS THERE IS *ANOTHER* WAY I COULD SHOW YOU THE BIRD...

THE *SHŌSŌIN*[†]...

...THERE'S A PHOENIX IN THERE IF I RECALL RIGHTLY...

† *SHŌSŌIN: THE IMPERIAL TREASURE HOUSE OF JAPAN.*

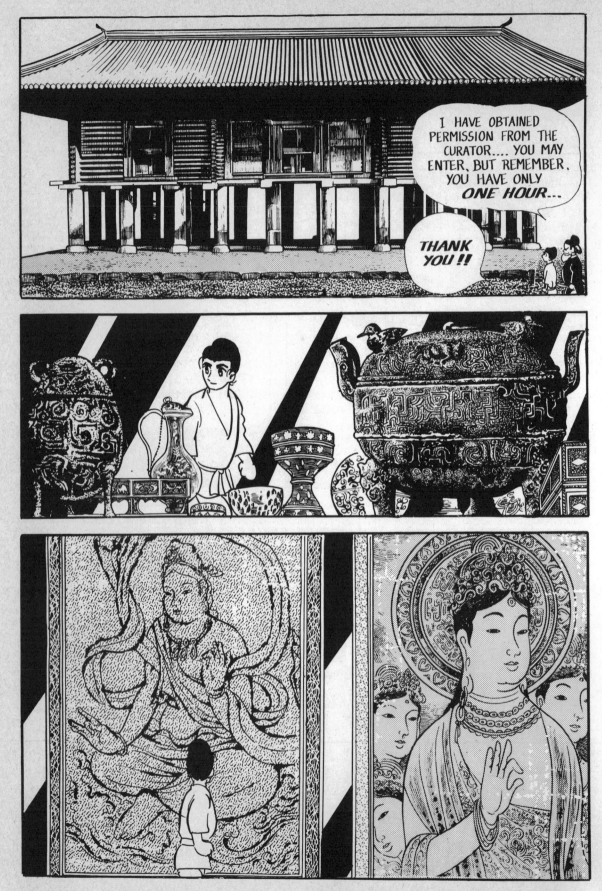

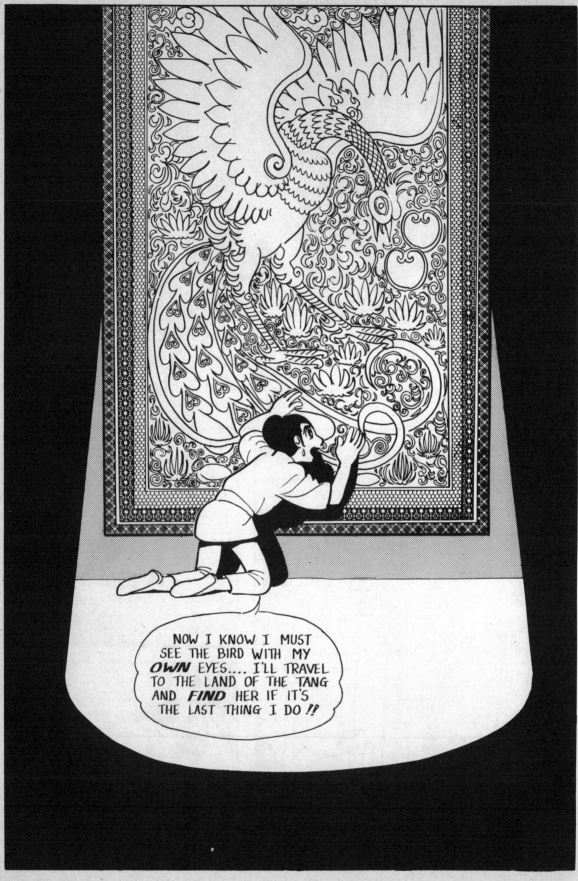

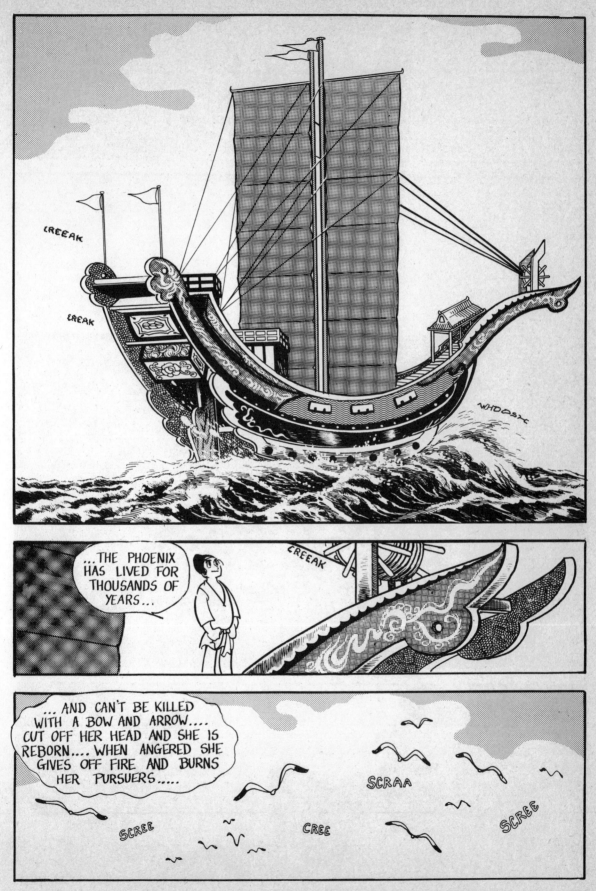

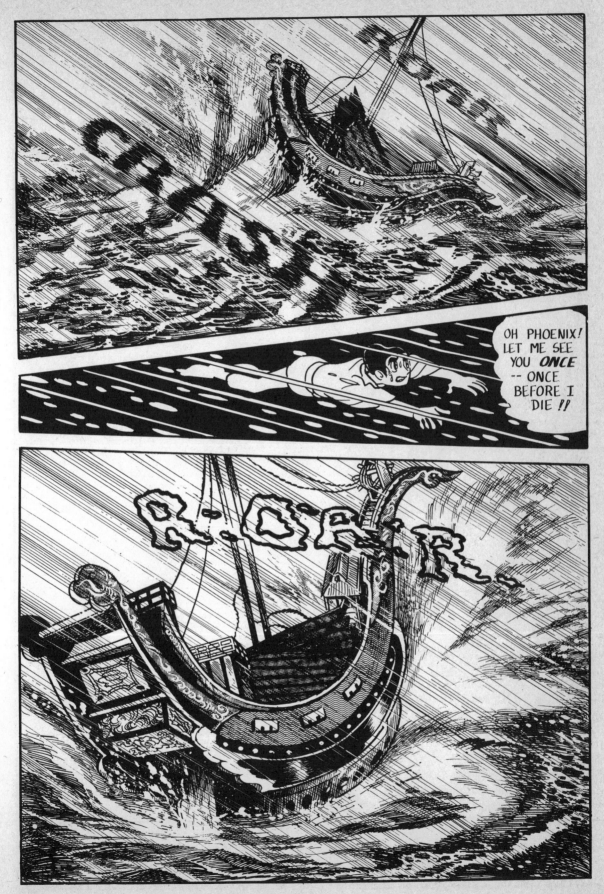

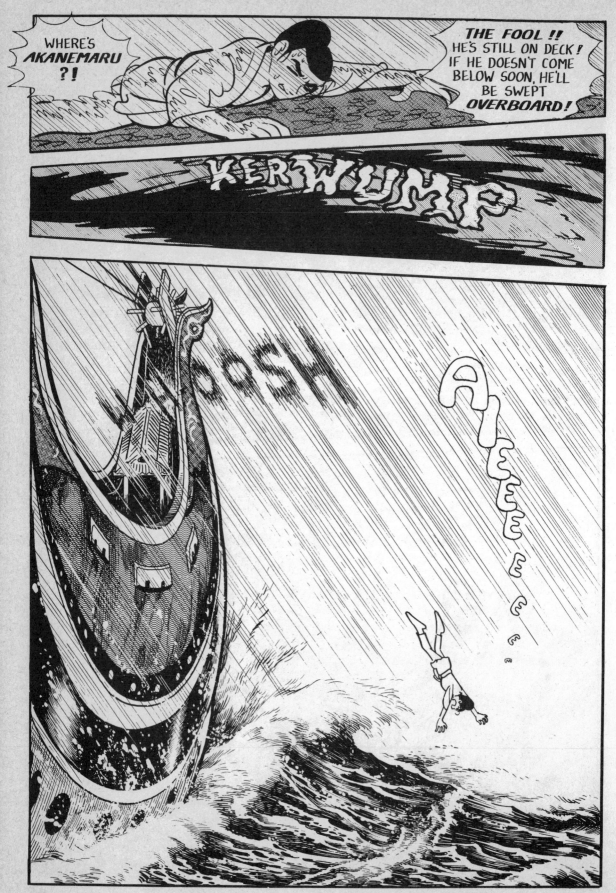

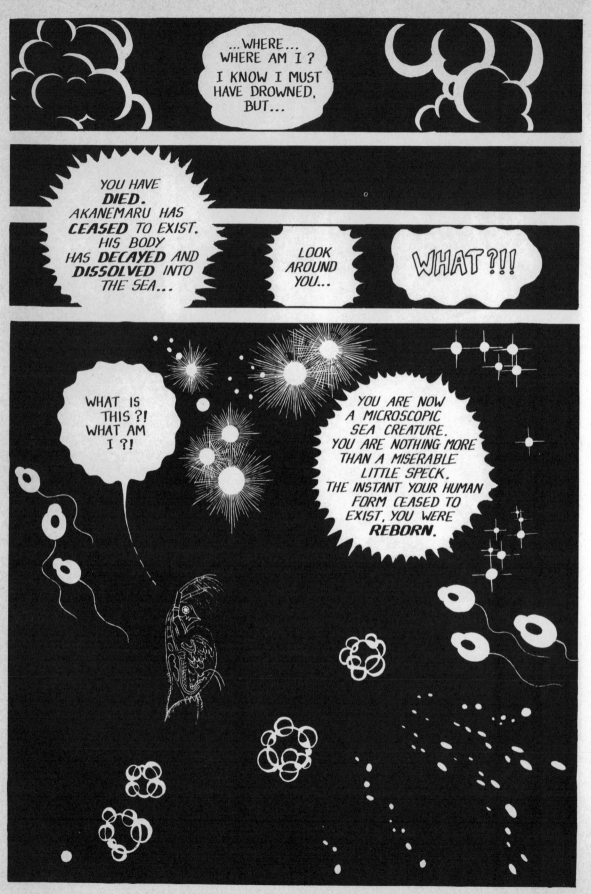

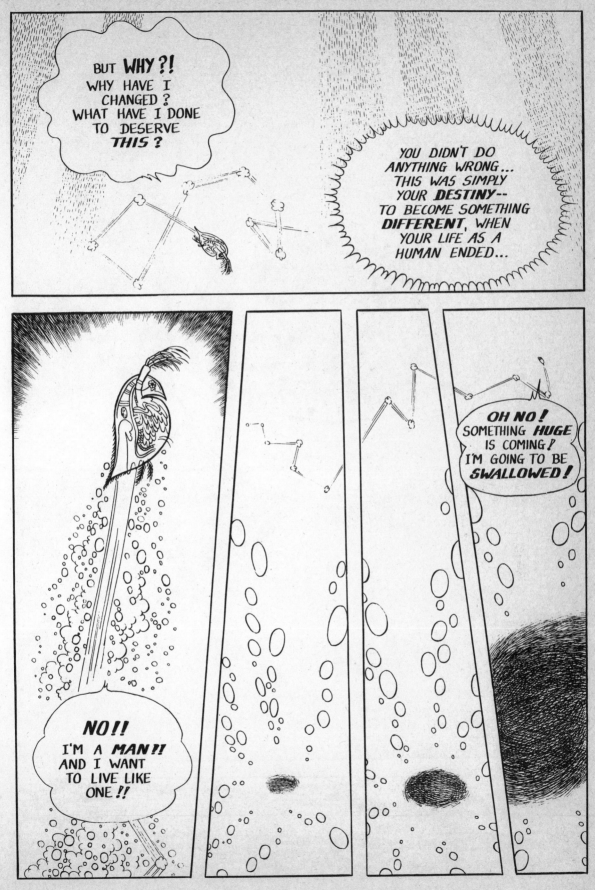

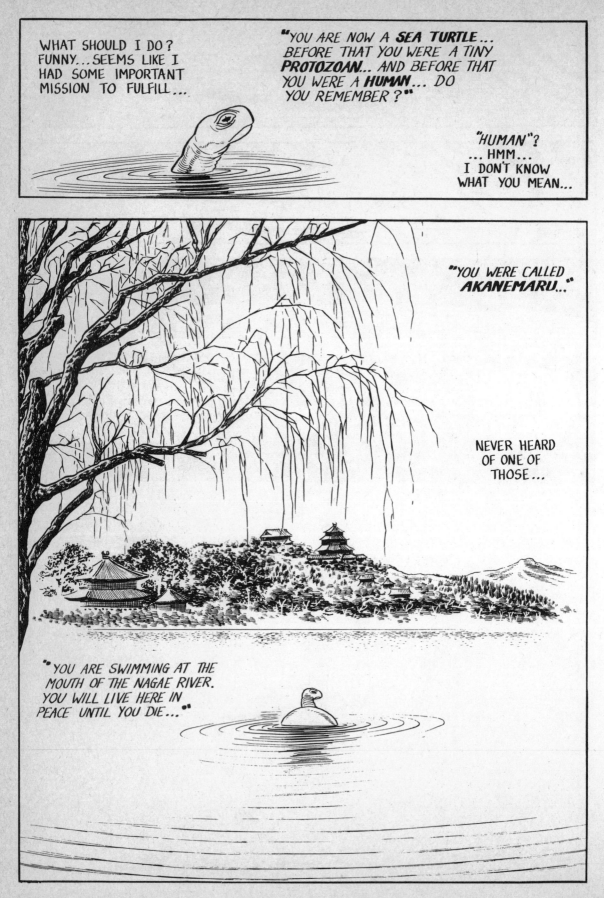

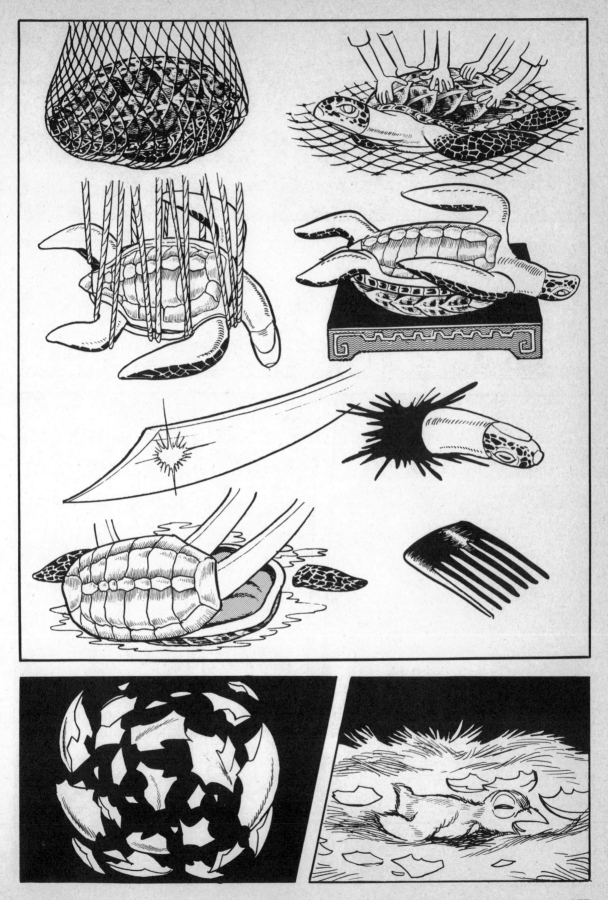

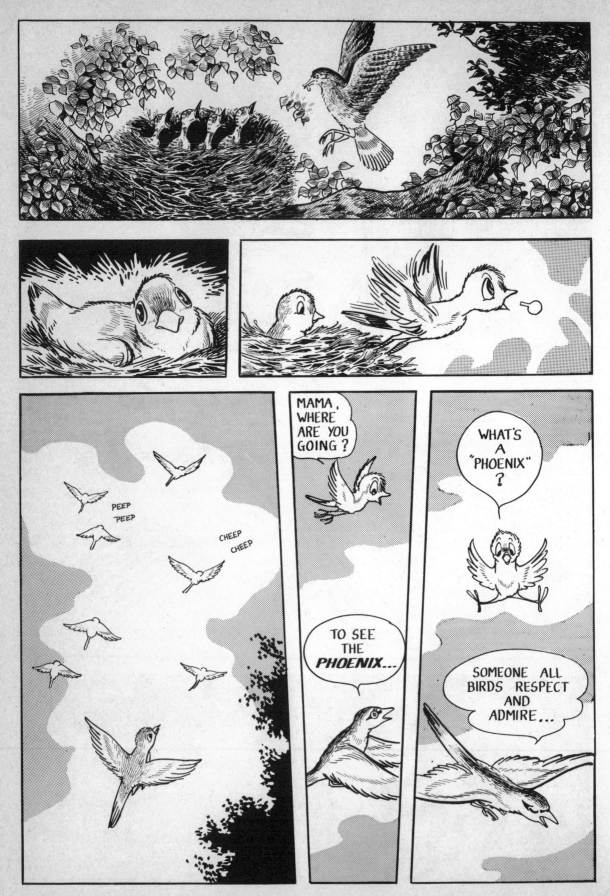

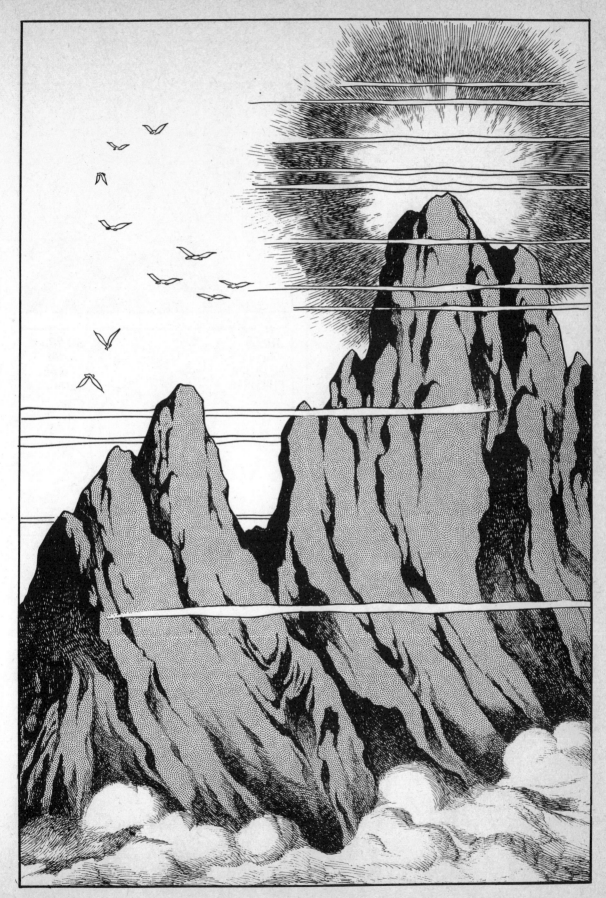

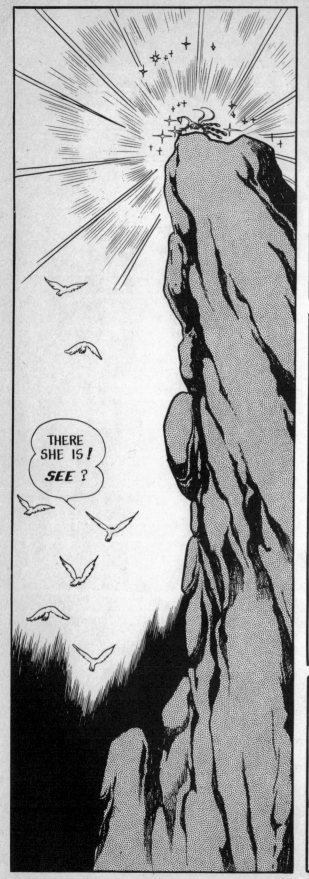

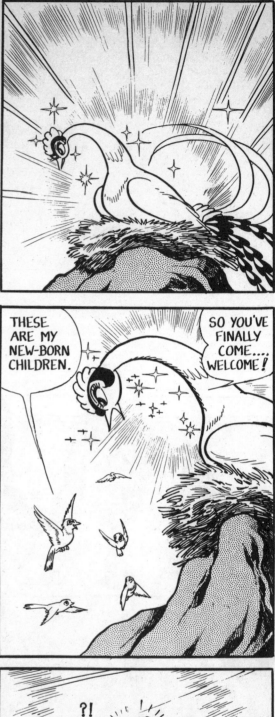

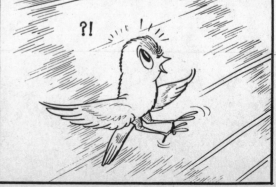

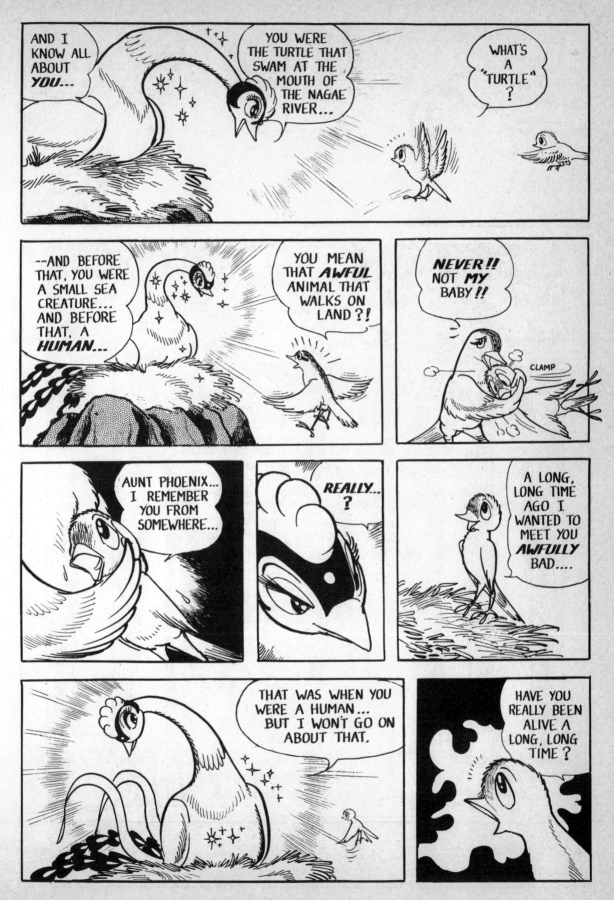

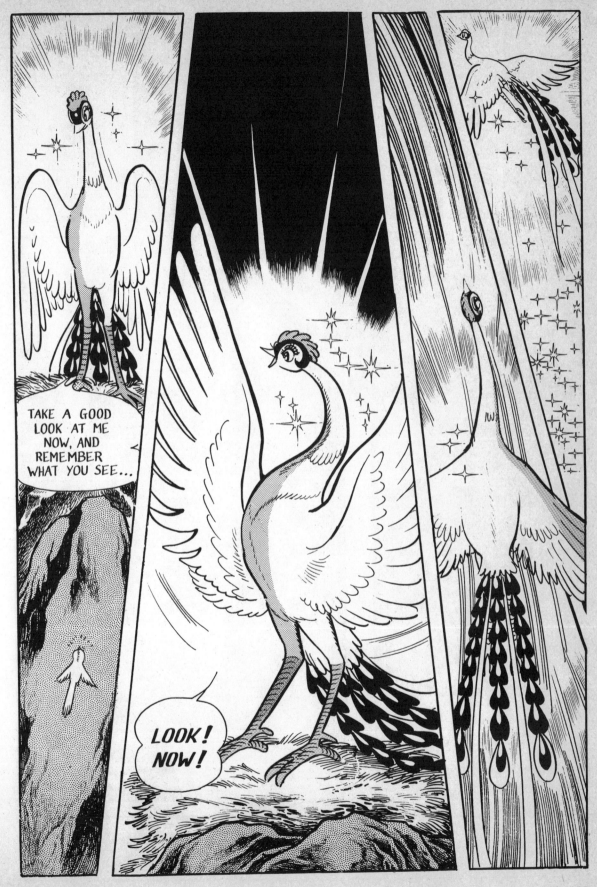

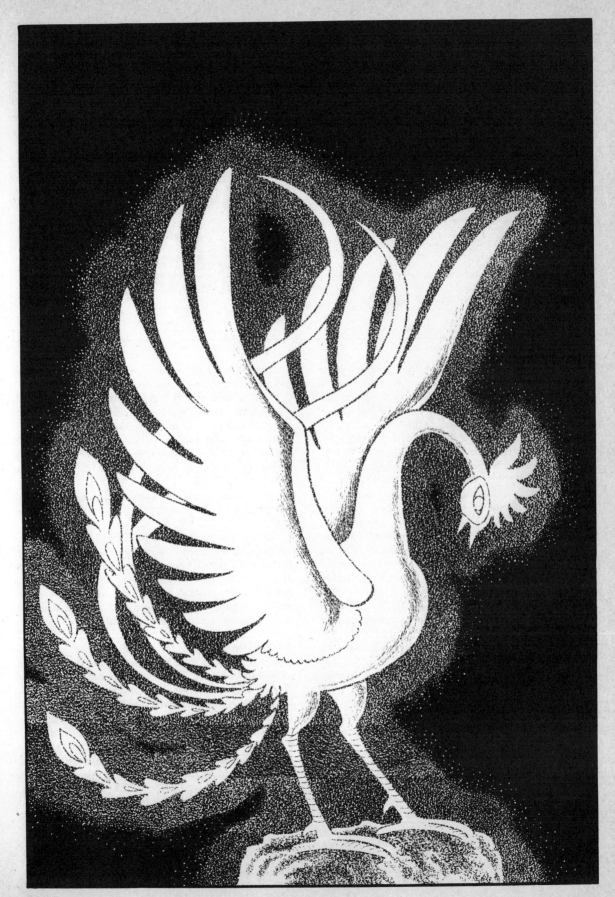

REIJI MATSUMOTO

Ghost Warrior

Reiji Matsumoto was born in 1938, the son of an officer in the Imperial Army Air Force, and from the age of eight on he was drawing comics. Like most aspiring artists, he was strongly influenced by Osamu Tezuka's success in the early postwar years. At fifteen he created his own story-comic, called "Adventures of a Honeybee," and when he sent it to the comic magazine *Manga Shōnen* it received an award and was published.

After high school, Matsumoto joined the flow of young artists into the burgeoning Tokyo comics industry, and like many of them he began drawing romances with starry-eyed heroines for girls' comic magazines. During this period he married the pioneering woman artist Miyako Maki. In 1970, Matsumoto began the first work that brought him real attention. *Otoko Oidon* ("I Am a Man"), published in the boys' weekly *Shōnen Magazine*, was a comedy story of a student without a school, and young adults loved it. Its semipathetic, humorously drawn hero, its loving attention to the details of daily life, and its sexy female supporting characters became trademarks of Matsumoto comics.

Matsumoto's real fame has subsequently come from science fiction comics and tie-ups with animation. In 1974, he worked on directing and designing the animated television series *Uchū Senkan Yamato* ("Space Cruiser Yamato," called *Star Blazers* in the United States) and created a comic story of the same name. When *Yamato* was later released as a theatrical feature, it triggered an unparalleled animation boom among children and young adults, with billion-dollar implications for merchandising firms and comic publishers. In the wake of *Yamato*, Matsumoto has created a string of science fiction comics with animation tie-ups, notably *Captain Harlock, Ginga Tetsudō 999* ("Galaxy Express 999"), and *Sennen Joō* ("Queen Millennia"). Reflecting the tendency of the Japanese animation industry to milk the market of all possible demand, these stories are first animated for television and then for theaters, and are followed by seemingly endless sequels.

What is the secret of Matsumoto's comics? Through plot, pacing, and artwork, he is able to create a lyrical mood that appeals to the Japanese—a muted feeling of melancholy and pathos pervades even his comedy stories. And male fans are ecstatic in their praise of his lavish detailing of what Japanese call *meka*, or "mechanisms," and machinery. Matsumoto's drawings of spaceships, airplanes, guns, and gadgetry have a romantic aura about them that few other artists can achieve.

Given these qualities, it is probably Matsumoto's war comics that are dearest to his own heart, even though they are not as well known as his science fiction stories. His war comics are neither prowar nor antiwar, but a romantic/existentialist view of the human struggle to survive—of the bonds between men and between men and machines in extraordinary situations.

Since 1973, Matsumoto has been drawing the *Senjō* ("Battlefield") series for boys' and men's comic magazines. Unlike most Japanese comics, the series consists of short stories. The following example, *Bōrei Senshi*, or *Ghost Warrior*, was first published in the 5 January 1976 edition of the adult biweekly *Big Comic Original*, and in some ways it is the most "Japanese" of the four selections in this section. It has a cinema-style opening with a quick change in perspective, twists and turns in the plot, pregnant pauses, a blonde (?) female character, and a dislocated hero reminiscent of the Japanese soldiers on South Pacific islands who never surrendered. One final note: Japanese soldiers have sunshades on the backs of their helmets. Americans do not.

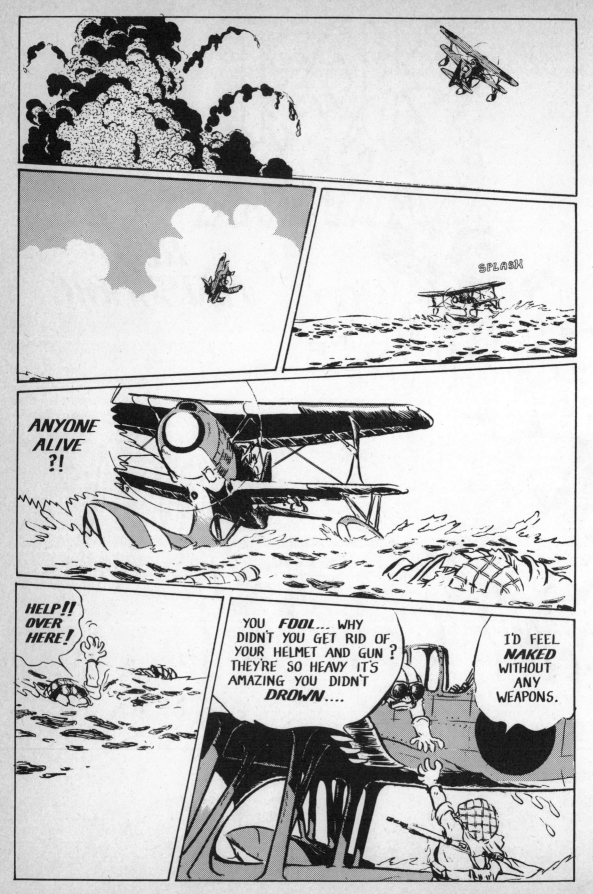

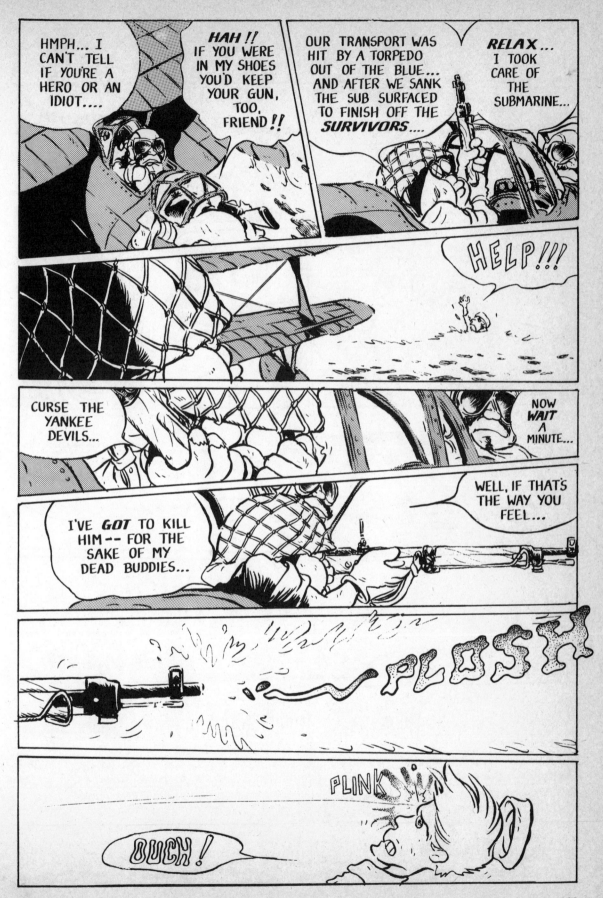

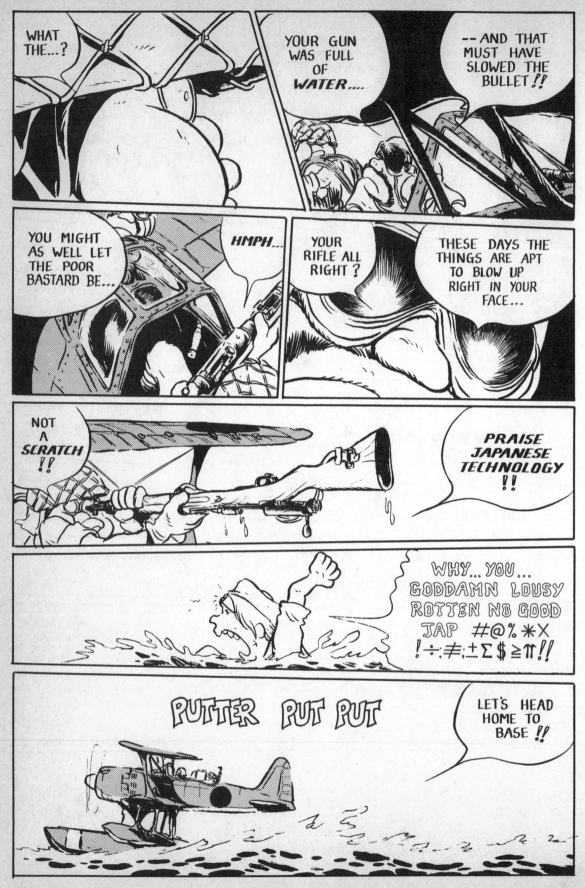

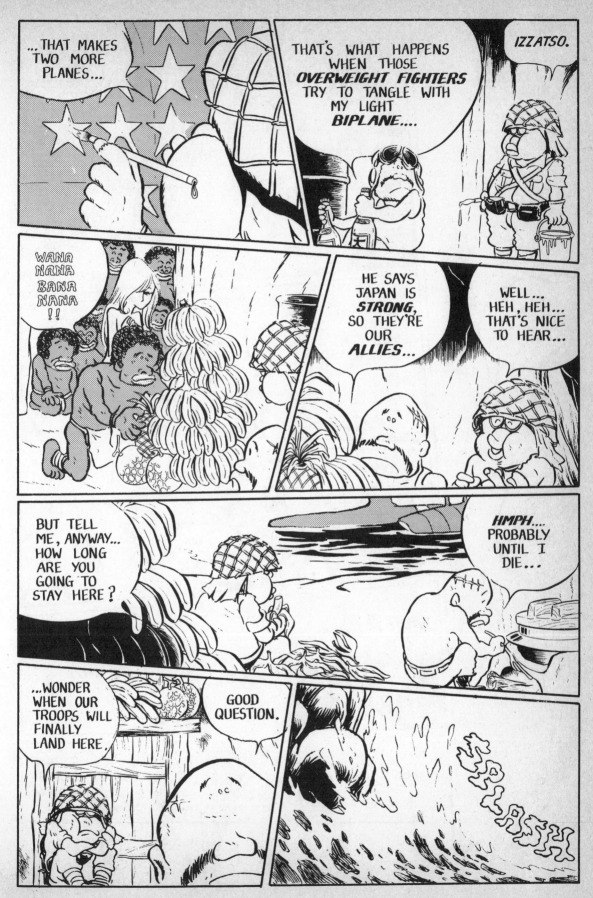

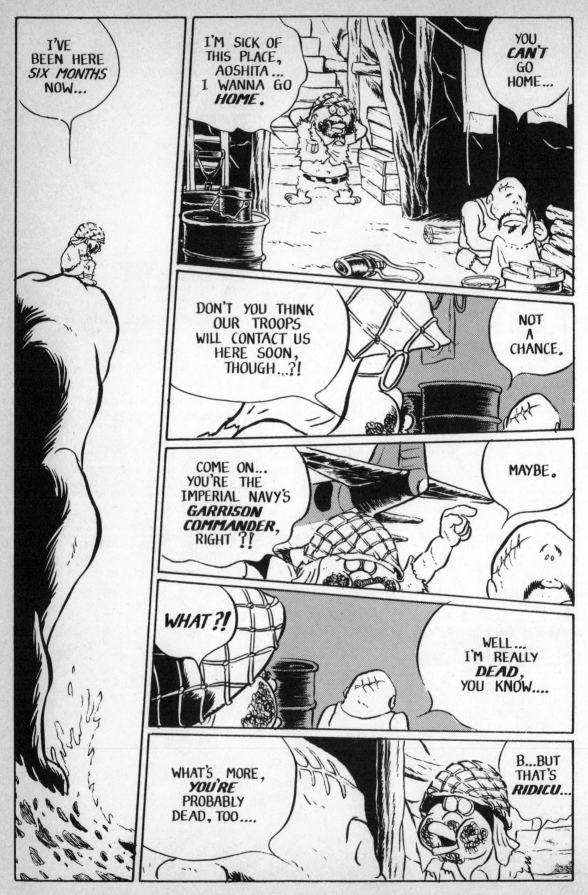

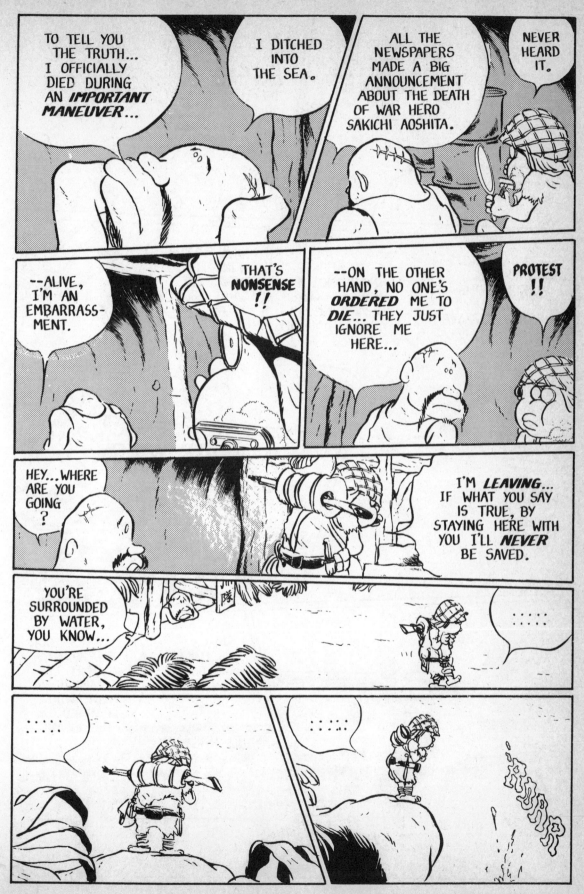

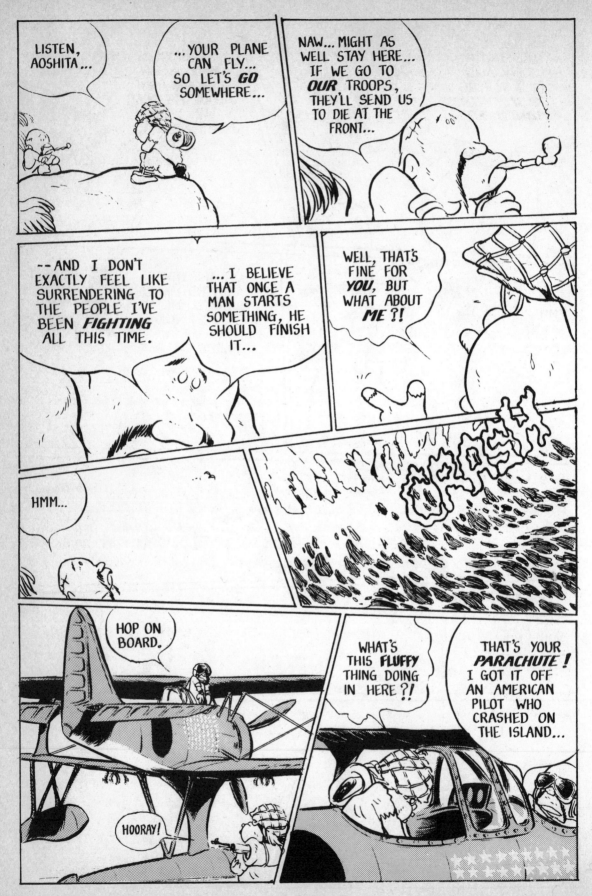

RIYOKO IKEDA

The Rose of Versailles

Riyoko Ikeda was born in 1947 and has been drawing comics for as long as she can remember, but like most Japanese artists she has had no formal art training. Her professional career in art began in 1967 after she dropped out of the philosophy department of the Tokyo University of Education. Fame came later, when she began serializing *Berusaiyu no Bara*, or *The Rose of Versailles*, in the weekly *Margaret* in 1972.

Like nearly all girls' comics, human relations, fashion, and infatuation are central to *The Rose of Versailles*, but it also skillfully incorporates the history of the French Revolution. It has three main characters: Marie Antoinette; her Swedish lover, Hans Axel Von Fersen; and Oscar François de Jarjayes. Oscar, a creation of Ikeda, is a girl who dresses like a man and becomes a commander of the palace guards. Like the heroine of Osamu Tezuka's early girls' comic, *Ribon no Kishi* ("Princess Knight"), Oscar's blurred sexuality allows her to take part in all the action and also to explore the thrills of love. In her flashy uniform, her beauty drives both men and women to distraction.

While Marie Antoinette, Fersen, Oscar, and the beautiful people of Versailles amuse themselves with court life, suspense is provided by the stirrings of revolution in Paris and the knowledge on the part of the readers that the good times will come to an abrupt end. Marie Antoinette, of course, has her head lopped off; Fersen is later stoned to death by an antimonarchist mob in his native Sweden; and a politically radicalized Oscar dies leading a charge on the Bastille.

The Rose of Versailles is more than 1,700 pages long and sells today as a set of eleven paperbacks, or five hardcover volumes. It first rocketed into national prominence when it was dramatized in 1974 by Japan's highly regarded all-female theatrical group, Takarazuka. By 1979 it reportedly had been performed nationally 635 times and seen by over 1.5 million people.

In 1978 the story was made into a live-action feature film with the English title *Lady Oscar*. Shot on location at Versailles, directed by Jacques Demy, and scored by Michel Legrand, the film used a Hollywood script and English-speaking actors. In Japan it was viewed with subtitles. In 1980 the story was released in Japan as an animated television series.

One of Riyoko Ikeda's biggest accomplishments has been to present history in a way that appeals to her readers. She is a stickler for detail. Most of the characters in *The Rose of Versailles* are real historical figures (with the obvious exception of Oscar), and most of the events actually took place.

In addition to *The Rose of Versailles*, Ikeda is probably best known for her other major epic, *Orufeusu no Mado* ("Orpheus's Window"), a saga of the Russian Revolution over 3,000 pages long with quotations from sources like John Reed's *Ten Days That Shook the World*.

The following excerpt is from an edited English version of *The Rose of Versailles*, published in Japan by San'yūsha. It is based on an actual incident at Versailles when the proud young Marie Antoinette, newly ensconced as crown princess, refuses to talk to King Louis XV's mistress, Madame Du Barry, and is encouraged not to do so by the king's scheming daughters. What seems trivial is a serious breach of etiquette. Antoinette, an Austrian, was married to the French crown prince in an effort to ensure peace between the Hapsburgs and the Bourbons. By angering the king, her conduct threatens to rupture the alliance between Austria and France. Count Mercy, who has been sent to Versailles to watch over Antoinette, quickly writes home to her mother, the empress of Austria. . . . Oscar, whose family has become embroiled in the squabble on the side of Antoinette, makes a brief appearance at the end of the selection.

The Rose of Versailles
by Riyoko Ikeda

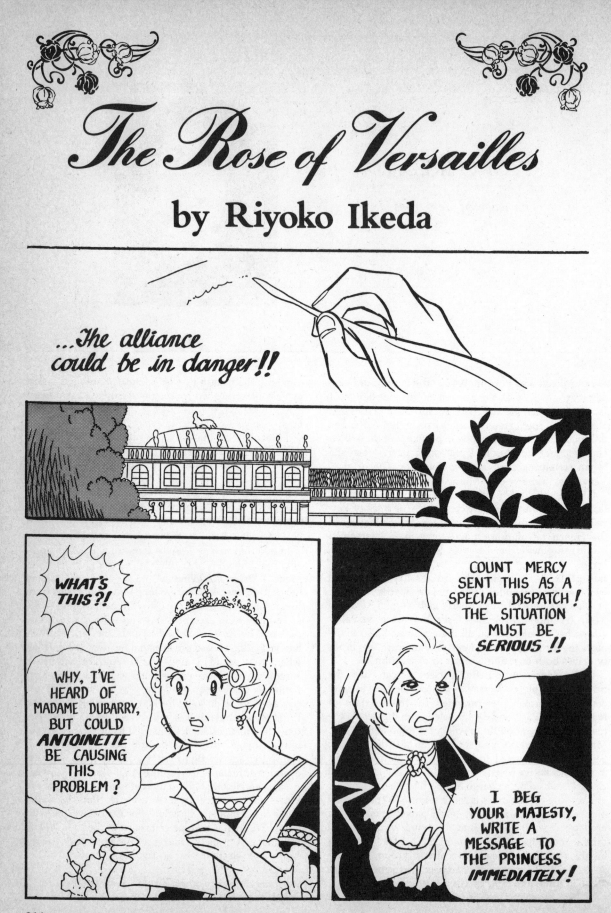

B...BUT...

...AH...WHAT SHALL I DO? I CAN'T REPRIMAND ANTOINETTE FOR THIS...!

--WHO TAUGHT HER THAT THE WORST THING A WOMAN CAN DO IS TO SELL HER BODY TO A MAN...

HOW CAN I NOW EXPECT HER TO BE POLITE TO A WOMAN LIKE MADAME DU BARRY?

...AFTER ALL, I'M THE ONE WHO TAUGHT HER...

STILL, I CAN'T LET HER DEFY THE KING of FRANCE !!

KAUNITZ, I WANT YOU TO WRITE ANTOINETTE...

I WANT YOU, AS FIRST MINISTER, TO WARN HER THAT HER BEHAVIOR IS POLITICALLY DANGEROUS.

YES, YOUR MAJESTY...

VERSAILLES...

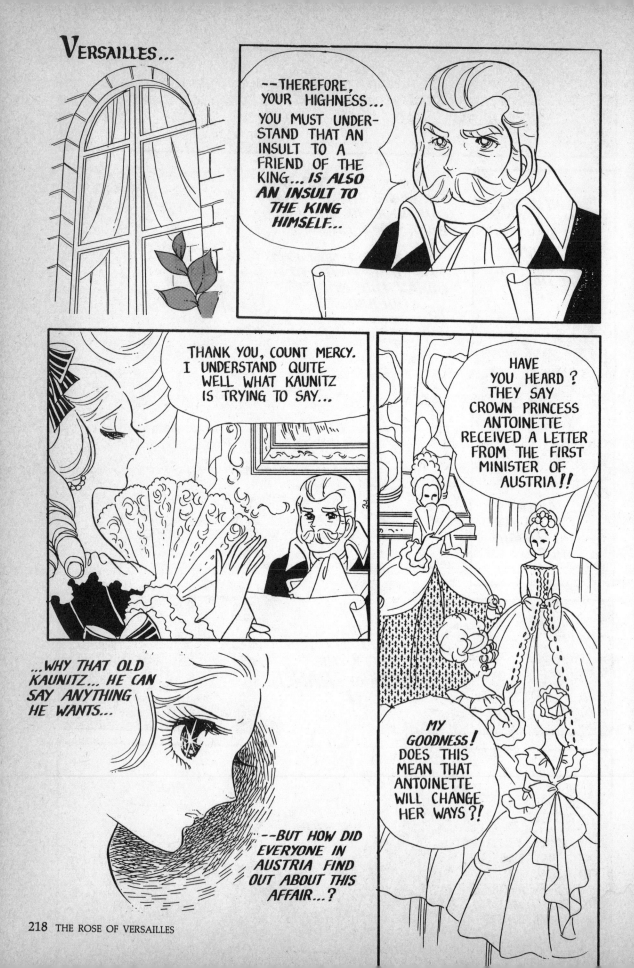

--THEREFORE, YOUR HIGHNESS... YOU MUST UNDERSTAND THAT AN INSULT TO A FRIEND OF THE KING... *IS ALSO AN INSULT TO THE KING HIMSELF...*

THANK YOU, COUNT MERCY. I UNDERSTAND QUITE WELL WHAT KAUNITZ IS TRYING TO SAY...

HAVE YOU HEARD? THEY SAY CROWN PRINCESS ANTOINETTE RECEIVED A LETTER FROM THE FIRST MINISTER OF AUSTRIA*!!*

...WHY THAT OLD KAUNITZ... HE CAN SAY ANYTHING HE WANTS...

--BUT HOW DID EVERYONE IN AUSTRIA FIND OUT ABOUT THIS AFFAIR...?

MY GOODNESS! DOES THIS MEAN THAT ANTOINETTE WILL CHANGE HER WAYS?!

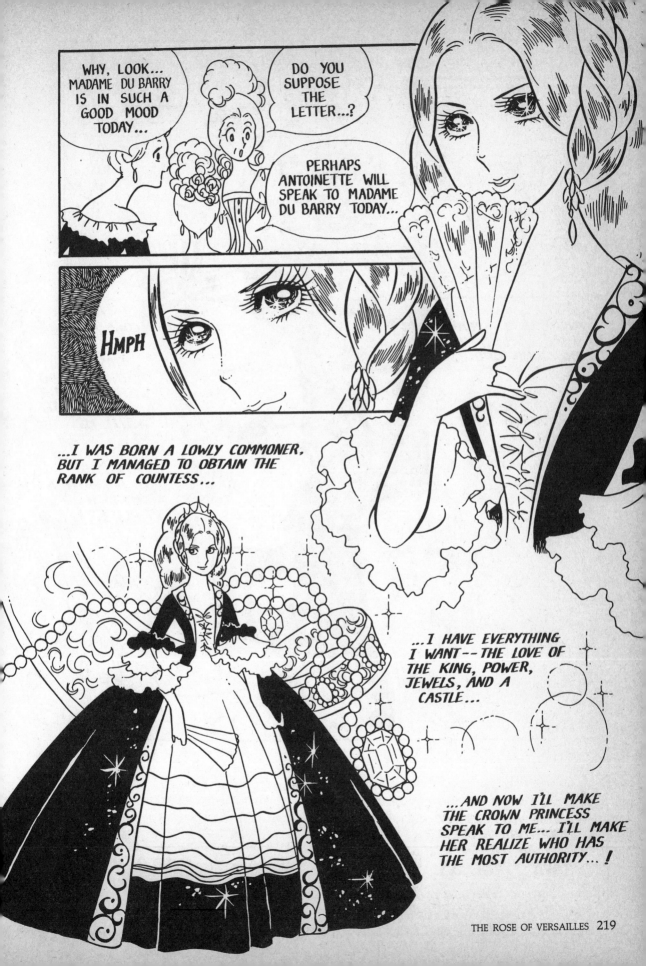

WHY, LOOK... MADAME DU BARRY IS IN SUCH A GOOD MOOD TODAY...

DO YOU SUPPOSE THE LETTER...?

PERHAPS ANTOINETTE WILL SPEAK TO MADAME DU BARRY TODAY...

HMPH

...I WAS BORN A LOWLY COMMONER, BUT I MANAGED TO OBTAIN THE RANK OF COUNTESS...

...I HAVE EVERYTHING I WANT -- THE LOVE OF THE KING, POWER, JEWELS, AND A CASTLE...

...AND NOW I'LL MAKE THE CROWN PRINCESS SPEAK TO ME... I'LL MAKE HER REALIZE WHO HAS THE MOST AUTHORITY...!

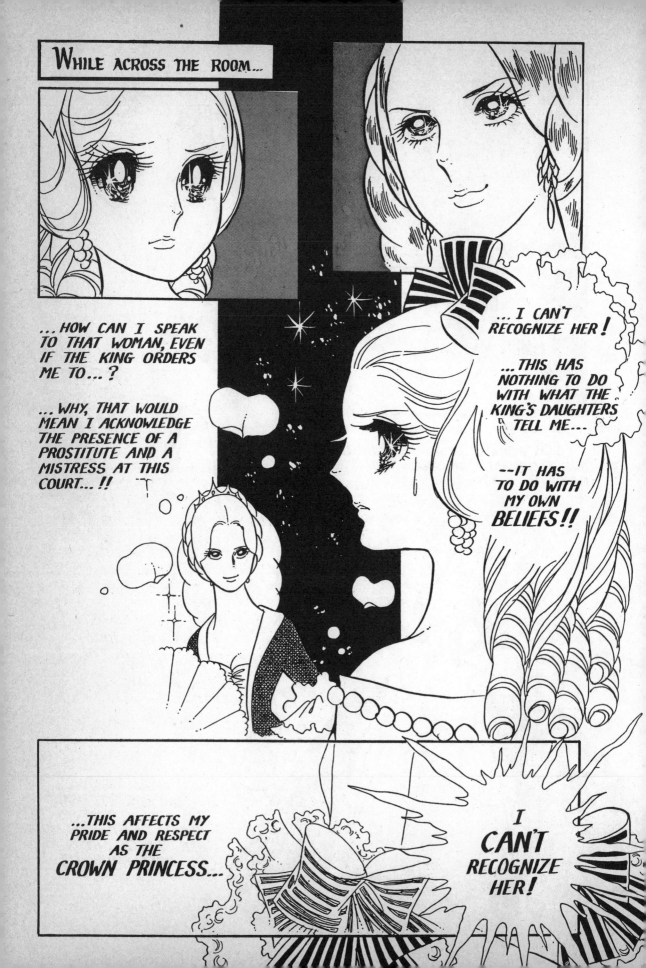

WHILE ACROSS THE ROOM...

...HOW CAN I SPEAK TO THAT WOMAN, EVEN IF THE KING ORDERS ME TO...?

...WHY, THAT WOULD MEAN I ACKNOWLEDGE THE PRESENCE OF A PROSTITUTE AND A MISTRESS AT THIS COURT...!!

...I CAN'T RECOGNIZE HER!

...THIS HAS NOTHING TO DO WITH WHAT THE KING'S DAUGHTERS TELL ME...

--IT HAS TO DO WITH MY OWN BELIEFS!!

...THIS AFFECTS MY PRIDE AND RESPECT AS THE CROWN PRINCESS...

I CAN'T RECOGNIZE HER!

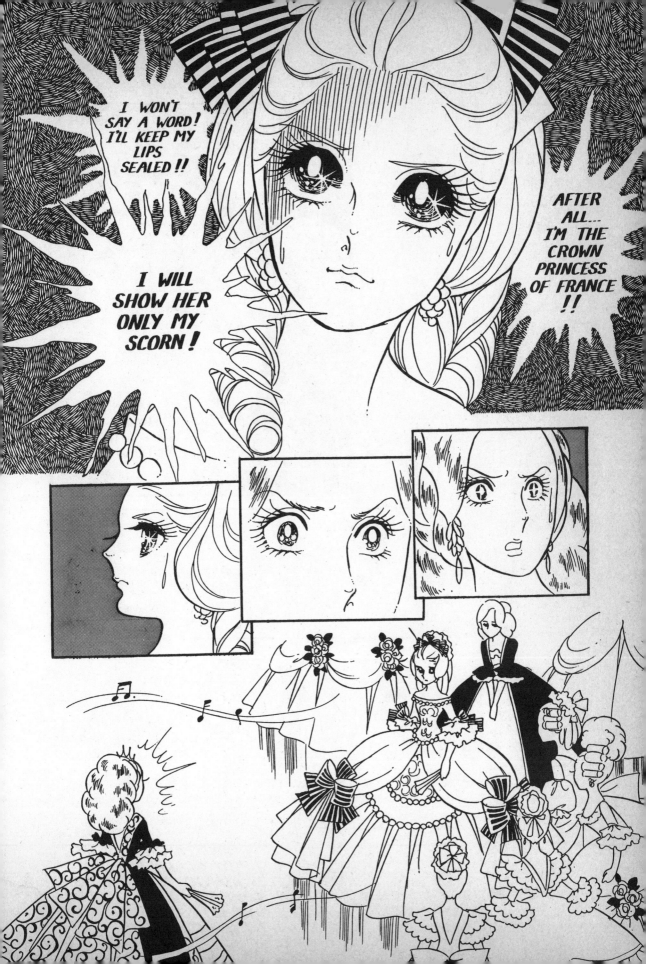

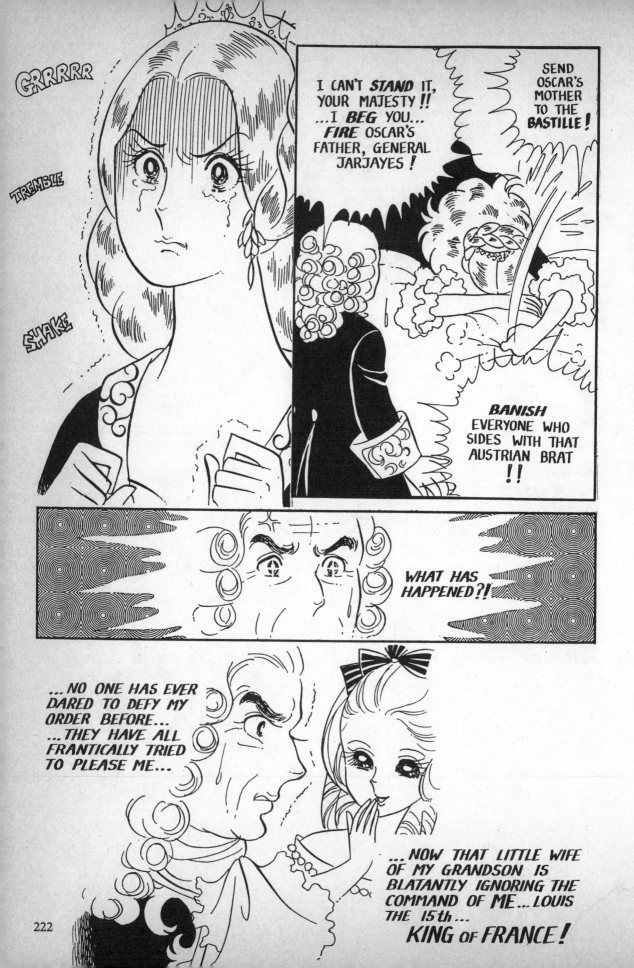

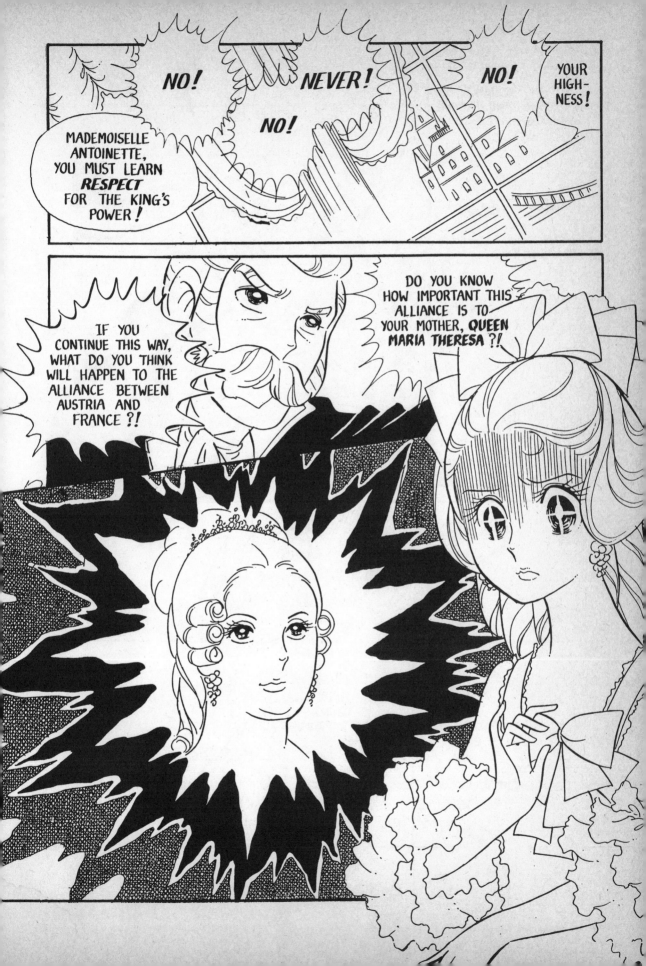

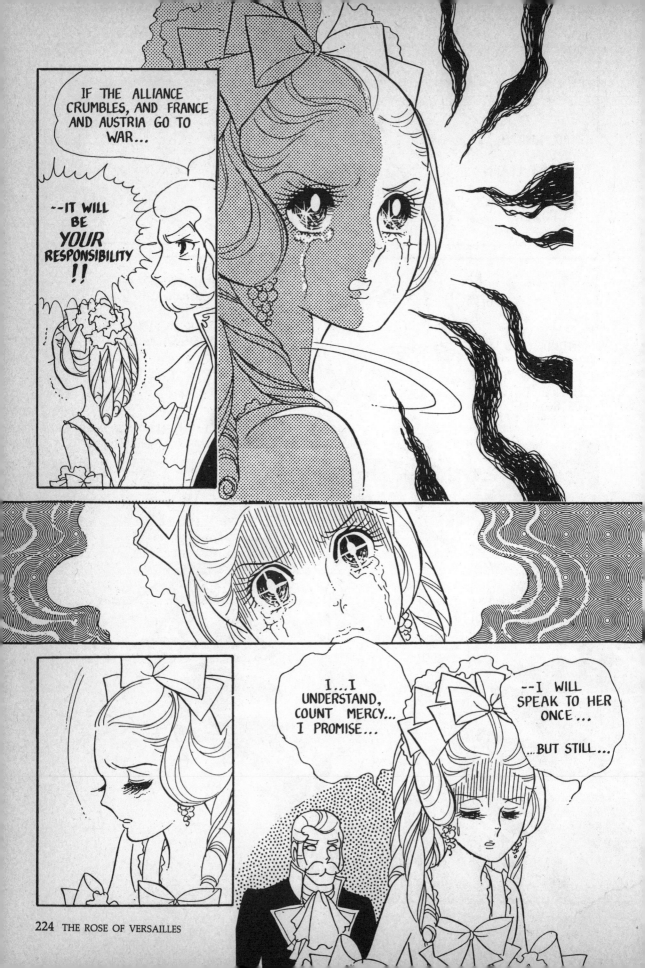

IF THE ALLIANCE CRUMBLES, AND FRANCE AND AUSTRIA GO TO WAR...

--IT WILL BE *YOUR* RESPONSIBILITY !!

I...I UNDERSTAND, COUNT MERCY... I PROMISE...

--I WILL SPEAK TO HER ONCE...

...BUT STILL...

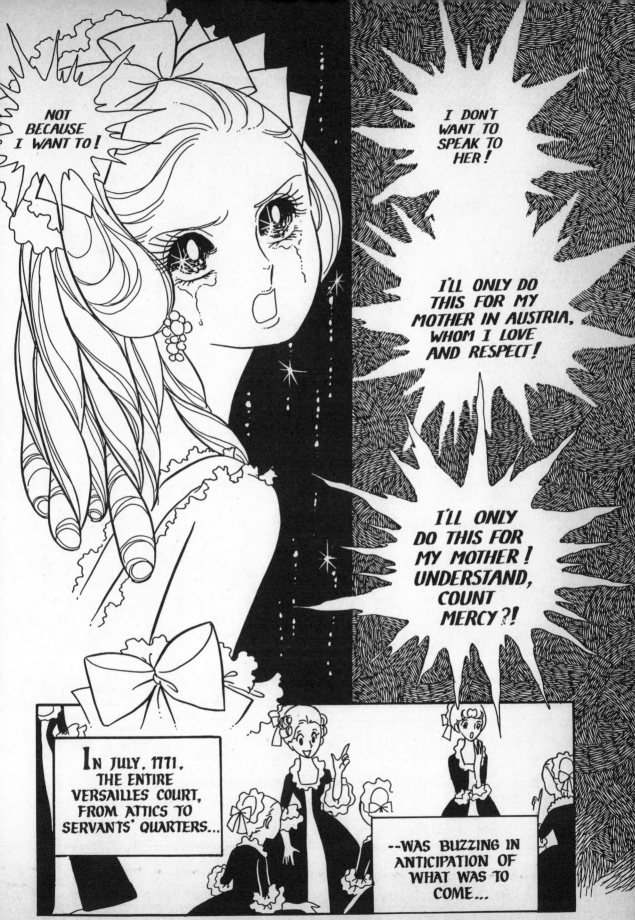

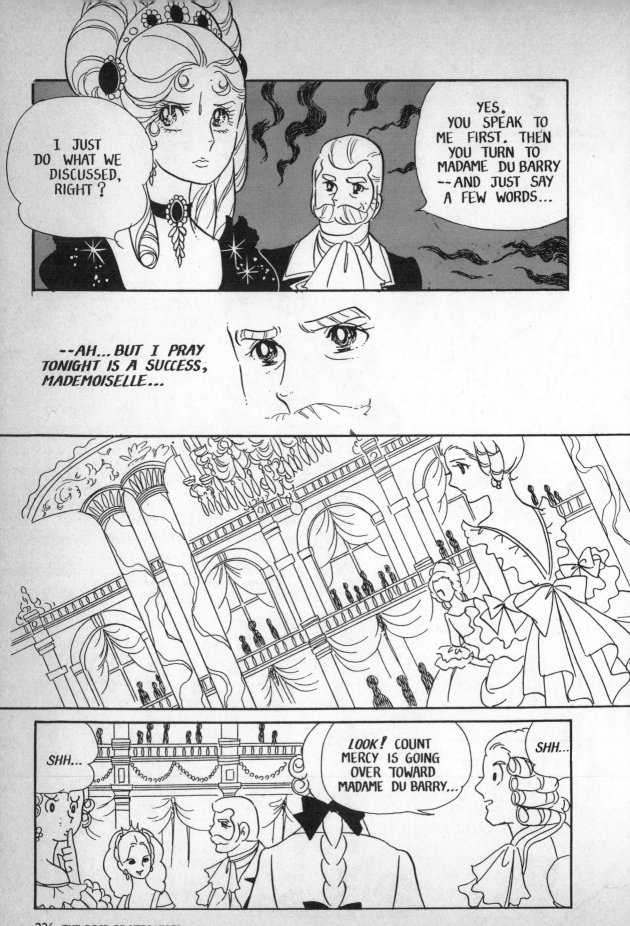

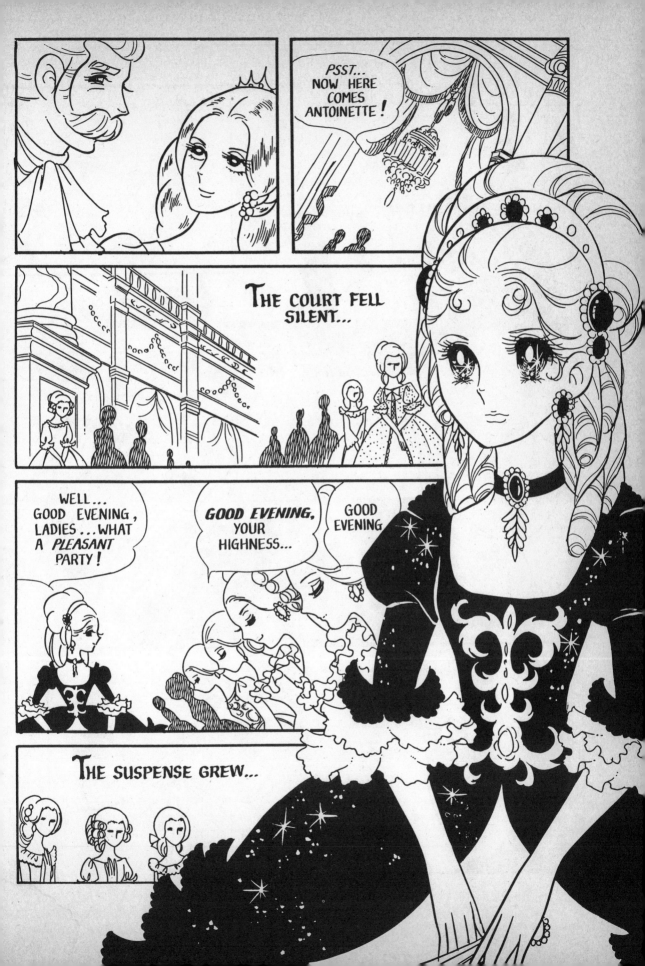

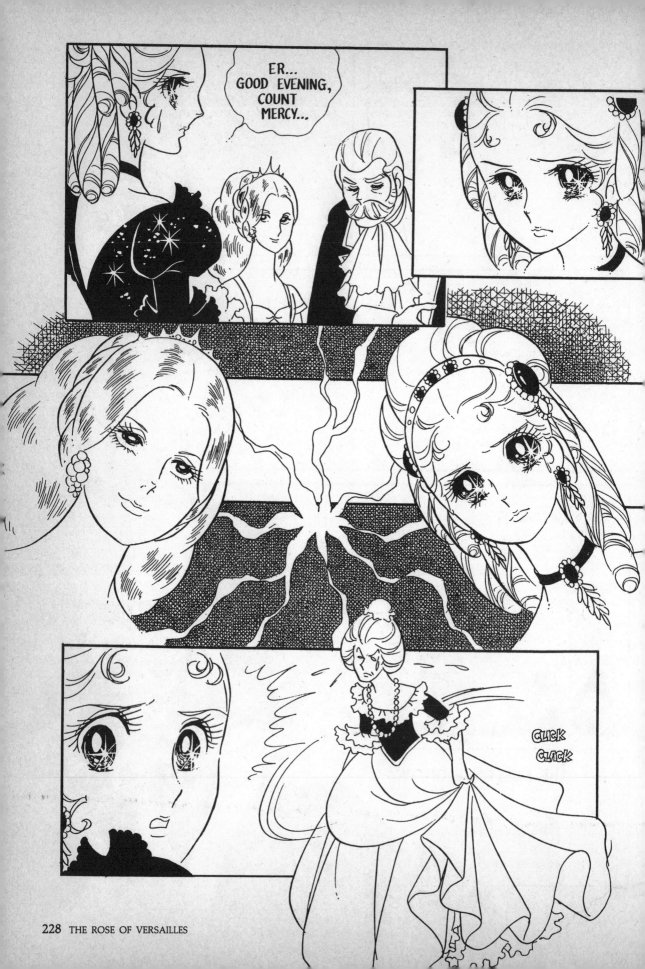

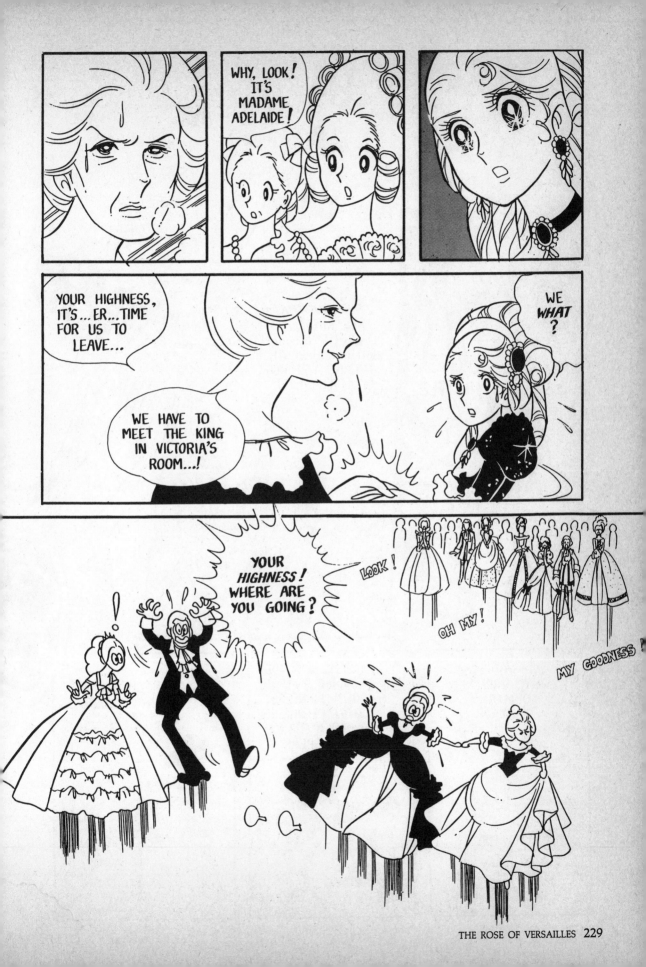

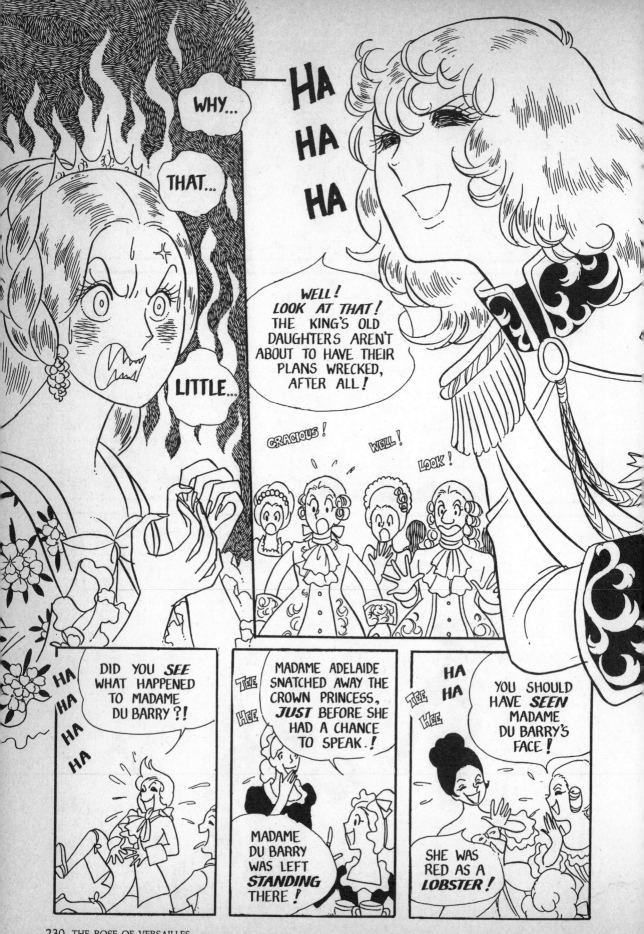

COUNT MERCY! PLEASE ASK HIS MAJESTY TO GIVE ME **ONE** MORE CHANCE! **PLEASE!**

I'LL TALK TO HER NEXT TIME! *I PROMISE* I WILL!!

AND SO, ON JANUARY 1st, 1772...

--MARIE ANTOINETTE FINALLY SPOKE TO MADAME DU BARRY...

IT HAD BEEN NEARLY TWO YEARS SINCE SHE FIRST DEBUTED AT VERSAILLES AS CROWN PRINCESS.

THE EVENT TOOK PLACE WHEN THE LADIES OF THE COURT FORMALLY GAVE ANTOINETTE THEIR NEW YEAR'S GREETINGS...

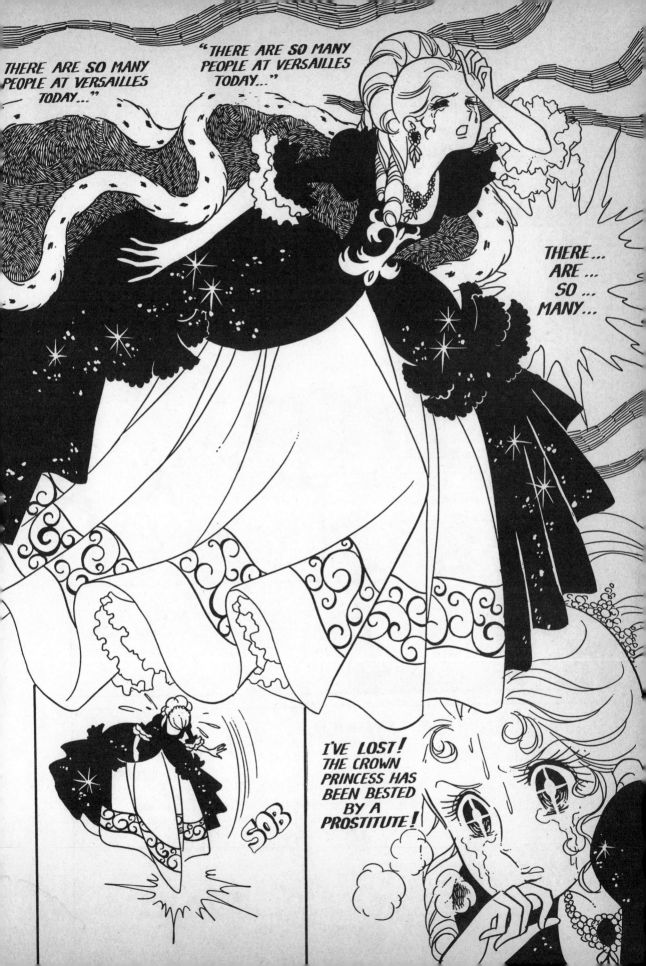

SOB SOB

YOUR HIGH-NESS:...

OH, *OSCAR*...

I SPOKE TO THAT WOMAN ONCE, BUT IT WAS THE *LAST* TIME...

--I'LL *NEVER, EVER* SPEAK TO HER AGAIN!

THE FRENCH COURT HAS BEEN *CORRUPTED!*

THE COURT HAS BEEN *CORRUPTED!!*

THE WIFE OF THE FUTURE KING HAS BEEN DEFEATED BY A *HARLOT!*

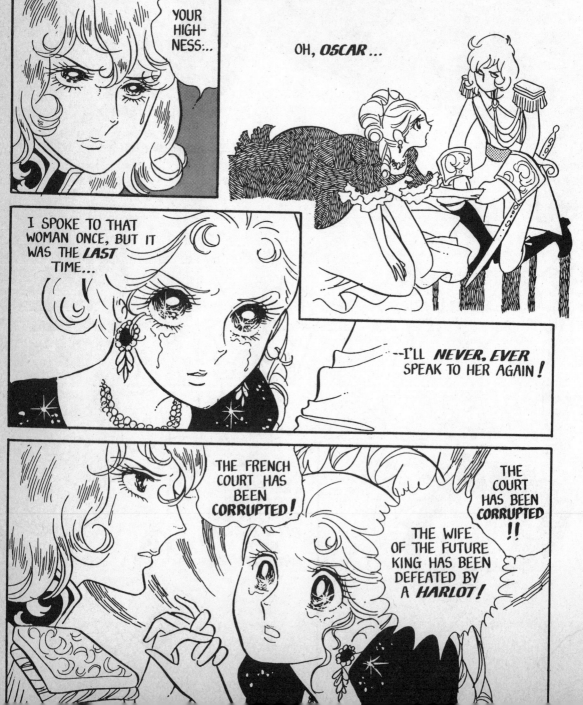

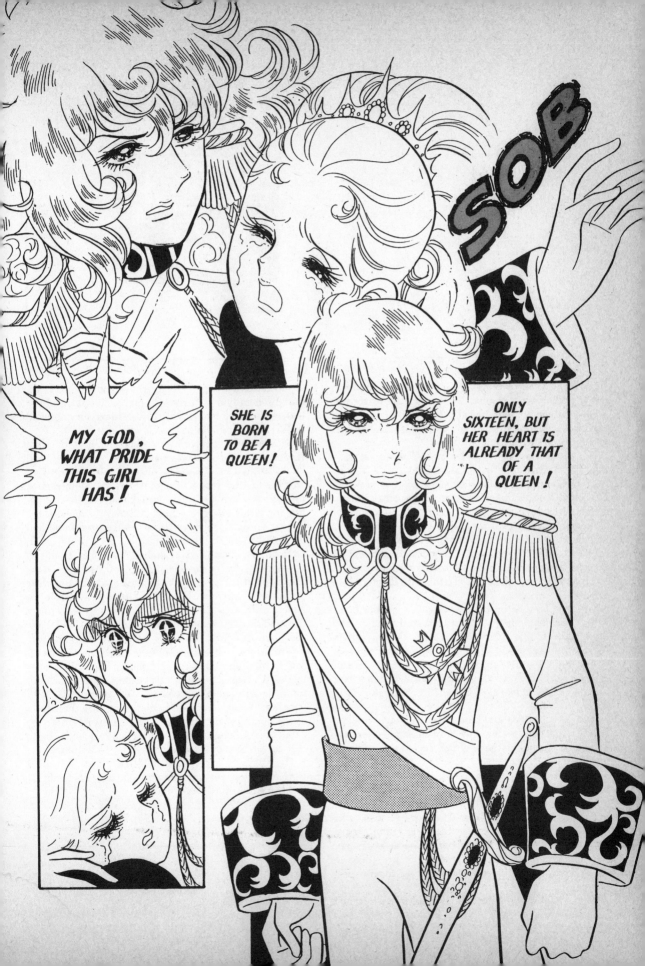

KEIJI NAKAZAWA

Barefoot Gen

Hadashi no Gen, or Barefoot Gen, is one of the most moving comics ever created, for very special reasons. It is the semiautobiographical story of artist Keiji Nakazawa, before, during, and after the atomic bomb was dropped on Hiroshima.

Nakazawa was six years old in 1945 when, at 0815 hours on 6 August, he witnessed a spectacle of destruction the world is still struggling to comprehend. Nakazawa lost his father, brother, and sister in the immediate bombing, and himself survived through sheer luck. With the horror of what he saw etched in his consciousness he grew up to become an artist with a mission: through the medium of comics to convey his experience to a generation that knows nothing of war, let alone an atomic holocaust. To this end, Barefoot Gen is his life's work.

Barefoot Gen first began serialization in the boys' weekly Shōnen Jump in 1973 and has continued off and on in other publications to this day. Drawn not to rehash old arguments of which nation was right or wrong in the war, it is an attack on injustice, militarism, and war itself. Barefoot Gen stars Nakazawa's alter ego, Gen Nakaoka, who in 1945 is in the second grade. Gen's family, because of its opposition to a war still being waged, is ostracized and persecuted by neighbors and police. And they are not the only ones to suffer: the story also touches on the plight of the Korean minority in wartime Japan.

After Hiroshima is devastated, through Gen's eyes readers see a bitter struggle unfold. Many initial survivors watch their hair fall out and their wounds fester with maggots; then they die. The "lucky" ones, who overcome radiation sickness, face starvation, social disorder, and lifelong discrimination because of their "contamination." But through it all, little Gen retains an indomitable, almost fierce spirit, inspiring all who meet him.

Barefoot Gen is presently nearly 2,000 pages long and is published in a variety of paperback and hardback editions, generally as a seven-volume set. It has also been made into three live-action feature films, an animated feature film, and a widely acclaimed opera.

Because of its universal message, Gen is the first Japanese story-comic to have been translated and published in a European language. In 1976 Project Gen was formed by Japanese and American volunteers to raise funds, translate, and eventually publish Gen in English for distribution to school children throughout the world. To date, volumes 1 and 2 have been published in English, while volume 1 has also been produced in German, Esperanto, and Tagalog. Volunteer groups in Bangladesh, Sri Lanka, Thailand, and Malaysia have also applied for permission to create editions in their languages. Barefoot Gen is presently available in America through the San Francisco branch of Project Gen and through some comic specialty stores and select peace groups, but it has never been widely distributed.

Gen has not been without its problems overseas. Scenes of supposed pacifists bonking each other over the head when angered puzzle readers unfamiliar with the melodramatic traditions of Japanese comics. And American readers sometimes complain that the effects of the bomb are depicted too "graphically."

But in whatever language or culture, the basic message of Gen is the same: No More Hiroshimas.

The following excerpt is taken from "Gen Digest," a 1977 prototype for later English editions; it is edited, and transitions have been added.

BAREFOOT GEN

by
KEIJI NAKAZAWA

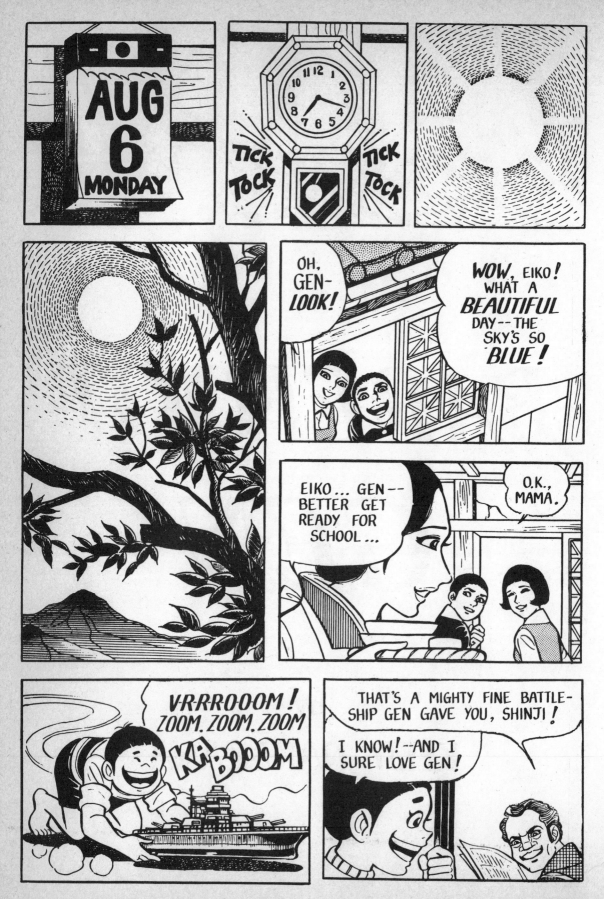

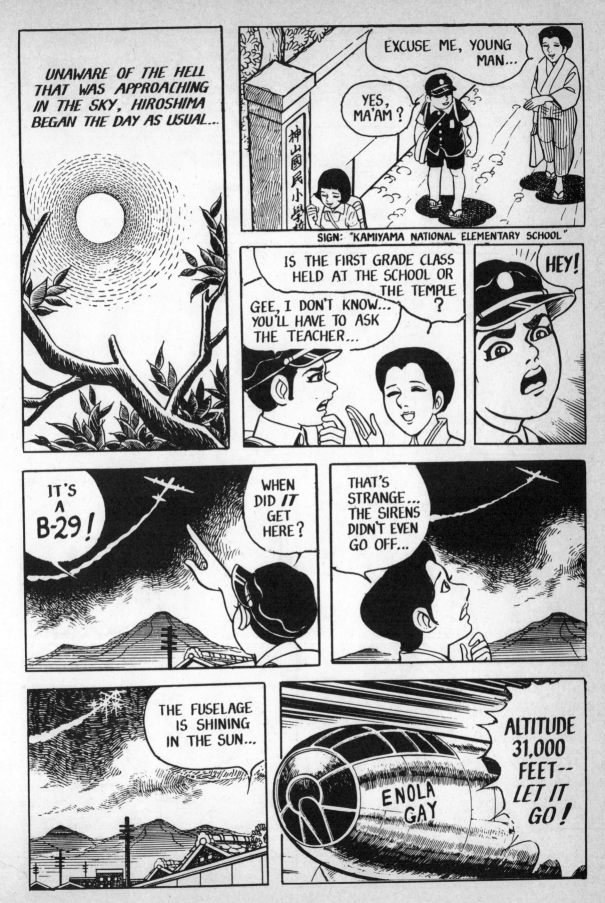

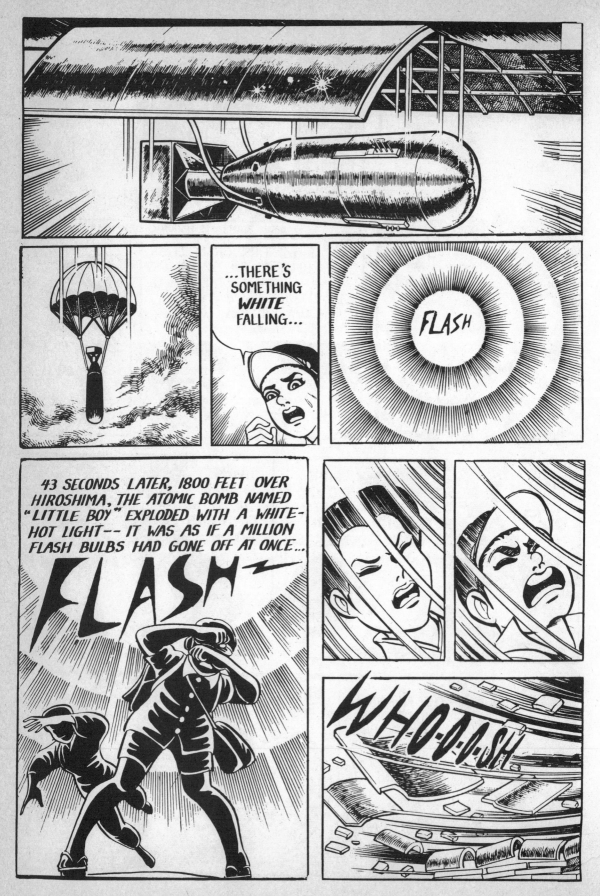

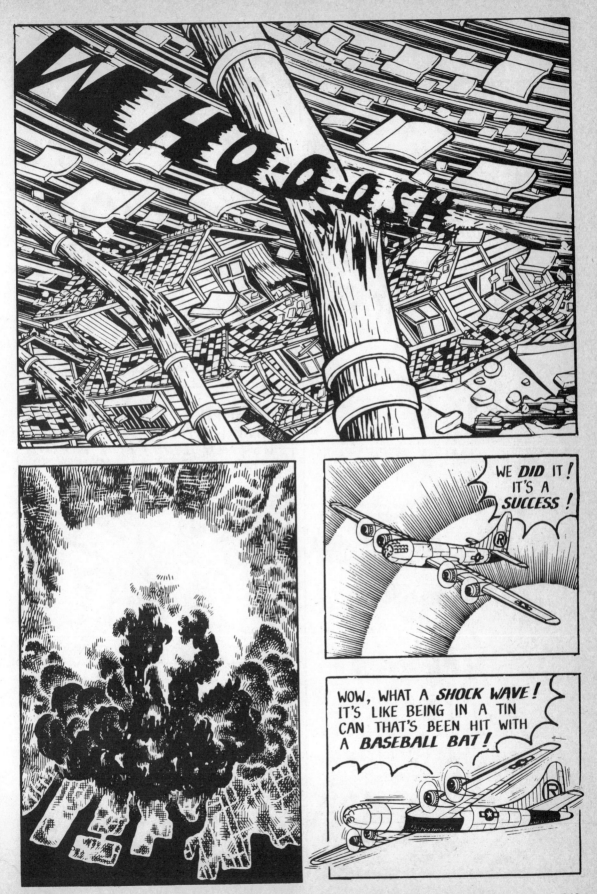

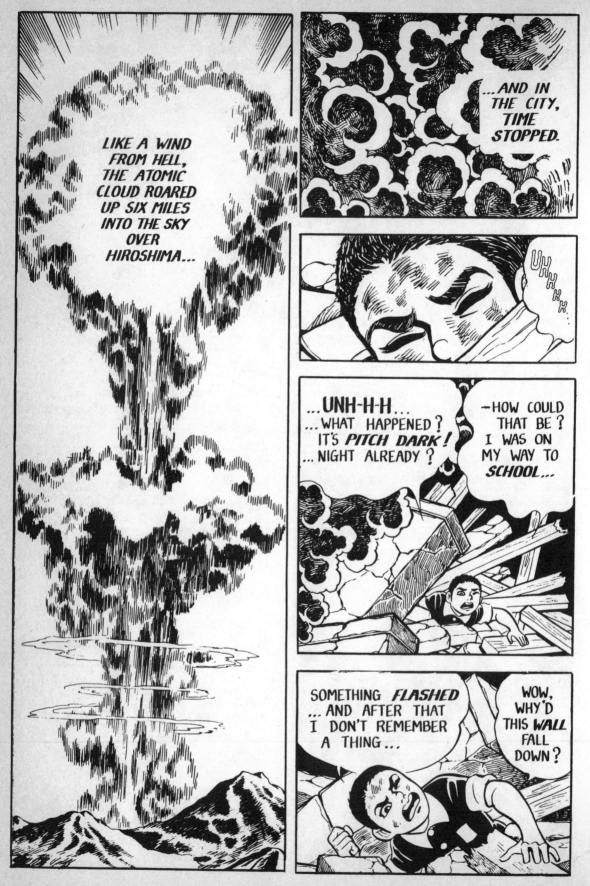

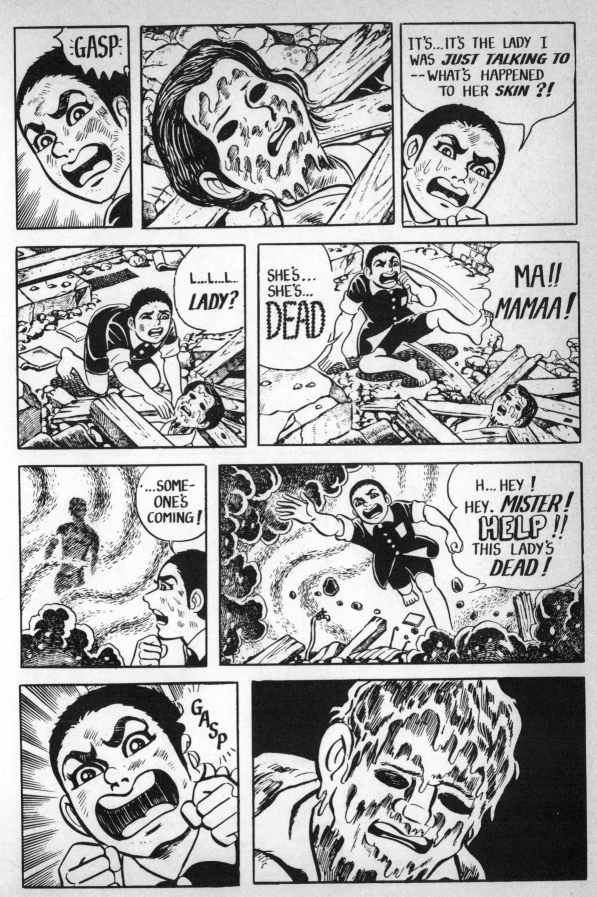

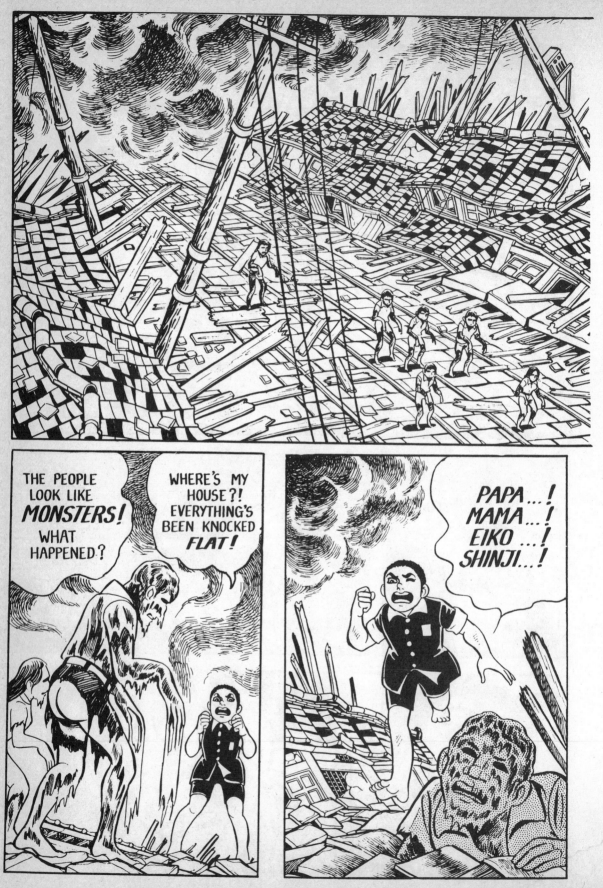

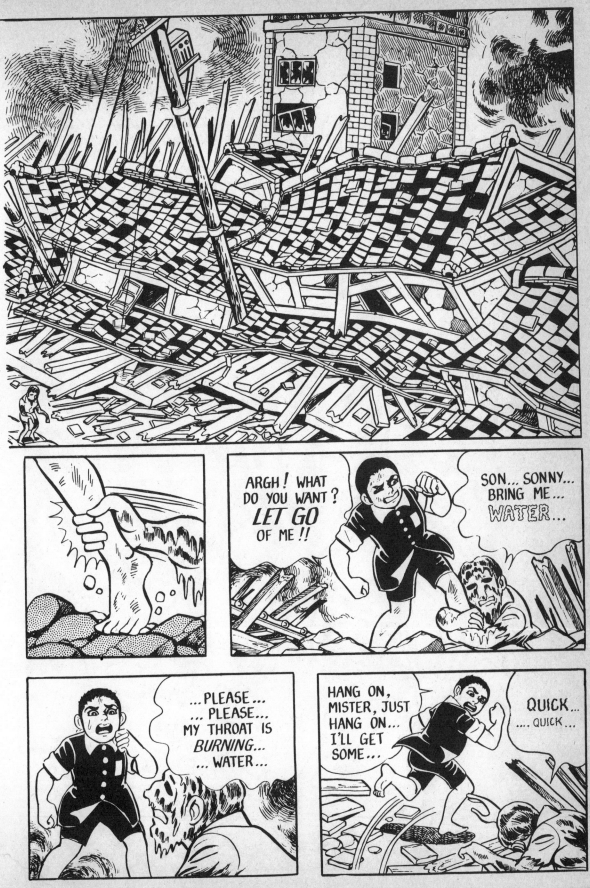

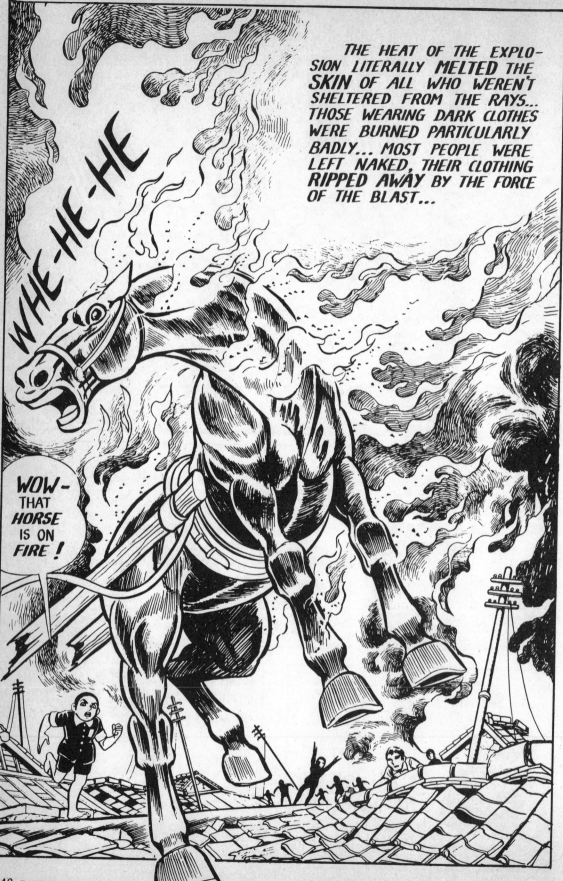

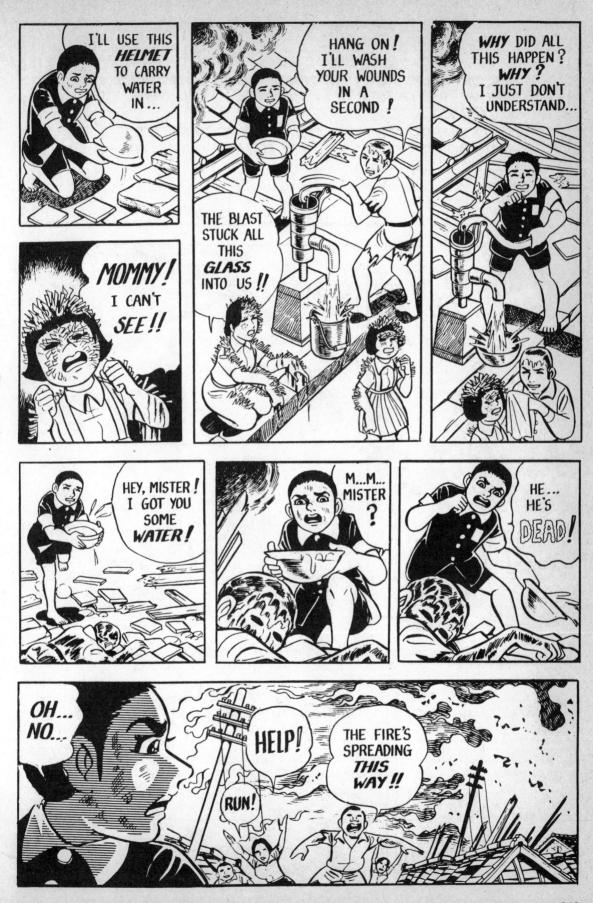

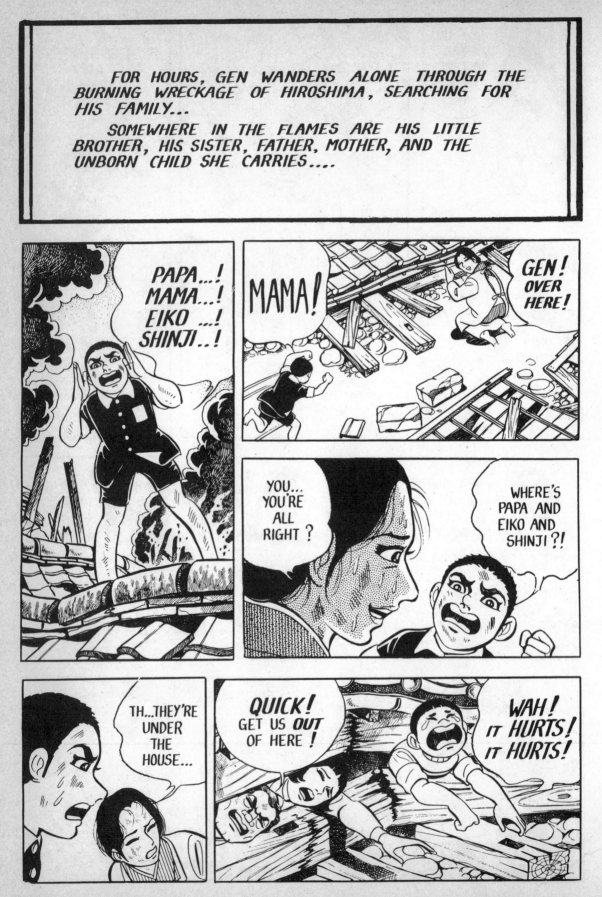

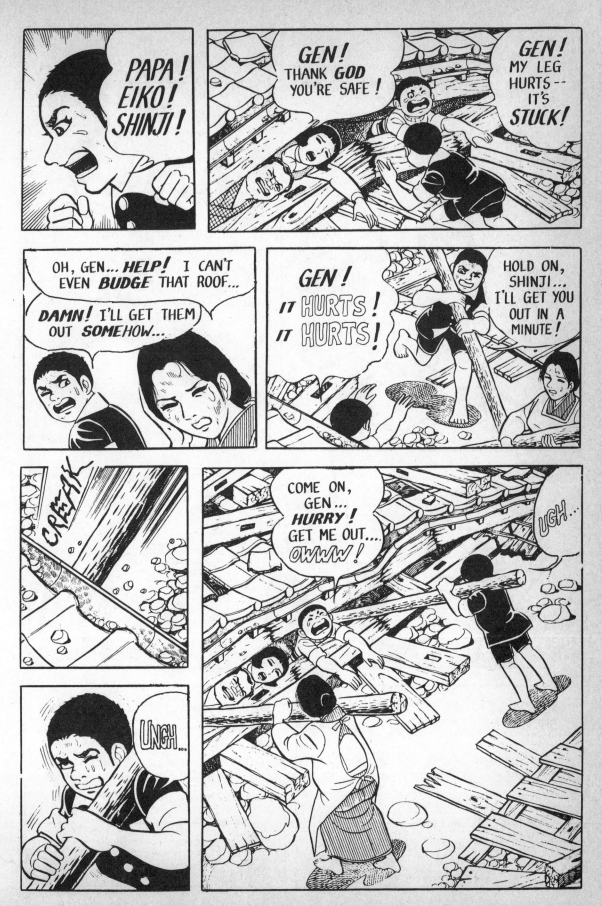

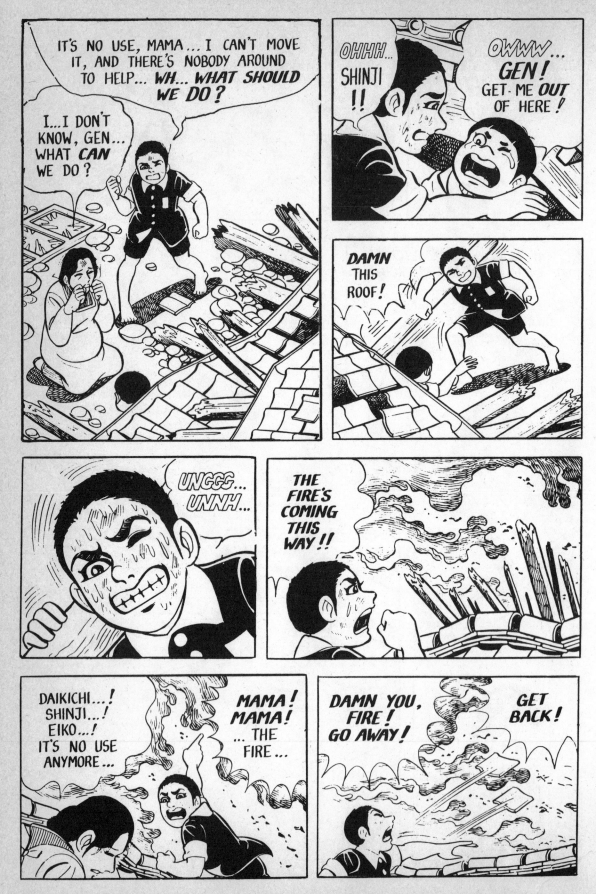

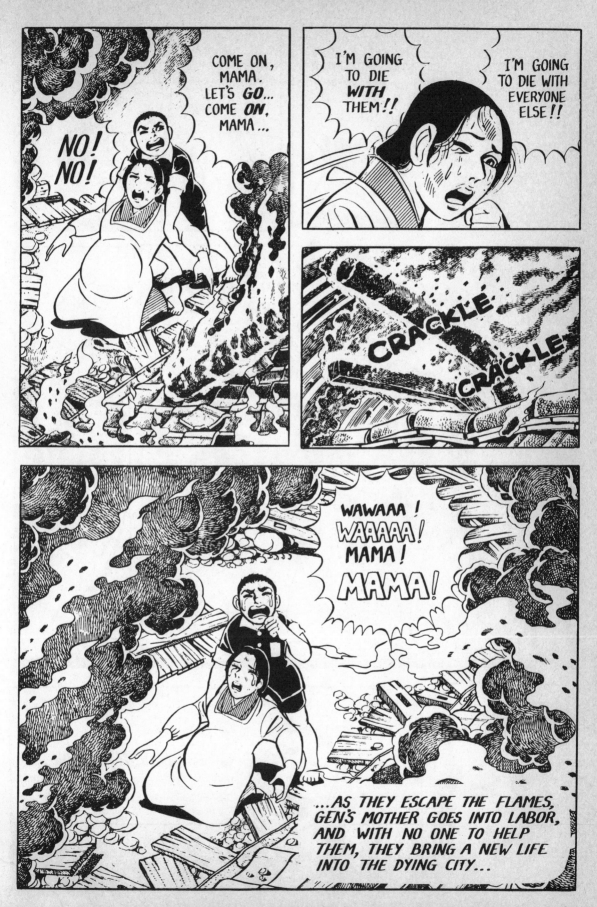

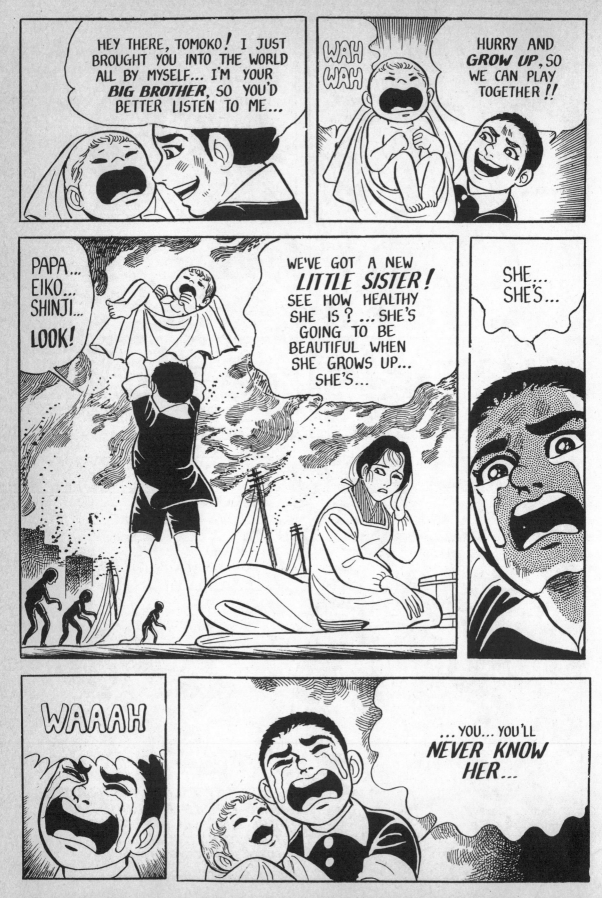

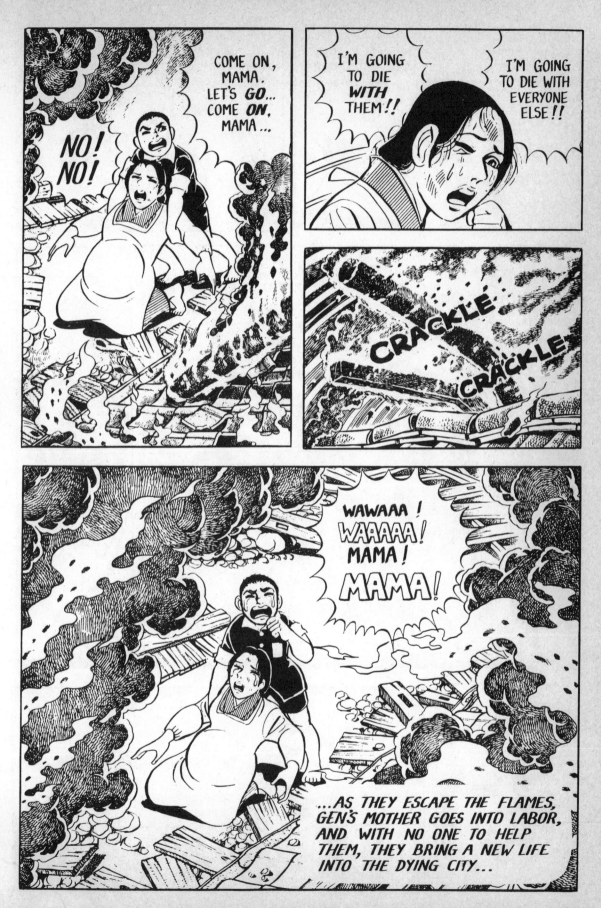

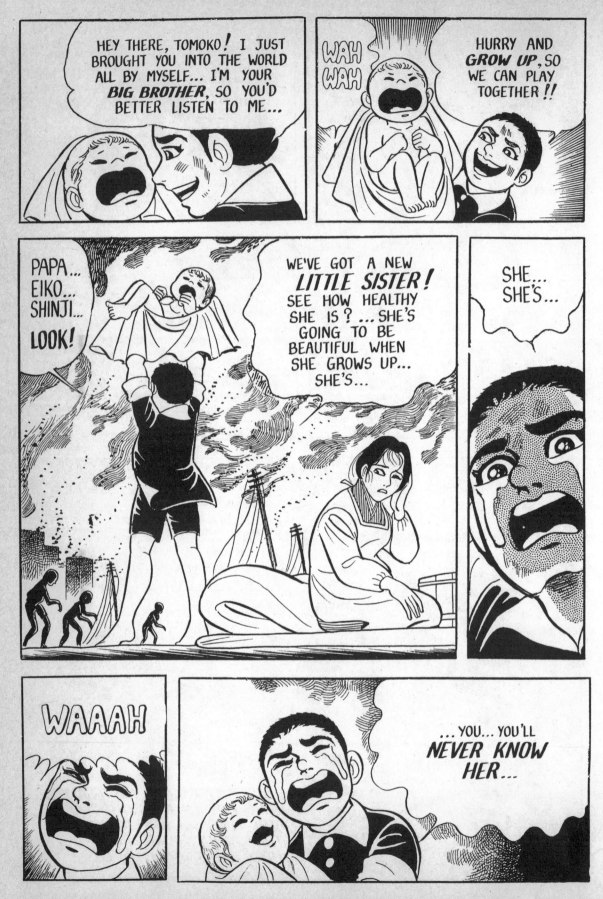

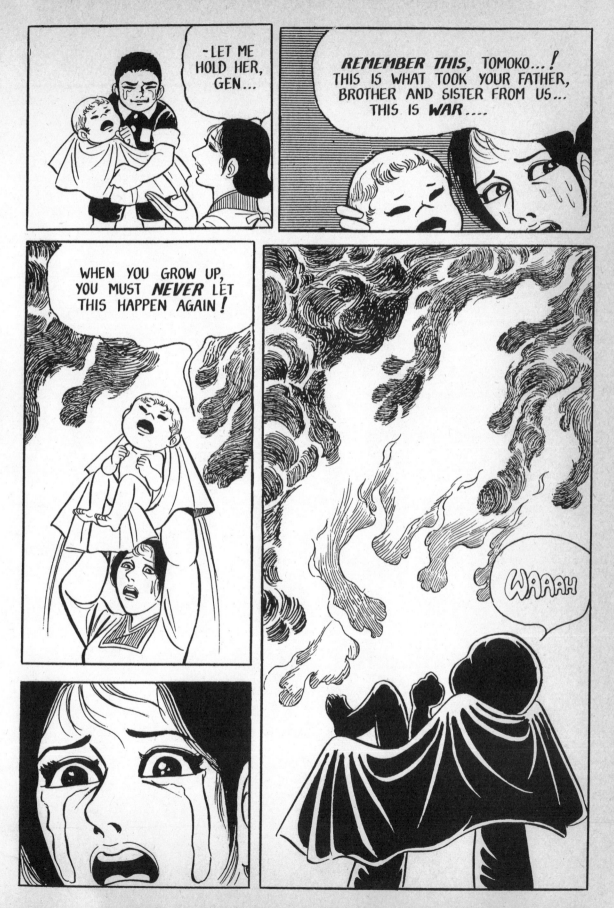

Index

General Information

adult comics, 13, 15, 17, 51, 102, 111–19, 124, 132, 136
animation, 146, 147, 154, 156
artists, 16, 66–67, 95–97, 138–43, 149, 150–51
awards, 151
baseball comics, 81–83
bisexuality in comics, 96, 101
Bishop Toba, 28, 30, 37
boys' comics, 13, 15, 51–52, 69, 79–80, 88, 106, 120, 125
Bringing up Father, 45, 48, 51
campus romance comics, 105
censorship, 36, 41, 51, 55, 60, 79, 128–29, 131–32, 133
children's comics, 61–62, 67
Chōjūgiga, 28, 29, 30
cinematic techniques, 20, 63, 64, 66
criticism directed at comics, 16, 54, 97, 122, 125, 129, 135–36, 150–53
critics, 102, 149
crossover in readership, 12, 16–17, 102
cultural attitudes, comics and, 16, 21–22, 25, 54, 68–69, 73–74, 80–81, 92, 93, 106, 131–32
dramatic effects, 16, 81, 109
editors, 144–45
education system, 25–26, 152–53
ero-guro-nansensu, 51
erotic comics, 35–36, 51, 58, 101, 115, 125, 132–37
exoticism, 92, 137
exporting Japanese comics, 153–54
eyes, stylized, 88, 91–92, 105
female culture, 94, 97
finances, 139, 140, 145–47
gag comics, 51, 69, 100, 116, 120–21
gambling comics, 114–19
gekiga ("drama pictures"), 67, 124
Genji Monogatari ("Tale of Genji"), 94
girls' comics, 13, 15, 88–105, 125
hardbound comics, 14, 51, 67, 146
hero figures, 77–78, 106, 112
Hokusai, 18, 35
homosexual love, 137
Japanese language, influence of, 22–23, 25
kami-shibai, 62, 67
kibyōshi, 37
magazines, 12–13, 14, 41, 64–66, 67, 97, 115–16, 145–46
mah jongg comics, 115–19
merchandising, 146, 147, 156–57
onomatopoeia, 23, 118
Ōtsu-e, 32
paperbacks, 13–14, 67, 146
pay-libraries, 66, 71, 124
picture scrolls, 28–30, 125, 131
political cartoons, 12, 41, 42, 43, 57, 60, 67, 151
postwar conditions, 60–62, 79, 95
production studios, 142–43
propaganda, 51–59
publishers, 13, 62, 67, 143–45
regulation, 126–32, 136
romance, 93, 97, 98–101, 136–37

"salary-man" comics, 111–14
sales and circulation, 12–13, 14, 17, 67, 115, 123, 138, 141, 145, 151
samurai comics, 68–72, 124
school-gang comics, 76–77
science fiction, 54, 61, 156
scriptwriters, 141–42
society, role of comics in, 25–27, 112, 132, 152–53
sports comics, 69, 79–87, 98
story-comics, 62, 64, 66–67, 95–96, 103, 149
symbolism, 21–22, 25, 101, 135, 154
taboo-smashing comics, 120–26
television, 67, 146, 156
Toba-e, 37
Tokiwasō, 66
ukiyo-e, 32–36, 71, 131, 134
U.S. comics, 12, 17, 41–49, 67, 73, 88, 126–27, 154
violence, 16, 35, 70, 71, 75, 123–24, 127, 131–32, 135
visual techniques, 16, 18–22, 23, 34, 35, 42, 63, 66, 69, 71, 89–93, 109, 112
war (and antiwar) comics, 73–76
warrior robots, 155, 156
Western influence, 38–49, 154
women in comics and society, 67, 79, 94–95, 96, 136
work comics, 106–11
World War II, 55–59, 69, 73–75
yakuza comics, 77
young people, attitudes of, 25–27, 67, 111, 136, 148–50
Zen pictures, 30–31

Modern-day Artists and Scriptwriters

Akatsuka, Fujio, 66, 108, 111, 120–21, 151
Akiyama, Jōji, 31, 72, 74, 125
Aoyagi, Yūsuke, 22
Arai, Mitsu, 96
Ariyoshi, Kyōko, 19
Asada, Tetsuya, 117, 118
Asahi, Tarō, 54
Asō, Yutaka, 43, 45, 47
Baron Yoshimoto, 126, 154
Biggu, Jō, 106, 107, 110, 111
Bigot, George, 38, 40–41
Chiba, Tetsuya, 76, 84, 85, 86, 96, 97, 138
Dōkuman, 128
Fujio-Fujiko, 14, 63, 66, 67, 111, 138, 139, 140, 146, 157
Fukuchi, Hōsuke, 112, 113
Fukui, Eiichi, 79, 80
Fukui, Fukujirō, 61
Fukushima, Masami, 133
Furuya, Mitsutoshi, 121, 122, 140, 152
Gyū, Jirō, 106, 107, 108, 111, 115, 135, 136, 141
Hagio, Moto, 97, 100, 102, 103
Hara, Taira, 139
Hasegawa, Machiko, 61, 96, 97
Hirai, Fusato, 56
Hirata, Hiroshi, 22, 71, 73, 130

Honda, Kinkichirō, 41
Igarashi, Yumiko, 88, 156
Ikeda, Riyoko, 93, 97, 100, 101, 215
Ikegami, Ryōichi, 77
Inagaki, Kogoro, 49
Ishii, Takashi, 136
Ishimori, Shōtarō, 21, 66, 71–72, 73, 96, 139, 141
Itasaka, Yasuhiro, 118, 119
Jimbo, Shirō, 20
Kabashima, Katsuichi, 48
Kajiwara, Ikki, 82–83, 84, 141
Kamimura, Kazuo, 16, 17
Kariya, Tetsu, 77
Katō, Etsurō, 55
Katō, Ken'ichi, 64
Kawasaki, Noboru, 82–83, 84, 87
Kawasaki, Yukio, 23
Kaze, Shinobu, 158
Kihara, Toshie, 92
Kitami, Ken'ichi, 113, 114
Kitano, Eimei, 117, 118
Kitazawa, Rakuten, 27, 42, 43, 44, 48
Kiyama, Yoshitaka, 45
Kobayashi, Kiyochika, 41
Koike, Kazuo, 21, 68, 71, 141, 143
Kojima, Gōseki, 21, 68, 71
Kojima, Kō, 132
Kondō, Hidezō, 56, 57, 58
Kondō, Yōko, 134
Kuragane, Shōsuke, 95
Kurogane, Hiroshi, 114, 131
Maetani, Koremitsu, 74
Maki, Miyako, 97, 104
Matsumoto, "Dirty," 134, 135
Matsumoto, Reiji, 15–16, 20, 21, 66, 96, 155, 156, 158, 188
Matsushita, Ichio, 56, 57, 61, 128
Matsuyama, Fumio, 60
Miyanishi, Keizō, 130
Miyao, Shigeo, 48–49, 69
Mizuki, Kyōko, 88, 156
Mizuki, Shigeru, 15, 31, 62, 74–75
Mizuno, Hideko, 66, 97, 98, 100
Mizushima, Shinji, 81, 140
Mochizuki, Akira, 20
Monkey Punch, 120, 129, 146, 154, 155
Morimura, Shin, 24, 129
Motomiya, Hiroshi, 76, 141
Murakami, Kazuhiko, 76
Muraoka, Eichi, 117
Nada, Asatarō, 118
Nagahara, Kōtarō, 42
Nagai, Gō, 24, 122, 124, 140, 142, 143, 155, 156, 157
Nagashima, Shinji, 141
Naka, Tomoko, 138
Nakahara, Jun'ichi, 94
Nakajima, Kikuo, 69
Nakamura, Ikumi, 134
Nakano, Yū, 135
Nakazawa, Keiji, 75, 108–9, 154, 155, 238
Narita, Akira, 153
Narushima, Sei, 117
Nishizawa, Shūhei, 112, 113
Nomura, Shimbo, 27

More on Japanese Comics

Many readers of this book will doubtless want to explore the world of Japanese comics on their own. Japanese comics—in magazine and book form—can usually be found anywhere in the world where there is a Japanese community with a bookstore. In the United States, Japanese comics are also beginning to appear in a few comic specialty shops in major cities. A good source of information is the Japan-oriented Cartoon/Fantasy Organization, a nationwide U.S. fan club with headquarters at 401 S. La Brea, Inglewood, California 90301. The following bibliography may also prove useful, for it includes general English-language references as well as visually oriented Japanese-language references that can be enjoyed without a knowledge of Japanese.

GENERAL ENGLISH-LANGUAGE REFERENCES

Blyth, R. H. *Oriental Humor*. Tokyo: Hokuseido Press, 1959.

Evans, Tom and Mary Anne. *Shunga: The Art of Love in Japan*. New York: Paddington, 1975.

Grant, Vernon. "Samurai Superstrips." *The Comics Journal*, no. 94 (October 1984), pp. 91–94.

Horn, Maurice. "Comix International." *Heavy Metal*, November 1980, p. 7. A good introductory article on Japanese comics.

——, ed. *The World Encyclopedia of Comics*. New York: Chelsea House Publishers, 1976. With entries for Japanese comics.

——, ed. *The World Encyclopedia of Cartoons*. New York: Chelsea House Publishers, 1980. With entries for Japanese cartoons and animation, and a brief history of both.

Imamura, Taihei. "Japanese Art and the Animated Cartoon." *The Quarterly of Film, Radio and Television 7*, Spring 1953, pp. 217–22.

Patten, Fred. "Dawn of the Warrior Robots: The Beginnings of a New Breed of Action Hero!" *Fangoria*, no. 4 (1980), pp. 30–35.

——. "TV Animation in Japan." *Fanfare*, no. 3 (1980), pp. 9–18.

——. "Mangamania!" *The Comics Journal*, no. 94 (October 1934), pp. 44–55.

Reitburger, Reinhold, and Fuchs, Wolfgang. *Comics: Anatomy of a Mass Medium*. Boston: Little, Brown and Co., 1971.

Rhodes, Anthony. *Propaganda: The Art of Persuasion*. New York: Chelsea House Publishers, 1976. Has excellent reproductions of Japanese wartime propaganda cartoons.

Schodt, Frederik. "Comics and Social Change." *PHP*, April 1984, pp. 15–25.

Stewart, Bhob. "Screaming Metal." *The Comic Journal*, no. 94 (October 1984), pp. 58–84.

Whitford, Frank. *Japanese Prints and Western Painters*. New York: Macmillan, 1977.

Yashima, Tarō. *The New Sun*. New York: Henry Holt, 1943. A dissident Japanese cartoonist's comic-book-style account of persecution prior to World War II.

Yronwode, Cat. "Gen of Hiroshima." *Comics Feature*, no. 2 (1980), p. 30.

VISUALLY ORIENTED JAPANESE-LANGUAGE REFERENCES

"Manga Dai Zukan" ("A Giant Pictorial of Comics"). Supplement of the series *Ichiokunin no Shōwashi*. Tokyo: Mainichi Shimbunsha, 1982.

Matsumoto, Reiji, and Hidaka, Satoshi, eds. *Manga Rekishi Dai Hakubutsukan* ("A Giant Museum of Comic History"). Tokyo: Buronzusha, 1980.

Miyao, Shigeo. *Nihon no Giga: Rekishi to Fūzoku* ("Japanese Cartoons: Their History and Place in Popular Culture"). Tokyo: Dai-ichi Hōki, 1967.

Nihon Manga Kyōkai, ed. *Nihon Manga Nenkan '76* ("The 1976 Annual of Japanese Comics"). Tokyo: Gurafikkusha, 1976.

"Nihon no Warai: Manga Sennenshi" ("The Humor of Japan: 1,000 Years of Comic Art"). Special edition of *Bungei Shunjū Derakkusu*, vol. 2, no. 10 (September 1975).

"Sashi-e/Manga ni Miru Shōwa no Gojūnen: Kabashima Katsuichi kara *Dame Oyaji* made" ("Fifty Years of the Shōwa Period, as Seen through Illustrations and Comic Art: From Katsuichi Kabashima to *Dame Oyaji*"). Special edition of *Asahi Graph*, 30 October 1974.

Shimizu, Isao. *Meiji Mangakan* ("A Museum of Meiji Comic Art"). Tokyo: Kōdansha, 1979.

——. *Meiji no Fūshi Gaka: Bigō* ("Bigot: The Meiji Period Parody Artist"). Tokyo: Shinchōsha, 1978.

——. *Taiheiyō Sensōki no Manga* ("Cartoons During the Pacific War"). Tokyo: Bijutsu Dōjinsha, 1971.

"Shōwa Mangashi" ("A History of Comics in the Shōwa Period"). A supplement in the series *Ichiokunin no Shōwashi*. Tokyo: Mainichi Shimbunsha, 1977.

"Shōwa Shimbun Mangashi" ("A History of Newspaper Comics in the Shōwa Period"). Supplement in *Ichiokunin no Shōwashi*. Tokyo: Mainichi Shimbunsha, 1981.

Terada, Hiro. *Manga Shōnen-shi* ("A History of *Manga Shōnen*"). Tokyo: Shōnan Shuppan, 1981.

Tezuka, Osamu. *Tezuka Osamu no Subete* ("Everything about Osamu Tezuka"). Tokyo: Daitosha, 1981. Has English notes.

Town Mook. *Gekigaka/Mangaka Ōru Meikan* ("Town Mook's Complete Encyclopedia of Comic Artists"). Tokyo: Tokuma Shoten, 1979.

TEXT-ORIENTED JAPANESE-LANGUAGE REFERENCES

"Ero Gekiga no Sekai" ("The World of Erotic Comics"). Supplement of *Shimpyō*, in a series on authors, Spring 1979.

Fujio-Fujiko. *Futari de Shōnen Manga Bakari Kaite Kita* ("All We've Ever Done Is Draw Boys' Comics"). Tokyo: Mainichi Shimbunsha, 1977.

"Gendai Manga no Techō" ("A Handbook of Modern Comics"). Special edition of *Kokubungaku: Kaishaku to Kyōzai no Kenkyū* ("Japanese Literature: Study of Criticism and Teaching Materials"), April 1981.

Hasebe, Toshio. *Shomin Manga no Gojūnen* ("Fifty Years of the People's Comics"). Tokyo: Nippon Jōhō Sentā, 1976.

Ishigami, Mitsutoshi. *Tezuka Osamu no Kimyō na Sekai* ("The Strange World of Osamu Tezuka"). Tokyo: Kisōtengaisha, 1977.

Ishiko, Jun. *Manga Meisakukan: Sengo Manga no Shujinkōtachi* ("A Museum of Comic Classics: Heroes of Postwar Comics"). Tokyo: Tokuma Shoten, 1977.

——. *Nihon Mangashi* ("A History of Japanese Comics"). Vols. 1 and 2. Tokyo: Ōtsuki Shoten, 1979.

——. *Shin Mangagaku* ("A New Comicology"). Tokyo: Mainichi Shimbunsha, 1978.

Ishiko, Junzō. *Gendai Manga no Shisō* ("Intellectual Currents in Modern Comics"). Tokyo: Taihei Shuppan, 1970.

——. *Sengo Mangashi Nōto* ("Notes on the Postwar History of Comics"). Tokyo: Kinokuniya Shoten, 1975.

Itō, Ippei. *Nihon no Mangaka* ("The Cartoonists of Japan"). Tokyo: Sangyō Keizai Shimbun, 1972.

Iwaya, Kokushi; Shimizu, Isao; Itō, Ippei; Ishigami, Mitsutoshi; Tanaka, Michio; and Yoshitomi, Yasuo. *Gendai Manga Shiatā 1: Tezuka Osamu* ("The Modern Comic Theater 1: Osamu Tezuka"). Tokyo: Seizansha, 1979.

JP Ripōto: Tokushū—Manga ("The Japan Paper-Pulp Company Report: Special Edition on Comics"). No. 36 (1981).

Kajii, Jun. *Sengo no Kashibon Bunka* ("Postwar Booklender Culture"). Tokyo: Tōkōsha, 1979.

Kusamori, Shin'ichi. *Manga-Erochishizumuko* ("Comics and

Thoughts on Eroticism"). Tokyo: Burēn Bukkusu, 1971.

Kyōdō Hōkoku-Jōhō Kyampusu V. *Teihen Emaki no Gakōtachi/Gekigaka* ("Unsung Painters of Picture Scrolls: The Drama Comic Artists"). Tokyo: Sangyō Hōkoku, 1972.

"Matsumoto Reiji no Sekai" ("The World of Reiji Matsumoto"). Supplement of *Shimpyō*, in a series on authors, Autumn 1979.

Matsuzawa, Mitsuo. *Nihonjin no Atama o Dame ni Shita Manga-Gekiga* ("The Comics That Have Ruined Japanese Minds"). Tokyo: Yamate Shobō, 1979.

Minejima, Masayuki. *Gendai Manga no Gojūnen: Mangaka Puraibashi* ("Fifty Years of Modern Comics: A Private History of Comic Artists"). Tokyo: Aoya Shoten, 1975.

Okamoto, Ippei. *Ippei Zenshū* ("The Collected Works of Ippei"). Tokyo: Senshinsha, 1930.

Ozaki, Hotsuki. *Gendai Manga no Genten: Warai Kotoba e no Atakku* ("The Origin of the Modern Comic: An Attack on Laughter"). Tokyo: Kōdansha, 1972.

——. *Manga no Aru Heya: Gendai Manga e no Shikaku* ("A Room with Comics: A Perspective on Modern Comics"). Tokyo: Jiji Tsūshinsha, 1978.

Satō, Tadao. *Nihon no Manga* ("Japanese Comics"). Tokyo: Hyōronsha, 1973.

Shimizu, Isao. *Meiji Manga Yūransen* ("An Excursion into Meiji Comic Art"). Tokyo: Bungei Shunjū, 1980.

"Shōjo Manga." Special edition of *Eureka: Shi to Hihyō*, vol. 13, no. 9 (July 1981).

Soeda, Yoshiya. *Gendai Mangaron* ("A Theory of Modern Comics"). Tokyo: Nihon Keizai Shimbunsha, 1975.

Suyama, Keiichi. *Manga Hakubutsushi: Nipponhen* ("An Almanac of Comics: Japan"). Tokyo: Banchō Shoten, 1972.

——. *Nihon Manga Hyakunen* ("One Hundred Years of Japanese Comic Art"). Tokyo: Haga Shoten, 1968.

Takemiya, Keiko, and Moto, Hagio. *Shōjo Mangaka ni Nareru Hon* ("How To Become a Girls' Comic Artist"). Tokyo: Futami Shobō, 1980.

Tezuka, Osamu. *Boku wa Mangaka: Tezuka Osamu Jiden 1* ("I Am a Cartoonist: Volume 1 of Osamu Tezuka's Autobiography"). Tokyo: Yamato Shobō, 1979.

——. *Manga no Kakikata: Nigao kara Chōhen made* ("How To Draw Comics: From Portraits to Story-Comics"). Tokyo: Kōbunsha, 1977.

——. *Tezuka Osamu Rando* ("Osamu Tezuka-Land"). Tokyo: Yamato Shobō, 1977.

——. *Tezuka Osamu Rando 2* ("Osamu Tezuka-Land: Volume 2"). Yamato Shobō, 1978.

Yokoyama, Ryūichi. *Waga Yūgiteki Jinsei* ("My Playful Life"). Tokyo: Nihon Keizai Shimbunsha, 1972.

Yonezawa, Yoshihiro. *Sengo Gyaggu Mangashi* ("A Postwar History of Gag Comics"). Tokyo: Shimpyōsha, 1981.

——. *Sengo SF Mangashi* ("A Postwar History of Science Fiction Comics"). Tokyo: Shimpyōsha, 1980.

——. *Sengo Shōjo Mangashi* ("A Postwar History of Girls' Comics"). Tokyo: Shimpyōsha, 1980.

Last Words

A book about Japanese comics?!! The idea had its genesis back in 1970. I was struggling to learn Japanese at a university in Tokyo where the textbook for foreigners contained passages from Einstein's theory of relativity. My Japanese student friends were reading gigantic comic magazines.

When I first picked up one of these magazines I found that it was written in a living language my studies had scarcely prepared me for, but that with the aid of the drawings I could make some sense of the plots. One story still sticks in my mind: it starred a young Japanese samurai who travels to the American Wild West and eventually becomes a gunslinger. Its familiar setting and curious mix of American and Japanese values made it both accessible and intriguing. I was hooked.

I would here like to thank the many people on two continents who helped make this book possible, particularly the artists, publishers, libraries, temples, and museums that consented to reproduction of drawings in their possession.

Some people also deserve specific mention. Without the help of my editor, Peter Goodman, all would have been naught. He is responsible for encouraging an idea vaguely expressed in 1978, and for guiding me as I struggled to build this book. When I floundered with bits and pieces and agonized over snags in negotiations, his advice was always clear and true. What seemed destined to fall on its face, finally flew.

I would also like to thank the following.

Artists Fujio Akatsuka, Fujio-Fujiko, Riyoko Ikeda, Shōtarō Ishimori, Hiroshi Kurogane, Reiji Matsumoto, Ichio Matsushita, Gō Nagai, Keiji Nakazawa, Akira Narita, Katsuhiro Ōtomo, Monkey Punch, Takao Saitō, Machiko Satonaka, Shin'ichi Suzuki, Osamu Tezuka (and his manager, Takayuki Matsutani), Waki Yamato, Mitsu Yashima, and Tarō Yashima.

Editors of Kōdansha, Shōgakkan, Hōbunsha, Shūeisha, San Shuppan, and the president of Futabasha, Fumito Shimizu.

Representatives of Kyōdō Insatsu (printers), Kokuhōsha (binders), Sankoshi (paper recyclers), Nippon Shuppan Hambai (distributors), Shuppan Kagaku Kenkyūjo (the Publishing Science Institute), the Sayama Warehouse of Dai-ichi Tosho Inc., the comic paperback sales division of Kōdansha, Marvel Comics in Japan, and Studioship.

Kōsei Ono, Isao Shimizu, and Ishiko Jun (three comic critics and historians), *kami-shibai* artist Masao Morishita, *Ōtsu-e*

artist Shōzan Takahashi, and the president of Hiro Media, Hiro Shibazaki.

Many libraries and individual collectors gave me permission to photograph their holdings, and I am particularly grateful to Kazuhiko Suyama, for his patience when I photographed his father's collection with the wrong exposure and had to do retakes (figs. 23, 33, 37, 38, 52, 54–56, 64, 67, 72); to Reiji Matsumoto; to the Kōdansha library; to the Hirō Public Library; to Isao Shimizu (figs. 39, 40, 42, 43); to the Ōmiya Manga Kaikan (figs. 31, 44, 45, 53); to the Schumolowitz Collection of Wit and Humor in the San Francisco Public Library (figs. 35, 46).

And thanks to the following for permissions: Eiseibunko (fig. 28); Emman'in, Miidera (fig. 27); Gotō Museum (fig. 112); Kōzanji (fig. 24); Mainichi Shimbunsha (fig. 78); Ichio Matsushita (fig. 68); the Naiki Collection (fig. 79); Shinjuan, Daitokuji (fig. 26); Tokyo National Museum (figs. 25, 32); University of California Berkeley Library (figs. 41, 48). Figure 36 is used courtesy of the Honolulu Academy of Arts, Gift of Mrs. Walter F. Dillingham given in memory of Alice Perry Grew, 1960. Figures 49 and 70 are reprinted by special permission of King Features Syndicate, Inc.; world rights protected. The Yoshitoshi sample on page 1 is from the Kanagawa Prefectural Museum.

Thanks also to my partners in Dadakai—Shinji Sakamoto and Jared Cook—especially for Jared's help in the initial brainstorming of this book; to the Narita family of artists, especially to Akira for the line drawings that adorn the text; to Michiko Uchiyama and Michiyo Kashiwagi for editorial, layout, and liaison work; to Shigeo Katakura for art direction; to Okada, the Murakamis, the Inoues, and all my friends in Japan for their spiritual and logistical support on my trips to that country; and to Project Gen on both sides of the Pacific.

Finally, thanks to Leonard Rifas, Robert Takagi, and my parents for comments on drafts, and to my special friend Peg Linde for her long-term assistance and understanding.

Frederik L. Schodt